Decorative Arts at Manchester City Art Galleries. She now works for Philips Auctioneers and specializes in ceramics and modern design.

The most authoritative and up-to-date reference
books for both students and the general reader.

Oxford Paperback Reference

The Concise
Oxford Dictionary of

Art
Terms

MICHAEL CLARKE

Consultant Editor, Decorative Arts
DEBORAH CLARKE

OXFORD
UNIVERSITY PRESS

OXFORD
UNIVERSITY PRESS

Great Clarendon Street, Oxford OX2 6DP

Oxford University Press is a department of the University of Oxford.
It furthers the University's objective of excellence in research, scholarship,
and education by publishing worldwide in

Oxford New York

Auckland Bangkok Buenos Aires Cape Town Chennai
Dar es Salaam Delhi Hong Kong Istanbul Karachi Kolkata
Kuala Lumpur Madrid Melbourne Mexico City Mumbai Nairobi
São Paulo Shanghai Taipei Tokyo Toronto

Oxford is a registered trade mark of Oxford University Press
in the UK and in certain other countries

Published in the United States
by Oxford University Press Inc., New York

British Library Cataloguing in Publication Data

Data available

Library of Congress Cataloging in Publication Data

Data available

ISBN 0-19-280043-4

10 9 8 7 6 5 4 3 2

Typeset in Swift and Frutiger by Kolam Information Services Pvt. Ltd, Pondicherry, India
Printed in Great Britain by Clays Ltd, St. Ives plc

Preface

The prime purpose of this dictionary is to be of use. Museums, galleries, books, and radio and television broadcasts ensure that we are surrounded by references to the visual arts. Art is no longer available only to princely collectors and their courts or to the Grand Tourists of the 18th century. It is widely discussed in the media, eagerly promoted in a dizzying and ever-changing programme of exhibitions world-wide, and its acquisition is encouraged in general and specialized magazines and in the supplements to broadsheet newspapers. The relatively low cost of international travel and the growth of 'cultural tour' packages to suit most wallets have meant that access to the world's treasures is open to an ever-growing number of us. And for those who are unable, or unwilling, to make the physical journey there is, increasingly, the opportunity of the 'virtual' visit on the Internet.

The vocabulary of art and architecture is often complex, however, and can constitute a real impediment to enjoyment and understanding. This concise dictionary, which should fit into most jacket pockets or travelling bags, is intended as a work of quick and easy reference, to be consulted as and when difficulties present themselves. It embraces a wider range than most dictionaries of its type and covers the fine and decorative arts as well as architecture.

As a first-time lexicographer I am acutely aware of my debts to others in this field. Particular mention should be made of *The Oxford Dictionary of Art* 2nd edn (Ian Chilvers, Harold Osborne, Dennis Farr) Oxford and New York, 1997, and of Ian Chilvers's wholly excellent *Oxford Dictionary of 20th-Century Art*, Oxford and New York, 1999. Inevitably, one is aware of the Herculean labours of John Fleming and Hugh Honour, notably *The Penguin Dictionary of Decorative Arts*, Harmondsworth, 1977 and (with Nikolaus Pevsner) *A Dictionary of Architecture* (revised edition), London, 1975. Architectural terms are also very well covered in James Stevens Curl's *Encyclopedia of Architectural Terms*, London, 1993. Since their appearance in 1996 there have, of course, been the magisterial thirty-four volumes of *The Dictionary of Art* (editor Jane Turner) London and New York, the most comprehensive publication of its type and a landmark in art publishing history. By its very nature, however, it is not a work of quick reference and is really intended for library or institutional purchase.

I would like to thank Professor Richard Thomson for initially suggesting I undertake this dictionary. At Oxford University Press, Angus Phillips enthusiastically set me on my way and I have been further sustained by Vicki Rodger and Ruth Langley. Tom Chandler corrected many infelicities and omissions, and Patrick Elliott also gave kind assistance. My greatest debt is to my wife Deborah, whose expert contribution is reflected in her designation as Consultant Editor, Decorative Arts.

For Oliver, Alexander, and Emily

abacus The slab at the top of a *capital which supports the *entablature above. In the *classical *Orders the Greek *Doric abacus is a thick square slab; in Greek *Ionic, *Tuscan, Roman Doric and *Ionic it is square with a moulded lower edge; and in the *Corinthian and *Composite it has concave sides with the corners cut off.

abbey The buildings occupied by a religious community, partially or wholly secluded from the world, of monks or nuns under the jurisdiction of an abbot or abbess. Abbeys frequently competed with each other as centres of pilgrimage and were often richly endowed with relics, furnishings, and libraries of great importance. During the Middle Ages abbeys were major centres of architecture and painting. For a discussion of the architecture, *see* MONASTERY.

abrasion A damaged area of paint in a painting, resulting from the scraping, rubbing down, or grinding away of the upper paint layers.

abstract art A term which can generally be applied to any non-representational art (most *decorative art, for example), but which is more specifically used, from the early 20th century onwards, to describe painting and sculpture which are deliberately non-representational. Implicit to abstract art is the notion that the work of art exists in its own right, and not necessarily as a mirror of reality. The Russian artist Wassily Kandinsky (1866–1944) is generally credited with producing the first abstract painting *c.*1910. In the decade 1910–20 a number of movements such as *Cubism, *Suprematism, and *De Stijl either developed or embraced abstraction. In its many forms abstraction has been one of the main preoccupations of much modern art.

Abstract Expressionism A description generally applied to aspects of modern American painting in the late 1940s and early 1950s which were concerned both with the various forms of abstraction and with psychic self-expression. Abstract Expressionism was more of an attitude than a style, drew on many historical sources from Van Gogh to Matisse and Kandinsky, and embraced a wide variety of paintings ranging from the *drip paintings of Jackson Pollock to the intensely coloured floating shapes of Mark Rothko. Although the term had been known since the 1920s, when it was used to describe Kandinsky's abstract paintings, it was first employed to describe contemporary painting in 1946, by Robert Coates in the *New Yorker* magazine. Championed by the critics Harold Rosenberg and Clement Greenberg (who in 1948 declared that the future of western art depended on this phase in American painting), Abstract Expressionism gained widespread acceptance in the 1950s, at first in America and then internationally (the first American movement to do so),

the European variant being *Art Informel, a term coined by Michel Tapié in 1952.

Abstraction-Création The name taken by a group of abstract painters and sculptors formed in Paris in 1931 in the wake of the first international exhibition of abstract art held there in 1930. The association, whose membership at one time rose to 400, was a loose one embracing a wide range of non-figurative art including *Constructivism (Gabo, Pevsner, and Lissitzky), *Neo-Plasticism (Mondrian), the expressive abstraction of Kandinsky, and some forms of abstract *Surrealism. Founded as a successor to the *Cercle et Carré, it was intended, as its name implies, to encourage 'creative' abstraction. It arranged group exhibitions and published an illustrated annual *Abstraction-Création: Art non-figuratif* 1932–6. The emphasis increasingly fell on geometrical rather than expressive or lyrical abstraction due to the predominance of the Constructivists and the supporters of *De Stijl. After *c*.1936 the activities of the association dwindled as some of the leading Constructivists moved from France to England.

abutment A solid architectural block, usually of masonry, designed to counteract the lateral thrust of a *vault or *arch. Abutments were typically used in massive, round-arched *Romanesque buildings.

académie A drawing of a human figure, usually a nude or partially clothed model, executed as a practice study or for purposes of instruction. So called because such studies were particularly associated with the courses of instruction given at the French Académie, both in Paris and Rome, where many fine chalk (usually red chalk) drawings were produced by the major artists of that national school, particularly in the 18th century.

academy [From the ancient Greek *akadēma*, a gymnasium near Athens where Plato taught his pupils philosophy] an association or school of artists, scholars, etc. arranged in a professional institution. In recent times the term was first used in Italy in the early 15th century to describe meetings of literati. By the 16th century it had been adopted to describe artists' corporations which included the teaching of subjects such as drawing after antique statuary and the live model, and also the study of anatomy, geometry, perspective, history, etc. Thus painting was raised from the status of a mere craft, as had been the case with medieval artists' *guilds, to that of a *liberal art. Around 1600 the concept of the artists' academy spread from Italy to Spain and the Netherlands, but took particularly powerful root in Louis XIV's France with the establishment in 1648 of the Académie Royale de Peinture et de Sculpture. Its teaching methods remained current in most art schools, such as the English Royal Academy (founded in 1768), until the mid-20th century.

academy board An inexpensive board, made of cardboard, used as a surface for oil painting since the early 19th century, primarily for small paintings and sketches. Its cheapness made it particularly popular with *amateurs.

acanthus A plant found on the shores of the Mediterranean and particularly admired by the Greeks and Romans for the elegance of its leaves. The acanthus was widely used in *classical architecture as a decorative feature, possibly the earliest instances being on the Parthenon and the Erechtheion in Athens. It was often employed to decorate the lower part of the *capitals of the *Corinthian and *Composite Orders.

acrolithic [From the Greek, literally 'stone-ended'] originally used to describe ancient Greek figure sculpture in which the extremities were made of stone or marble. The main body was of wood (often painted and gilded) or limestone, with head and arms and feet of marble. In a development from Greek acrolithic sculpture, many Roman sculptures were made from a combination of materials such as *porphyry, *bronze, and *marble.

acropolis [From the Greek, literally a 'high city'] the *citadel of a Greek city, placed at its highest point and containing the chief *temples and buildings, as at Athens.

acroterion The *plinth or *pedestal at the apex and lower extremity of a *pediment, it can support statuary or be left empty.

acrylic colour An *emulsion paint employing a synthetic *medium (acrylic resin), first used in the 1940s. It has proved a serious rival to *oil paint with many modern artists, most famously with David Hockney. It is soluble in water, quick-drying, and can be used on a variety of surfaces. Acrylic colours do not yellow and can be easily removed with mineral spirits or turpentine. For these reasons they are often used in conservation work.

Action painting A technique of painting in which paint is dribbled, splashed, and poured over the canvas. Its most famous exponent was the American painter Jackson Pollock (1912–56). The term was first used in 1952 by the critic Harold Rosenberg in his affirmation of the then current belief that a painting should reflect the actions of its creation. *See* ABSTRACT EXPRESSIONISM.

Actions (or Aktionismus) Proceeding from the notion of the artist as actor and from an interest in the nature of the creative process, Actions was a catch-all term for live works presented inside art galleries or on city streets in the late 1950s and the 1960s by artists such as Yves Klein and Piero Manzoni. Around 1960 Klein started to make paintings with 'living' brushes—nude women covered in paint and 'blotted' onto canvas. Manzoni's 'living sculptures' consisted of individuals signed by the artist. 'Aktionismus' was a group of Viennese artists who created thematically related Actions beginning around 1960. They explored Freudian themes of erotic violence using bodily materials such as blood, meat, and semen in specially staged events. Their investigation of the dark side of the psyche was partly a reaction against the interest in creative abstraction which had characterized the 1950s. Actions and Aktionismus both anticipated the *body art which followed in the later 1960s and 1970s.

Adam style An architectural style based on the works of the Scottish architect Robert Adam (1728–92) and his brothers John and James. Essentially a picturesque version of *Neoclassicism and particularly concerned with decoration, it dominated British taste between 1760 and 1780 and greatly influenced interior and furniture design. It was characterized by clarity of form, subtle detail, and, in architectural decoration, by unified schemes of clear colouring, often set against relatively shallow and elegant *stucco work. Fine examples of Adam's decorative style can be seen at Syon House, Middlesex (1762–4) and Kedleston Hall, Derbyshire (1761).

adobe Unburned brick dried in the sun, most commonly used for building in Spain and Latin America.

aedicular frame The architectural, sometimes free-standing type of picture frame which evolved in Italy in the 14th century and was used in the *Renaissance for altarpieces and devotional images. In structure it drew on both classical and ecclesiastical architecture and reflected regional styles. In its simplified, less ambitious, form it was also known as a 'tabernacle frame'.

aedicule [From the Latin *aedicula*, 'a small building/temple'] originally a shrine set in a temple containing a statue framed by columns supporting an *entablature and a *pediment. The term is used generally to describe the architectural framing of doors, windows, or other openings with *columns or *pilasters supporting *gables, pediments, *lintels, etc.

aerial perspective The illusion of distance in the landscape in a painting achieved by making objects paler and bluer the further they are from the viewer. The term was invented by Leonardo da Vinci, though aerial perspective had been known since antique mural painting. Among its most famous later exponents were the landscape painters Claude Lorrain and Turner. The French *Neoclassical landscape painter P.-H. de Valenciennes, in his fundamental treatise of 1800, *Élémens de perspective . . .*, described aerial perspective as 'the effect of vaporous or ambient air between different objects'. For perspective achieved by linear means, *see* PERSPECTIVE.

Aeropittura A later manifestation of *Futurism, concerned with the sensations induced by the technical phenomena of modern life, especially flying. Filippo Tommaso Marinetti published the manifesto *Aeropittura* in 1929 and exhibitions of the same name were held in 1931, 1932, and 1934, the last in Berlin, where the artists enjoyed the patronage of Goebbels.

Aesthetic Movement A movement in the *fine and *decorative arts and architecture of the 1870s and 1880s, which manifested itself first in Great Britain and subsequently in the United States. Its defining beliefs were in the supremacy of the beautiful and the autonomy of a work of art, adapted from the French concept of *'art for art's sake'. The artist who most closely approached these ideals was the American James McNeill Whistler, most famously in the *Peacock Room* he decorated for F. R. Leyland (now in the Freer

Art Gallery, Washington, DC). In addition to the peacock, the sunflower was also a popular motif of the Aesthetic Movement, and featured, for example, in the tiles and vases designed by William de Morgan. Among critics, the movement found its most eloquent supporters in Walter Pater, Algernon Swinburne, and Oscar Wilde.

aesthetics [From the Greek *aisthētíka*, 'perceptible things'] the philosophy of the beautiful in art and *taste. The term was first used around the middle of the 18th century by the German philosopher Alexander Gottlieb Baumgarten.

after When used before an artist's name in descriptions of a work of art, for example 'after Rubens', it denotes that the design or painting is of a later date and made in direct imitation of a known work by Rubens. In the context of reproductive printmaking, 'after' preceding an artist's name denotes the original design was by him but the print was made by another, i.e. a specialist printmaker.

after-cast A *cast, normally in metal, made from a *mould taken from a finished piece of sculpture. Because metal shrinks on cooling, the after-cast is smaller than the original. Its details are also usually less precise.

agate A fine-grained, banded *chalcedony which can come in all colours in a variety of strengths. It is often an opaque grey which can be sliced and polished to bring out the concentric patterns. It can also be dyed to strengthen the colour, an art known to the Romans. By the 16th century the most important deposits were in the Rhineland and a local industry sprang up at Idar-Oberstein, creating gemstones from locally mined agate. In the mid-19th century there were 153 polishing shops in the area and agate had to be imported from Brazil. Agate was used for a wide variety of decorative objects. The Egyptians used it for cylinder seals, ring stones, and small vessels. Later it was employed as a layer stone from which *cameos were cut and mounted into jewellery, as well as other small items such as handles for knives and forks, manicure sets, and pill boxes. The main sources of good agate today are in Brazil and Uruguay.

agate ware *Pottery made to resemble *agate. Different coloured clays were combined to imitate the veining of the hard stone. It was made by the Romans and revived in the 18th century in *Staffordshire.

agora An open space in an ancient Greek city which served as a marketplace and general place of rendezvous. It was usually surrounded by *colonnades.

agrafe A French term for a curved, convex relief ornament whose sinuous form is suggestive of shells, soft marine creatures, and *cartouches. They were often used as window *keystones in the first half of the 18th century.

agréé [French, 'accepted'] denoted a French artist who, on the strength of winning the *Prix de Rome, had been awarded a travelling scholarship to study at the French Academy in Rome, at the end of which period he was

expected to submit a *morceau de réception* ('reception piece') to the main Academy back in Paris, on the acceptance of which he would be **reçu* ('received') into full membership of the Academy.

airbrush An instrument, looking rather like an outsize fountain pen, which sprays paint or varnish by means of compressed air. It was first developed in the earlier 20th century in the fields of the graphic and commercial arts. Later it was adopted by various artists in movements such as *Pop art and *Superrealism who wished to give a smooth finish to their works, often in conscious imitation of the airbrush's association with the world of advertising.

airtwist Spiral patterns drawn from air bubbles enclosed in the stem of a wine glass, used as a form of decoration in the 18th century. White or coloured threads in spiral patterns were known as 'opaque twist'.

aisle The lateral divisions of a *basilica or *church parallel to the *nave, *choir, or *transept, from which they are divided by *piers, *columns, or, more rarely, by screen walls. Normally the aisles are lower than the central part of the building, but in German *hall churches they are the same height as the nave.

alabaster A form of *gypsum or *limestone, alabaster is a soft and easily carved stone which has been particularly used for sculpture that is not exposed to the elements. It is found, for example, in the wall reliefs of ancient Assyrian palaces and in the tomb effigies of medieval European churches. It was much used in late medieval and early *Renaissance sculpture in northern Europe, with Malines being a notable centre of excellence. More specifically, in England it was frequently used from the mid-14th century until the Reformation for small carvings of religious scenes. A particular centre of manufacture was Nottingham. Since its revival as a popular medium in late 18th-century Italy for ornamental objects such as vases, *pedestals, and clock-cases, it has continued to be used for such purposes to the present day.

à la polonaise A term used to describe an elaborate canopy over a bed, heavily draped and culminating in a peaked, tent-like structure.

à la reine A term used to describe chairs without arms and with slightly inclined flat backs.

album A bound and mounted collection of drawings, prints, or photographs. The word is sometimes included in the nomenclature for an otherwise unidentified artist who is associated with a particular album, for example the so-called Master of the Egmont Albums (active in the second half of the 16th century), so named after the albums put together in the early 18th century by the first Earl of Egmont.

albumen print Photographic prints made from glass negatives on paper coated with albumen (white of egg) containing salt and sensitized before

use with silver salts. The method came into widespread use in the 1850s and its popularity lasted until the 1890s.

alcazar A Spanish palace or fortress of Moorish origin.

alentours [From the French, 'surroundings'] denotes a type of border for tapestries, first produced at the *Gobelins factory for a set illustrating Don Quixote in 1714. Whereas earlier tapestry surrounds had simulated a picture frame, alentours consisted of *trompe l'oeil garlands of flowers, ribbons, birds, etc. which filled the greater part of each composition with a figurative scene, often in a simulated picture-frame, placed in the centre.

all'antica [From the Italian, 'after the antique'] denotes a work of art based on a classical model.

alla prima [From the Italian, 'at first'] used to describe painting directly on to the canvas without preliminary underdrawing or underpainting (i.e. building up successive layers of paint). Synonymous terms are 'wet on wet', 'direct painting', and the French *au premier coup*.

allegory The representation of an abstract quality or idea through a series of symbols or persons given symbolic meaning. Allegories were particularly popular in *Renaissance and *Baroque art. For example, Rubens's famous *Allegory of War and Peace* (National Gallery, London) of 1629–30, the political sub-text of which was the desired peace between England and Spain, is enacted by Minerva, Goddess of Wisdom, driving away Mars, God of War, in order to protect the fulsome figure of Pax (Peace).

Alliance of Youth An artists' association formed in St Petersburg, Russia, in 1909, it was pro-western and particularly pro-Munich (where artists such as Kandinsky, Jawlensky, and Münter had settled). It held exhibitions 1910–13.

Allied Artists' Association Formed in London in 1908, it was a group of progressive, pro-French artists which was led by Walter Sickert. Their models were Cézanne, Gauguin, and Van Gogh and their first exhibition was held in 1908. The *Camden Town Group evolved from the Association in 1911.

all-over painting A term first applied to the *Abstract Expressionist *drip paintings of Jackson Pollock which appeared to have no top or bottom and implied extension beyond the canvas. Later the term was applied to the works of other artists which had an overall design of almost identical elements or a nearly uniform colour-field, both of which, by implication, could extend beyond the confines of the canvas.

alloy A metal made by combining two or more metallic elements to give greater strength, for example *tin mixed with *copper creates the alloy *bronze, widely used for sculpture since ancient times.

almonry A building near the church in an *abbey provided with offices for the distribution of alms and accommodation for the almoner.

almshouse A house for the shelter of the poor or old persons. Almshouses were privately endowed and in England the majority came into being to fill the gap in such care after the Dissolution of the *Monasteries completed by Henry VIII 1539–40. Almshouses often comprise ranges of houses round a courtyard with a hall and a chapel, though in their humbler form they can consist of just a few houses.

altar Originally the elevated table or podium on which sacrificial offerings to the deities were placed. In Christian churches the altar is consecrated for the celebration of the Sacrament. The principal or high altar is at the east end of the church, other altars devoted to particular saints may be in the side chapels. From the 6th century onwards altars were of stone and often enclosed relics in the altar-slab. The Reformation encouraged the use of wooden Communion tables instead.

altar-frontal A rectangular hanging covering the front face of the altar.

altarpiece A picture, sculpture, screen, or decorated wall standing on or behind an *altar in a Christian church. There are two main types: the *reredos, which rises from the ground behind the altar; and the *retable, which stands either on the back of the altar or on a pedestal behind it.

alto-rilievo Italian for *high relief.

amateur Of French origin, 'amateur' originally denoted a lover of art and, by implication, often a collector. French sale catalogues of the 18th century were frequently of the collections of '*un grand amateur*'. By the end of that century, however, the word had taken on a different meaning in English, describing someone who practised art for pleasure and interest, but not for money, i.e. professionally. Amateur artists usually worked in the graphic media—drawing and watercolour—in which they received instruction from *drawing-masters or *drawing manuals.

amber A fossil *resin found most extensively in East Prussia on the shores of the Baltic Sea, it was often fashioned into beads and ornaments and used for the decoration of furniture. Medieval writers frequently refer to it in their recipes as a binding agent, but it is extremely hard and therefore not particularly soluble: they may have confused it with other softer resins.

ambient light A term used to describe general, even illumination of a scene from no apparent direction, as opposed to directional or localized illumination.

amboyna A richly coloured, tightly grained wood, commonly used during the 18th century and *Regency period, usually as a *veneer.

ambrotype An early photographic process, which involved bleaching a glass negative and laying it on a black background, the ambrotype was a cheaper and easier alternative to the *daguerrotype. It became a popular portrait medium in the 1850s.

ambulatory A covered place in which to walk, such as a *cloister. It is more specifically used to describe the *aisle, used for processions, enclosing a sanctuary and joining two chancel-aisles behind the high altar—as in an ambulatory church.

American Colonial A style of architecture and furniture developed by settlers in America between 1620 and 1775 and deriving broadly from English styles. Perhaps the most notable achievements were the clapboard (weather-boarded) timber frame houses with posts and beams and sometimes a *verandah. These were broadly based on the *Georgian style and in the 18th century a simplified form of *Palladianism was developed. Gradually distinctive regional variations evolved in centres such as Albany, Boston, and Philadelphia.

American Scene painting A movement in American painting, beginning in the mid-1920s and culminating in the 1930s, which concentrated on realistic art with a social content. It was nationalistic and small-town in spirit, anti-modernist and anti-international, and was symptomatic of the isolationism of parts of America in the period following the First World War. Its first major painters were Charles Burchfield and Edward Hopper.

amethyst A gemstone which is a type of *quartz, purple or violet in colour. It used to be the favourite gemstone of high officials of the Christian Church. The finest crystalline amethyst occurs in gas cavities in volcanic rocks in India, Uruguay, and Brazil.

amorino [Italian, 'little cupid'] a chubby, naked winged boy used in European *decorative art from the *Renaissance onwards. The type derives from Greek and Roman representations of the love-god Eros/Cupid but is reinterpreted in Christian art as a child-angel.

amphitheatre An elliptical or circular space, surrounded by rising tiers of seats, used by the Romans for large-scale spectacles and gladiatorial contests. The best-known example is probably the Colosseum in Rome.

amphora An ancient Greek jar, of two-handled form, with flared neck, used for the storage of oil or wine.

Analytical Cubism A term used to describe the first phase (1909–11) of the mature *Cubism of Picasso and Braque. During this period of cerebral analysis and near-abstraction in their paintings they visually took objects apart and then reassembled them on the canvas in a different order, using a very shallow projection of space and a minimum of colour. Typical examples are Braque's *The Portuguese* (Kunstmuseum, Basel) and Picasso's *The Accordionist* (Guggenheim Museum, New York), both of 1911.

anamorphosis [From the Greek *anamorphōsis*, 'transformation'] a visual trick consisting of a deliberate distortion (such as elongation) of an object represented in a painting or drawing which, if viewed from a certain point or reflected in a curved mirror, appears normal again. Famous examples

include the skull in Holbein's painting of *The Ambassadors* of 1533 (National Gallery, London) or the portrait of *Edward VI* (National Portrait Gallery, London).

anastasis [Greek, 'raising or setting up again'] the Easter picture of the Orthodox Church, it depicts the 'Harrowing of Hell' with Adam and Eve rising from their graves and stretching out their hands to Christ.

andiron A metal object to hold burning logs above the level of the hearth. Normally made of iron, finer examples were made of *bronze, *brass, or even *silver.

Anglo-Saxon Art produced in England during the period between the Germanic invasions of the later 5th century and the Norman Conquest of 1066. The invading Angles, Saxons, Jutes, and possibly Frisians settled all over lowland England, pushing the native British into Wales and the far south-west. Paganism replaced the Christianity that had survived from late Roman times and little of artistic interest survives from these years. However, missions of the 6th and 7th centuries encouraged a conversion to Christianity which led to the construction of stone buildings and crosses and the production of liturgical books, vessels, and vestments. At the same time a strong *Celtic influence from the outlying parts of Britain ensured a rich mixture of traditions. This was severely disrupted, however, by the *Viking invasions beginning in the mid-9th century. The main artistic impact of Viking art was in the field of metalwork. Under the church reforms of the late 10th century there was a renewed flowering of art and architecture.

animal style A term applied to a style of ornamental decoration on portable goods which first appeared in the 7th century BC and which was spread eastwards by nomadic peoples from Europe to Asia. It did not become well known until the 18th and 19th centuries when the barrows (grave-mounds) of southern Russia were first excavated.

animation A technique used in motion pictures or video production, produced frame by frame, in which inanimate objects, such as cartoon drawings or puppets, appear to move of their own accord.

anneal A toughening process in *firing an object by exposure to a heat that is only slowly reduced. Normally applied to *glass that would otherwise be too brittle, it is also sometimes used for metals, *pottery, and *porcelain.

annulet In architecture, a horizontal ring round a *column.

antechamber An apartment through which access is gained to the main room beyond it.

antependium The finish or covering for the front of an *altar, often of elaborately woven fabric, or of metal. Also known as an altar-front or altar-facing.

antepodium A seat for the clergy in the *choir of a church.

anthemion [From the Greek *anthē*, 'flower, blossom'] it describes a band of architectural decoration consisting of alternating *palmettes and lotus motifs or two types of palmette (one open, the other closed). Normally applied to a cornice or the necking of an *Ionic capital, this type of ornament was much used in the late 18th century.

anti-art A loosely used term associated with art which debunks the traditional categories or concepts of art. It was supposedly coined by Marcel Duchamp in 1914. *Dada was considered the first anti-art movement.

antic A term used to denote the fantastic, bizarre, or distorted nature of a particular piece of sculpture or decoration.

anti-macassar A protective covering for the back of chairs and sofas, used to prevent macassar hair oil staining upholstery. It originated in the early 19th century with the introduction of hair oil in place of powdered wigs for men. Anti-macassars were made in a wide variety of materials, such as embroidered cloth, white crochet-work, *Berlin woolwork, and patchwork. Popular until the end of the century, anti-macassars were also widespread in America, where they were known as 'tidies'.

antimony A metallic element, grey in colour, used especially in *alloys, commonly with *lead.

antiphonary (or antiphonal) A type of *choir book, used for the singing of the antiphons, the responses for the Divine Office. Although antiphonaries had been in common use since *Early Christian times, they only began to be illustrated from around AD 1000. In the Middle Ages rich pictorial cycles were preferred, but from the 14th century word and music took precedence over pictures, the latter confined to *historiated initials and *grotesques in the margins.

antiquary A student or collector of antiques or antiquities.

antique The physical remains of the Greek and Roman world, especially sculpture. The antique proved an inspiration for artists through the ages and, for many, a canon of perfection. Although traces of the antique are found throughout medieval art, it was in the early *Renaissance of the 15th century that there was a strong revival of interest, with artists such as the sculptors Ghiberti and Donatello attesting to their admiration of antique statuary. Famous collections of antique art were formed, such as that of Lorenzo de' Medici in the gardens of San Marco, Florence, where the young Michelangelo first encountered the antique in any quantity. Vasari claimed that the perfection achieved by Leonardo, Michelangelo, and Raphael was due in large measure to their study of the classical statues in the Vatican collection, especially the *Apollo Belvedere* and the *Laocoon*. By the mid-16th century the study of the antique was firmly established in the curriculum of many artists. In the following century it was famously defended by G. P. Bellori, collector, theorist, and friend of Poussin, in his essay *Idea* in which

he claimed for classical statuary the embodiment of an absolute beauty. Further statues joined the academic canon such as the *Farnese Hercules* and the *Medici Venus*. After the perceived frivolities of the *Rococo in the first half of the 18th century, the antique was seen as a necessary corrective, extolled in the writings of Winckelmann and manifested in *Neoclassical art. The perception of classical art was radically altered in the late 18th century by the discoveries of travellers to Greece and the growing realization that many Roman works of art were actually copies of Greek originals. By extension, 'antique' can generally be used to refer to anything that is vaguely old. Thus an 'antiques shop' can sell a whole variety of fine and decorative art that ranges in 'antiquity' from a few decades to (much more rarely) thousands of years.

Antwerp Mannerism A term coined by the art historian Max Friedländer in 1915 to describe the style of painting practised by artists in Antwerp from *c.*1500 to 1530. It was essentially a late *Gothic style and depicted religious subjects, though in its depiction of architecture it also displayed borrowings from the Italian *Renaissance. Its most celebrated practitioner was Jan de Beer.

applied art Art that is created for useful objects and remains subservient to the functions of those objects. The broad range of the applied arts includes *ceramics, furniture, *glass, leather, metalwork, *textiles, arms and armour, clocks, and jewellery.

appliqué A technique in which one fabric is applied on top of another, usually of contrasting colour or texture, creating a surface decoration. It was used, for example, in the Bayeux Tapestry in the 11th century.

apron An ornamental structure beneath the seat rail of a chair or *settee, or between the legs of a *commode.

apse Usually a circular or multi-angular termination of a church at its eastern end, first found in Roman *basilicas, with a rounded vault above. The apse was mainly a Continental development, whereas English *Gothic churches tended to have square terminations. However, in the increasingly subtle and complex spatial development of later Gothic architecture apses are found in chancel-aisles or even as chapels on the east sides of *transepts (Lincoln Cathedral).

aquamanile [From the Latin *aqua*, 'water', and *manus*, 'hand'] a vessel to hold water for washing hands, either of the priest before the celebration of Mass or, more generally, of diners at meals. Aquamanilia were fashionable throughout Europe from the 13th to the 16th centuries. Many were in the form of strange beasts or animals, particularly lions, with the tail arched across the back to form the handle, filled with liquid through an opening in the back and poured through the mouth. They were usually cast in *bronze and referred to in medieval texts as *auricalcum* because they resembled gold when polished—a few examples were actually made of *gold or *silver. In

England in the 14th century they were also made of *lead-glazed earthenware and in Italy of *maiolica.

aquamarine A pale greenish-blue gemstone of the beryl group; also a colour.

aquatint A tonal method of printmaking that is used in conjunction with linear *etching. The technique was invented by Jean Baptiste Le Prince (1734–81). As in etching, the copper plate is bitten by the action of immersion in acid. Granules of acid-resist laid on the plate result in a fine, reticulated patterning when the plate is inked and printed from, thus producing an effect not unlike a wash. For that reason, aquatint was particularly used in late 18th- and early 19th-century Britain for the reproduction of *watercolours and topographical views, for example in the prints of Paul Sandby and Thomas Girtin. There are two distinct methods of aquatint. In the first a dust-box is used to blow particles of resin onto the copper plate. In the second the resin is dissolved in alcohol which is brushed over the plate; as the alcohol evaporates, particles of resin are left on the plate. The artist can vary the tones of different parts of his aquatint by subjecting them to bitings in the acid-bath of differing duration. The parts he wishes to print relatively light in tone can be protected by coating with stopping-out varnish, resistant to acid; those that are to print darker can be rebitten.

aqueduct An artificial channel for carrying water, invented by the Romans, often raised on brick or stone *piers carrying *arches, above which the duct or casing was built to prevent evaporation or pollution.

arabesque Fanciful and intricate surface decoration based on geometrical patterns, found from *classical art onwards and not necessarily of Arab origin. Unlike *grotesque ornament it does not contain human figures.

arabesque style The style of decoration epitomized by the use of interlaced patterns or *arabesques. The term came into use in the 16th century when Europeans began to take an interest in the Arab world, and the style can be seen in the flowing lines intertwined with fruit and flowers used by *Renaissance decorators.

arboretum [From the Latin *arbor*, 'a tree'] a garden in which trees are cultivated for display, study, or propagation.

arcade A series of *arches carried on *piers, *columns, or *pilasters, either free-standing or attached to a wall (a 'blind arcade'). The term is also used to denote a covered avenue with shops on one or both sides, for example Burlington Arcade in Piccadilly, London.

arcanum [From the Latin *arcanum*, 'mystery'] the name given in the early 18th century to the formula for making true *porcelain. An arcanist was someone in possession of this secret.

arch A construction of a block of materials in a curved form used as a support, for example of a bridge, floor, or roof. The simplest arches are

semicircular. Pointed arches appeared in Moorish and *Gothic architecture. The following are the most commonly encountered types of arch: a basket or three-centred arch (French *anse de panier*) has a curve that resembles the handle of a basket, and is formed by a segment of a large circle continued left and right by two segments of much smaller circles; a drop arch is pointed with a span greater than its radii; an elliptical arch is a half ellipse with its centre on the *springing line; a false arch is formed by progressively *cantilevering or *corbelling from the two sides with horizontal joints; a four-centred or depressed arch is a late medieval form— a pointed arch of four arcs springing from centres on the springing line; a horseshoe arch is often found in *Islamic buildings and can be either a pointed or round horseshoe; a *lancet arch is pointed, with radii much larger than the span; an *ogee arch is pointed and usually of four arcs, the centres of two inside the arch, the other two outside, this produces a compound curve of two parts, one concave and the other convex, introduced *c.*1300 it was popular throughout the late Middle Ages, especially in England in the early 14th century; a relieving or discharging arch is a strengthening device placed in the wall above an arch or any opening to protect it from much of the weight that would otherwise fall on it; a shouldered arch consists of a *lintel connected with the *jambs of a doorway by corbels; a stilted arch is one with its springing line raised by vertical piers above the *impost level; a strainer arch is one inserted across a *nave or an *aisle to prevent the walls from leaning; a Tudor arch is a late medieval pointed arch.

Archaic *Greek art of the period *c.*700–480 BC, preceding the *Classical period, in which statues are characterized by a particular smiling expression (*see* KOUROS). Vase painting changed from *black-figure to *red-figure during this period. The term is also used to describe art which appears old-fashioned for its time.

architrave The lowest of the three main parts of an *entablature that rests on the *abacus of a *column. The term is used more loosely to describe the moulded frame that surrounds a door or window. It can also be applied to the ornamental mouldings round the exterior curve of an *arch.

archivolt The continuous, concentric mouldings on the face of a round *arch.

armature An internal support or framework for a sculpture modelled in a soft material such as clay or wax. Armatures are usually made of iron or wood. They can also be inserted into casts of clay or plaster, or into a *core before it hardens.

armoire A large cupboard with one or two doors, originating in France in the 16th century

armorial A *coat of arms used as a decorative motif, especially on 18th-century *Chinese export porcelain, where pieces were decorated in China with European coats of arms for export to Europe.

arras The Old English name for a tapestry, called after the town of Arras in north-eastern France which exported many hangings to England.

arretine ware Red glossy pottery of the Roman period which often had decoration imitating *repoussé metalwork. Its name derives from Arretium (Arezzo), which in the 1st century BC was the prime centre of production of such pottery, although it came to be produced throughout Europe. It was also known as *Samian ware or *terra sigillata*.

Art Brut ['Raw art'] the term used by the French painter Jean Dubuffet (1901–85) to describe the kind of art he discerned in the work of psychotics, children, and amateur painters and of which he formed a large collection (now in a museum in Lausanne). In 1948 Dubuffet founded a company, the *Compagnie de l'art brut*, to promote Art Brut, but it folded in 1951. Dubuffet's own paintings were strongly influenced by such art, which he perceived as refreshingly direct and emerging spontaneously from the unconscious mind.

Art Deco The decorative style of the 1920s and 1930s. The name was derived from the first major exhibition of decorative arts after the Great War, 'Exposition Internationale des Arts Décoratifs et Industriels Modernes', held in Paris in 1925. The characteristic shapes of Art Deco were geometric or stylized, derived from the modernist forms of *Art Nouveau. The style could be seen in the *glass of René Lalique and Daum Frères, *silver by Georg Jensen, and *ceramics by Clarice Cliff and Susie Cooper. Elements of the style, including bright colours, sunbursts, and Egyptian motifs, could be found in many mass-produced objects, furniture, wireless sets, and ceramics and in architecture such as cinema buildings.

Arte Povera A term coined in 1967 by Germano Celant, 'Poor Art' was made from everyday materials such as cement, twigs, or newspapers, in deliberate contrast to traditional sculptural materials such as stone and metal. Its often metaphorical imagery was taken from nature, history, or contemporary life. Arte Povera was a phenomenon of the later 1960s and 1970s and is primarily associated with artists such as Michelangelo Pistoletto and Giulio Paolini, though it can also accurately be applied to non-Italian figures such as Joseph Beuys.

'art for art's sake' A concept which originated in literary circles in France ('*l'art pour l'art*') in the earlier 19th century and transferred to art criticism in discussions of Manet and his circle. It was first used in print in English in 1868 and became associated with the *Aesthetic Movement and the belief that the formal qualities of a work of art were more important than its subject-matter.

art history An academic discipline which, as its name implies, is concerned with the historical study of art in all its manifestations throughout the ages to the present day. Its origins can be traced back to the 1st century AD in the writings of Pliny the Elder who, in his *Natural History*, gave an account of the evolution of *Greek sculpture and painting. In the

*Renaissance the Italian artist Giorgio Vasari, in his celebrated *Lives of the Artists* 1550, chronicled the rise to pre-eminence of Italian artists. His essentially biographical approach was followed by a number of writers in Italy and northern Europe in the 16th and 17th centuries. Art history really took root in western thought and culture in the 19th century, particularly in the German-speaking countries where chairs of art history were established at various universities. Many of the major public museums and galleries were also established around this time. A further intellectual impetus came about in the 1930s, its unfortunate cause being the enforced diaspora of many German and Central European Jewish intellectuals under the persecution of the Nazi regime. Among the many unintentional beneficiaries of this were the Universities of London (with its specialized art-historical institutes) and Princeton. At the heart of the modern conception of art history lies an apparent contradiction between object-based research and a desire to endow the subject with every conceivable degree of intellectual respectability and nuance. The latter has led, particularly since the Second World War, to the ever more frenzied incorporation of aspects of social history, Marxism, structuralism, feminism, *semiotics, etc., and to the adoption, in the worst cases, of an almost impenetrable jargon which serves to obfuscate rather than clarify understanding and appreciation of the visual arts.

Art Informel A term devised by the French critic Michel Tapié in 1952. A Parisian counterpart of *Abstract Expressionism, Art Informel emphasized intuition and spontaneity over the *Cubist tradition which had dominated *École de Paris painting. The artists of Art Informel, such as Pierre Soulages, rejected the discipline and structure of geometric abstraction in favour of a less cerebral approach.

artists' books In the later 1960s and through the 1970s artists frequently turned to the book as a form suited to expressing ideas too complex for a single painting or sculpture. Dianne Vanderlip, to whom the term is credited, organized the exhibition *Artists Books* at the Moore College of Art, Philadelphia in 1967. International in scope, it consisted of works by major contemporary artists. Books could assume sculptural form as a pop-up book, or they might be investigations of the very nature of the book itself.

Art Nouveau A style which originated in the 1880s and lasted until the outbreak of the First World War in 1914, encompassing the decorative arts, design, and architecture. Its characteristics were the use of flowing, expressive lines and *whiplash curves, flower and leaf motifs, and female figures with long, undulating hair. The style developed in Britain from the *Arts and Crafts Movement, but influences also included Japanese art, *Rococo, and *Celtic art. From Britain it spread rapidly across Europe and North America. Designs could be seen in *The Studio* and *Jugend* magazines, at large international exhibitions, such as in Paris in 1900, and in department stores, such as Liberty in London. The style took its name from a shop, *La Maison de l'Art Nouveau*, opened in Paris in 1895 by Siegfried Bing, although in Italy it was known as *'Stile Liberty' and in Germany and Scandinavia as

*'Jugendstil'. Art Nouveau could be seen throughout Europe in the architecture of Antonio Gaudi (Barcelona) and Victor Horta (Brussels), the interior designs of Henry van der Velde, the glass of Louis Comfort Tiffany and Émile Gallé, the jewellery of René Lalique, the drawings of Aubrey Beardsley, and the posters of Alphonse Mucha. In Scotland, Charles Rennie Mackintosh developed a more rectilinear version in his architecture and furniture, which influenced artists of the Vienna *Sezession and led the way to progressive industrial design in the 20th century.

Arts and Crafts Movement The name given to the movement begun in England during the second half of the *Victorian period, which revived handicrafts and raised the standards of design. It was inspired by the writings and teachings of William Morris (1834–96) and John Ruskin (1819–1900), who both deplored the effects of mass-production and mechanization on design and harked back to the standards of craftsmanship of the Middle Ages. Morris set out to re-create a hand-crafted industry with his hand-produced *textiles, *wallpaper, book-designs, and furniture. His ideas and methods had a great influence on many craftsmen and designers of the period, such as C. R. Ashbee, Walter Crane, and A. H. Mackmurdo, and led to the foundation of a number of guilds, including the Guild of Handicraft and the Art Workers Guild. Designs, which usually incorporated naturalistic and plant forms, broke away from traditional Victorian fashions and, through exhibitions, had an influence on the developing *Art Nouveau style. The difficulty of producing hand-crafted pieces for a mass market led to the decline of the movement, but it left a legacy of studio potters, weavers, and silversmiths in the 20th century who chose traditional methods over industrial mass-production.

Ashcan School A term later applied in the 1930s to a disparate American school of realistic painting formed in the first decade of the 20th century and known as *The Eight. Its members concentrated on scenes of everyday life derived from sketches made rapidly on the spot. Four of them, of whom the most famous was John Sloan, had been artist-reporters on the *Philadelphia Press* and had joined Robert Henri, generally credited as the founder of the Ashcan School, at his Philadelphia studio.

ashlar Blocks of masonry cut to even faces and square edges, laid in horizontal courses and used on the fronts of buildings (as opposed to the uncut stone or rubble often deployed on rear walls, unseen by most viewers).

Assyrian Revival A style of the second half of the 19th century and early 20th which was inspired by Assyrian works of art, most specifically sculpture, of the 9th to 7th centuries BC. These had been brought to public attention in Britain and France by excavations at Khorsabad and Nimrud in the 1840s. Although its influence was far more limited than, for example, that of the *Gothic Revival, the Assyrian Revival manifested itself both in the decorative arts, in the form of the 'Assyrian style' jewellery produced in England, and in the fine arts in the paintings of a number of later 19th-

century French *Salon painters. Assyrian motifs were also incorporated in a fairly wide range of buildings in the early 20th century, particularly in the United States.

astragal [From the Greek, literally 'knuckle-bone'] the term generally implies decorative enrichment of architectural features with *bead and reel moulding, semi-circular in section. It is properly only applied to the ring that separates the *capital from the *shaft in a *classical *column. 'Astragals' is also a term used, particularly in Scotland, to denote glazing bars in windows.

atelier A French term for an artist's studio or workshop.

Athenaeum A school founded by Hadrian (Roman emperor AD 117–38) in Athens, then considered the intellectual centre of the Graeco-Roman world, and dedicated to Athene, daughter of Zeus, patroness of the city and a benevolent and civilizing influence.

atlantes Sculptures of male figures, nude or scantily clad, supporting *entablatures, *balconies, or other decorative elements. The term derives from Atlas, the Titan condemned by Zeus to support the vault of heaven on his shoulders.

atrium The inner court, roofed but with the centre open to the sky, in Roman domestic buildings; in *Early Christian and medieval architecture it denoted an open courtyard in front of a church and was often in the form of a colonnaded quadrangle. The term is also used to describe large, top-lit spaces rising through several floors in modern buildings.

attic A room inside or partly inside the roof of a building. The architectural term originated in the late 17th century, meaning a small *Order (*column or *entablature) above a taller one. When spelt with a capital 'A' it describes anything relating to Attica, the region of eastern Greece in which Athens is situated, and often, by extension, to *classical Greece in general.

attribute A symbolic or decorative object conventionally associated with a given individual or activity. For example, in Roman mythology the peacock is the traditional attribute of Juno, the chief goddess of Olympus. The classical author Ovid (*Metamorphoses*) relates how Argus of the hundred eyes, set by Juno to watch over Io, was murdered by Mercury. In memory of Argus, Juno took his eyes and set them in the tail of her peacock.

attributed to An art-historical qualification found in collection and auction house catalogues implying that the attribution of a work to a particular artist carries some degree of uncertainty.

Aubusson tapestries *Tapestries and carpets made at Aubusson in central France. The workshops, established in the early 16th century, were granted the status of Royal Manufactory by Louis XIV in 1665. Its finest period was the second half of the 18th century when it created hangings

and furniture covers depicting scenes from the fables of La Fontaine and designs derived from contemporary prints, by artists such as François Boucher and Nicolas Lancret. Smooth-faced tapestry-woven carpets were produced there in the 19th century in large quantities.

auditorium The main room or hall of a theatre or concert-hall where the audience assembles to listen and view the performance. In antiquity it denoted the place where orators could recite to an audience.

auditory The section of an ancient church (in fact the *nave) where the audience stood to hear the Gospel.

aulaeum [Latin, 'curtain'] generally used to describe a hanging in a home such as a curtain or tapestry. In antiquity it denoted the curtain, usually decorated pictorially, that was lowered as a backdrop to a play or performance; it was also the curtain that was hung in a temple to veil the statue of a deity.

aureole Light shown as encircling the head or body of a sacred personage (for example Christ, the Virgin, or saints).

auricular A term used to describe ornament that is curved like the forms found in the human ear. More specifically, it is applied to a particular style of Dutch 17th-century silverware, derived from Dutch Mannerist engravings and German *silver, in which the curving forms resemble the interior of a shell or the lobes of an ear. Auricular motifs also occurred on carved ornament in 17th-century Dutch and German furniture. The auricular style can be viewed as a transitional phase between *Mannerism and *Baroque.

auto-destructive art Art which is deliberately intended to self-destruct. The concept was developed in the 1950s, most notably by Gustav Metzger who originated the term and wrote several manifestos. An example of his auto-destructive art was his painting patterns in acid on nylon until the nylon was eventually destroyed. Another major exponent was Jean Tinguely, whose giant motorized junk assemblage *Homage to New York* self-destructed in front of a distinguished audience in the sculpture garden of the Museum of Modern Art, New York, in 1960.

automata Figures animated by clockwork or other mechanism, first made by the Greeks and Arabs, but particularly popular during the Middle Ages and *Renaissance. Early examples usually formed part of large clocks but they were also used as elaborate table decorations. By the 16th century a wide range of fantastic ornaments with miniature mechanisms were made in Switzerland, France, and England. From the 19th century onwards automata were made mainly as amusements for children.

automatism A method of painting or drawing in which conscious control is suppressed, allowing the subconscious to take over. André Breton wrote in the *Surrealist manifesto of 1924 of 'pure psychic automatism', of art being produced in the state of a dream. Although artists such as Arp and the

Zurich *Dadaists had shown an interest in such artistic phenomena a few years earlier, it was really the Surrealists who developed them and, through their later links, transmitted such an interest to the United States where it was taken up by Jackson Pollock and certain of the *Abstract Expressionists.

aventurine *Gold flecks in dark brown *glass, made by mixing *copper crystals with the molten glass, a technique discovered accidentally at Murano, near Venice, in the 16th century. A similar effect was also achieved on *lacquer by sprinkling minute clippings of gold wire over the surface.

Axminster carpets Carpets made in the small town in Devon where Thomas Whitty founded the Axminster carpet factory in 1755, the most important centre for hand-knotted carpet weaving in Britain. Its products were intended for the luxury market. In 1835 the factory closed and its equipment was relocated to *Wilton.

azurite Also known as blue malachite or chessylite, azurite is a deep-blue, crystalline mineral. It was used from at least early Roman times in powdered form as a paint *pigment. Although unsuitable for use in oil paint, it worked well in *tempera and *watercolour until it was replaced by cheaper blues such as *smalt.

back frame The structural part of a picture frame to which decorative carved mouldings may be attached. It is often made of wood inferior in quality to that of the carved mouldings as it forms an unseen part of the frame.

backing Protection, such as *relining or a sheet of board or wood, placed at the back of a picture to save it from physical or atmospheric damage.

Backsteingotik The later medieval brick (*Backstein*) architecture of northern Germany, particularly the great cathedrals (such as Lübeck), churches, and town-halls of the Hanseatic ports.

badigeon A mixture (of plaster and ground stone) used to repair statuary or carving; also applied to a mixture of sawdust and strong glue used to repair blemishes in timber.

'Bad' painting Takes its name from the title of an exhibition held at the New Museum of Contemporary Art, New York in 1978. More an approach than a movement, it was characterized by figurative subject-matter which was often eccentric, narrative, and crudely painted. It was the deliberate opposite of the emotionally detached *Conceptualism and *Minimalism, then held in many circles to be the 'good' art of the day.

bailey Originally used to describe the walls round a *castle, but more specifically the outer space between the outer circuits of the castle and the *keep.

bakelite An early plastic, invented in 1907 by Leo Hendrik Baekeland, a Belgian who had emigrated to the United States. Formally defined as 'a condensation product of the reaction between phenol and formaldehyde', bakelite had far greater properties of durability and resistance than its predecessor celluloid. Dubbed by Baekeland 'The Material of a Thousand Uses', bakelite was used for the manufacture of a wide range of products—fountain pens, radios, combs, cameras, costume jewellery, furniture, tableware and some of the vital components of cars, planes, and industrial machinery. Although eventually superseded by more advanced plastics, bakelite enjoyed a revival of popularity in the style-conscious 1980s.

balcony A platform projecting from the surface of the wall of a building, normally placed before windows or openings and protected by a railing or *balustrade. Also an upper floor projecting into an *auditorium.

baldacchino A canopy over an altar, tomb, or throne. The original meaning of 'baldachin' is a silk cloth from Baghdad (*baldacco* in Italian). A baldacchino is supported by columns and can be portable or fixed, the most famous example of the latter being Bernini's great structure, built 1624–33,

for the interior of St Peter's, Rome and placed, as a symbol of the enduring power of the Catholic Church, over the tomb of Christ's earthly successor, St Peter. *See* CIBORIUM.

Ballets Russes A ballet and opera company founded in 1909 by the Russian impresario Sergei Diaghilev; its combining the arts of visual design, music, choreography, and scenario derived from 19th-century theories of correspondence and *Gesamtkunstwerk. It performed in Paris and toured Europe and the Americas: in 1922 it established a permanent base in Monte Carlo until it was disbanded on Diaghilev's death in 1929. Among the visual artists who designed costumes and sets for the company were Léon Bakst, Natalia Goncharova and Mikhail Larionov, and Picasso. The choreographers included Mikhail Fokine and Vaslav Nijinsky, and among the many famous dancers were Ninette de Valois, Anton Dolin, and Alicia Markova. The distinguished composers from whom Diaghilev commissioned work included Stravinsky, Prokofiev, and Satie. The Ballets Russes was at the forefront in reforms in stage design and public taste and acted as an intermediary between the public and the avant-garde.

ballflower The most distinctive ornament of English *Decorated architecture in the early 14th century, particularly in Hereford and Gloucester cathedrals, it consists of a globular shaped carving, usually of three stylized leaves clutching a small ball. Ballflower (or 'bellflower') is an antiquarian term, suggesting analogies with a flower bud, or possibly small bells, as on an animal collar.

ball foot A round, turned foot, popular on late 17th-century furniture.

baluster A short *pillar or post supporting a rail or *coping and forming part of a *balustrade. Alternatively, a *ceramic or *glass vase or vessel, of elongated pear shape, derived from the architectural term.

balustrade The ensemble of rail or *coping supported by *balusters forming a railing.

Bamboccianti A group of painters in 17th-century Rome who worked in the style of Pieter van Laer (*il Bamboccio* or 'clumsy little one') from whom the name derives. They specialized in *bambocciate* (the singular is *bambocciata* or 'childishness'), small genre scenes of everyday Italian life. Most of the artists in the group were of north European origin, though there were also some Italians such as Michelangelo Cerquozzi. Van Laer returned to his native Haarlem in 1639. *See* SCHILDERSBENT.

bamboo furniture Furniture made from the wood of the bamboo plant, mainly of the simple, household type, in use in Europe from the 19th century. The term is also used for furniture of the late 18th and early 19th centuries carved and painted to look like bamboo.

banded column A *column whose *shaft is broken up by the addition of bands or blocks of stonework. Such columns are a common feature of *Mannerist and *Baroque architecture.

banding An ornamental border used on furniture, made of contrasting woods, such as *satinwood with *mahogany.

banquette A French term used to describe a small bench without a back, usually upholstered.

baptistery Part of a church used for the rites of baptism. Sometimes found in an *apse of the main building, more often a separate structure, usually circular or polygonal. Early baptisteries had large pools for total immersion, but it became more normal for symbolic baptism to be from a *font.

barbican An outwork, such as a watchtower, defending the entrance to a *castle, fortress, or town

Barbizon School A group of French landscape painters who worked in the forest of Fontainebleau south-east of Paris c.1830–70 and were based in the village of Barbizon on the western edge of the forest. The most important members were Jean-François Millet, Théodore Rousseau, Charles Jacque, Jules Dupré, Narcisse Diaz, and Constant Troyon; also associated with them were Camille Corot and Charles Daubigny. Much of their forest imagery of ancient oaks and desolate heaths, sometimes populated by the local peasants and their livestock, was inspired by Dutch 17th-century art. Their choice of imagery represented a reaction to the rapid urban growth of Paris and answered an increasing demand from bourgeois patrons for paintings of rural landscape, often imbued with a melancholy *Romanticism. The term 'Barbizon School' was not actually coined until 1890 when the Scottish dealer David Croal Thomson published his book *The Barbizon School of Painters*. By that time the so-called Barbizon artists were widely collected in Britain (especially Scotland), Europe, and the United States. Despite claims made for Barbizon as a forerunner of *Impressionism, its aims, its rural setting, and the techniques it employed were really very different to those of that later Paris-based movement.

barium yellow (or lemon yellow) A pale green-yellow *pigment made by mixing solutions of neutral potassium chromate and barium chloride.

Baroque A term now generally used to describe art in Europe between c.1600 and c.1750. It is broadly accepted today that 'Baroque' implies dynamism and movement (particularly in architecture and sculpture), and a theatricality dependent on a mastery of space and geometry. The *illusionism of Baroque painting is, nevertheless, founded on the ability to depict reality. All Baroque art, however outwardly dissimilar it may appear, is indebted to the technical achievements of the *Renaissance. The term itself originated in the mid-18th century when used by Johann Joachim Winckelmann (1717–68) in a derogatory sense, to describe the allegedly excessive art of the preceding era. The word 'Baroque' was claimed to derive from the Portuguese *barroco* meaning a 'pearl or tooth of unequal size'. It therefore implied imbalance and ugliness, as opposed to the ideal beauty and perfection sought by Winckelmann through the imitation of ancient,

more particularly *Greek, art. It was not until the later 19th century that 'Baroque', through the writings of a series of distinguished German art historians, lost its pejorative connotations and was considered as an art that was vital and distinct from that of the hallowed Renaissance. The Baroque was originally associated with post-Counter-Reformation Italy and with the concept of the unity of the arts, best exemplified in the work of Gianlorenzo Bernini (1598–1680), architect, sculptor, theatre set designer, and painter and the presiding artistic genius of 17th-century Rome. Essentially a Catholic art, the Baroque spread from Italy to Spain, the Spanish Netherlands, and later to southern Germany, numbering among its many masters such diverse figures as Borromini, Pietro da Cortona, and Rubens.

Baroque Revival An architectural style adopted for many major public and institutional buildings in Great Britain and the British Empire between 1885 and the outbreak of the First World War in 1914. Known at the time as the English Renaissance style, it adopted many of its motifs such as *domes and *cupolas from what is now regarded as the English Baroque style of Wren, Hawksmoor, Vanbrugh, and Gibbs. One of many notable examples of the Baroque Revival style is the Old Bailey (Central Criminal Courts), London, of 1900–6 with its central dome modelled after Wren's Royal Hospital at Greenwich.

barrel vault (or tunnel vault) The simplest form of *vault, consisting of a continuous vault of semi-circular or pointed section, unbroken in its length by cross vaults. Developed by the Romans, barrel vaults were used in Christian churches until the invention of *rib-vaulting around 1100.

basalt A dark, hard (and therefore durable) igneous rock used for sculpture, for example in ancient Egypt and in parts of the southern Indian subcontinent. It is sometimes confused with the softer *basanite.

basanite A type of greywacke (conglomerate rock formed as a by-product of the decomposition of basaltic rock). It was highly prized and first used for sculpture by the ancient Egyptians who, until the conquest of Egypt by Alexander the Great c.332 BC, reserved it for statues of the gods. Varying in colour from very dark green to dark rusty brown, it was known to the Egyptians as the 'stone of Bekhan' and extracted, with considerable difficulty, from Mount Uadi Hammāmāt. In the 18th century Josiah Wedgwood invented and sold an imitation of basanite known as *black basalt.

base [From the Greek *basis*, 'that on which one stands'] the lower portion of any structure or architectural feature. Also the lower part of an heraldic shield. *See* CHIEF.

basilica [From the Greek *basilikē*, 'royal'] a church with *aisles and a *nave higher than the aisles. The nave was usually lit by the windows of a *clerestory. Such churches first came into being in the *Early Christian era and were modelled on Roman basilicas (large meeting places or halls of

justice). With its longtitudinal axis, usually terminating with an *apse at one end of the nave, the basilica plan was later adapted for *Romanesque and *Gothic cathedrals.

basketry The process of making containers out of a mesh of vegetable fibres in a technique similar to *weaving. It is one of the oldest crafts and the earliest examples date from c.5000 BC in Iraq. Basketry probably preceded both *textile weaving and *pottery.

bas-relief (or basso-rilievo) 'Low relief', that is relief sculpture in which the figures never project more than half their true depth from the background.

bastide A medieval fortified town built for the colonization or pacification of an area, particularly associated with the south of France; also in modern usage in Provence to describe a small country house.

bastille A building used as a prison (famously associated with the 'Storming of the Bastille' in Paris at the start of the 1789 French Revolution), tower, or bulwark in the fortifications of a town.

batik A technique for decorating fabric which originated in Java. A design is drawn on cloth with liquid wax and immersed in dye, which resists the waxed areas. When the wax is melted with boiling water, the pattern is visible. The process is repeated for each colour used.

bat-printing A method of applying a print to a *ceramic surface, used mainly in the late 18th century. An engraved copper plate is inked with ceramic colour, a print is taken on to a flexible bat of soft glue or gelatine and then pressed on to the surface of the object to be decorated, resulting in a particularly soft effect.

batter An inclined plane. A wall that is sloping, thicker at the bottom than at the top, with a face that inclines or rakes, is described as battered.

battlement A *parapet with alternating indentations or *embrasures and raised portions or *merlons. A wall with battlements is said to be *crenellated.

battle-piece A painting of a battle or military scene. The great *Renaissance battle pictures of Leonardo (*Battle of Anghiari* 1503–6) and Michelangelo (*Battle of Cascina* c.1506) are now lost but are known through copies and fragments. This tradition of the heroic battle scene displayed a considerable formal debt to scenes of battle as depicted on *classical *sarcophagi. The 17th century saw the development of specialist battle painters such as Jacques Courtois ('Il Borgognone'), Aniello Falcone, and Philips Wouwerman. Battles were also portrayed in tapestries which, from the 17th century onwards, largely took over from fresco as the medium for official military art. In the 19th century there was a renewed enthusiasm for the genre both in Europe and America with the production of many large-scale canvases depicting the numerous battles of that era.

Bauhaus An early 20th-century school combining the *fine and *applied arts and architecture, its name was based on the *Bauhütten* or masons' lodges of medieval times. This reflected the concept of workshop training as opposed to academic studio education. Such communal idealism, partly a reaction against the horrors of the First World War, was very much based on the thinking of 19th-century writers such as John Ruskin and William Morris. The first Bauhaus was located in Weimar, Germany, and developed from the school of arts and crafts founded there in 1906 by the Grand Duke of Saxe-Weimar. In 1919 Walter Gropius was appointed as its director. It was Gropius who renamed it the Bauhaus and undertook extensive reorganization. A generally *Expressionist aesthetic was soon replaced by the growing influence of *Functionalism and an interest in industrial design, and artists of the calibre of Kandinsky, Klee, Feininger, and Schlemmer came to work at the Bauhaus. In 1925 it removed to Dessau in Anhalt where it acquired a splendid new glass and reinforced concrete building designed and built by Gropius in 1925–6. The architect Mies van der Rohe later became director and the Bauhaus was forced to transfer to Berlin in 1932 and was finally closed down by the Nazis the following year.

Baxter print A method of coloured printmaking devised and patented in 1835 by George Baxter (1804–67). It involved the use of a 'key' metal plate or stone for the main design, and the print resulting from this was then coloured in oil- or water-based inks by means of a succession of *woodblocks, all of which had to be correctly *registered against the original design. The process represented the first commercially viable alternative to the hand-coloured print and enjoyed great success for a quarter of a century.

bay A compartment or division of the interior or exterior of a building, it can be marked by a variety of architectural features such as *buttresses, *vaulting, etc.

Bay Area Figurative style A style evolved by artists in the San Francisco Bay Area between the late 1940s and early 1960s. It took from *Abstract Expressionism a liking for thickly painted surfaces, expressive colour, and gestural brushwork, but rejected abstraction in favour of figurative imagery. Its most famous exponent was Richard Diebenkorn.

bay-leaf garland A classical decorative motif consisting of bound garlands of bay leaves, used to enrich *torus mouldings, etc.

bead A small cylindrical or partly cylindrical moulding.

bead and reel A classical motif of round *beads alternated with oblong reels.

beadwork A technique in which coloured *beads are stitched together on cloth to form a *mosaic, used from the late Middle Ages until the 18th century, mainly on costume. It was revived and popularized in the 19th century; large numbers of coloured beads were exported from Germany to

other European countries, together with stencilled sheets of *canvas. Beadwork was applied to a variety of small objects, including pin cushions, napkin rings, slippers, and table mats.

Beauvais A French tapestry factory founded in 1664 by Colbert and patronized by the Crown. In 1726 J. B. Oudry was appointed chief designer and the factory specialized in *Rococo designs. The painter François Boucher designed 45 tapestries for Beauvais, including *The Story of Psyche* (1741) and *The Loves of the Gods* (1749). Even during the *Neoclassical period the factory continued to produce lively and bucolic scenes. After closure in 1793, the factory reopened in 1794 as a State concern and during the 19th century it specialized in covers for furniture.

Beaux-Arts A term applied to the style of classically inspired architecture, deriving from the teaching of the École des Beaux-Arts in Paris, which laid emphasis on the architecture of antiquity and that of the *Renaissance and 17th- and 18th-century France. It was particularly prevalent in the United States and France in the late 19th and early 20th centuries and was characterized by formal planning overlaid with rich detail that was often overemphasized or overscaled. Victor Laloux's Hôtel de Ville in Paris (1897–1904) and Warren & Wetmore's Grand Central Station in New York (1903–13) are good examples. The style can be found in Manhattan skyscrapers and town houses, Parisian blocks of flats, and British department stores. After 1918 the traditional Beaux-Arts style became obsolete and was superseded by the emerging modern movement.

belfry [From the Old French *beffroi*, 'tower'] the upper room or storey, in which bells are rung, of a *tower which is usually attached to a main building (ecclesiastical or secular). It can also be used to describe the timber frame inside a church *steeple to which bells are attached or fastened.

bellarmine A *stoneware jug with beard mask incised below the neck of the vessel, made in the Rhineland from the 16th century onwards. It was named after Cardinal Bellarmine (1542–1621), a zealous supporter of the Counter-Reformation.

Belleek porcelain A porcelain factory founded in 1857 in County Fermanagh, Northern Ireland, which produced a very light, translucent *body covered with an iridescent glaze. It manufactured small, ornate objects as well as elaborated baskets and decorative vases.

belvedere A small apartment on a roof with a view. *See* GAZEBO.

bentwood Plywood furniture shaped in rod or, more frequently, sheet form and bent under steam heat into curves. It was first developed in the early 19th century in the USA, though a number of 20th-century designers have also utilized it.

bergère An armchair with a rounded back and a broad seat, upholstered between the arm and the seat. The shape was determined by the wide dresses worn by society women in the early 18th century. The term was

derived from the French for 'shepherdess': *L'heure du berger* ('the hour of the shepherd') was an idiomatic expression meaning a favourable moment for the lover to take action.

Berlin ironwork Decorative objects made in *iron at the Royal Prussian Iron Foundry in Berlin from *c*.1800 until *c*.1840. Items included jewellery and small statuary as well as accessories for sewing, writing, and smoking. Prussian artists, such as Schinkel, provided designs in both the *Neoclassical and the Neo-Gothic (*see* GOTHIC REVIVAL) styles. Berlin ironwork was much copied in the 1930s.

Berlin porcelain *Porcelain made in Berlin from 1751. The first factory was founded by Wilhelm Kaspar Wegely and operated for five years producing good quality, *hard-paste porcelain table wares, vases, and figures. A second factory, founded in 1761 by Johann Ernst Gotzkowsky, was acquired in 1763 by Frederick the Great and has been run by the State ever since. The early products were tea and coffee wares and figures, in a restrained Rococo style. By 1770, the factory developed a severer style, influenced by *Neoclassicism. In the early 19th century, the *Empire style became popular, with ornamental vases often painted with views in and around Berlin. The mark of the Berlin factory from 1763 onwards was a sceptre in *underglaze blue.

Berlin tapestries Tapestries were produced in Berlin from the late 17th century after a factory was founded by Huguenot refugees from *Aubusson, in France. The factory mainly copied French tapestries, notably those at *Beauvais.

Berlin woolwork A method of textile decoration popular in Europe and America in the second half of the 19th century. Canvas with pre-printed or stencilled designs was exported from Germany, mainly Berlin, together with brightly coloured wools. These were worked into floral patterns, portraits, fashionable paintings, and landscapes to form cushion covers, firescreens, wall hangings, and other domestic items.

bestiary A type of medieval *illuminated manuscript which used depictions of animals or fabulous beasts to point out moral lessons. It was based on the Greek *Physiologus*, a pseudo-scientific natural history which was translated into Latin around the 9th century. By the late 12th and early 13th centuries it was one of the leading types of picture books and especially popular in England.

béton brut Concrete left in its natural state still bearing the marks of the metal or wooden mould which shaped it, especially fashionable in the 1950s. A particularly well-known, if unattractive, example of its use is at the South Bank Centre, London.

bevel A sloping edge, usually used on furniture or glass (such as mirrors).

bezant A medieval *Byzantine coin, and by extension an ornamental relief consisting of repeated roundels.

bezel The setting for a stone in jewellery, particularly a ring. It is also the name of the metal frame which holds a watch or clock glass securely in position, and the inside rim of the cover of an object, particularly a box.

bianco-sopra-bianco [Italian, 'white-on-white'] a decorative border on *tin-glazed *earthenware painted in opaque white on a bluish ground, an effect which originated in Italy in the 16th century and spread to northern Europe and Britain.

bibelot In French the term denotes an object without value such as a trinket or curio, though the workmanship can vary from the crude to the luxurious.

Biblia Pauperum [Latin, 'The Poor Man's Bible'] was the first medieval textbook of *typology and showed in pictures how episodes in Christ's life were prefigured by events in the Old Testament. It was first produced in south Germany in the late 13th century as one of the earliest *block-books to be printed. Its designs were widely adopted in late medieval art, for example in easel painting, sculpture, and tapestry design.

Biedermeier A style of art which appealed particularly to the middle and upper-middle classes of Germanic Europe (Austria, Germany) and Denmark, between the Congress of Vienna in 1815 and the revolutions of 1848. The term was originally coined as a nom de plume, 'Gottlieb Biedermeier', by Ludwig Eichrodt and Adolf Kussmaul for publishing poetry in the Munich journal *Fliegende Blätter* 1854–7. The German adjective *bieder*, meaning plain, solid, unpretentious, allied to *meier* (closest to *Maier*, the equivalent of Smith or Jones) denotes the parodic nature of the enterprise. Biedermeier painting was distinguished by its concern with everyday subject-matter such as portraiture (particularly of the family), landscape, and still life, as opposed to the grand gestures of *Neoclassicism and *Romanticism. Its other great achievement lay in the field of furniture, initially modelled very much on the French *Empire style, but with a strong preference for comfort and unpretentiousness allied to fine craftsmanship. By the 1880s the term was generally used in a pejorative sense, but the beginning of its rehabilitation can be dated to the Congress of Vienna exhibition of 1896, and its more general application to the fine arts dates from the Berlin Centennial exhibition of 1906 (itself an exercise in turn-of-the-century nostalgia and an attempt to reorder the history of German art).

biennale An international art exhibition, held every two years, adjudicated by a committee. The earliest, and still the most famous, was the Venice Biennale, first held in 1895 as the 'International Exhibition of Art of the City of Venice'. When this resumed in 1948 following the Second World War it rapidly inspired other biennales, of which those at São Paulo and Paris are perhaps the best-known.

binder The colloid substance of a paint vehicle, for example *linseed oil in *oil paint. The binder holds the *pigment particles together to form a cohesive coating and attach it securely to the *ground.

biomorphic A term used to describe forms in abstract art which derive from organic rather than geometric shapes, as, for example, in the sculpture of Hans Arp (1887–1966) or Henry Moore (1898–1986).

bird's-eye view A scene, usually a landscape or townscape, depicted from an imaginary viewpoint high up so as to give a comprehensive overview. Bird's-eye views first appeared in late medieval art, and were further developed in the 16th and 17th centuries (particularly in Flemish art). They were extensively used in engraved views of towns and country houses.

biscuit Unglazed, fired *clay ware. White, *soft-paste biscuit *porcelain was particularly developed at *Sèvres from 1753 onwards for the manufacture of figures and groups. Its appearance is similar to *marble, therefore it was thought especially suitable for reductions and imitations of antique statuary. By the late 18th century it was produced by many leading European porcelain factories. In the 19th, however, it was to a large degree supplanted by *Parian ware, which was cheaper.

bistre An ink or *wash made from wood soot dissolved in water, in colour it varies from brownish yellow to a deep blackish brown depending on the type of wood and the concentration of soot in the ink. Bistre was used in the late Middle Ages but the term did not become current until the 16th century in France and was not widely used until the 18th century. Among its prime exponents were Rembrandt (1606–69) and G. B. Tiepolo (1696–1770). Bistre is difficult to distinguish from other brownish inks, but one of its characteristics is an uneven granulated surface caused by undissolved soot particles. It is particularly suitable for broad wash effects.

biting The *mordant action of acid on metal, usually copper, in the printmaking process of *etching. An etching plate that is reimmersed in the acid bath is said to have been rebitten and such further bitings result in deeper channels in the plate capable of holding greater amounts of printing ink. Plates may have to be rebitten due to wear incurred in the printing process.

bitumen (or asphaltum) A tarry compound used as a transparent brown *pigment, particularly in painting in Britain in the later 18th and early 19th centuries. Unfortunately it never completely dries and becomes opaque and disfigured with extensive *craquelure. Artists whose work was particularly affected by its use include Sir Joshua Reynolds (1723–92) and Sir David Wilkie (1785–1841).

bizarre silks Silks with asymmetrical designs of flowers and foliage, influenced by oriental textiles but produced in Europe (notably in Lyons, France and in Spitalfields, London) c.1695–c.1720.

black-and-white style An architectural style of the 16th and 17th centuries, found particularly in the English Midlands, and characterised by a timber framework which is stained or painted black, with the plaster in-between painted white.

black basalt A hard, black unglazed *stoneware created by Josiah Wedgwood by 1769, used for busts, medallions, and vases, often with the addition of engine-turned decoration.

black chalk A black or dark-grey chalk, containing carbon or shale, sometimes used as a crayon.

black-figure vase painting A style of decoration on *Greek pottery of the 7th and 6th centuries BC, originating in Corinth, in which black decoration appears silhouetted on a red ground. Clay was mixed with iron oxide, wood ash, and rain water, painted on to the vase, and when fired, the decoration changed to black, leaving the ground red. This was later replaced by the more sophisticated *red-figure vase painting.

black lead An obsolete term, used until the early 19th century, to denote the drawing material *graphite.

black marble Strictly speaking this is not a *marble but a *limestone which can be polished and was mainly used for sculpture. Its principal source was in Belgium. By the end of the 16th century it was also being used in Italy.

bladder A container for oil colours, first used in the 17th century, it was made from a tough animal membrane such as sausage casing and was filled with paint and secured with twine. The artist would puncture the bladder with an ivory tack when he needed paint, and then reseal it with the tack. Colours kept in this way only stayed fresh for a few months. The bladder was in wide use by the late 18th century but was replaced by the collapsible metal tube around 1840.

blanc de chine A French name given in the 19th century to pure white Chinese *porcelain made at Dehua, Fujian province from the 17th century onwards. Figures, especially of deities, animals, cups, and dishes were the main products. It was exported in large numbers to Europe where it was copied by many porcelain factories.

Blaue Reiter, Der [German, 'Blue Rider'] an artists' movement which was active in Munich 1911–14. The principal members were Wassily Kandinsky, Franz Marc, Gabriele Münter, Alfred Kubin, Paul Klee, and August Macke. A successor to the *Neue Künstlervereinigung, the Blaue Reiter held its first exhibition 1911–12. Despite Franz and Maria Marc's claim that they invented the title based on their liking of the colour blue and riding, the name, with its resonance of medieval knights and Christian warrior saints, probably had deeper roots in German and Russian culture. An explanation of the group's aims appeared in the almanac *Der Blaue Reiter* (the cover of which featured a drawing of a blue horseman by Kandinsky), published in

1912 and edited by Kandinsky and Marc. One of the most important volumes on art produced in the 20th century, it included Kandinsky's statement: 'None of us seeks to reproduce nature directly...We are seeking to give artistic form to inner nature, i.e. spiritual experience.' With its bright colours and often semi-abstract images inspired by a wide variety of sources, the Blaue Reiter was perhaps the most lyrical of the *Expressionist movements of the early 20th century. Today the major holding of Blaue Reiter art is in the Lehnbachhaus in Munich.

bleed In painting the term describes the staining or migrating of a darker colour into the adjacent area of a lighter one. In the graphic arts and in printing, images can be 'bled', implying they run right up to the edges of the paper rather than being surrounded by a margin.

blending The gradation of colour in painting so that two *hues or values merge imperceptibly

blind blocked (or stamped, tooled) In leather bookbinding this refers to ornamentation achieved by the impress of blocks, ties, or tools, without the addition of gold or colour.

blind printing A technique of printing from an uninked plate to create a subtle embossed texture on the paper surface. The process was popular in Japan and has been adopted by western contemporary artists.

blind tracery A decorative feature in *Gothic architecture, it is *tracery applied to walls but without glazing or openings.

blister A small, raised area of paint indicating separation of the paint and/or *ground layers, either from each other or from the support.

block-book A type of book in which both the text and image are carved on and printed from one block of wood. The block is inked and printed by hand-rubbing on a dampened sheet of paper. The earliest examples of block-printing, in scroll form, date from 8th-century China. Block-books appeared in northern Europe around the middle of the 15th century in Germany and the Netherlands. They were intended to spread stories from the Bible and other moralizing texts, in simple form, to the population at large. Block-books were soon superseded by Johann Gutenberg's invention of moveable type cast in metal.

bloom The white or cloudy appearance of the surface of aged *varnish films on paintings, it is caused by the presence of minute cracks or pores which diffuse light.

Bloomsbury Group The name given to a disparate group, based principally on friendships, of artists, writers, and intellectuals who met regularly in the early decades of the 20th century in various houses in the Bloomsbury area of central London. Its members included Lytton Strachey, Clive and Vanessa Bell, Virginia Woolf, Duncan Grant, and Roger Fry. An inconsistent mix of the conventional and the unconventional, it drew

opprobium from both left and right and numbered among its strongest critics Wyndham Lewis, D. H. Lawrence, and F. R. Leavis. Nevertheless, Bloomsburyites contributed some of the great British novels; art criticism that opened the way to a proper appreciation in Britain of *Impressionism, *Post-Impressionism, and much else besides; and themselves produced fine and decorative art of variable quality. Since the 1960s there has been a revival of interest in Bloomsbury which has outstripped, at least in its level of production, the original achievements of the group.

blot drawing A technique devised by the watercolourist Alexander Cozens (1717–86) and described in his *A New Method of Assisting the Invention in Drawing Original Compositions of Landscape* (1785/6). Illustrated with *aquatint prints, it prescribed the use of accidental stains or 'blots' on the paper as the starting-point for the invention of landscape compositions. Cozens had first described this method in an earlier *Essay* of 1759 in which he acknowledged his debt to and awareness of Leonardo da Vinci's similar suggestion, made in his *Treatise on Painting*, which Cozens knew from the English edition of 1724. Comparable techniques were also employed in the 20th century by the *Surrealists for stimulating subconscious imagery.

bluejohn A decorative variety of fluospar found in Derbyshire. It is translucent with bands of colour that range from deep purple through blue to light brown and yellow. Although known to the Romans, the first large deposit was found near Castleton in Derbyshire in 1743. It became popular for ornaments, especially in France. Matthew Boulton, the Birmingham metalwork manufacturer, used it for decorative objects with *ormolu mounts, particularly candelabra.

Blue Rose Group A group of Russian painters active in the first decade of the 20th century and considerably influenced by *Symbolism and, to a lesser extent, by *Fauvism. They adopted the name for their exhibition in Moscow in 1907: both the colour blue (associated with the sky and spirituality) and the rose had symbolist overtones. The inspiration of the group was Victor Borisov-Musatov, whose most talented follower was Pavel Kuznetsov. Other members included Larionov and Goncharova. The group published a magazine, *The Golden Fleece*.

board Is stiffer and heavier than *paper. There are many types of board, some of which are laminate and others not. Surfaced with paper, cloth, or a *ground, boards are often used as supports for painting or drawing.

bocage [Norman French, 'farmland criss-crossed by hedges and trees'] moulded leaves and flowers which form the background to a *porcelain figure or group.

bodegón In Spanish *bodegón* was the name given to the cellar or lower entrance of a *bodega* (wine-vault). By the late 16th century it was also associated with paintings of kitchen scenes, the earliest examples of which appear to have been imported from Flanders into Spain. Velázquez painted a number of *bodegones* early in his career in Seville, the best-known of which

is perhaps the *Old Woman Cooking Eggs* of 1618 (National Gallery of Scotland, Edinburgh).

bodhisattva A saintly being, destined to become a Buddha but choosing to remain on earth to help others, represented in Buddhist art.

body The term used to describe the material *pottery or *porcelain is made from.

body art A widespread movement of the later 1960s and 1970s, in which the artist's body was the medium. It varied widely, ranging from the masochistic, in which the body was mutilated (for example the artist Gina Pane cutting herself in precise patterns with razor blades), to the spiritual (eastern-influenced attempts to levitate). Body art often manifested itself in public or private performance events which were recorded in documentary photographs or videotapes. Precedents can be found in *Dada art (for example Marcel Duchamp's star-shaped haircut) and in the *Actions of Yves Klein and Piero Manzoni in the early 1960s. Body art rejected the cool *Minimalism of the 1960s and embraced the body-oriented culture of that era.

bodycolour Another name for opaque *watercolour, that is watercolour mixed with *Chinese or *lead white. Many Victorian watercolours contained a considerable element of bodycolour in order to achieve an additional element of brilliancy and enable them to rival oil paintings in that respect.

Bohemian glass Decorative glassware produced by a group of factories in Bohemia. The earliest was founded in the 15th century and by the 17th they were creating many finely engraved pieces. The industry was revived in the early 19th century and produced large quantities of glass in brilliant colours, such as ruby and amber, often elaborately engraved with hunting scenes.

Bohemian School A term used to describe art produced in Bohemia in the second half of the 14th century, in particular during the reign of Charles IV, King of Bohemia from 1346 and Holy Roman Emperor from 1355. The particular strength of Bohemian art lay in *panel painting and *fresco, produced in a style that formed part of the *International Gothic movement, combining both Sienese and French influences.

boiserie [French, 'wood panelling'], used to describe 17th- and 18th-century panelling carved with shallow relief decoration of foliage. It was often painted white with the decoration picked out in gold.

bole A natural *clay sometimes used for *grounds in oil painting (especially early Italian *gold ground *panel pictures). The most common is red bole, used since the Middle Ages as a ground for *gilding. Clay grounds tend to retain moisture and can show through in thinly painted pictures, thus unintentionally darkening the overall effect.

bolection (or reverse rebate) A term applied to picture frames in which the profile is in reverse to the normal pattern and the raised moulding is

adjacent to the picture surface rather than on the outer part of the frame. This has the visual effect of seemingly pushing the picture out from the wall. More generally, bolection moulding describes moulding used to cover the joint between two members with different surface levels. It projects beyond both surfaces and is usually of S-section.

Bolognese School Normally understood to refer to the high point of Bolognese achievements in the visual arts, brought about in the late 16th and early 17th centuries by painters such as the Carracci, Guido Reni, Francesco Albani, Lanfranco, and Guercino. The capital of the province of Emilia-Romagna in central Italy, Bologna straddles the Roman Via Emilia linking Rome and Ravenna. It underwent considerable expansion in the 15th century during the rule of the Bentivoglio family and became the second city of the Papal States following the Sack of Rome (1527). As a result of the reforms brought about by the Council of Trent mid-century, Bologna was very much in the vanguard of the Catholic Church. A number of art academies were formed there, the most important being Agostino and Annibale Carracci's founded in 1582, the teaching of which stressed both the study of nature and the importance of Roman classicism, as exemplified by Raphael's *St Cecilia*, which had arrived in the city in 1515. Annibale was called to Rome in 1595 to work for Cardinal Farnese in his palace there, where he produced his great *fresco cycle *The Loves of the Gods*. He was rapidly followed to Rome by many of the best Bolognese artists, who proceeded to dominate fresco decoration in Rome for the first 25 or so years of the century, aided in part by the papacy of the Bolognese Gregory XV (1621-3). The subsequent reputation of the Bolognese school remained high in academic circles: in the 18th century Guido Reni was considered by many to be second only to Raphael. In the 19th century, however, it was condemned by writers such as John Ruskin and has only emerged relatively recently from critical neglect.

bombé [French, 'blown out'], used to describe the swelling, projecting fronts often found in *Rococo furniture.

bone china A type of *porcelain containing bone ash, making it pure white, hard, and translucent. A patent was first taken out in the 1740s by Thomas Fry at *Bow for the use of bone ash, but bone china in its present form was first introduced by *Spode in 1796-7. Softer than *hard-paste porcelain, more durable and economical than *soft-paste, it became the standard English porcelain *body in the 19th century and is still used today.

bonheur-du-jour An 18th-century French term for a lady's writing-desk or *escritoire consisting of a table with an organizer along its rear edge, often with drawers or pigeon-holes. They were especially popular in the final decades of the *ancien régime*.

Book of Hours A prayer book for private devotional use containing prayers or meditations suitable for certain hours of the day, days of the week, months, or seasons. By the 15th century they were so popular they outnumbered all other forms of *illuminated manuscript. Perhaps the most

celebrated example is the *Très Riches Heures du Duc de Berry* (Musée Condé, Chantilly), the illumination of which was begun by the Limburg brothers *c*.1413.

Book of the Dead A term used to describe selections from ancient Egyptian funerary literature which were placed inside the coffins and later on the *papyri buried with the dead. The name 'Book of the Dead' was invented by the German Egyptologist Richard Lepsius, who was the first to publish a selection of the texts in 1842.

book-plate A decorative label stuck in the front of a book, bearing the name of the book's owner.

boss A small, circular, projecting ornament, often used as a decorative motif on furniture to cover a join in mouldings, also found in architecture. *See* RIB.

bottega [Italian, 'shop'] the workshop of an established Italian artist of the Middle Ages or *Renaissance, where he worked with his assistants.

boucharde A steel hammer used for sculpture, it has pyramidal teeth on the striking face. When the stone, such as *marble, is struck at right angles by the boucharde this produces a grainy effect, a finish greatly favoured by French sculptors in the 18th century. Also known as a *bush hammer in North America.

boudoir A room set aside for the lady of the house for privacy and informal activities such as reading or sewing.

boulevard A wide thoroughfare in a French town or city, often planted with trees to separate the pavements from the carriageway; the *grands boulevards* are those that run in Paris from République to the Madeleine.

boulle A type of *marquetry, using tortoiseshell and brass. Originally an Italian process, it was perfected by André-Charles Boulle in France in the 18th century. It was produced by gluing together sheets of *tortoiseshell and *brass, which were then cut to the design using a fretwork technique. The layers could be combined to produce a tortoiseshell ground inlaid with brass ('first-part') or a brass ground inlaid with tortoiseshell ('counter-part'). This could be used to great decorative effect on furniture. The brass was often engraved to provide greater richness. During the 19th century a machine-based process, 'Buhl work', was used to simulate this technique.

bouquetière From the French for an arranger and seller of flowers, it was a form of glass bowl in late 18th- and early 19th-century France, being a revival of an early Venetian type which had a flared, wide mouth and a wavy-edged brim. It was mounted on a stem and foot and often decorated with *mascarons and *fluting.

bourdaloue An oval-shaped chamber pot, usually of *porcelain, used mainly by ladies when travelling. It was named after Louis Bourdaloue (1632–1704), a French Jesuit preacher, whose sermons were so popular that

crowds assembled hours in advance. They were produced throughout Europe, as well as the Far East, for export, and were also made in *faience, silver, and *japanned metal.

Bow One of the earliest English *porcelain factories, situated in Stratford, in the East End of London. It was founded in the mid-1740s by the Irish painter Thomas Frye and glass maker Edward Heylyn. *Soft-paste porcelain appears to have been made by 1748, although the earliest dated wares are of 1750. During the first decade the factory produced a wide range of useful wares and a variety of figure models in its characteristic heavy, thickly potted paste. After 1760 most products were richly enamelled in the *Rococo style. The factory was sold in 1775.

bower A sheltered area, or a covered room or *gazebo in a garden.

bow front The convex curved front found on 18th-century furniture, especially chests of drawers and *commodes.

boxwood A very hard yellowish or brownish wood with a fine grain, from the box tree, which is commonly found in Europe and elsewhere. Boxwood has been used for small ornamental carvings and also in furniture making (for example for fillets to frame a decorative motif).

bozzetto [Italian *bozzo*, 'rough stone'] strictly speaking a small-scale, three-dimensional sketch made by a sculptor in wax or clay in preparation for a larger, more finished work. By extension the term is also applied to a rapid sketch in *oil paint made for a larger picture.

bracket A small ornamental shelf attached to a wall for the support of a clock or decorative object.

bracket foot A squared foot, used on 18th-century cabinet furniture.

braiding *Embroidery made of coloured braid.

brass A gold-coloured *alloy of *copper and *zinc, it is malleable and takes a high polish. It was introduced to Europe from Asia by the Romans in the 1st century AD and was at first used mainly for coinage. Thereafter it became the principal European copper alloy. In medieval times most metal sculpture was made of either brass or copper. Brass has also been widely used in west Africa and northern India. More recently in Europe brass has been employed for the manufacture of lighting fixtures and drawer handles.

brazier A vessel in which charcoal may be burnt to heat a room. It is usually portable and made of metal (*bronze, *brass, occasionally *silver in the 17th century) with a pierced cover. Braziers have been used since ancient times, especially in warmer countries where houses had fewer fireplaces.

brazing A method of joining one piece of metal to another by making both red-hot so that the metal fuses.

breakfast piece A type of *still-life painting showing the ingredients of a simple meal. *Banketjestukken* were developed in the 1620s and 1630s in

Holland, particularly in Haarlem by artists such as Pieter Claesz. and Willem Claesz. Heda. Typical contents included bread, cheese, fish, fruit and nuts, and a tankard of ale, all carefully laid out on a table. Breakfast pieces were painted in a relatively severe, monochrome palette, very different from the show and splendour of the *pronkstilleven*.

breakfront The central section of a piece of furniture which projects in front of the side sections, especially on bookcases or cabinets of the 18th century.

breccia *Rock consisting of fragments of stone such as *marble or *limestones within a natural cement of a contrasting colour.

breviary A liturgical book containing the service for each day, to be recited by those in orders in the Roman Catholic Church. From the 11th century onwards these services began to be gathered in one, as opposed to several, books (the word 'breviary' derives from the Latin *breviarum*, 'abridgement'). Only those breviaries reserved for the use of kings, nobles, or Church dignitaries were richly illustrated.

brick A building block made of clay, sand, and lime or concrete and moulded into a rectangular shape; it is of relatively small size and capable of being held in the hand. Clay bricks may be sun-dried or fired in a *kiln. A 'stretcher' is a brick laid along the line of the wall so only its side is visible; a 'header' is a brick laid at right angles to the wall so that the end only appears.

bridge A construction with one or more open intervals under it to span a river, road, railway, etc. Bridges can be built of brick, concrete, iron, rope, or wood or a combination of these. The first wooden bridges appeared during the Bronze Age *c.*4000 BC; around the same time the first suspension bridges appeared in Africa and India. The arch bridge was developed in Mesopotamia, was known in Egypt by 3600 BC, but did not reach Rome until *c.*200 BC. Pontoon bridges, made up of boats joined together, were used in military operations by the ancient kings of Persia and the concept remains valid for military operations today. The first cast-iron bridge was built over the River Severn at Coalbrookdale in 1779. In the 19th century the railways dominated bridge-building, whereas in the 20th century the needs of road-users have been paramount.

brise-soleil [French, 'sun-break'] a louvred sun-screen incorporated into the *facade of a building to reduce glare. The device was invented by the architect Le Corbusier in 1933.

Bristol glass Glasshouses were established in Bristol in the 1740s and specialized in a deep blue coloured *glass, made into decanters and *goblets, often decorated with *gilding. Isaac Jacobs is known to have worked as a gilder in Bristol in the late 18th and early 19th centuries and a few pieces bear his signature. The term 'Bristol' glass is often erroneously used to describe any coloured glass made during this period.

Bristol porcelain Benjamin Lund set up a factory making *soft-paste
*porcelain in Bristol in 1749, producing small items such as cream jugs and
sauce boats, but in 1752 the factory was taken over by *Worcester, so its
products are rare. In 1770 William Cookworthy transferred his *hard-paste
porcelain factory from *Plymouth to Bristol. In 1774 the patent was
assigned to Richard Champion, but the factory closed in 1782 after much
litigation and the patent passed to the New Hall factory in Staffordshire.

Bristol pottery There were a number of potteries in the Bristol area
making *tin-glazed *earthenware or *delftware from the late 17th and
through the 18th centuries. Early pieces included blue-dash *chargers,
large boldly decorated dishes with blue slanting dashes around the rim. By
the 18th century blue and white *chinoiserie decoration was very popular,
and products included plates, punch bowls, flower bricks, and *posset pots.

Britannia metal A cheap and popular substitute for *pewter, invented in
England in the mid-18th century, made from an *alloy of *tin, *copper, and
*antimony. It was economical to produce as it could be rolled into a sheet
and then spun over wooden moulds into hollow vessels without any hand
finishing. Production on a large scale began in the 1780s and in 1804 a
factory was established in Sheffield.

Britart The 1990s phenomenon of 'Britart' (an abbreviation) grew out of
an interest in new British art stimulated by the Turner Prize, inaugurated in
1984, held annually at the Tate Gallery, London. Further influential factors
were the patronage of the collector Charles Saatchi and the exhibition
Freeze, curated by Damien Hirst in an empty London warehouse in 1988.

Broad Manner *See* Fine Manner.

brocade A loosely applied term that denotes a richly patterned *textile,
particularly with a raised gold or silver thread.

brocard A French term for a *silk fabric brocaded with patterns of flowers
or figures in gold or silver thread.

broderie anglaise A type of *embroidery popular in the 19th century in
which holes cut into material are overcast in satin stitch. It was usually all
white and was popular for underwear.

broken pediment In architecture, a *pediment which is broken, that is
the centre part of the base is omitted. It was introduced in the *Mannerist
style and thereafter widely adopted. It was also used on furniture, especially
*Chippendale-style pieces.

bronze An *alloy of *copper containing more than 1 per cent of *tin,
and sometimes other metals as well (most notably *lead). It is more
easily melted and cast than pure copper as well as being harder and
more durable. Bronze was developed by many of the ancient civilizations
and was widely used from the Bronze Age onwards for weaponry, tools,
and armour, as well as for sculpture, for which it became the most

favoured medium. There are a few surviving examples of Greek statuary in bronze, and innumerable ones from Roman times. By the 12th century bronze was also used in the West for candlesticks, altar fittings, and liturgical objects. In the early *Renaissance artists such as Ghiberti utilized bronze for the sculptural decoration of church doors (for example the Florence Baptistery). Donatello and Verrocchio revived the antique practice of casting large-scale statuary in bronze and by the mid-16th century bronze was in widespread use for the production of small-scale statuettes. In the 18th century much fine French furniture was ornamented in bronze. The term has only been used accurately in Britain for the last 200 years or so; prior to then most metal sculpture had been described as being made of *brass.

bronze disease A degeneration of the surface of *bronze, it is generally thought to be caused by the corrosive effect of chlorides on the metal.

bronzes d'ameublement Small *bronze fixtures and furnishings such as clock-cases, *fire-dogs, lamps, and keyhole guards. High quality designs for these were produced by sculptors in France in the 18th century. The term does not apply to bronze furniture mounts.

Brücke, Die [German, 'The Bridge'] a group of German *Expressionist artists formed in Dresden in 1905 by Ernst Ludwig Kirchner, Karl Schmidt-Rottluff, Erich Heckel, and Fritz Bleyl, all of whom were architectural students at the Dresden Technical School. The name was chosen by Schmidt-Rottluff and suggested the group's faith in the art of the future to which they would act as a bridge. Kirchner wrote the group's short manifesto issued in 1906, the year in which Emil Nolde joined (he left the following year). Medieval and primitive art were important influences: the latter could be studied in the Dresden Ethnological Museum. The art of Die Brücke remained strongly figurative, often depicting figures in a landscape. Graphic art was a particular speciality, especially the dramatic *woodcuts produced by Heckel and Schmidt-Rottluff with their characteristic strong patterns of black and white and bold cutting of the block. By 1911 most of the major Brücke artists had moved to Berlin where their art was seen in opposition to the German Impressionism promoted by Max Liebermann and his followers.

brush A painting tool made of fibres bound and inserted into a handle. Brushes have been used since ancient times, and in ancient Egypt were made of macerated reed fibres. A wide variety of animal hairs have been employed including sable, squirrel, and hog-bristle. The hairs are first sterilized and then sorted and grouped according to size. Synthetic fibres were introduced to brushmaking in the late 1960s, with polyester proving superior to nylon. Historically, and confusingly, a brush was usually referred to as a 'pencil'.

Brussels lace Brussels was one of the major centres of *lace production since the early 16th century, specializing in *needlepoint lace (point de gaze) of great delicacy and *pillow lace.

Brussels pottery A *pottery factory was founded in Brussels in 1705 producing *faience wares from 1724. Particularly notable were large tureens and vessels in natural forms, such as cabbages, melons, ducks, and fish, similar to those produced at *Strasbourg.

Brussels tapestries One of the most important *tapestry factories in Europe, which first rose to prominence during the late 15th century. Impressed by the technical expertise of the factory, Pope Leo X commissioned Pieter van Aelst to weave *The Acts of the Apostles* series after Raphael's cartoons (1516–19), which were then hung in the Sistine Chapel in the Vatican on grand occasions, establishing Brussels as the leading tapestry centre in Europe. Other factories copied this set, including *Mortlake. In the early 17th century Rubens provided many cartoons for the weavers. Although Brussels continued to produce tapestries throughout the 17th and 18th centuries, the main centre for production passed to Paris in 1663, when the *Gobelins factory was taken over by Colbert for the king, attracting many of the best Flemish weavers away from Brussels.

Brutalism A term coined in England in 1954 to describe the architecture of Le Corbusier at Marseilles and Chandigarh, it is characterized by its use of concrete exposed at its roughest (*béton brut*), with an emphasis on big, chunky members which collide ruthlessly.

buckling The appearance of waves or bulges in a *canvas that has slackened from its *stretcher; also used to describe *cleavage from the support in which the *ground and upper layers of the painting give way, or crumple up under pressure from shrinkage of the canvas support, and are pushed up along the edges of cracks.

bucranium An ox-skull, usually garlanded, often carved in the *metopes of a *Doric frieze. Also frequently used as an ornamental motif for the decoration of furniture, *porcelain, etc., in the late 18th century.

Buen Retiro A *porcelain factory in Buen Retiro park, Madrid, founded in 1759 by Charles III when he acceded to the Spanish throne. All equipment, materials, and craftsmen were brought from the *Capodimonte factory in Italy. One of the first creations was a porcelain room for the royal palace at Aranjuez (1760–5). Early wares, in the characteristic creamy white *paste, included a wide range of figures and large figure groups; later products were mainly vases in the *Neoclassical style. The factory closed in 1808.

buffet A term originally given, perhaps erroneously, to various types of 16th-century doorless, generally rather heavy, pieces of furniture with two or more tiers often used as sideboards. From the 18th century onwards buffet became a synonym for sideboard.

bull's eye In architecture, a small circular or elliptical aperture for the admission of light and air, also called an *oeil-de-boeuf or *oculus.

bungalow A single-storey dwelling, derived from the Hindustani word for a thatched house. Bungalows were originally devised as light dwellings

with *verandahs erected in India, mainly for the British administrators there. They have since become very popular in Britain and can be found in distressingly large numbers in the suburbs of most British towns and cities.

buon fresco True *fresco painting, in which paint is applied directly to the wet plaster.

bureau [French, 'writing table or desk'] the term derives from *bure*, a type of coarse linen used in the Middle Ages to cover the tables and chests on which clerks wrote. A variety of distinct types of bureau evolved in France. A *bureau plat* is a flat-topped writing table, usually with a leather top and drawers in the frieze, which was particularly popular from the late 17th century onwards. A *tableau à écrire* is a small *bureau plat*. A *bureau à gradin* is a *bureau plat* with a set of drawers and/or pigeon holes along one side of the top. A *bureau à cylindre* is like a *bureau à gradin* with a roll-top which, when closed, covers both the pigeon holes and writing surface with a quarter cylinder of slats of wood. A similar but smaller desk with a sloping fall-front instead of a roll-top is called a *bureau en pente*. Outside of France, bureau describes the lean-to, fall-front writing desk popular in England and America from the late 17th century (if surmounted by a bookcase it is called a bureau-bookcase).

burin A small metal tool with a square, lozenge, or triangular section cut at an angle to a sharp point. It is used for engraving a design on a hard surface, usually metal. The pattern thus produced can either be decoration of a sculptural surface, or the incising of a design on to *copper in the production of an engraved print. The burin is pushed by the hand and normally has a mushroom-shaped handle.

burlap A coarse *canvas.

burnisher A tool with a hard, smooth, rounded end or surface, used for smoothing and polishing. Its various applications include *gilding, in which the gold surface is polished, and metal-plate printmaking techniques, in which any unwanted roughness on the printing plate is removed before inking and printing. A burnisher is particularly crucial to the *mezzotint process in which the final design is scraped from the roughened plate with a variety of burnishers.

burnt carmine A deep brown-purple *pigment made by roasting or charring *carmine.

burnt ochre A red *ochre pigment made by calcining (oxidising by strong heat) yellow ochre.

burnt sienna One of the most versatile of all the permanent *pigments, it is used in most of the painting techniques. It is red-brown with an orange undertone and is made by calcining *raw sienna.

burr The ridge of copper fragments deposited either side of the line incised by the *drypoint needle in the printmaking technique of that name.

When printed from, drypoint plates to which burr still adheres produce rich, smudged lines. However, the burr rapidly wears away with each subsequent impression as the burr is lifted off by the paper in the pressure of the printing process. Particularly famous prints with burr still in evidence are early *impressions of Rembrandt's drypoints such as *The Three Crosses*.

burr wood A malformation on the trunk of a tree, which could be several feet across, forming an irregular, dense wood. Burr from oak, maple, and walnut were used on furniture for *inlay and *veneers from the 16th century.

bush hammer *See* BOUCHARD.

bust A sculpted portrait or representation consisting of the head and part of the shoulders (sometimes erroneously applied to the head alone).

buttress A mass of masonry or brickwork built against or projecting from a wall to give it added strength. A 'flying buttress', found in later *Gothic architecture, is a more elegant form whereby the thrust is carried through an *arch or half-arch from the upper wall or roof of the main building to the supporting *pier.

Byzantine A term used to describe the art associated with the eastern Roman empire, which commenced with the emperor Constantine's foundation of his capital, Constantinople, on the site of the small town of Byzantion 324–30. The empire is generally considered finally to have ceased in 1453 with the fall of Constantinople to the Turks, who renamed it Istanbul and made it the capital of the *Ottoman empire. Byzantine two-dimensional art was above all religious and hieratic, centred on the divine rather than the earth-bound, and executed in a relatively unchanging style. It is most clearly manifested in mural paintings, *illuminated manuscripts, and *mosaics. Byzantine architecture was originally based on and developed from that of the later Roman empire in the east. Among its great architectural monuments are the churches of Hagia Sophia in Istanbul (532–7), San Vitale in Ravenna (completed 547), and San Marco in Venice (1063–95).

Byzantine Revival A revivalist style, based on *Byzantine art, which took root in western Europe and north America in the second half of the 19th and early 20th century. It affected all the arts, but especially decorative arts and architecture. Interest was originally stimulated in Byzantine art by travellers' accounts of their visits to Greece and Turkey. It reached its peak between 1890 and 1914, stimulated by Lethaby and Swainson's monograph on *The Church of Santa Sophia, Constantinople* (1894), and was most clearly manifested in the design for the Roman Catholic Westminster Cathedral, London (begun 1895).

C

cabinet A piece of furniture with a series of small drawers, fronted by doors, for the storage of small objects of curiosity and interest. It is usually mounted on four legs. The cabinet originated in 16th-century Italy and was quickly adopted in northern Europe, especially in the Netherlands, where fine *ebony examples were produced, and in Germany (particularly Augsburg), where *marquetry decoration was employed. From the later 17th century oriental *lacquer cabinets (and their European imitations) became very popular. Cabinets were often embellished with elaborate decoration such as *pietra dure and pieces of *ivory.

cabinet-maker A term first applied in 1681 to a superior type of joiner on account of the *cabinet often being the grandest and most complex piece of furniture in a household.

cabinet picture A type of small picture, first developed in Antwerp and Prague, for the *Kunstkammern of collectors and *connoisseurs in northern and central Europe in the late 16th and early 17th centuries. The subject-matter of such pictures ranged widely: biblical, allegorical, and historical themes, portraits, landscapes, sea-pieces, and still lifes. Today such pictures are often displayed in the small side galleries in museums such as the Alte Pinakothek in Munich and the Kunsthistorisches Museum in Vienna.

cabochon A smooth, convex, uncut gemstone.

cabriole A curved, S-shaped leg used on furniture in the 18th century; a stylized form of an animal hind leg, terminating in a paw, hoof, or *claw-and-ball foot.

caduceus A herald's wand, more specifically the wand carried by Mercury, the messenger of the gods; it is usually represented with two serpents twined round it.

calico A cotton fabric, in particular the brightly painted fabrics popular in 17th-century Europe. The term derives from 'Calicut', i.e. Calcutta in India, from where such fabrics were first imported into England in the 16th century.

calligraphy The art of fine writing with brush and ink or pen and ink, it is also frequently used as a means of decoration and artistic expression as well as for written communication. Although common to many cultures, calligraphy has played a particularly important role in those of the Far East.

calotype The first widely used photographic process in which images could be produced on paper. Writing paper is prepared with solutions of silver nitrate and then potassium iodide. When required for use it is treated

with a freshly prepared solution of gallo-nitrate of silver. It is then exposed and the image is brought out by a further treatment with gallo-nitrate of silver and fixed with *hypo. It was invented by the English scientist William Henry Fox Talbot in 1839, patented in 1841, and was also known as Talbotype.

Calvary A sculptural representation of Christ's crucifixion on the hill of Calvary. The term is sometimes applied to any wayside crucifix or to chapels with a series of carvings of the Passion of Christ. The greatest concentration of sculpted Calvaries is to be found in Brittany, dating from the late 15th to the early 17th century.

camaïeu A French term which means 'monochrome'. Painting *en camaïeu* is found on *porcelain, *pottery, and *enamel and was particularly popular at *Sèvres in the 18th century.

Camden Town Group An exhibiting society of sixteen British painters that flourished 1911–14, working in a style generally derived from *Impressionism but addressed to relatively low-key subjects such as nudes on a bed or at their toilet, or informal portraits of friends and models in shabby bed-sit interiors. The term is said to have been coined by Walter Sickert (1860–1942) in whose studio in Fitzroy Street, London the group had first gathered.

cameo A small-scale, low relief sculpture, carved from banded or stratified material, usually a hardstone such as *onyx (black and white) or *sardonyx (brown or red and white). The upper layer is cut away in relief while the lower one is revealed as a blank ground. The technique was first developed at the *Hellenistic courts and enthusiastically taken up by the Romans, mainly for portraiture and mythological scenes. Extraordinarily subtle effects of light and shadow were achieved in these delicate sculptures and they were highly prized by collectors from ancient times onwards. Imitations of cameos were made from coloured glass and, in the late 19th century, from a *porcelain technique known as *pâte-sur-pâte*.

camera lucida [Latin, 'light chamber'] an optical device used as an aid in drawing or copying. It consists of a prism mounted on a drawing board: the image to be drawn is reflected at right angles by the prism onto the board. A lightweight and portable piece of equipment, it was used by professionals and *amateurs alike. Dr William Hyde Wollaston patented its design in 1807 and is generally credited with its invention.

camera obscura [Latin, 'dark chamber'] a light box, with a small hole on one side (sometimes fitted with a lens), through which an image passes onto a mirror mounted at 45° and is reflected onto a drawing or painting surface. In a sense it was the precursor of the modern camera and was used as an aid by many artists, most famously the 18th-century view painter Canaletto (1697–1768). The camera obscura had been known since antiquity and one of its earlier uses had been for the safe observation of eclipses.

campanile The Italian name for a bell-tower, usually attached to a church but sometimes separated from it. The earliest recorded campanile was a square one, dating from the mid-8th century, at St Peter's, Rome; the first surviving example is circular and is at Ravenna, probably dating from the 9th century.

canapé A term of French origin, used in the 18th century to describe a type of *sofa or *settee.

cancelled plates When the printing of a *limited edition of prints has been completed the original printing plate or stone is deliberately defaced, or 'cancelled', to ensure no further *impressions can be printed.

candelabrum A candlestick with nozzles for two or more candles.

canopic vase A vase with a cover in the form of an animal or human head, first made by the ancient Egyptians to hold the entrails of an embalmed body. The shape was revived by *Wedgwood in the 18th century, but only as a decorative object.

canterbury A stand with vertical slats to hold sheet music, popular in the late 18th and early 19th centuries; originally a low trolley for plates and cutlery for use at supper parties without servants.

cantilever A horizontal projection, such as a step, balcony, beam, or canopy, which appears to be self-supporting but is in fact counterbalanced by a downward force on the far side of a fulcrum.

cantilevered chair A chair whose design makes use of the *cantilever principle, with the seat supported on a U-shaped structure of metal tubing or *bentwood. Mart Stam first developed the design in 1924 and put it into production in 1926, closely followed by Mies van der Rohe and Marcel Breuer.

Canton The term given to a distinctive style of *Chinese export *porcelain of the 19th century, which was first produced for the Middle East and then later for Europe and America. Large vases, dessert services, and tea wares were decorated with dense, colourful patterns of figures, flowers, and insects in the *famille rose palette.

canvas A cloth made from cotton, hemp, flax (the commonest material for canvases of any age), or sometimes *silk, used as a paint support. Canvas began to rival wooden panel (which was more expensive and took longer to prepare) as a support around 1500. Unlike *panel, canvas could not crack or split on account of climate changes and it soon became the preferred support. The term can also denote the finished painting itself.

capital The upper part of a *column or *pilaster set above the *shaft. Each of the classical architectural *Orders has a distinctive capital.

Capodimonte A *porcelain factory founded in 1743 by Charles III, king of Naples. Its wares are usually of a fine, pure white, translucent *soft-paste

which provides a suitable background for the painted designs which were variously inspired by the *porcelain of *Meissen and of Vienna, and by the designs of French artists such as Watteau. Characteristic also of Capodimonte, however, was the Neapolitan style of the bouquets of flowers, landscapes, and fleshy mythological scenes frequently used as decoration. In 1759 Charles succeeded to the Spanish throne and the factory moved to the park of *Buen Retiro in Madrid.

capriccio [Italian, 'caprice'] a painted or drawn composition combining real or imaginary architectural features in a fantasy setting. The capriccio was essentially developed in the 18th century and associated, though not exclusively, with Italy and Venice in particular (Canaletto, Piranesi, and Tiepolo). *See* VEDUTA.

carat A measure of weight for gemstones, in use since antiquity. The name is derived from *keration*, Greek for kernel of the carob bean. A carat weighs 200 milligrams. Carat is also the name used by goldsmiths to measure the purity of *gold. Pure gold is 24 carats; most gold used for jewellery is 9 or 18 carats.

carbon black A black *pigment produced from the soot deposits left by natural gas flames. It is used in printing and *lithographic inks.

carcase The main body of a piece of furniture, over which a *veneer is applied.

caricature [From the Italian *caricare*, 'to load, exaggerate'] a form of art, usually portraiture, in which the characteristic features of the subject are exaggerated or distorted for comic effect. The Bolognese artist Annibale Carracci (1560–1609) is normally credited with its invention at the end of the 16th century. He justified it as a counterpart to idealization—just as the serious artist penetrated to the idea behind outward appearances, so the caricaturist portrayed his victim as if Nature had wholly had her way. Political caricature emerged in the last three decades of the 18th century with artists such as James Gillray and found perhaps its greatest exponent in the middle of the 19th century in the work of Honoré Daumier.

Carlo Maratta An English variation of the *Salvator Rosa picture frame, it was so called because it was first found on works by Maratta (1625–1713). In its enriched form (for example with *acanthus leaf moulding in the centre *scotia) the Maratta frame was especially popular in England in the 18th century when the great *Grand Tour collections were being formed.

carmine A red *lake *pigment, popular as an artists' colour from the mid-16th to the 19th centuries. It was made from cochineal, a dyestuff of insect origin imported from Mexico. The first recipes for its manufacture appear in Spain *c*.1560; in the 17th and 18th centuries Venice, Antwerp, and France were important centres for its production.

Carolingian A term first used in 1837 specifically to describe the art associated with Charlemagne, king of the Franks, who was crowned Holy

Roman Emperor in Rome in 800. Charlemagne's own empire expanded to include parts of modern-day France, Switzerland, Germany, Austria, and Italy. He was particularly concerned to achieve a revival of the idea of the later, Christian Roman empire under the emperors Constantine and Theodosius. The art produced during his reign was a fusion of *Insular, late antique, and *Byzantine traditions. It embraced architecture, sculpture, manuscript illumination, and liturgical objects: amongst its many glories were the palace complex at Aachen and the abbey churches of St Denis and Fulda. More generally the term is also applied to the art produced under Charlemagne's successors up to the beginning of the 10th century.

Carrara The main area in the Apuan Alps north-west of Pisa and Lucca for the quarrying of 'white marble'. Carrara marble had been used from the time of the emperor Augustus for architecture. Its finer qualities came to be increasingly appreciated for sculpture, and it enjoyed high prestige during the *Renaissance. Perhaps the most famous statue to have been sculpted in Carrara marble is Michelangelo's *David* (Accademia, Florence), though it was also used later by many other great sculptors including Bernini and Canova. From the Renaissance onwards Carrara marble was exported from Italy in ever greater quantities.

carte-de-visite [French, 'calling card'] a small card, bearing a photographic portrait, used as a supplement to the normal visiting card. Such cards were especially popular just after the middle of the 19th century and were collected in *albums.

cartoon A full-size drawing used by an artist to transfer a design to a large, finished work. The most frequent use of a cartoon was in *fresco painting, particularly in the *Renaissance. The drawing was made on a strong paper, usually with *charcoal or *chalk, sometimes heightened with white or *watercolour. It was then cut into pieces and the section needed for that day's painting campaign on the wet wall surface was laid against it. A *stylus was then pressed heavily along the lines imprinting them in the wet plaster of the wall, or the design was pricked and powdered charcoal was rubbed through the holes (a process known as *pouncing). Cartoons were also used for *easel paintings, for example Leonardo da Vinci's *Virgin and Child with St Anne and the Infant St John* (National Gallery, London), and for tapestries, such as Raphael's cartoons for the Acts of the Apostles (on loan from Her Majesty the Queen to the Victoria and Albert Museum, London). The second meaning of cartoon, as a humorous drawing arose in the 19th century from the parodies in the magazine *Punch* of the designs submitted for the frescoes in the Houses of Parliament, London.

cartouche An ornamental panel shaped as a scroll or piece of paper with curling edges, usually bearing an inscription and sometimes ornately framed.

cartridge paper A term employed to describe the coarser, less expensive grades of drawing paper; it derives from the use of such papers for making cartridges and wrapping dynamite.

caryatid A sculptured female figure used as a column to support an *entablature. The term *carytades* derives from Vitruvius (fl. *c*.50–26 BC), who believed the female figures of the Erechtheion in Athens represented Carian prisoners. 'Caryatid' is also used more generally (and incorrectly) to describe *columns or *pilasters wholly or partly in the shape of the human form.

casein A *binder, of milk protein, used in the production of casein colours. Some authorities believe casein was the binder used in some of the paints of early civilizations. It is produced by drying the curd of soured skim milk to form a yellowish powder. Once it has dried, casein is water-resistant and is only water-soluble in the presence of alkali such as ammonia. Casein was first produced commercially in the 19th century.

casino Originally meaning a defence-post, it was more generally employed to describe a small country house or lodge in a park. In the 18th century it could also describe a dancing salon. In modern usage it is normally used to designate a room or building in which gambling takes place.

cassetta [Italian, 'little box'] the rectangular picture frame which evolved in Italy in the 16th and 17th centuries from the inner mouldings of *tabernacle frames. The *pilasters, *pediments, and *bases of the latter were dispensed with and one was left with what are commonly regarded as the basic elements of a picture frame. The Renaissance *cassetta* frame was essentially a decorative frieze between two narrow mouldings. The first truly movable *cassetta* frames were made in the Veneto in the early 16th century. Streamlined *cassetta* frames were used for framing whole collections, for example at the Capitoline and Spada galleries in Rome. In the *Baroque era the decoration of the basic *cassetta* frame became more elaborate with the addition of centre and corner mouldings.

cassone [Italian, 'a large chest'] a term first used in the 16th century to describe the painted wooden chests produced in Italy from the 14th to 16th centuries, mainly to celebrate famous weddings. The majority were made in 15th-century Florence and decorated with scenes painted both by famous artists such as Uccello, Botticelli, and Filippino Lippi and also by specialist workshops such as that run by Apollonio di Giovanni. Cassoni derived their long, thin shape from Roman *sarcophagi. The stories illustrated on their side panels came not only from the Bible, but also from a variety of secular sources popular in the humanist culture of the *Renaissance such as Ovid, Virgil, and Boccaccio. Placed for display on the floors of the grandest rooms in Renaissance palaces, cassoni were frequently damaged and their painted side panels later removed and hung as panel paintings in picture galleries, their original purpose long forgotten. In the 16th century cassoni came to be carved, often in a dark wood such as walnut, rather than painted, and by *c*.1550 their production had virtually ceased. *See* DESCO DA PARTO; SPALLIERA.

cast To reproduce an object, such as a piece of sculpture, by means of a *mould (usually of plaster) taken from it. A cast is also the copy so produced.

Castel Durante A group of *maiolica factories in Umbria, founded in the early 16th century, which produced outstanding wares decorated with *istoriato* painting. Nicola Pellipario began to develop this decoration 1510–15 on numerous plates and dishes painted with mythological scenes and became one of the leading painters in this manner. After the mid-16th century the factories went into decline and produced inferior wares until the mid-18th century.

castella (or castelle, castellum) A receptacle for the collection of water for distribution, usually a chamber with vaulted rooms. A *castellum* was also a small fortified town.

castellated An architectural term used to describe a building, usually a house, decorated with *battlements.

casting In metalwork it means the pouring of molten metal into a *mould; in joinery it refers to warping or bending.

castle Originally associated with the Middle Ages, a castle is a habitation fortified for defence with towers, surrounding walls, and moats. The moat or fosse had a bridge that could be raised, leading to the gates which were protected by descending grilles known as portcullises. In front of the castle was a *barbican, in tower or mound form, which defended the entrance. Inside the castle was the outer *bailey or wall and gatehouse, usually containing stables and offices. The inner bailey was the innermost defence in the corner of which was the *keep or *donjon containing the state apartments, a well, chapel, and other important rooms. Elements of castle architecture were adapted by later architects such as Robert Adam, and the 'Castle Style' is found in *follies, gateways, *picturesque cottages, and many country houses.

cast medal A *medal made by pouring molten metal into a *mould which is usually created from a wax model of the medal design. Freshly cast medals are neatened up by hand, using an engraving tool, which means that each medal is slightly different. *See* STRUCK MEDAL.

cast shadow The shadow of a figure or object portrayed in a painting as it falls or is cast into another surface. The depiction of such shadows is an important element of realistic depiction and must accord with the source of the light and be drawn in perspective.

catacomb An underground cemetery, often on several levels, consisting of linked chambers or galleries with recesses for the tombs. The word *catacumbas* (of uncertain origin) was first applied in the 5th century to the Christian cemetery beneath the church of S. Sebastiano on the Appian Way outside Rome. It was then generally used to describe many similar *Early Christian cemeteries throughout the Roman empire. However, catacombs were rarely used for burial after the 6th century as open-air burials were preferred. The term is also used to describe later underground burial chambers such as the 18th-century catacombs of Paris in the disused stone quarries of Montparnasse.

catafalque A temporary structure, decorated and usually draped, representing a tomb or *cenotaph and used in funeral ceremonies to support the coffin. Permanent catafalques can be found in some mortuary chapels, cemeteries, and crematoria.

catalogue raisonné [French, 'reasoned catalogue'] the complete published catalogue of an artist's work. Such catalogues, for example Paul-André Lemoisne's four-volume *Degas et son oeuvre* ('Degas and his work'), published in Paris, 1946–9, are normally regarded as standard publications on the subject and are often referred to in abbreviated form. Degas's famous portrait of *Diego Martelli* (National Gallery of Scotland, Edinburgh), for example, would be 'Lemoisne no. 519'.

cathedra The bishop's chair or throne in his *cathedral church, originally placed in the *apse behind the high altar.

cathedral The main church of a diocese in which the *cathedra is housed.

cavetto A hollow moulding, about a quarter of a circle in section, principally used in *cornices. The term is also used to describe a concave moulding, quarter circular in profile, in a picture frame.

celadon A European name given to Chinese *stoneware or *porcelain covered with a greyish olive green *glaze, derived from iron oxide. It was first developed and perfected during the *Song dynasty (960–1279). The name probably derives from the character Celadon, who wore grey-green ribbons, in Honoré d'Urfe's early 17th-century pastoral *L'Astrée*.

cella The main part of a *classical temple containing the cult image.

Celtic A style of European Iron Age art which flourished *c.*450–50 BC in the temperate parts of Europe and lasted until *c.*600 in Britain and Ireland. Surviving Celtic art consists mainly of metalwork in *gold, *bronze, *iron, and occasionally *silver, and of a few stone statues and some *pottery and glassware. Much of it was used to adorn weapons, eating and drinking vessels, and ornaments worn by men and women in what was essentially a warrior society supported by mixed farming. Celtic art is non-narrative, with a tendency to abstraction and a love of interlocking pattern and shape-changing ambiguity.

Celtic cross A cross with a tall vertical shaft and a shorter horizontal one (i.e. a *Latin cross) and with a ring or halo centred on the point of their intersection.

Celtic Revival A style based on an antiquarian revival of interest in ancient *Celtic art in Britain and Ireland. Mainly a decorative style, it first appeared in the 1840s and reached its peak in the late 19th and early 20th centuries. It manifested itself in metalwork, jewellery, *embroidery, wall decoration, wood inlay, stone-carving, and textiles. Its most celebrated practitioners included the Scottish architect Charles Rennie Mackintosh and the English metalwork designer Archibald Knox.

cenotaph [From the Greek, 'empty tomb'] a monument to a person or persons buried elsewhere, such as the victims of war.

centaur A creature from classical mythology represented with the head and torso of a man and the body of a horse. Centaurs feature in some of the earliest Greek art and in sculpture and reliefs of the *Classical period. To *Renaissance humanists, the centaur symbolized man's partly animal nature. The Elgin Marbles (the *metopes from the Parthenon, mid-5th century BC) depict the Battle of the Lapiths and the Centaurs, a theme which symbolized the victory of civilization over barbarism. It was also a popular subject with *Baroque painters.

Century Guild A group of artists and craftsmen, founded in 1882 by Arthur Heygate Mackmurdo (1851–1942), whose aim was to widen the scope of what was regarded as art to include activities which were then regarded more as the prerogative of the tradesman than the artist, such as 'building, decoration, glass-painting and sculpture'. Much of the work they produced was in an early *Art Nouveau style, using *whiplash curves and foliage with long, flowing tendrils.

ceramic [From the Greek *keramos*, 'potter's earth'] a *clay-based product, usually divided into *pottery (such as *earthenware, *stoneware, and *faience) and *porcelain (*soft-paste, *hard-paste, and *bone china).

Cercle et Carré [French, 'Circle and Square'] a discussion and exhibition society for *Constructivist artists formed in Paris in 1929 by the critic Michel Seuphor and the painter Joaquin Torres-Garcia. A journal of the same name appeared 1929–30, to which Mondrian contributed an article. In 1931 the Cercle et Carré was succeeded by the more important *Abstraction-Création group.

chaise longue An elongated upholstered chair or *daybed, suitable for a single person to recline upon, popular during the *Regency period.

chalcedony A gemstone of microcrystalline *quartz that is usually grey or green. *Onyx, *agate, and *cornelian are all forms of chalcedony. Since ancient times it has been used for miniature sculpture and *cameos.

chalcography An establishment in which large holdings of engraved plates are kept and which maintains large stocks from which *impressions are printed as ordered by the public. There are three main national chalcographies: Rome, founded by Clement XII in 1738, which includes most of the plates of the great 18th-century Italian printmaker Giovanni Battista Piranesi (1720–78); Madrid, founded in 1789; and Paris, established in 1797.

chalk A soft white or whitish form of *limestone composed of the remains of small marine organisms. It can be pulverized and bound with animal glue to make *whiting, a covering layer over stone, wood, or *earthenware prior to painting and/or gilding.

chamfer A canted surface, produced by bevelling off an angle.

champlevé [From the French *champlever*, 'to hollow out'] *enamel that is poured into grooves engraved as surface decoration on *silver, *bronze, or *copper. It is then fired and polished down to the same level as the surrounding metal. Used by the Romans and Celts, it was perfected in *Mosan enamels of the 12th century and widely employed in *Limoges enamels of the 12th to 14th centuries. *See* CLOISONNÉ.

chancel [From the Latin *cancellus*, 'a screen'] the space in the east end of a church reserved for the clergy and choir. Strictly speaking this area is separated by a screen from the main body of the church. In practice, the chancel is often the continuation of the *nave east of the *crossing and contains the high altar.

Chantilly A *porcelain factory founded at Chantilly, outside Paris, by Louis-Henri Bourbon, Prince de Condé, who was a great collector of Japanese porcelain. It produced *soft-paste porcelain initially covered with an opaque *tin glaze. Early products, with their sparse decoration, show the influence of Japan. The decorative cornflower motif known as 'Chantilly sprig' was created at the factory and much copied elsewhere. The factory mark was a hunting horn, which was frequently faked in the 19th century.

chantry (or chauntry) [From the French *chanter*, 'to sing'] a small chapel attached to or inside a church for the celebration of Masses for the soul of the founder or of others nominated by him.

chapel A place for worship, in a church, in honour of particular saints. Chapels are sometimes erected as separate buildings.

chaplet Retaining pin used in the cire perdue or *lost-wax technique of casting hollow sculpture. The pins are driven through the wax into the *core. When the wax is heated and poured away the chaplets ensure the core stays in position. The chaplets remain when metal is poured into the void between the mould and the core and are still in the metal cast once it has cooled and solidified. Depending on their compatibility with, and the thickness of, the sculpture they have helped to form, they subsequently either fall out or are smoothed down to the surface of the surrounding metal.

chapter-house The place of assembly for abbot or prior and members of a *monastery for the discussion of business. It is usually reached from the *cloisters. In England chapter-houses were normally polygonal in plan.

charcoal A black crayon made from charred twigs of wood, usually willow or vine. It is one of the oldest known drawing materials and was used for sketching in free-hand mural compositions by the Greeks and Romans and during the Middle Ages and the *Renaissance. Like *pastel it smudges easily and can be manipulated on the drawing surface with a finger or with the artist's tool known as a *stump. Charcoal is normally available in varying degrees of thickness and hardness.

charge In *heraldry, a figure represented on a shield.

charger A large, usually wooden, plate or dish on which a joint of meat is served and cut. *See* TRENCHER.

charterhouse A Carthusian *monastery.

chasing The tooling of a metal surface by denting or hammering (as opposed to *engraving). It is used to remove surface blemishes (for example in the *lost wax technique of casting sculpture) and to raise patterns in relief (for example in the decoration of silver).

chasuble The principal vestment worn by the priest for the celebration of the Mass. Medieval chasubles were originally more or less conical in form, but nearly all have been subsequently curtailed at the sides.

château A *castle or country house in France, particularly associated with the reign of Francis I and the region of the Loire.

chatelaine A triangular ornament, which could be attached to a sash or belt, from which hung several small articles fixed by fine chains. Fashionable in the 18th and 19th centuries, they were worn by both men and women and could be made of *gold, *silver gilt, *silver, or *enamel, fitted with articles of matching decoration. A wide variety of objects could be attached to a chatelaine, including a watch, scissors, seal, *étui, button hook, *vinaigrette, needle case, and pencil.

Chelsea Probably the first English *porcelain factory, founded about 1744, Chelsea produced the highest quality and most fashionable wares in England during its short period of manufacture. The porcelain was *soft-paste, translucent, with a mellow *glaze, which, in the early days, showed slight tears and warping. Nicholas Sprimont, a silversmith, was probably associated with the factory from the beginning, becoming manager in 1749, and early products are derived from *silver prototypes. By the 1750s many useful wares were produced, with restrained, simple decoration, often botanical in theme, as well as a wide range of allegorical and peasant figures. Later creations, such as *garnitures of vases and figure groups, were much more ornate in manner. In 1769 the factory was sold to William Duesbury of Derby and products were known as 'Chelsea-Derby' until the factory finally closed in 1784.

cherub A child angel, usually in the form of a chubby infant, depicted in western art from the 15th century onwards.

chevet The French term for the east end of a church containing the *apse and *ambulatory, usually with radiating chapels.

chevron A zigzag moulding found in *Norman architecture; also the seventh Honourable *Ordinary in *heraldry, consisting of two diagonals commencing in *dexter and *sinister *base meeting in the centre of the shield and resembling the silhouette of a pitched roof or the inverted letter V.

chiaroscuro [Italian, 'light-dark'] a term used to describe the effects of light and dark in a work of art, particularly when they are strongly contrasting. Leonardo da Vinci was a pioneer of chiaroscuro but it is most frequently discussed in relation to the paintings of the 17th-century artists Caravaggio and Rembrandt. The English landscape painter John Constable (1776–1837), mindful of the effects of contrast he wished to achieve in his work, wrote of the 'Chiaroscuro of Nature'.

chiaroscuro woodcut A technique of producing *woodcut prints with more than one colour. This is achieved by using different woodblocks for each of the colours and cutting the designs accordingly. It was first used in the early 16th century in Germany by artists such as Hans Baldung Grien, from where the technique spread to the Netherlands. It enjoyed its greatest popularity, however, in Italy where printmakers such as Ugo da Carpi and Antonio da Trento employed it to spread the designs of Raphael and Parmigianino. Its popularity lasted in north and south Europe until the early 17th century. It enjoyed later revivals in the early 18th century and at the end of the 19th, when it was taken up again by artists such as Paul Gauguin and Edvard Munch.

Chicago School A term generally applied to the loose grouping of architects, most notably Louis Sullivan, working in Chicago after the Great Fire of 1871. Their high-rise buildings were consciously designed with fireproofing in mind and were built around iron and steel frames clad in masonry: decoration was normally in red brick or terracotta. Among the most distinguished buildings produced in this period were Burnham and Atwood's Reliance Building (1891–5) and Adler and Sullivan's Wainwright Building (1890–1). A second 'Chicago School' of architects is perceived to have appeared after the World's Columbian Exhibition held in Chicago in 1893. This group emerged from the Chicago Architectural Club and included Frank Lloyd Wright. It was anti-historical and invented ornament based on botanical forms and also used boxy, geometrical massing. Notable examples include Maher's Patten House (1901, destroyed), Evanston, Illinois, and Garden's Madlener House (1902), Chicago.

chief The upper part of a heraldic shield. *See* BASE.

chiffonier A piece of French furniture, usually a low chest of drawers, used for storing *chiffons* (stuffs) and small items of clothing, popular during the 18th century.

chimney-breast The part of a wall which contains the chimney and the flues and which usually projects into a room.

chimney-piece The decorative architectural surround of a fireplace, usually surmounted by a shelf. Also called a mantelpiece.

china A broad term that refers, inaccurately, to any *ceramic ware. It is derived from the phrase 'porcelain from China', used since the 15th century, when Chinese porcelain began arriving in large quantities in the West.

Chinese export porcelain The term used for Chinese *porcelain made specifically for the European market. *Ming blue and white wares were exported during the 16th century and by the 17th century large quantities of porcelain, made at the kilns of *Jingdezhen, were shipped to Europe, mainly by the Dutch East India Company. Pieces were often decorated in *famille rose* and *famille verte* *enamels to appeal to western taste. Large *armorial dinner services were commissioned by European families, who sent to China drawings of their *coats of arms to be incorporated in the design.

Chinese white A colour prepared from *zinc white and introduced in 1834 by the firm of Winsor and Newton. It was much used for the *white heightening found in many British *watercolours around the middle of the 19th century.

chinoiserie A term used to describe western imitation of Chinese art, the patterns and motifs of which were adopted relatively early in the West as a result of the opening up of the trade routes to the East; examples included the *silks produced in the 14th century at the Lucca silk factories and the blue-and-white *porcelain manufactured in the late 16th century at the Medici porcelain factory. However, the term *chinoiserie* is more normally applied to objects produced in the 17th and, especially, the 18th centuries in which Chinese decoration was combined with European motifs. Examples from the 17th century included the pottery produced at *Delft, Nevers, and Southwark; French and English embroideries; Soho tapestries; Dutch and English *japanned furniture; and English *silver of the 1680s engraved with oriental figures. In the 18th century the *Rococo style (whose practitioners included artists such as Watteau and Boucher) encouraged the further proliferation of Chinese motifs such as dragons, exotic birds, and strangely dressed Chinamen. Whole rooms were decorated in the Chinese taste, most notably those lined throughout with porcelain at *Capodimonte, Italy, and Aranjuez, Spain. Chinese objects were often displayed together with Chinese wallpaper and *Chinese export porcelain. Different countries specialized in various aspects of chinoiserie—England in Chinese *Chippendale furniture, Germany in porcelain figures, France in elaborate *ormolu mounts for Chinese or European porcelain vases. Despite the reaction against the Rococo engendered by *Neoclassicism at the end of the 18th century, Chinese influences persisted, for example in the decorations of the Royal Pavilion, Brighton (1802–91), and in Sir William Chambers' pagoda at Kew Gardens. In the mid-19th century the *Rococo Revival brought chinoiserie back into fashion, but it was rapidly superseded by *japonaiserie.

chintz [An English variation of the Sanskrit word for 'variegated'] originally used in the 16th and 17th centuries to describe imported Indian *calico, and later applied to European printed cotton fabrics. Such was chintz's popularity in England that legislation was passed in 1722 against both its importation and manufacture (the latter rescinded in 1774).

Chippendale A term regularly used to describe English *Rococo furniture inspired by the designs in Thomas Chippendale's (1718–79) famous pattern book, the *Gentleman and Cabinet maker's Director*, first published in 1754 with further editions in 1755 and, considerably enlarged and revised, in 1762.

chisel A sculptor's carving tool. Those employed for wooden sculpture are struck with a mallet and have wooden handles, those for stone sculpture are metal and struck with a hammer. There are three main types of chisel used by sculptors in stone: a point chisel for the rough shaping of a block, a claw chisel for intermediate work (these vary in shape from those with two long points to notched flat chisels), and flat chisels for the final cutting.

choir The part of a *church where divine service is sung.

choir book A book containing the words and music for the chants sung during the celebration of Mass or the Divine Office. There were two main types of choir book: the *gradual, which contains all the chants sung by the choir during the celebration of the Mass, and the *antiphonary (or antiphonal), which contains the chants sung during the celebration of the Divine Office. Elaborately decorated, large choir books were produced during the late *Gothic period, with particularly sumptuous examples being made in Italy in the 14th and 15th centuries.

chrome yellow A lead chromate *pigment (as well as the title of a novel by Aldous Huxley), which unfortunately has produced adverse results since it was introduced in the early 19th century. Also produced in other shades such as chrome orange and chrome red, chrome yellow turns brown on contact with sulphur in the atmosphere, reacts with other pigments, and may turn green on exposure to sunlight.

chromolithograph A colour *lithograph, in which different stones (sometimes as many as twenty) are used from which to print each of the different colours in the print. Chromolithographs were produced mainly in the *Victorian period, particularly for book illustrations or portfolios of prints.

chryselephantine Used to describe ancient Greek sculpture which is overlaid with gold and ivory.

church A building consecrated for public Christian worship.

Churrigueresque A lavish 18th-century Spanish *Baroque style of florid architectural ornament, named after the Churriguera family, found in Spain (mainly in Castile) and Spanish America (especially Mexico).

ciborium A canopy raised over the high *altar, it is normally a dome supported on columns. The term comes from the lidded vessel on the altar in which the Sacrament was preserved. *See* BALDACCHINO.

cinerarium A depository for chests or urns containing cremated remains.

Cinquecento [Italian, 'five hundred'] a term used to describe the 16th century (the 1500s) in Italian art.

cinquefoil An ornamental foliation in *tracery or panels in the *Gothic style having five petals or leaves.

cippus A small, low *column, often with no *base or *capital, frequently bearing an inscription. It was used by the Romans for milestones, markers, and funerary monuments.

circle of A cataloguing term denoting an artist whose work is closely related to that of a particular master but did not work in his studio, for example 'circle of Rubens'.

circus A long, narrow building used by the Romans for chariot races. It had a central barrier, curved ends, and tiered seating. In the 18th century the term was used to describe a circular or nearly circular range of houses, for example the Circus (1754–c.1770) designed by John Wood the Elder in Bath. In modern town planning a circus denotes a circular road or street junction.

cire perdue *See* LOST-WAX CASTING.

citadel A fort with four to six bastions. It was usually sited at a corner of a fortified town but connected with it, for example as at Arras and Copenhagen.

Classical In the context of *Greek art 'Classical' refers to the period between the *Archaic and *Hellenistic periods, c.480–323 BC, when Greek culture is considered to have reached its greatest splendour. It encompassed the major building programme at Athens (instigated by Pericles), the great age of Greek oratory, and the conquests of Alexander the Great.

classical A general term which can either refer broadly to ancient *Greek and *Roman art or imply inspiration from the art of the *antique.

Classical Revival A backward-looking style of contemporary architecture which makes extensive use of such classical features as *columns, *keystones, *porticoes, and *pediments to recreate the authority of another time and place in history. Its best-known exponent in Britain is Quinlan Terry. Many of the clients of the Classical Revival are corporate ones.

Classicism A confusing term, most often used as the antithesis of *Romanticism and implying an adherence to certain fixed ideals or rules in art, as opposed to freedom of individual expression. For example, in the 19th century J. A. D. Ingres (1780–1867) was often upheld as the champion of Classicism in comparison to the arch-Romantic Eugène Delacroix (1798–1863).

Claude glass A device, developed in England in the 18th century for the benefit of the *picturesque tourist, with which to view the natural landscape in the blue and golden hues associated with the 17th-century landscape painter Claude Lorrain (1600–82). It consisted of a small, slightly

convex mirror backed with black foil and was cased like a pocket-book. It could be rectangular or circular in shape. Thomas West's *Guide to the Lakes* (1778) advised: 'the person using it ought always to turn his back to the object that he views ... It should be suspended by the upper part of the case, holding it a little to the right (as the position of the parts to be viewed require) and the face screened from the sun.'

claw-and-ball foot A style of foot used on furniture legs in the 18th century. Of oriental origin, in Europe the dragon's claw around a ball was replaced by an eagle's claw.

clay Soil composed of the dust from igneous rocks mixed with water. Soft and sticky, it can be moulded or cut into shapes which are hardened on exposure to heat. The first known form of handwriting, *cuneiform script, was on tablets of clay and developed in Mesopotamia *c.*3000 BC. Clay has been used for many purposes including the manufacture of seals, bricks, tiles, jars, and jugs. In sculpture it has been used to make models for larger pieces, for *moulds of works to be cast in metal, or as sculpture in its own right. Clay is also the main ingredient for all *ceramic *bodies.

cleavage The separation in a painting between paint layers, paint and *ground layers, or ground and support; it occurs when adhesion between layers has deteriorated, and may often be found where a heavy glue layer has been placed between *support and *ground.

clerestory Also known as the 'overstorey', the upper stage of the main walls of a church above the adjacent *aisle, *choir, or *transept roofs and pierced by windows. In *Romanesque churches the clerestory often has a narrow wall-passage on the inside.

cliché-verre A photographic method of printmaking, invented in the mid-19th century in France, which was used mainly for landscape compositions by Corot, Daubigny, and members of the *Barbizon School. It consisted of producing an image on light-sensitive photographic paper by exposing the paper to light which had passed through a glass plate. There were two different techniques of applying the design. One was essentially linear, whereby a whitened glass plate was laid on a black cloth and the design was scratched on to it. The black lines which appeared as a result of the scratching and partial exposure of the black cloth underneath corresponded exactly with the black lines that would be produced when the scratched plate was taken away from the cloth and laid face down in the sunlight over the light-sensitive paper. The other, rarer, method was a tonal one and involved building up, with a brush, layers of emulsion paint on the glass plate before it was placed over the paper for exposure. The thinner the paint, the more light would pass through and the darker that part of the image would print, and vice versa. Cliché-verre was taken up again in America in the 1970s.

clobbered A type of Chinese blue and white *porcelain, painted over at a later date in Europe with coloured *enamels and new decoration, conflicting with the original theme.

cloisonné [From the French *cloison*, 'partition'] *enamel that is fired within compartments formed by narrow walls of metal. The areas of coloured enamel are thus separated from one another. It was one of the earliest techniques of decoration of metal surfaces and probably originated in the Near East. It was much employed by *Celtic and *Byzantine craftsmen and was spread by the latter to the Orient. *See* CHAMPLEVÉ.

cloister A covered *ambulatory, arranged round a quadrangle, connecting the monastic church with the domestic parts of the *monastery (usually south of the *nave and west of the *transept). Cloisters often contained places for study and frequently had lavatories and places to wash.

Coade stone A very durable manufactured stone, first successfully produced and marketed in 1770 by Mrs Eleanor Coade from the factory she took over in Lambeth, south London. It consisted of 30 per cent *grog, 60 per cent *clay, and 10 per cent ground glass (acting as a vitrifying agent). Its ability to withstand heat and frost made it particularly suitable for architectural ornament and garden sculpture (which was hollow and cast from *piece moulds).

Coalport porcelain *Porcelain produced by the Coalport factory in Shropshire, founded by John Rose in 1796. During the 19th century the factory became famous for elaborate porcelain encrusted with delicate flowers, known as 'Coalbrookdale'.

coat of arms A shield bearing a person or institution's *heraldic bearings. The term derives from the linen surcoat worn by medieval knights over their chain mail. Strictly speaking, only the shield itself can be referred to as the coat of arms, though it is often used incorrectly to describe the whole heraldic ensemble of the shield with its adjuncts including crest, motto, and *supporters. A coat of arms consists either of a pattern formed by geometrical divisions or of beasts, birds, or other animate or inanimate objects arranged in a particular manner in certain colours.

cobalt blue Also known as Leyden blue or Thénard's blue, it is a bright, clear blue *pigment which is permanent in all techniques including *fresco. Discovered by Baron Thénard in 1802, it was introduced to artists about twenty years later and became a standard colour, replacing the unsatisfactory *smalt.

cobalt yellow (or aureolin) Consisting of cobalt-potassium nitrite, it is a permanent *pigment with a brilliant yellow-golden transparency useful for *glazes and for tinting. It was first introduced in the mid-19th century and offered a greater permanency than earlier transparent yellows.

Cobra A group of *Expressionist painters formed in Paris in 1948. The name derived from the first letters of the capital cities of the three countries of the artists involved—Copenhagen, Brussels, and Amsterdam. They were interested in art derived from unconscious gesture and in that respect had affinities with American *Action painting. However, they also placed an emphasis on the development of strange and fantastic imagery, related in

some cases to Nordic mythology and folklore, in others to various magical or mystical symbols of the unconscious. The leading members of the group were Asger Jorn, Karel Appel, and Corneille, who were soon joined by Jean Atlan and Pierre Alechinsky. The group organized a number of exhibitions 1948–51 and then disbanded.

cochineal A red, natural dyestuff of insect origin which was imported into Europe from Mexico as early as 1560. Until the introduction of synthetic dyes in the 19th century it was used to make *carmine and some scarlet *lakes.

cockling A ripple or wrinkle distortion between paint layers, paint and *ground layers, or *ground and *support, which usually occurs during hand *lining when the *canvas reacts severely to localized heat, expanding or contracting unevenly. The term is also applied to similar distortions in paper, caused by changes in temperature and humidity.

coliseum (or colosseum) A large Roman *amphitheatre, the term is particularly associated with the 'Colosseum' in Rome, the Amphiteatrum Flavium begun by Vespasian between AD 70 and 76 and dedicated by Titus in AD 80. The Colosseum has long been acknowledged as one of the major sights of Rome and was frequently depicted by artists, particularly in the 18th and early 19th centuries.

collage [From the French *coller*, 'to gum'] a pictorial technique in which pieces of cut paper of all shapes and types are combined and stuck down on to another surface to create a design. Already popular with children and *amateurs, it was taken up by major artists in the early 20th century beginning with the *Cubists, who incorporated fragments of newspapers and photographs with which to make ambiguous reference to the conventional pictorial reality they were in the process of destroying. Later it was adopted by the *Futurists, *Dadaists, and *Surrealists, the last emphasizing the juxtaposition of disparate and incongruous imagery.

collector's mark A mark which is normally stamped (with or without ink) on a print or drawing by its owner. Such marks often play a crucial role in reconstructing the *provenance of such works of art. The earliest examples date from the 17th century and collectors' marks are still being devised today.

collodion process In photography, a method of achieving light-sensitive surfaces which remain in place on their supports. The process was successfully pioneered by Frederick Scott Archer in 1851 using a mixture of nitrocellulose dissolved in ethyl ether and ethyl alcohol called collodion (based on the Greek word for glue) as a vehicle for coating potassium iodide on glass. In the 20th century collodion plates were used in photomechanical reproduction for line and *half-tone blockmaking.

collotype A photomechanical technique related to the *cliché-verre and the *lithograph. A surface (usually heavy plate glass) is coated with light-sensitive gelatine and exposed to light under a photographic negative. The

areas exposed to more light harden, whereas those that are not remain capable of absorbing moisture. The surface can then be inked up and printed from lithographically, the moist areas rejecting ink, the dryer ones accepting it. The collotype was developed in Germany and France at the end of the 1860s. Until the advent of the *half-tone screen it was the only photomechanical process able to reproduce tone (apart from hand *photogravure). Unfortunately the delicate gelatine surface was only capable of yielding a maximum of about 2,000 impressions, therefore commercial viability was strictly limited. The collotype was therefore restricted to luxury publications and was largely abandoned after the Second World War.

Cologne School The term was first coined by collectors in the late 19th century generally to describe old German paintings. It is now applied specifically to painting produced in Cologne from the late 14th to the early 16th centuries. Cologne painting reached its high-point in the mid-15th century in the work of Stephan Lochner (active 1442–51).

Colonial Revival A term applied to architecture and interior decoration produced in the United States and Australia in the late 19th century in a style based on buildings of earlier colonial periods. It was promoted as a 'national' style, harking back to those nations' roots, as opposed to the then prevalent classicism.

colonnade A row of *columns carrying an *entablature or *arches. *See* PERISTYLE; PORTICO.

Colour Field painting A type of painting which evolved in the United States in the mid-1950s and continued until the late 1960s. Fields of colour were applied in an abstract manner across the canvas, which was regarded as a two-dimensional plane: conventional pictorial depth and gestural brushwork were rejected. Among the most important of the Colour Field painters were Elsworth Kelly, Morris Louis, and Kenneth Noland. Also known as *Post-Painterly Abstraction, the title of an influential exhibition curated by Clement Greenberg for the Los Angeles County Museum of Art in 1964, which incorporated *Hard Edge painting.

column [From the Latin *columna*, 'a post'] a vertical support, usually circular and slightly tapering towards the top. In *classical architecture it normally consists of a *base, *shaft, and *capital. It is designed to carry an *entablature or other load, but can be used decoratively in isolation. It should not be confused with a *pier, which is more massive.

Combine art A term coined by the American artist Robert Rauschenberg to describe the radical form of *collage he devised in which the flat painting surface is 'combined' with a wide variety of objects including photographs, stuffed animals, and electrical apparatus such as radios, fans, and light bulbs. Rauschenberg's Combines date from 1953 to the early 1960s and reflect the widespread use of 'junk' objects in avant-garde art in the 1950s. *See* JUNK ART.

comic-strip art Comic-strips were invented in the late 19th century and first featured in the Sunday supplements of North American newspapers. Essentially narrative *cartoons, they have played a major role in popular culture throughout the world. Various artists, such as some of those identified with *Pop art, have incorporated comic-strip features in their own work. The most celebrated examples are probably the large-scale paintings of Roy Lichtenstein.

Commedia dell'Arte The Italian term for 'professional comedy', a type of improvised comic play popular in Italy and France from the 16th to the 18th centuries. It was performed in masks by travelling actors each of whom specialized in a character, such as Pantaloon, Harlequin, Scaramouche, and Pulcinella. These characters appeared in painted decorations as early as the 16th century but became popular throughout Europe during the 18th. They provided the models for many *porcelain figures, produced in groups or series. In 1736 J. J. Kändler began his designs for *Meissen, which influenced those produced at other factories such as *Chelsea, *Bow, Höchst, and *Capodimonte. F. A. Bustelli at *Nymphenburg made the most elegant series in porcelain 1754–63. Characters were also painted on glass and incorporated in *marquetry panels on furniture.

commode A low chest of drawers, originally of French design, for use in the drawing room. Its appearance was usually decorative and it became very popular during the 18th century, as its height matched that of the *dado and did not interfere with the wall above. Various types of commodes were given particular names: a *commode en console*, with long legs and one shallow drawer, was intended to be placed beneath a mirror, a *commode à vantaux* had doors in front of the drawers, and a *petite commode* was small, with long legs and tiers of drawers. In the 19th century it was also the name for a bedroom cupboard.

complementary colours Pairs of colours seen to be in strong contrast to one another. This is achieved through the strengthening of a *secondary (i.e. mixed) colour (for example green) when it is placed opposite the *primary colour (in this instance red) that is adjacently positioned in the colour circle (see below) next to the two primaries (blue and yellow) which together make up that secondary colour. Similarly, blue strengthens orange and yellow strengthens violet. The optical interaction of colours in this manner was explored in particular by the chemist Michel-Eugène Chevreul who was appointed Director of Dyeing at the *Gobelins tapestry workshops in 1824. He published his chromatic circle of colours in 1839. The findings of Chevreul, and also of the aesthetician Charles Blanc, the latter first published in 1866, were highly influential on the *Impressionists and, to an even greater degree, on Georges Seurat (1859–91). His pseudo-scientific system of using dots of pure colour relied on the 'blending' of these separate colours by the eye, resulting in a vibrancy of colour in his work unmatched by previous artists.

Composite Order *See* ORDER.

composition Often abbreviated to 'compo': a mixture of *whiting and *linseed oil or some similar mixture used for casting small-sized ornament. It was also frequently used instead of carved wood for the ornamentation of picture frames, particularly in France in the 19th century.

Computer art Art produced with the aid of or in imitation of what can be achieved with a computer. Computer art first appeared in the 1950s and was usually graphic in nature, consisting of the random arrangement of geometric shapes, for example. However, the increasing sophistication of computers and the development in the 1970s of tools such as the stylus or 'light pen' led artists such as Richard Hamilton and David Hockney to work interactively with displays on screens in what amounted to relatively direct 'painting' techniques. Computers have also been used to control or programme displays of *Kinetic art.

Conceptual art A widespread movement from the mid-1960s through the 1970s, Conceptual art emphasized the artist's thinking, making any activity or thought a work of art without the necessity of translating it into physical form. The term gained currency after the publication in the summer 1967 issue of *Artforum* of the *Minimal artist Sol Lewitt's article 'Paragraphs on Conceptual Art'. This dealt with the 'primary structures' of Robert Morris, simple polyhedrons which could be 'visualized' from any point of view. In its broadest sense, Conceptual art can be traced back to the primitive artist who included the backbone in his drawing of a fish because he 'knew' it was there, even though it was outwardly invisible. The *Renaissance, with its concern for accurate depiction, could be said to have firmly placed the emphasis on the perceptual rather than the conceptual.

concrete A mixture of water, fine and coarse sand and stone gravel, and a *binder, concrete was first used by the Romans, who employed it extensively in *domes and *vaults, often in association with brick or stone reinforcing. Since the 17th century Portland cement (a mixture of lime and clay) has been used as the binder, considerably increasing the strength of concrete. Reinforced with steel, concrete has revolutionized building construction and can be used for *beams, *columns, and many other structural functions.

Concrete art A term coined by Theo van Doesburg (1883–1931) who issued the manifesto *Art Concret* in Paris in 1930. It is applied to abstract art which is deliberately without any figurative or symbolic content. According to van Doesburg a picture had no other justification than 'itself' and was therefore completely autonomous: its construction would be simple and mechanical. Concrete art was taken up by the *Abstraction-Création group who ensured its survival beyond the Second World War.

connoisseurship A specifically visual knowledge gained from looking at works of art. Connoisseurship requires the gift, and the constant exercise, of a keen visual memory and the ability to sympathize with the process of artistic creativity. A connoisseur (from the French *connaisseur*, 'one who knows') is someone who is often described as having 'a good eye' with

which to attribute works of art, to distinguish different styles or periods. The term is particularly associated with the art historian Bernard Berenson (1865–1959), who identified so many Italian *Renaissance works of art (and frequently provided certificates of authentification).

console An S-shaped *bracket or *corbel whose height usually exceeds its projection. Consoles can support a *bust or *urn or, placed either side of a door case, a superimposed *cornice.

console table A side table with two front legs supported by a decorative wall bracket, usually placed beneath a mirror.

Constructivism A movement that originated in Russia c.1914, it dominated art there after the 1917 Revolution and spread to the West in the 1920s. It was characterized by its abstraction and its use of industrial materials such as glass, plastic, and standardized metal parts. Its arch-proponent, Vladimir Tatlin, put forward the concept of the 'artist-engineer', fulfilling the social needs of Soviet post-Revolutionary society. With the triumph of Constructivism and the founding of the Institute of Art Culture (*Inkhuk) many Russian artists wedded to the more traditional concepts of the fine arts left their native country: among the émigrés were figures such as Wassily Kandinsky and the brothers Naum Gabo and Antoine Pevsner. In Russia, with the devaluation of traditional easel painting, Constructivism exerted its clearest influence in a number of other fields including architecture, *typography, and theatre. Tatlin's wooden model for the gigantic monument (never built) he planned for the Third International became the symbol of Soviet Constructivism.

conté crayon Originally developed in the late 18th century as a substitute for pure *graphite, conté crayons were widely used throughout the 19th century. Named after their inventor, Nicolas-Jacques Conté, they consisted of a mixture of *clay and graphite with black pigment combined with a slightly waxy *binder and compressed into short sticks. They came in different grades of hardness and were available either as sticks of crayon or encased in wood like a *pencil. Although the tonal range of conté crayons might seem similar to other black drawing materials, they have their own distinctive qualities. Whereas *charcoal, for example, quickly clogs the surface of textured paper with its splintering, fragmentary particles, conté crayon is easier to control and the degree of darkness is directly proportionate to the pressure employed. Its most telling use was by Georges Seurat in his drawings of the 1880s.

Continuità A group of artists founded in Rome in 1961 with the critic Giulio Carlo Argan as its spokesman. It was opposed to the perceived looseness of *Art Informel and sought instead to create a modern Italian art that would establish a continuity with the great art of that country's past.

contrapposto [Italian, 'set against'] a term applied to poses in which one part of a figure turns or twists away from another part. Originally used in

the *Renaissance to describe certain poses in ancient sculpture, it is now used in a more general sense and also applied to painting, particularly with regard to many Italian 16th-century masters.

copal Resin from various tropical trees which, during the 19th century, was cooked with oil to produce a picture *varnish. Copal varnishes have been blamed for much of the cracking and darkening found in pictures of that period.

cope The principal vestment worn for ecclesiastical ceremonies, it is a semi-circular cloak, fastened across the chest by a brooch or strip of material called a morse. The front edges are often adorned with decorative bands and at the back of the neck there is a triangular or shield-shaped hood which is, however, vestigial and can not be used to cover the head.

copper A metal which has been used by man since the Bronze Age. In its pure state it can be hammered into shapes from sheets, but it is more normally cast in the form of *alloys such as *brass or *bronze. A wide variety of articles and sculptures have been made from copper by both western and eastern cultures. From the 15th century copper has been the material normally used for the *plate in *intaglio printmaking, and in the 16th and 17th centuries it enjoyed a limited popularity as the *support for small, highly detailed oil paintings.

Coptic art The style of art associated with the Copts, the Christian Egyptians, who flourished from the 4th to the 7th century AD. They developed their own Coptic script, a version of the Egyptian language written in Greek letters. Their early art displays a mixture of *Hellenistic and *Egyptian styles. A unique style soon developed, seen in architecture, manuscripts, *glass, *pottery, and metalwork. Particularly remarkable were the woven *textiles of the 5th and 6th centuries, *embroidered or painted with simple designs of figures and animals in a limited range of colours. With the entry of the Arabs into Egypt in 641, Coptic culture gradually gave way to that of *Islam.

coquillage [From the French *coquille*, 'shell'] carved *Rococo ornament in a shell form.

coral A material of organic origin, used as a gemstone, formed from calcified skeletons of marine creatures, found mainly in the western Mediterranean, the Red Sea, and the waters off Malaysia, Japan, and Hawaii. Coral is a dull red, but when polished becomes reddish-pink with a vitreous lustre. It is used for beads for necklaces, bracelets, and other jewellery and for small decorative objects and sculpture.

corbel A block of stone, often elaborately carved, projecting from a wall and supporting the beams of a roof, floor, or *vault.

core The centre of the hollow metal cast used in casting metal sculpture. It is usually made of *clay or plaster with *grog and is generally removed after casting.

Corinthian Order *See* ORDER.

cornelian A gemstone which is a type of *quartz, red or pink in colour, and much favoured for *seals or *intaglios.

corner cupboard A cupboard designed to fit into the corner or a room, either hanging or free-standing, popular during the 18th-century.

cornice The crowning or uppermost portion of an *entablature in *classical and *Renaissance architecture; also, and more generally, any projecting ornamental moulding along the top of a building, wall, arch, etc., finishing or crowning it.

cornucopia A classical motif in the form of a goat's horn, out of which spill flowers and fruit; it symbolizes abundance and fertility.

coromandel A type of wood from the Coromandel coast of India, used for *banding and *inlay on furniture, particularly popular during the *Regency period.

cortile The Italian term for a courtyard, usually an open one in the centre of a building and surrounded by *arcades.

Cosmati work A term generally used to describe decorative art produced in the 13th century in Rome, in particular *mosaic work in *marble with inlays of glass or coloured stones. The name derives from the Cosmati school of marble workers, mosaicists, and sculptors active in Rome from the 12th to the 14th centuries.

cottage orné [French, 'decorated cottage'] a product of the *Picturesque movement in England in the late 18th and early 19th centuries. Usually a small building built on an asymmetrical plan in a deliberately rustic style, often with a thatched roof. Some were constructed merely for decoration of the park landscape, others were used as lodges or as farm labourers' houses. John Nash designed an entire village of such cottages at Blaise Hamlet. Occasionally they were built on a larger scale as residences of the gentry.

counterproof An *offset from an existing print or drawing, made by running it through the press together with a sheet of blank paper onto which is forced an, albeit weaker, *impression of the original in reverse. Counterproofs of prints, because they were in the same direction as the original *plate, were sometimes used by printmakers to check on 'work in progress'. Counterproofs of drawings were most commonly made of originals in richly coloured chalks, for example the drawings of Rubens, Watteau, and Boucher.

cour d'honneur [French, 'courtyard of honour'] a monumental forecourt to a building, usually flanked by *colonnades and wings.

Cox paper A type of roughened paper named after the English landscape painter David Cox (1783–1859) who discovered it. It was based on a Scottish wrapping paper, which Cox came across by chance, and was hard and firm.

Being relatively non-absorbent it facilitated the painting of richly coloured
*watercolours, the colours drying in the paper surface rather than sinking
into the paper.

crachis A technique used in *lithography, by artists such as Toulouse-
Lautrec, of modulating colour and creating a sense of atmosphere. A stiff
brush loaded with printing ink of the required colour is dragged over an
iron screen (*grille de crachis*) placed on the printing surface, thus creating a
'spatter' effect in the required area.

cradling A traditional technique for the reinforcement of the backs of
painted wooden *panels. Strips of hardwood are glued round the edge of
the back and then further strips, which are not glued, are placed inside this
framing stricture, often in a criss-cross intersecting pattern. The original
panel is thus held firm but allowed to 'move' at the same time. Such a
technique takes account of the fact that wood can expand or contract in
reaction to changes in temperature and humidity.

craquelure The cracks that may occur on the surface of a painting as it
ages, caused by the shrinkage of the *medium or *binder.

crayon Any drawing material made in stick form. Modern coloured
crayons are usually encased in wood.

crayon-manner A printmaking technique used for imitating *sanguines
(red or brown chalk drawings on rough paper), which were extremely
popular in 18th-century France. It was invented in 1757 by the engraver J. C.
François who developed new types of *roulettes and *mattoirs with which
the design was drawn onto a suitably prepared etching plate. As in
*etching, the design was then bitten, inked up, and printed from. The
resulting print would have been printed in red or brown ink. A further
development was made by Louis-Marin Bonnet who produced multi-
coloured prints in this manner by using different plates for each colour.

crazing The term used to describe the cracking of the *glaze on *ceramics,
resulting from the differences in the expansion and contraction of the *clay
body and the glaze when fired. Initially a fault, it was turned into a
decorative effect, particularly in China during the *Song period (960–1279).

creamware The term is an abbreviation of cream-coloured *earthenware,
a type of pottery made from a buff-coloured *clay which contained flint to
whiten it and covered with a lead *glaze. It was developed by Josiah
Wedgwood in Staffordshire by 1765 to compete with *porcelain and named
'Queensware' by him, after Queen Charlotte. It was durable, cheap, and
lightweight, and the creamy white body was a perfect base for *enamel
painting and *transfer printing. A great commercial success, it was copied
by other English potteries, particularly Leeds, putting out of business most
*tin-glaze factories. *See* WEDGWOOD.

credenza The Italian term for a sideboard with doors, usually surmounted
by drawers and used as a sideboard.

crenellation *See* BATTLEMENT.

crepidoma The stepped base of a Greek temple.

crescent A concave row of buildings. The concept was invented by John Wood the Younger with his Royal Crescent (1767–*c.*1775) at Bath, a vast semi-elliptical frontage of 30 houses.

crest A device mounted on the helmet in the days of chivalry and still so used in *heraldry.

cresting The carved ornament on top of a piece of furniture, such as a mirror frame, the top rail of a chair, or the headboard of a bed.

criselling A very fine network of cracks on old glass, caused by its degeneration.

crocket A decorative feature in *Gothic architecture, carved in a variety of leaf shapes and projecting at regular intervals from the angles of *spires.

cromlech *See* DOLMEN.

croqueton A term devised by the *Pointillist painter Georges Seurat (1859–91) to describe the small sketches painted in oil on wooden panels he made in preparation for his large exhibition paintings such as the *Bathers at Asnières* 1883–4 (National Gallery, London). It is derived from *croquis* and can literally be translated as 'sketchette'.

croquis [French, 'sketch'] a preliminary sketch done in pen, pencil, or crayon to set down on paper the concept of a projected work of architecture, sculpture, or painting.

cross The symbol of Christianity (the cross on which Christ died), it is often used as an architectural ornament. The basic form is a vertical member with a shorter one across it at right-angles. The cross has been used as the basic plan of most Christian churches. Of these the *Latin cross, with three arms of equal length and one longer, has been most used in western Europe from the Middle Ages. The equal-armed *Greek cross was favoured in Byzantium and in Italy during the *Renaissance.

crossbanding Thin strips of decorative cross-grained *veneer, used to decorate the edge of furniture. *See* FEATHER BANDING.

crosshatching Crossing lines of *hatching, used to denote shading in a drawing, print, or *tempera painting.

crossing The intersection of *nave, *chancel, and *transepts of a *church, often crowned with a crossing tower.

crown In architecture, the upper part of any building or the highest point or centre of an arched structure.

cruciform Cross-shaped, such as a *church planned in the shape of a cross, i.e. with intersecting *nave and *transepts.

crypt A chamber or vault in a church beneath the main floor, but not necessarily underground, usually containing graves or relics.

crystal A general term used for *glass. In the 15th century the Venetians rediscovered a Roman method of making clear, colourless glass by adding manganese to the *frit, which they called 'vetro di cristallo', because of its similarity to *rock crystal. In England in the late 17th century George Ravenscroft produced a clear glass with the addition of lead oxide, often called *lead crystal, which formed the basis for English glass that is still produced today.

Cubism Generally acknowledged to have been the most significant movement in 20th-century art, Cubism was created by Georges Braque (1882–1963) and Pablo Picasso (1881–1973) in the period 1907–14. It abandoned the traditional fixed viewpoint which had dominated western painting since the *Renaissance, and instead explored a multiplicity of viewpoints to develop an accumulated idea of the subject. The term was first applied to a group of landscapes painted by Braque at L'Estaque in the summer of 1908 and rejected for exhibition that year at the *Salon d'Automne. A member of the selection jury is said to have denigrated them as *petits cubes*, 'little cubes'. By 1911 the word 'Cubism' had entered the English language. The stylistic genesis of Cubism lay in the late art of Cézanne (whose memorial exhibition had been held in 1907) and African art. These two influences were clearly visible in Picasso's *Les Demoiselles d'Avignon* (Museum of Modern Art, New York) of 1906–7. Mature Cubism can be divided into two phases: *Analytical (1909–11) and *Synthetic (1912–14). The former often involved an analysis of objects into their compound elements and rearranging them on the canvas in a new pictorial order. In both Picasso's and Braque's work there is a complex interpenetration of small intricate planes which fuse with one another and the surrounding space. There is little if any sense of spatial recession and colours are muted, often virtually monochromatic greys or browns. Braque was the first of the two to introduce stencilled lettering into his compositions around this time. He also experimented with mixing materials such as sand and sawdust with his paint to create new textures, thereby emphasizing the idea that a picture was a physical object in its own right rather than an illusionistic representation of something else. Picasso produced his first *collages in 1912, heralding a break with the cerebral near-abstraction of Analytical Cubism. In Synthetic Cubism, in which the Spanish painter Juan Gris also played a vital role, the image was built up from pre-existing elements or objects, rather than being created through a process of fragmentation, as in Analytical Cubism. Colour was also reintroduced. By 1911 Cubism had become the dominant avant-garde idiom in Paris and was first shown in any quantity at the *Salon des Indépendants. In 1912 two of the many artists who had been attracted to Cubism, Gleizes and Metzinger, published *Du Cubisme*, which was translated into English in 1913. The English-speaking public was acquainted with Cubism by Roger Fry's second Post-Impressionist Exhibition held in London in 1912 and by the 1913

Armory Show in New York, in both of which Cubist works figured prominently. Among the movements which took Cubism as a starting point or an essential component were *Constructivism, *Futurism, *Orphism, *Purism, and *Vorticism. Cubism was not confined to painting: a significant quantity of Cubist sculpture was produced, not least by Picasso, and, in the brief flowering of Cubism there before the First World War, Prague saw the construction of an innovative form of Cubist architecture.

cuneiform [From the Latin *cuneus*, 'wedge'] the wedge-shaped characters used in the ancient writing systems of Mesopotamia, Persia, and Ugarit, which survive mainly impressed upon *clay tablets.

Cupid The god of love (Greek Eros, Latin Amor), Cupid is normally represented as a naked winged boy with bow and arrows. The description is often applied to any depiction of a naked winged child, a frequent decorative motif since classical times.

cupola A *dome, often of small size, on a circular or polygonal base crowning a roof or turret.

cupping Convex, saucer-shaped islands of aged paint on the surface of a picture, surrounded by cracks; they can be caused by a slight shrinkage of the canvas support or by chemical contractions of the paint and/or varnish layers.

cusp A point formed by the meeting of two curves in architectural decoration such as *Gothic *tracery.

cyanotype From the Greek meaning dark blue impression, cyanotype is a simple photographic process involving a light-sensitive solution that is coated on a paper or cloth support onto which the image is then printed by exposure to ultraviolet radiation. The technique was invented by Sir John Herschel who presented his findings in a paper to the Royal Society of London in 1842.

Cycladic art A term that describes the art and architecture produced during the Bronze Age in the Cyclades, a large archipelago in the Aegean Sea between Greece and Turkey. The name derives from *kuklos* 'circle': the islands of the group encircled the holy island of Delos.

D

Dada An anarchic movement which flourished *c*.1915–*c*.1922 and ridiculed traditional notions of form and beauty. Originally European, though it also took root in America, it was partly born out of the disillusionment engendered by the First World War. The name was apparently chosen at random by inserting a penknife in the pages of a dictionary ('dada' is French for 'hobby-horse'). It was first used in 1916—by the poet Tristan Tzara according to the artist Jean Arp. Both were members of Dada's founding group of artists and writers in Zurich. Traditional media such as painting and sculpture were abandoned in favour of techniques and devices such as *collage, *photomontage, and *ready-mades. Chance was credited with a valid role in the act of creation. By the end of the war Dada had spread to a number of German cities such as Berlin, Cologne, and Hanover, but it also took root almost simultaneously in New York, independently of Europe. Its main practitioners were figures such as Duchamp, Picabia, and Man Ray. Other centres of Dada came to include Paris and Prague. Although it was short-lived, Dada was highly influential and inspired many later anti-art movements in the course of the 20th century.

dado In *classical architecture the portion of a *pedestal between its base and *cornice; in modern usage the lower portion of an interior wall when decorated separately.

daguerrotype The earliest viable photographic process, in which the image is produced by the action of light on a silvered copper plate sensitized by iodine and bromine. After exposure the image is brought out by the action of mercury vapour. Fixing is accomplished with *hypo and the image is usually gilded with a solution of gold salt. Each image is unique, there is no reproductive printing from a negative, and the size is limited by that of the copper plate, normally 16.5 × 21.5 cm. Exposure can last from 6–7 to 30–40 minutes, therefore many of the earliest daguerrotypes were landscapes rather than portraits. The process was invented by Louis-Jacques-Mandé Daguerre (1787–1851), based in part on the experiments of his former collaborater Niepce, and made public in 1839. *See* DIORAMA.

dais Originally the raised portion of a medieval hall where the master dined with his family circle; the term is also more generally applied to any raised platform.

dalmatic A shin-length, sleeved tunic worn by church deacons.

damascening The original definition applies to the process of giving a watered pattern to steel, mainly sword blades. The technique was originally developed in the Near East (taking its name from Damascus). Wrought iron was broken up, mixed with charcoal, and heated at a high temperature,

then allowed to cool slowly, resulting in a brittle high-carbon steel. This was then reheated in a current of air with intermittent forging, whereby some of the carbon was removed and the metal ready for its final forging. The term is now generally applied to the process of decorating steel with *gold or *silver beaten into undercut grooves.

damask A reversible figured white or monochrome *textile in which the pattern is formed by two faces of the same weave. The patterns are often revealed in the surface sheen, as in 19th-century tablecloths. The term is also loosely applied to any *silk fabric with a raised pattern.

dammar A pale yellow *resin gathered from trees in Indonesia and Malaysia, it is one of the few tree resins still approved for use in a picture *varnish. Dammar is relatively quick drying and is dissolved in oil of turpentine.

Danube School A term coined in 1892 by Theodor von Frimmel to describe artists working *c.*1500–50 in the Danube region around Regensburg, Passau, and Linz. The most prominent figures were Albrecht Altdorfer and Wolf Huber. The characteristic features of the school were the prominence of landscape, which was usually mountainous and covered in thick forests, and the depiction of the human figure in a manner which often involved contorted poses and expressive drapery.

Davenport A small chest of drawers with a sloping desk top, first made in England in the late 18th century by Gillow of Lancaster for a Captain Davenport and very popular during the early part of the 19th century.

daybed *See* CHAISE LONGUE.

death mask A *cast made of the face after the subject's death. Since the *Renaissance such masks have been made by oiling the skin of the deceased and taking a plaster cast.

decalcomania A method of decoration using cut-up paper sheets of printed designs, which are then applied to a surface, such as *glass. The technique was popular during the Victorian period for decorating glass bottles, rolling pins, and other novelties, where the illustrations were stuck to the interior of the glass.

deckle The uncut, rough edge of a fine-quality sheet of paper such as that used for *watercolour or printmaking.

Decorated style The phase of English *Gothic architecture which followed the *Early English style and which developed from the late 13th until the second half of the 14th century. As its name implies, it concentrated very much on surface decoration, characterized by a very stylized form of foliage. It also developed the *ogee or S-shaped curve which occurred in arches and in richly ornate *tracery. *Vaulting became complex and decorative as much as structural. Principal examples of the Decorated style include the *chapter-house at Southwell Minster, the east parts of

Bristol and Wells Cathedrals, and the *lady chapel and octagon at Ely
Cathedral.

decorative art Art that is used to decorate or embellish an object that has
a practical purpose, as opposed to *fine art, which exists as an end in itself.

decorum [From the Latin *decorus*, 'seemly'] originally a literary term, it is
first used in relation to the visual arts in the *Renaissance in the writings of
Leonardo da Vinci. According to Leonardo's theory of Decorum, the
gestures which a figure makes must not only demonstrate feelings, but
must be appropriate to age, rank, and position. So must also be dress, the
setting in which the subject moves, and all the other details of the
composition. Such thinking greatly influenced academic art, in particular
*history painting, from the Renaissance through to the 19th century.

découpage The technique of cutting designs out of paper and applying
them to a flat surface, it was popular during the *Victorian period for the
decoration of folding screens and fire-screens.

Degenerate art [German, *entartete Kunst*] a pejorative term viciously
applied by the Nazis to all art which did not conform to their ideology and
their promotion of *National Socialist art during the period 1933–45 when
they ruled Germany. The avant-garde *Bauhaus was closed in 1933 and the
infamous 'Entartete Kunst' exhibition was held in Munich in 1937, opening
a day after the first annual 'Great German Art Exhibition' of officially
approved art. The works of the so-called 'degenerate' artists were mocked
by being shown alongside the art produced by the inmates of lunatic
asylums. Among the ridiculed artists were some of the major figures of the
20th century: Beckmann, Ernst, Grosz, Mondrian, and Picasso. Sadly, the
exhibition of Degenerate art proved a huge propaganda success, was seen
by more than two million visitors in Munich, and toured other major
German cities.

dehumidifier A device that removes humidity from the atmosphere and
is often used in museums and galleries to ensure a stable environment for
the exhibits. An ideal climate is generally considered to be 55% ±5%
*relative humidity.

del. An abbreviation of the Latin *delineavit*, 'he/she drew [it]', sometimes
occurs in the lower margin or corner of a print, usually an *engraving or an
*etching, to indicate a particular artist on whose original drawing the print
is based. *See* sc.

Delft The name given to *tin-glazed earthenware produced at the Dutch
town of Delft. It is also the name given to similar wares produced in other
countries, especially Britain, where it is known as *delftware. Inspired by
Italian *maiolica, *earthenware covered with an opaque white tin-glaze
was first made in Holland in the 16th century. Decoration was mainly in
*cobalt blue, in imitation of Chinese *porcelain, imported in large
quantities by the Dutch East India Company. By the mid-17th century, Delft

was the most important centre with many factories producing a huge variety of ornamental wares, vases, and tiles. By the 18th century standards had fallen and potteries could not compete with the new European *porcelain factories. The industry revived in the 19th century with the introduction of mass production.

Delft School The name given to the group of Dutch painters who worked in Delft in the second half of the 17th century. A number of them, including Gerrit Houckgeest, Hendrick van Vliet, and Emmanuel de Witte, concentrated on architectural interiors, often based on Delft churches. Others specialized in *genre scenes and included Carel Fabritius, Pieter de Hooch, and Jan Vermeer.

delftware The term for *tin-glazed *earthenware made in Britain from the 16th century, named after the Dutch town of Delft. The main centres for delftware were London, Bristol, Liverpool, and Glasgow, but the factories went out of business with the introduction of *creamware.

Della Robbia pottery A *pottery started in 1894 by Harold Rathbone in Birkenhead. It made tiles, vases, and plaques, usually in brightly coloured *glazes in an *Art Nouveau style. A large team of individual artists worked at the factory, which closed in 1906.

dentil A feature of classical architecture which became a popular decorative edging in the 17th century, consisting of a series of square, tooth-like blocks.

Derby A *porcelain factory, founded in 1750 which by 1756 was advertising itself as the 'Second Dresden' under the ownership of William Duesbury. The lightweight, glassy, *soft-paste porcelain was made into a variety of figures and tea-wares, influenced by *Chelsea and *Meissen, and elaborate vases, inspired by *Sèvres. By the late 18th century the factory had assembled a team of outstanding painters who produced high quality hand-decorated pieces. The factory closed in 1848. It was revived in 1877 as Crown Derby, later Royal Crown Derby, and became famous for elaborate 'Japan' or *Imari patterned porcelain.

Deruta A group of *maiolica potteries in Umbria, which began production in the late 15th century. They specialized in large dishes decorated with portraits, often with the addition of *lustre, as well as drug jars, plates, and panels painted in the *istoriato style.

desco da parto [Italian, 'tray of birth'] *deschi da parto* were painted circular trays (*c.*60 cm. in diameter), usually painted by *Renaissance *cassone painters, to celebrate the birth of a baby. They were used for the presentation of food, sweetmeats, and wine to the mother who had just given birth. They often bear the coat of arms or *impresa* (personal emblem) of the family concerned on the back, while on the front there is usually a scene of male or female dominance depending on the sex of the baby. *Deschi* were painted not only for wealthy patrons, but also those of more modest means such as butchers, bakers, and notaries.

De Stijl [Dutch, 'The Style'] the name of a loosely associated group of mainly Dutch artists founded in 1917 and of the journal they published to promote their ideas. The moving spirit was Theo van Doesburg (1883–1931) and other associates included the painter Piet Mondrian, the architect Gerrit Rietveld, and the sculptor Georges Vantongerloo. Their common aim was to find laws of equilibrium and harmony that would be applicable to life and society as well as art, and the style that is associated with them is one of austere abstract clarity. The greatest impact of De Stijl was not on painting but on architecture and the applied arts (including furniture design and *typography). It was particularly influential upon the founders of the *Bauhaus.

dexter [Latin, 'right'], used in *heraldry to describe the right-hand part of the shield, but as viewed from behind, therefore meaning left when the shield is seen from the front. *See* SINISTER.

diamond The best known *precious stone, a clear, colourless crystalline form of pure carbon and the hardest known natural substance. It has a brilliant lustre and can be cut in many ways to enhance the internal reflection and refraction of light to produce a spectacular jewel. Until the 18th century most diamonds came from India and then from Brazil. By the 19th century South Africa dominated the diamond market, with new discoveries in Russia, China, and Australia in the 20th century. Used for adornment since ancient times, the diamond is the main precious stone used in jewellery.

diamond point A technique for decorating *glass, in which a diamond-tipped stylus is used to scratch or stipple the surface. Probably developed in Venice in the 16th century, this type of decoration spread to northern Europe, especially Holland.

diaper A trellis of repetitive square or diamond shapes, found on furniture, *textiles, and *ceramics as a decorative border.

diorama Invented in 1822 by L. J. M. Daguerre (*see* DAGUERROTYPE), the diorama was originally a large, translucent scenic painting which could be variously illuminated to simulate the effects of sunrise, changing weather, etc. The current meaning of the term denotes an illusional display, very often in a museum context, in which the foreground is modelled in three dimensions and is seen against a two-dimensional painted background.

diptych A picture consisting of two separate panels facing each other and usually joined at the centre by a hinge.

Directoire style The style of decoration and design prevailing in France between the reign of Louis XVI and the *Empire, roughly the decade 1793–1804 (though the last five years are sometimes referred to as the Consulate style). It takes its name from the period of the *Directoire* (1795–9) when France was ruled by an executive of five *directeurs*. As a term it is mainly used in connection with the *applied (furniture, *textiles, costume, etc.) as opposed

to the *fine arts. Directoire art incorporated a wide range of motifs drawn from *antique and *Egyptian art and from the French Revolution itself.

disegno [Italian, 'design or drawing'] in Italian *Renaissance theory *disegno* referred to the total concept or design of a work of art. Some *Mannerist theorists wrote of the *disegno interno*, the artist's ideal visualization of an object or scene, as opposed to its actual appearance. Less specifically, *disegno* referred to drawing in general, the very basis of a visual artist's training. In the Renaissance, Florentine artists were perceived as being more concerned with drawing, whereas those from Venice attached greater importance to colour. This apparent dichotomy persisted in the debates in 17th-century France at the Académie royale, where the two opposing camps of the *Poussinistes and the *Rubénistes pursued the drawing versus colour argument.

distemper Generally used to describe a range of water-based paints with glue or *casein binders which are used for wall decoration or stage scenery.

Divisionism The name preferred by Georges Seurat and his chief disciple Paul Signac for *Neo-Impressionism or *Pointillism, the technique developed in the 1880s of painting with dots of pure colour which then blend at a certain distance to provide a powerful optical mixture in the eye of the viewer. A distinction can be drawn between Pointillism, which refers specifically to the use of dots in painting, and Divisionism, which refers to the general principle of the separation of colour. 'Divisionism' was also the name of an Italian movement, a version of Neo-Impressionism, which flourished in the late 19th and early 20th centuries in Italy and was also concerned with social themes such as justice for the working classes.

Documenta A large international exhibition of contemporary art held every four or five years at Kassel, Germany since 1955. The first Documenta exhibition was of great cultural and political significance as it heralded Germany's reacceptance of avant-garde art which had been banned as *degenerate by the Nazis.

Dog of Fo A Chinese mythical beast, half-dog and half-lion, used to guard Buddhist temples and works of art. It was frequently employed as a *finial on Chinese *porcelain vases and copied on European ceramics of the 17th and 18th centuries.

dolmen A *megalithic tomb consisting of three or more upright stones capped by a large flat stone to form a chamber and covered by a mound; also known as *cromlech.

dome A *vault of even curvature over a circular base; the section can be segmental, semicircular, pointed, or bulbous. If a vault is erected over a square base, *squinches or *pendentives must be inserted at the corners to connect the dome to the base.

Domestic Revival A 19th-century architectural style, born of the *Gothic Revival, which involved a revival of many traditional vernacular motifs in

English architecture such as timber-framing, tall chimneys, and leaded lights.

donjon The *keep of a *castle.

donor In the context of the visual arts, the commissioner of a religious work of art. In *Renaissance painting, especially that of northern Europe, the donor was often portrayed in the altarpiece he had commissioned kneeling in front of the saints portrayed, who acted as his intercessor, in the altarpiece he had commissioned.

Doric Order See ORDER.

dormer window [From the Old French *dormeor*, 'dormitory', from *dormir*, 'to sleep'] a window set in a sloping roof with a roof of its own. The name derives from the fact that dormer windows traditionally served as sleeping quarters.

dormitory A sleeping apartment shared by a number of people; in the United States a college hostel. A dormitory town or suburb, usually just outside or connected to a larger conurbation, is one in which most of the residents work elsewhere.

dotted manner A printmaking technique which is a decorative elaboration of *metalcut (printing from a metal design in relief) in which the large uncut areas that would normally print black are broken up by the use of *punches and *stamps. Also known as *manière criblée*, this technique was developed in Germany and France in the second half of the 15th century.

Doultonware The name given to the *pottery produced by Doulton of Lambeth, South London, founded in 1815 by John Doulton. The factory initially produced a wide range of sanitary and useful items, until in the 1860s it began to revive earlier, historical styles. A long association began with Lambeth School of Art with artists from the school, such as George Tinworth, working or producing designs for the factory. These artistic products became very popular and the number of 'art potters' employed increased, producing a wide range of hand-decorated *stoneware. In 1884 a *porcelain factory was opened in Burslem, Staffordshire, which continued the tradition of hand-decorated, experimental wares as well as producing dinner and tea services and the ever popular Royal Doulton figures.

dovetail A right-angled joint used in the construction of furniture, in which two pieces of wood are held together by interlocking, fan-shaped tenons.

drawing frame A rectangular framing device set up by the artist between himself and the object or scene he wishes to draw in order to aid precision. Sometimes the frame encloses a wire grid to enable further subdivision. Such devices were known in the *Renaissance and described in their writings by artists such as Leonardo da Vinci and Albrecht Dürer.

drawing manual An educational publication expounding the drawing methods of a particular *drawing-master in a series of illustrated lessons. Such manuals were widely purchased by *amateur artists and were usually cheaper than a course of lessons.

drawing-master A teacher of drawing, the term was in common usage in Britain in the 18th and 19th centuries and denoted an independent master who might teach both at educational establishments and on an individual basis to private pupils. Many of these masters were itinerant, especially during the summer months, and had to travel to seek employment, often to spa and county towns. Their clients were mostly drawn from the landed gentry and leisured classes which feature so memorably in the novels of Jane Austen. Many of the great English *watercolourists, such as John Sell Cotman, had to supplement their incomes with employment of this nature.

drill A tool which bores holes when revolved. Drills have been used by sculptors since the earliest Mediterranean civilizations. The deep cutting which can be made with the drill enabled ancient Greek and Roman sculptors, the carvers of intricate medieval *capitals, and later masters such as the *Baroque sculptor Bernini to produce their virtuosic effects.

drip painting A painting technique in which paint is allowed to drip onto the canvas rather than being applied with a brush, spatula, or similar tool. Although it had been used earlier in the 20th century by some of the *Surrealists, especially Max Ernst, it really came to the fore in the 1940s when it was adopted by *Action painters such as Jackson Pollock, whose method was to lay the canvas flat on the floor and then drip the paint on with great accuracy.

drôlerie [French, 'comicalness'] the term used for the *grotesques or comic scenes found in the borders of medieval *illuminated manuscripts.

drying oil Any vegetable oil that will dry to a tough, leathery surface when spread out in thin layers. Drying oils such as *linseed oil and poppyseed oil are typically used as the *binder in *oil paint.

dry mounting A method of attaching a drawing, photograph, or *print on to a cardboard backing. Instead of glue or paste a sheet of thin, dry-mounting tissue is placed between the paper and the mount and the resulting sandwich is stuck together by the application of heat and pressure in a special press or with a hand iron. Dry mounting is employed mainly in commercial work.

drypoint A technique of printmaking, often used in conjunction with *etching, whereby the design is scratched on to the copper plate with a sharp round point, thereby throwing up a deposit of *burr which attracts a rich inking when the plate is printed. Successive printings rapidly wear away the burr, therefore only the first few *impressions are of high quality. Drypoint was most famously used by Rembrandt in prints such as the *Three Crosses* and enjoyed a later revival in the 19th century among the artists of the *Etching Revival, including Whistler and Seymour Haden.

Duecento The 13th century, commonly used to designate Italian art of that period.

dumb waiter A mechanism, in effect a miniature hand-operated lift, for transporting items, usually food and drink, within a building; also a piece of furniture consisting of tiers or trays fixed to a central stem, first made in the early 18th century and used for diners to help themselves after the servants have withdrawn.

Dürer Renaissance A term used since 1971 (the quincentenary of Albrecht Dürer's birth) to describe the increased interest in the German artist's work which developed in Europe *c.*1570–*c.*1630. He was praised both for his inventiveness and for his Catholic faith, and new editions of his three books on art theory were published. The designs of his prints were enormously influential and were copied and adapted for both paintings and sculptures. Deceptive copies of his *engravings and *woodcuts were produced in northern Europe, particularly by the Wierix brothers in Antwerp. Many copies are either unsigned or bear the false AD monogram.

Düsseldorf School A group of painters who worked and studied in Germany at the Düsseldorf Kunstakademie between the mid-1820s and 1860s. Some of them had been pupils of Willem Schadow in Berlin and followed him when he became Director at Düsseldorf in 1826. Schadow placed great emphasis in his teaching on accuracy of representation. Among the principal artists of the school were Carl Friedrich Lessing, Ferdinand Theodor Hildebrandt, and Karl Wilhelm Hübner. By 1850 Düsseldorf had replaced Dresden as the premier art academy in Germany.

Dutch Italianates A term, first coined in the early 20th century, used to describe Dutch artists who worked in Rome in the 17th and early 18th centuries, and to distinguish them from home-based artists such as Jan van Goyen and Jacob van Ruisdael. Artists who travelled to Italy, such as Jan Both and Herman van Swanewelt, imbued their landscapes with a golden, Italianate light which was also taken up by artists such as Aelbert Cuyp who never actually visited Italy.

E

Early Christian A term generally applied to Christian art dating from the 3rd century to around 750, particularly that emanating from Italy and the western Mediterranean. The art of eastern Europe of this period is usually referred to as *Byzantine, while that of the barbarian German tribes is labelled *Migration Period.

Early English The first of the *Gothic styles of architecture in England, it succeeded the *Romanesque or *Norman and was in general use from the end of the 12th to the end of the 13th centuries. Although the Gothic style, with its use of the pointed *arch, originated in France, it soon acquired distinct English features after crossing the Channel, most notably in the English fondness for what might best be described as additive, spread-out ground-plans for their great cathedrals such as Salisbury (begun 1220). In France, on the other hand, there was a sense of spatial compression, of everything being pulled together, as for example at Rheims.

Earth art (or Environmental art) A broad-based, international movement of the 1960s and 1970s, embracing artists such as Alan Sonfist, Nancy Holt, and Richard Long, which rejected the commercialization of art and supported the emerging ecological movement. Earth art took many different forms including the landscaping of urban sites, massive earth sculptures in the desert, and the recording of journeys through the landscape.

earth colours Paint *pigments produced by the refining of naturally coloured clays, rocks, and earths. The term is also applied to the pure iron-oxide reds (Indian red, light red, and Mars red), although they are not native red earths.

earthenware Baked *clay, used primarily for *pottery, sometimes for sculpture, which is fired at a relatively low temperature. It remains porous until it is *glazed. *Creamware, *maiolica, *faience, and *pearlware are all types of earthenware.

easel A free-standing structure designed to hold a painting while an artist works on it. Easels were known since Egyptian and Roman times and by the *Renaissance the three-legged easel with pegs, with which one is familiar today, had developed. Lightweight easels appeared in the 18th century when artists, including *amateurs, wished to work out of doors and needed portable equipment. The heavyweight, studio easel, running on castors or wheels, was a phenomenon of the 19th century and was intended to impress clients when they visited professional artists' studios.

Eastlake style A late 19th-century style of American architecture and furniture, named after the furniture designs of Charles Lock Eastlake whose

Hints on Household Taste in Furniture, Upholstery and Other Details was published in London (1868) and Boston (1872).

ébauche [French, probably from the Italian *abozza*, which, according to Vasari, was the roughing in of the final work on the prepared pictorial surface] *ébauche* was a term mainly applied to French art in the 19th century to denote the primary laying in of the rough outlines and tones of a composition, carried out in fairly monochrome colours before colours and *glazes were laid on top. An *ébauche* could also be an independent studio exercise, for example the study of a model's head, but using the technique already described. The term can additionally be applied to sculpture, the *ébauche* being blocked out in *terracotta or wax.

ébéniste A French furniture maker who specialized in *veneered furniture.

ebonized Wood stained and polished black to simulate *ebony.

ebony A heavy, hard, black or blackish wood from tropical trees of the genus Diospyros. It is found in Africa, Madagascar, India, and Ceylon. It was greatly valued in ancient Egypt and other Mediterranean countries and employed for small sculpture and ornamental utensils. The use of ebony was revived in Europe in the second half of the 16th century for small sculpture and ornamental utensils. Many Dutch picture frames of the 17th century have a *veneer of ebony or another dark wood.

échoppe A printmaker's tool, it is a needle with a bevelled, oval point. In *etching it is used to draw lines of different width in the *ground (achieved by turning the oval point) and in *engraving it is employed to widen lines already engraved with the *burin. The lines produced with an *échoppe* are sometimes referred to as 'swelling lines' and perhaps the best-known and most spectacular example is Claude Mellan's engraving of the *Sudarium of St Veronica* (1642).

eclecticism A term, rather than a style, used to describe the combination of different elements from various historical styles, principally in architecture, but also in the fine and decorative arts. Its attractions became apparent in the later 19th century in opposition to various critics' and architects' advocacy of adherence to one particular historical style, such as the *Gothic or the *classical, for all types of buildings. The proponents of eclecticism argued that the demands of modernity could be met by skilful adaptation of features from many styles of the past. Many public and commercial buildings constructed in Britain and the United States in the later 19th century were designed in a fusion of various historical styles.

École de Paris [French, 'School of Paris'] a term originally applied to those artists of non-French, very often Jewish, origin who played prominent roles in the Parisian art world in the early years of the 20th century—artists such as Chagall (Russian), Foujita (Japanese), Modigliani (Italian), Soutine (Lithuanian), and Pascin (Belgian)—and who did not fit neatly into any of

the main movements such as *Fauvism, *Cubism, *Surrealism. The term is now used more generally to cover those movements and reflects the importance that Paris held in the art world for the first half of the 20th century. A major exhibition of the École de Paris 1900–50 was held at the New Burlington Galleries, London in 1951.

ecological architecture An environmentally friendly development of *high tech architecture. Eco architecture is designed to cool or warm buildings efficiently through shape as much as orientation, and with the efficient use of glass and solar panels. Larger buildings often have 'sky gardens' to serve as parks for the residents.

écorché [From the French, 'flayed'] a representation of a human or animal body from which the skin has been removed to reveal the underlying musculature. Écorché studies were particularly undertaken in fine art academies for the teaching of anatomy. Prints and statues of écorchés were also used for the dissemination of such information. Perhaps the most famous écorché studies were those drawn by George Stubbs (1724–1806) for *The Anatomy of the Horse* (1766).

écuelle A shallow, two-handled bowl and cover, used for individual servings of soup. Usually made of *silver or *porcelain, occasionally *faience, it was a popular shape in France in the 18th century.

Edwardian style A term which embraces the various architectural styles (*Gothic Revival, *Arts and Crafts Movement, *Neo-Georgian, *Baroque Revival, *Beaux-Arts) practised in Britain and its colonies during the period 1890–1914, with the reign of Edward VII (1901–10) at its core.

egg and dart A decorative motif of classical origin consisting of egg shapes (Latin *ovolo*) alternating with leafy arrowheads.

Egyptian art The art of ancient Egypt, dating from about 3000 BC to the conquest of Egypt by Alexander the Great in 332 BC. It can be divided into the following major dynastic periods: Early (*c.*2925–*c.*2575 BC); Old Kingdom (*c.*2575–*c.*2150 BC); First Intermediate (*c.*2150–*c.*2018 BC); Middle Kingdom (*c.*2008–*c.*1630 BC); Second Intermediate (*c.*1630–*c.*1540 BC); New Kingdom (*c.*1540–*c.*1075 BC); Third Intermediate (*c.*1075–*c.*750 BC); Late (*c.*750–332 BC). There was also a Graeco-Roman postscript, dating from 332 BC–AD 395, testimony to the later domination of the Mediterranean world by Greece and Rome. Ancient Egyptian art reflected that civilization's religious beliefs, according to which the terrestrial life was merely a brief interlude compared to the eternal life which followed. The complex pantheon of deities (less familiar than that of *Greek and *Roman art) was in a constant state of flux, however, and varied according to the shifts in regional domination. The principal Egyptian gods were Amun, normally worshipped as a sun-god; Mut, originally a lion-headed war-goddess; Khonsu, a moon god; Isis, the divine mother goddess, patroness of the dead and of magic, wife of Osiris, and mother of Horus; Osiris, god of the next world, fertility, and regeneration, and with whom the dead king was

identified; Horus, hawk and sky-god, with whom the living ruler was normally associated; Ptah, the creator god and patron of craftsmen, usually shown as a mummified king; Anubis, the jackal-headed god of *necropolises and embalming; Re, the sun-god, closely identified with the king, who held the title 'Son of Re'; Thoth, a god who appears in ibis and baboon forms and was patron of writing and scribers and god of the moon; Bastet, a cat or lioness goddess and a popular fertility deity; Bes, primarily a domestic god, protector of women in childbirth and associated with dance and music, depicted as a grotesque dwarf. The major monuments of Egyptian art consisted of its funerary statues and decorated tombs, with the *pyramids of the Pharoahs and the smaller tombs of the lesser nobility situated in the extensive funerary districts. The most significant flowering of the arts occurred during the New Kingdom when great structures were erected along the entire length of the Nile valley in Egypt and Nubia. Enormous stone temples were built for the worship of the gods. A typical temple consisted of a massive gateway, a colonnaded courtyard, a hall of columns, a shrine chamber, and one or more chapels. The design of the *columns and *capitals was based on plants, such as the palm and papyrus, and the walls were decorated with plant motifs. Some of the greatest temple remains are to be found at Luxor, Karnak, Abydos, Tell el-Amarna, and Abu Simbel. Stylistic conventions in painting remained relatively unchanged throughout the dynastic periods: the eye is shown frontally in a profile face and the shoulders are turned round so as to be presented parallel to the picture plane. A new note of three-dimensional realism was introduced in the Graeco-Roman period, however, and the coffin portraits of Roman Egypt are remarkably accurate portraits of real individuals.

Egyptian blue A mixture of copper silicates and one of the earliest known artificial *pigments, it was used as a water-based pigment for blues and greens in ancient Egyptian wall paintings. Its use spread around the ancient Mediterranean world and it was later manufactured in Italy where it was known as Pompeian blue.

Egyptian hall A large room with an internal *peristyle with a smaller superimposed peristyle above the *entablature. The form was devised by the *Renaissance architect Andrea Palladio, based on his study of Vitruvius, and has nothing to do with Egyptian architecture. A fine example can be found in Lord Burlington's Assembly Rooms (1731–2) in York.

Egyptian Revival A style of architectural and interior design, using ancient Egyptian motifs, which is normally described as a severe and monumental variation of *Neoclassicism. It reached its peak in the late 18th and early 19th centuries, stimulated in part by Napoleon's Egyptian campaign of 1798, which inspired two major publications, both lavishly illustrated, Baron Vivant Denon's *Voyage dans la basse et la haute Égypte pendant les campagnes du Général Bonaparte* (1802) and the *Description d'Égypte* (1809–28), compiled by a team of scholars and published in 20 volumes. Architects and designers therefore had access to a wide repertoire of Egyptian ornament, including sphinxes, *obelisks, pyramids, mummy-

cases, etc. Among the outstanding achievements of the Egyptian Revival were Thomas Hope's 'Egyptian' or 'Black Room' (destroyed 1850) created for his London house off Portland Place, London; the enormous 'Service égyptienne' made at *Sèvres 1810–12 to Napoleon's directions and later presented by Louis XVIII to the Duke of Wellington (Apsley House, London); William Bullock's Egyptian Hall, Piccadilly, London (destroyed 1811); and numerous funerary buildings and tombs in such celebrated cemeteries as Père-Lachaise in Paris, and Kensal Green and Highgate, both in London.

Eidophusikon [From the Greek, 'image of nature'] a miniature theatre, without actors, intended as an 'imitation of Natural Phenomena, represented by Moving Pictures'. The Eidophusikon depicted events such as sunrise and sunset, storms, running waters, and conflagrations. It was devised by the painter Philippe Jacques de Loutherbourg (1740–1812), who had extensive experience of theatre design, and was first performed in 1781 in his house in Lisle Street, London. The performances took place in an aperture approximately six feet wide, three feet high, and up to ten feet deep. There was often musical accompaniment. The Eidophusikon greatly impressed the painters Reynolds and Gainsborough and inspired the latter to devise his shadow box, constructed of movable glass plates, on which he painted landscapes and other subjects.

Eight, The A group of American artists formed by Robert Henri in 1907 to protest at the restrictive exhibition policies of the National Academy of Design. Other members included John Sloan, William Glackens, George Luks, Everett Shinn, Arthur Davies, Maurice Prendergast, and Ernest Lawson. They exhibited as an independent group at the Macbeth Galleries, New York in 1908, attracting large crowds and subsequently touring the exhibition to eight other cities, mainly in the Mid-West. Their non-academic, realist art won a large public following. The 1908 exhibition is now considered a landmark in the foundation of a popularist, democratic American art. *See* ASHCAN SCHOOL.

ekphrasis A rhetoric *manner devised in ancient Roman literature for the vivid description of works of art, whether real or imaginary. It played an important role in the *Renaissance when artists and architects were stimulated by *classical texts to emulate the great masterpieces of *antiquity.

electroplate A technique, using electrolysis, of coating a base metal (usually nickel but also *copper) with *silver or *gold. Seemingly high-quality tableware, for example, could be produced quickly and cheaply. An electric current passed through a conducting fluid brought about the transfer. The process was developed in the early 19th century and first patented in 1840, by George Elkington of Birmingham.

electrotype The copying by electrolysis of a complete (often historical) model, such as a piece of *Renaissance *silver. A *mould taken from the original is coated by this means with metal (usually *copper). The technique was developed in the 1830s.

Elizabethan Describes the art and architecture produced in England
during the reign of Elizabeth I (1558–1603). In painting (especially portrait
*miniatures by artists such as Nicholas Hilliard) there was emphasis on
exquisite detail and surface pattern, with vivid yet subtle colouring and
complex silhouettes. Netherlandish influence was strongly felt in both
sculpture and ornament, and in the *decorative arts *embroidery was
highly prized. The leading architect was Robert Smythson whose work at
Longleat House (Wiltshire), Wollaton Hall (Nottinghamshire), and
Hardwick Hall (Derbyshire) was characterized by a synthesis of traditional
English planning allied to *Renaissance classicism. Typical features
included a love of symmetry, extensive fenestration, and the use of carved
ornamental *strapwork.

Elizabethan Revival An antiquarian style popular in England from the
1830s to 1860s and inspired by the *Elizabethan style of the 16th century.
In architecture the full Elizabethan vocabulary was employed with the
reappearance of features such as gables, octagonal turrets, tall chimney-
stacks, and heraldic ornament. The great hall reasserted its importance as
the most important room in the house, wainscots were in oak, fireplaces
were in the 16th-century style, and elaborate plaster ceilings of lozenge
design were favoured. Possibly the most elaborate example of Elizabethan
Revival architecture was Mentmore Towers, Buckinghamshire (1851–4),
designed by Paxton and Stokes for Baron Mayer Amschel de Rothschild. The
Revival also extended to furniture, silverware, and *ceramics.

emblem A visual image imbued with a symbolic meaning, usually
accompanied by an explanatory text. Printed collections of emblems
(emblem books) were extremely popular in 16th- and 17th-century Europe,
especially in the Netherlands. A typical example would consist of a picture,
motto, and explanatory verse (epigram), prompting thoughts of larger
issues, frequently moral in nature. A considerable number of Dutch *genre
scenes, by artists such as Jan Steen, carry moralizing meanings derived
from emblem books.

emboss The hammering out (*repoussé) of relatively soft metals such as
gold or silver to form a design in relief. Finer details on the front are
*chased. The technique has been known since ancient times.

embrasure A small opening in the wall or *parapet of a fortified building,
it is usually bigger on one side of the wall than the other.

embroidery Decorative surface stitching, usually in wool or *silk, on
fabric, practised in all parts of the world.

emerald Part of the beryl group of stones, the name derives from the
Greek *smaragdos* meaning green stone. Emeralds are a rich green colour,
with only the finest specimens being transparent. Cleopatra owned an
emerald mine east of Aswan in Upper Egypt. Today the best specimens
come from Columbia, Zimbabwe, and South Africa. There are many well-
known emeralds, including those used in the British Crown Jewels. In the

Treasury in Vienna there is a jug 12 cm. high, weighing 2,205 *carats, cut
from a single emerald.

Empire A term which, strictly speaking, describes the decorative and
architectural style that developed in France during Napoleon's reign as
emperor (1804–14), though it is often extended to cover the period *c.*1750–
*c.*1840 and is thereby loosely synonymous with French *Neoclassicism. The
artistic vocabulary of the Empire style had been set down in Percier and
Fontaine's *Recueil de décorations intérieures comprenant tout ce qui a rapport à
l'ameublement* (1801) which basically established a repertoire of antique
forms that would be incorporated into furniture, *ceramics, metalwork,
*textiles, and *wallpaper. This new and powerfully assertive decorative
language was seen, for example, at Napoleon's château at Malmaison or in
Ingres's preposterously grandiose portrait of *Napoleon on the Imperial Throne*
1806 (Musée de l'Armée, Paris). Essentially the Roman imperial style, as it
was then perceived, was appropriated and adapted by the artists and
architects working for Napoleon to promote the hegemony of his regime.
Its motifs included imperial eagles, swans, cornucopias, winged torches,
and fasces of arms. It was saved from a Cecil B. de Mille-like vulgarity by the
superb quality of its practitioners, men such as Jacob-Desmalter, Molitor,
Thomire, Odiot, and Biennais.

Empiricism A process of analysis based on the proposition that all
knowledge derives from experiment and comparative analysis. In the
context of *art history empiricism has encouraged *connoisseurship and in
particular the study of individual works of art. This approach dominated
19th-century art history and found perhaps its most enthusiastic exponent
in the Italian Giovanni Morelli who devised a system of artist recognition—
codified in illustrations of the individual treatment of eyes, hands, etc.—
which negated the very intuition on which it was originally based. By the
early 20th century a more philosophical and theoretical school of criticism
prevailed and came to dominate the discipline.

emulsion A suspension of one liquid in another, each of which is
normally antithetical to the other, for example oil and water. This is
achieved by the addition of an emulsifier such as albumen. Milk and egg
yolk are naturally occurring emulsions. The latter is used as the *medium
in *tempera painting. All emulsions are naturally opaque or milky in their
liquid state but become transparent when they dry. Like *casein, another
emulsion used in painting, egg yolk has the advantage that once set it is not
soluble in water.

enamel A vitreous substance (usually mixed with colourants) that is fused
under heat to a metal surface for decorative purposes. It is normally applied
ground up as a paste. The colours in enamels are obtained from metal
oxides; for example, *copper (green), *iron or *silver (yellow), *cobalt
(blue), *gold (red), manganese (purple). The technique was used by the
Romans, Celts, and in medieval times. In the 18th century a method of
painting in enamels (mixed in powdered form with oil) was widely

employed for portrait *miniatures and for the decoration of objects such as snuff boxes. Enamel colours were also employed for decorating of *porcelain. *See* CHAMPLEVÉ; CLOISONNÉ; PLIQUE-À-JOUR.

encarnado [Spanish, 'flesh-coloured'] a term applied in Spanish art to the painting of the flesh parts of wooden sculptures in more or less naturalistic colours. The term *estofado* (literally 'quilted') is applied to the painting of draperies. In the 16th century most of this painting was done with a gloss finish, but in the following century a matt effect came to be preferred. Specialist *encarnadores* and *estofadores* undertook much of this work, but it was also sometimes done by distinguished painters such as Velázquez's father-in-law Francisco Pacheco (1564–1644), who frequently collaborated with the greatest of the Spanish wood sculptors, Juan Martínez Montañés (1568–1649).

encaustic [From the Greek *enkaustikos*, 'burning in'] a technique of painting with hot wax colours, invented by the ancient Greeks. The colours are made by mixing *pigments with molten beeswax and a little *resin. After being painted on to their support they are fused to it by passing a heat source over them, though not so closely that the colours are made to run. The technique was widely used in the ancient world and was said to have been perfected by the Greek painter Pausias in the 4th century BC, who employed it for painting small figures on ceiling panels. Perhaps the most famous surviving examples of encaustic painting are the mummy portraits from Faiyoum, dating from the 1st century BC to around the 3rd century AD. These paintings show traces of brushwork which superseded the earlier use of spatulate instruments. Roman writers praised the durability of encaustic and its ability to withstand the elements: Pliny recorded that it had been used to paint designs on ships. It remained the most common technique of painting in the *Early Christian era but fell into disuse around the 8th or 9th century. It was revived, partly through historical curiosity, in the 18th century and was used, for example, by the *Nazarene painter Julius Schnorr von Carolsfeld for the murals he painted in the Munich Residenz in 1831, in the mistaken belief that the encaustic paint would be able to withstand harsh conditions. Unfortunately, in unsympathetic conditions such as those of a Bavarian winter, encaustic is susceptible to damage from moisture seeping in from behind. In the later 20th century Jasper Johns used encaustic for his *Target* and *Flag* paintings, but the technique attracts few exponents on account of its cumbersome procedures.

enfilade The French system of aligning internal doors so that a vista through a series of rooms is obtained when all the doors are open. The enfilade was adopted as an important feature of palace architecture in the *Baroque era.

engaged Used to describe an architectural feature, most frequently a *column, attached to or concealed within a wall. Engaged columns, also called applied or attached columns, have between half and three-quarters of the shafts exposed and should not be confused with *pilasters. Engaged

picture frames, such as early Italian panels, physically support the panels they surround and could be carved from the same piece of wood.

engraving The main and oldest *intaglio technique of printmaking. The design is made on the *copper plate with the aid of a *graver or *burin. Held in the palm of the hand, it is pushed against the copper and cuts a V-shaped groove. The plate is then inked up and printed from, the ink retained in the grooves being forced out under the pressure of the printing process on to the paper. The technique was first developed in the early 15th century in Germany, probably by goldsmiths who wished to keep records of the designs they had engraved on their wares (designs had been engraved into metal as decorations since ancient times). From Germany the technique spread to the Netherlands. Slightly later it developed independently in Italy. The heyday of engraving was probably reached in the late 15th and early 16th centuries with the achievements of Albrecht Dürer in Germany and, in Italy, of the reproductive engravers such as Marcantonio Raimondi. Engraving continued to be used in the succeeding centuries, particularly for reproducing paintings in print form (for example prints after Rubens). Copper being a relatively soft metal and subject to wear, the plates often had to be reworked (see STATES). In the early 19th century steel plates were developed which could produce an unlimited number of *impressions, and in 1857 the *steel-facing of copper plates was introduced. The term 'engraving' is sometimes used loosely, and incorrectly, to cover all intaglio prints.

entablature In *classical architecture, the upper part of the *Order consisting of the *architrave, *frieze, and *cornice.

entasis The slight convex curve applied to columns in *classical architecture to counter the illusion that would otherwise occur of the columns being slightly concave. It is also used on *spires and other structures for the same reason.

entresol An intermediate floor introduced into a tall space with a high ceiling; also called a mezzanine.

Environment art A type of art, which began to establish itself in the 1960s, in which the artist creates a three-dimensional space to enclose the spectator and involve him in a whole range of sensory experiences—visual, auditory, kinetic, tactile, and sometimes even olfactory. The spectator was encouraged to become a participant in the 'game' or *happening. Exponents of Environment art included Allen Kaprow, Ed Kienholz, and Claes Oldenburg.

Environmental art See EARTH ART.

epergne An elaborate table centrepiece usually of *silver, but also made in *glass or *porcelain, incorporating baskets for sweetmeats.

escritoire Originally the name given to a small, portable type of writing desk, consisting of a set of drawers in a box, with a hinged, sloping front

that could be let down for a writing surface. From the late 17th century an escritoire was a full-fronted desk mounted on legs or a chest of drawers.

escutcheon A metal plate placed around the keyhole on a piece of furniture, for protection and decoration.

espagnolette A female mask with a ruff round the head and under the chin, it was a popular motif in 18th-century French decoration.

esquisse [French, 'sketch', from the Italian *schizzo*] a compositional sketch, painted or drawn, representing the first worked-out idea for a finished painting. The *esquisse peinte* ('the painted sketch') played an important role in the French academic tradition of historical, mythological, and religious painting from the 17th century onwards and became a particular subject of debate during the 19th century. The qualities of invention and technical freedom displayed in the *esquisse* were increasingly perceived to be at variance with the aridity of much 'official' art and, with hindsight, can be seen to have anticipated the looser handling of *Impressionism. *See* ÉBAUCHE.

essence *Oil paint which has been thinned by blotting the oil from it and thinning the paint with turpentine. The resulting effect has the dryness and delicacy of an eggshell. Essence was used by a number of later 19th-century French painters, most famously by Degas who referred to it as *peinture à l'essence*.

Estilo desornamentado [Spanish, 'stripped or unornamented style'] a term, apparently in use by the 19th century, that describes a phase in Spanish architecture of the 16th and early 17th centuries which was in reaction to the very rich decoration of the *Plateresque style. This much sparer style, which maintained the use of the classical *Orders and reflected Jesuit disapproval of decorative excess, is exemplified by the work (1563–84) of Juan de Herrera at the great complex of the Escorial outside Madrid. The term is used by both British and American architectural historians, but not in Spain where writers have preferred to use the word 'classicism' to describe this episode in their native architecture.

estofado *See* ENCARNADO.

étagère A set of free-standing or wall shelves used for display, known in the 19th century as a *whatnot.

etching After *engraving, the most important of the *intaglio printmaking processes. In etching the design is bitten by acid on to the printing plate. The technique was first adapted in Germany in the early 16th century from the practice of etching decorative designs on to metal, for example suits of armour. In the printmaking process the printing plate is first covered with a layer of acid-resistant *ground made of various *waxes, *gums, and *resins. The ground is often darkened, usually with the smoke of lighted tapers; this aids the visibility of the process of drawing the design, which is done with an etching needle into the ground, thus clearing a path

through to the printing plate, which is immersed in a bath of acid. The depth of the lines is determined by the strength of the acid and the length of time the plate is left therein. Plates can be wholly or partially 'rebitten' by further immersions. Parts of the design can be selected for further 'bitings' by covering over or 'stopping-out' those sections of the design considered to have been sufficiently bitten already. Once 'biting' has been completed, the acid-resistant ground is cleaned off and the plate is inked up and printed from. The more deeply bitten the lines the more distinctly they print. Some of the earliest etchings, such as those by Burgkmair and Dürer, were on *iron plates which rapidly rusted; thereafter *copper was used (though zinc has also been employed in the 20th century). Etching is often perceived as a more fluid technique than engraving, allowing the artist a greater range of expression. Its greatest masters have included Rembrandt and Piranesi. In the mid-19th century there was a revived interest in etching in France (*see* PEINTRE-GRAVEUR) and England, where its most famous exponent was the American artist Whistler (*See* ETCHING REVIVAL).

Etching Revival A revival of interest in, at times almost a mania for, *etching in Britain, which lasted from the 1860s to the outbreak of the First World War. Its origins are generally traced to the American artist J. M. Whistler, who settled in England in 1859 and profoundly influenced his brother-in-law, Sir Francis Seymour Haden (a surgeon by profession), his friend Alphonse Legros (who became a celebrated teacher of etching at the Slade School), and his most talented pupil, W. R. Sickert. Other important adherents of the revival included Muirhead Bone, Sir D. Y. Cameron, Frank Short, and William Strang. The type of etching which was promoted was of the open, *painterly variety, as exemplified by the etchings and *drypoints of Rembrandt. Etching was considered the artistic antidote to the highly worked reproductive (i.e. after paintings) engravings which were so typical of and popular in the Victorian era.

Etruscan School A group of Italian and British landscape painters working in Italy from the 1860s and formally associated in Rome in 1883–4. The moving spirit was Giovanni Costa and its members included George Heming Mason and Frederic, Lord Leighton. Their preferences were for a subdued tonality and broad panoramas evocative of the landscape tradition that stretched back through P. H. de Valenciennes to Claude Lorrain. Costa also stressed the importance of sentiment in landscape painting. The work of the group was relatively well known in London, being first exhibited at the Grosvenor Gallery until allegiances were switched to the New Gallery.

Etruscan style A style of delicate *Neoclassical decoration, the main features of which were the use of contrasting colours of black, white, and terracotta, based on the murals and vase paintings found at Pompeii, Herculaneum, and Rome in the 18th century. These were believed to date from around the 9th century BC and to derive from the Etruscans, who at that time were considered as the forerunners of the Romans. It is now known that these works were either provincial Greek or Roman. The

Etruscan style was found in French furniture design and elsewhere on the Continent. It was most popular in Britain, however, and was first manifested in *Wedgwood's *black basalt ware. It was further developed by James Wyatt and the Adam brothers in the 1770s and is found, for example, in Robert Adam's Etruscan Dressing Room at Osterley Park House, London. At the end of the 18th century it was eclipsed by the more vigorous and archaeologically accurate *Pompeian Revival.

étude [French, 'study'] a drawing, or an oil-sketch, of an individual motif prior to its incorporation into a larger composition. Etudes could be made from the model (of a head or limb for example) or, in the case of a landscape, *en plein air* (out of doors).

étui A small box or case, usually made of decorated *enamel, used to hold personal items, such as scissors, needles, and thimbles. It was designed to be carried in a pocket or attached to a *chatelaine and was popular throughout the 18th century.

European Rationalism A later development and modification of architectural *Modernism, dating from the late 1960s and the 1970s. Architects such as Aldo Rossi gave a stone-faced massiveness to the basic forms of Modernism, whereas Mario Botta banded the bold geometry of his articulated volumes in different coloured *travertine.

Euston Road School A movement in British painting that lasted 1937–9. It eschewed abstraction and much contemporary European art in favour of a strong sense of structure and a relatively straightforward naturalism. Its members included Claude Rogers, Graham Bell, Victor Pasmore, and William Coldstream. They turned for their inspiration to Sickert and the *Camden Town Group. The Euston Road label was given them by the critic Clive Bell in 1938, based on the fact that they had recently moved to 316 Euston Road from nearby Fitzroy Street where they had originally established their 'School of Drawing and Painting'.

ewer A large jug, dating from the Middle Ages, used for pouring water for washing hands. Usually of globular shape, with loop handle and small spout, elaborate ewers were made in France, in the 18th century, in *silver and *faience. During the 19th century they were usually made in *earthenware with matching washbowls and other toilet articles.

exc. (or excud.) [Latin, an abbreviation of *excudit*, 'he or she executed it'] sometimes found in a lower corner of the margin of a print following the name of the printer and identifying him as such.

exedra [From the Latin, 'a hall or room for conversation or debate'] in classical architecture a semi-circular or rectangular recess with raised seats; more generally, any *apse or *niche or the apsidal end of a room which opens out into a larger space.

Expressionism When used generally, with a small 'e', this is a term which implies heightened subjectivity or emotion, such as is found in

Grünewald's great Isenheim altarpiece, completed in 1515, or the visionary art of El Greco. More specifically, it is employed with reference to two German movements of the early 20th century, Die *Brücke and Der *Blaue Reiter, both of which utilized heightened, non-naturalistic colour and striking forms to key up the emotional content of their work. Important immediate forerunners of these movements included Van Gogh, Edvard Munch, and Gauguin.

extrados The outer curved surface of an *arch or *vault.

ex-voto An object, such as a picture or art object, presented at a shrine as a votive offering.

F

facade Any exterior surface or face of a building, but particularly that perceived to be the principal or most architecturally ambitious one.

factory-mark A mark used on *ceramics, painted, impressed, moulded, or printed, to indicate the name of the company which produced the piece and sometimes the country of origin. Some marks can include the name of the designer, painter, or modeller. Factory-marks are a useful tool in dating an item, as usually marks were only used at certain times and may include a code to determine the exact year. Marks were first applied in Italy in the 15th century, but their widespread use began in the 18th century. The *Meissen factory, with its crossed swords mark, was the first to mark pieces consistently. During the 19th century factory-marks became common throughout the world and by the end of the century were required by law.

facture A term which came into use in the later 19th century to denote an artist's characteristic handling of paint, for example 'Manet's sensuous facture'.

Faenza A group of Italian *maiolica potteries, centred around Faenza, which rose to prominence in the mid-15th century and, by the end of the century, were producing some of the finest maiolica in Italy. Using strong colour schemes they produced large dishes, drug jars, and plaques, with bold patterns giving way to the *istoriato style of decoration. Potteries in Faenza have continued in production, following the changing fashions, until the present day.

faience The French name, derived from the Italian town *Faenza, given to *tin-glazed earthenware, also used in Germany, Scandinavia, and Spain.

fake [From the German *fegen*, 'to furbish or clean up'] a work of art or artifact that is not genuine and is intended to deceive. The etymology points to one characteristic of many fakes: they are often made up from fragments of various original works, for example from fragments of *antique sculpture.

famille rose, verte, noire A type of Chinese *porcelain, made mainly for export to Europe from the 17th century onwards, given the name according to which colour predominates. The French terminology originated in the 19th century.

fancy picture As a genre it can trace its history from studies of carousing musicians or children playing with animals that were popular in the Low Countries in the 17th century. Developed by artists such as Watteau and Chardin in the 18th century, it crossed the Channel, most notably in the art of the French Huguenot émigré Philip Mercier, to become one of the staples

of British art in the hands of a succession of artists from Hogarth to Reynolds and Gainsborough. The genre allowed artists to exercise their imaginations with light and attractive vignettes of what Hazlitt was to call 'subjects of common life', providing a more palatable alternative to the grand subjects of *history painting. These paintings often appealed to the cult of sensibility, with images of *picturesque cottage girls, naughty boys, etc. They frequently carried a moral import, paving the way for the sentimentalized moralizing of much *Victorian art.

fan-vaulting A system of *vaulting used in the *Perpendicular period of English *Gothic architecture in which all the ribs have the same curve and diverge equally in every direction, producing the effect of an open fan. It was frequently used over tombs and other small enclosures in churches. A famous large-scale example is that at King's College Chapel, Cambridge.

fascia A plain horizontal band, usually in an *architrave, sometimes made up of two or three stepped fasciae separated by narrow mouldings. The term is also used to describe a moulding in a picture frame which resembles a narrow, shallow step in profile.

fauteuil French for armchair, used in English to describe a form of armchair with an open back and sides.

Fauvism The first of the major European avant-garde movements to have emerged between the turn of the 20th century and the outbreak of the First World War, it was distinguished by its concentration on a use of colour freed from a purely descriptive role and employed, instead, for expressive and emotional effect. The leading figure of Fauvism was Henri Matisse (1869–1954), who had come to realize the expressive power of colour when painting with Signac at St Tropez and then with Derain at Collioure in the summers of 1904 and 1905 respectively. The name Fauvism derives from a remark of the critic Louis Vauxcelles at the 1905 *Salon d'Automne where Matisse and his associates first exhibited as a discernible group. Pointing to a *Quattrocento-like sculpture in the middle of one of the galleries he exclaimed: 'Donatello [the great early *Renaissance sculptor] entre les fauves' (Donatello among the wild beasts). In addition to Matisse, other members of the group included Derain, Marquet, Rouault, Vlaminck, Braque, and Dufy. Their work was again prominently in evidence at the 1906 *Salon des Indépendants. However, Fauvism can best be described as a phase and many of these artists rapidly moved in different directions. Fauvism had drawn on a variety of sources for its inspiration including Gauguin, Van Gogh, the *Neo-Impressionists, and Cézanne. It would, in turn, itself prove highly influential, notably on both major German Expressionist movements, Die *Brücke and Der *Blaue Reiter.

favrile glass An iridescent, hand-made *glass developed and manufactured by Louis Comfort Tiffany (1848–1933), named after the old English word 'fabrile' meaning 'hand made'. It was registered by Tiffany as a trade name in 1894.

feather banding A form of decoration used on furniture in which a band of *veneer of two strips was placed together, the grain of each running diagonally, to produce a feather or herringbone effect, found particularly on drawer fronts of the late 17th and 18th centuries.

featherwork Decorative panels made with birds' feathers, they were mainly produced by *amateurs in 18th-century England and were often quite large and used as hangings. In the 19th century they were worked into realistic pictures of birds and framed.

fecit [Latin, 'he/she made [it]'] sometimes inscribed on a painting, print, sculpture, or building after the artist's name or initials and clearly indicating the artist's authorship. It can also be abbreviated to *fec.* or *f.*

Federal Art Project A project instituted by the United States Government in 1935 and lasting until 1943. It was designed to give employment to artists during the Depression and also to stimulate the decoration of public buildings and places. It formed part of the Works Progress Administration brought in as part of President F. D. Roosevelt's 'New Deal'. Directed by Holger Cahill, a collector of American *folk art, it engaged artists on a monthly salary and at its peak employed more than 5,000 people. Although a huge amount of work was created under the programme, most of it was of unremarkable quality and little survives.

Federal style An American architectural and decorative style which was *Neoclassical in manner and derived mainly from French architecture and the *Adam style. It played a dominant role from the Declaration of Independence in 1776 until around 1820. The term is derived from the period surrounding the creation of the federal constitution in 1787. An early example of the style was the Virginia State Capitol, Richmond (c.1785–96), designed by Thomas Jefferson, with the assistance of Charles-Louis Clérisseau. Among the major monuments of the Federal style are the city plan of Washington, DC, and its two principal public buildings, the Capitol and the President's House (the White House).

feminist art The production of overtly feminist artworks dates from the late 1960s onwards. It involved a whole range of issues including a re-examination of history from a feminist viewpoint, a reversal of the historical bias against crafts as opposed to high art, and the creation of women's art groups, institutions, and galleries.

festoon A carved ornament, used as decoration in classical and classically influenced architecture, consisting of fruit and flowers suspended in tied swags; often deployed on a *frieze or panel.

fête champêtre [French, 'outdoor feast'] a type of outdoor *genre scene in which costumed figures are shown in an idealized, poetic setting engaged in a variety of pleasurable pursuits which can include eating, dancing, flirting, or listening to music. The variations on the theme of amorous engagement

reflect the subject's origins in the Garden of Love, a popular theme in European art and literature since the Middle Ages. The fête champêtre was particularly favoured in 16th-century Venetian painting, the most famous example being the *Concert Champêtre* in the Louvre (traditionally thought to be by Giorgione but more recently attributed to Titian).

fête galante [French, 'courtship party'] a category of painting specially devised by the French Academy in 1717 to describe Antoine Watteau's (1684–1721) variations on the theme of the *fête champêtre in which figures in ball dress or masquerade costume disport themselves amorously in parkland settings. There is often an underlying melancholy to Watteau's pictures of this type, however, as in his great reception piece for the Academy *The Pilgrimage to Cythera* (Louvre, Paris).

figurative An adjective used to describe art which represents the human figure by means of a figure, *symbol, or likeness.

file A tool for shaping and smoothing sculpture and architectural ornament. Files used for smoothing metal and often for wood are made of steel that has a grooved surface. When the file is both toothed and perforated it is called a *rasp.

filigree A type of openwork decoration made out of threads of *gold or *silver, used in jewellery since classical times. It was popular in the Middle Ages and also became fashionable for small decorative objects during the 17th century, such as spoon and fork handles and small caskets. A workshop was opened in Rome in the early 19th century for filigree jewellery in the Etruscan style which became very fashionable and much imitated. It is still made in Italy, but mainly for souvenirs.

fine art Art created primarily for aesthetic reasons and not for functional use (*see* APPLIED ART). Examples of the fine arts are painting, drawing, sculpture, and printmaking.

Fine Manner One of two early *engraving styles which appeared in Florence in the 1460s, the other being the *Broad Manner. As their names imply, the distinction between the two was made by the breadth of the engraved lines. The terms were devised by print collectors and *connoisseurs. Modern scholarship has established that the major exponent of the Fine Manner was Baccio Baldini, and of the Broad Manner Francesco Rosselli.

finger painting The application of colours to a surface with the fingertips, this is now particularly encouraged in young children's art classes with the aid of specially developed finger paints. Chinese artists of various periods have also practised finger painting. Traces of the manipulation of the surface of the paint are also found in the works of a number of distinguished artists through the ages: for example, Nicolas Poussin's fingerprints are clearly visible in the paint surface of his masterpiece of *c.*1638–40 *A Dance to the Music of Time* (Wallace Collection, London).

finial A formal ornament (often in detached, foliated *fleur-de-lis form) at the top of a canopy, *gable, pinnacle, cover of vase, etc.

fire-back As its name implies, a thick panel of cast iron placed at the back of a fire to protect the wall behind from the heat of the fire. Fire-backs have been made since the 16th century and were often decorated in relief with *heraldry, biblical or mythological scenes, or ornamental motifs.

fire-dog One of a pair of decorative metal supports for wood burning in a fireplace.

firing The process of heating a *ceramic body in a *kiln to harden it, fuse the components, and to melt the applied *glaze so that it vitrifies to the surface. It can take several firings at different temperatures to complete the process. An initial *biscuit firing transforms the *clay mixture to a hard object, both physically and chemically. The temperature varies depending on the type of clay or *paste: 700–1200 degrees celsius for *earthenware, 1200–1350 degrees celsius for *stoneware, and 1250–1450 degrees celsius for *porcelain. A further *glost firing fuses the glaze to the body. *Enamel colours, used to decorate the body over the glaze, are then applied and the piece is fired again at a lower temperature in a muffle kiln, usually between 700 and 900 degrees celsius. A final firing takes place, at a lower temperature still, if *gilding is required.

fixative A thin liquid sprayed over artworks such as *charcoal or *pastel drawings in order to prevent smudging or the loss of loose particles of *pigment. A typical fixative usually consists of a glutinous *binder such as *resin mixed with a rapidly dissolving *solvent such as alcohol. The use of fixative on pastels is now discouraged on account of the inevitable discoloration it causes.

flabellum A liturgical fan, used from *Early Christian times to keep insects away from the altar during the celebration of Mass.

flambé A Chinese *glaze made from reduced copper, first used in the *Song dynasty. It is usually deep red, flecked with blue or purple, sometimes faintly crackled. It was also copied in Europe, particularly by art potters in the 19th century. Royal Doulton made a range of flambé glazes in the early 20th century.

flambeau [French, 'flaming torch'] the symbol of life; if reversed it symbolizes death. Flambeaux are found on tombs and memorials and in *Neoclassical decorative schemes.

Flamboyant The late *Gothic style of architecture in France, the name is derived from the flame-like forms of the *tracery in which bars of stonework form long, wavy divisions. The Flamboyant style is found most frequently in Normandy (for example the *facade of St Maclou in Rouen).

Flemish Used to describe the nationality of artists working in the southern Netherlands after the Union of Utrecht in 1579 which united the

seven northern provinces into what is now called Holland. Those artists working in the northern Netherlands are generally referred to as 'Dutch'.

fleur-de-lis [French, 'lily flower'] a heraldic flower with three petals forming a stylized lily. It was a central emblem in the French royal arms from as early as the 12th century and was used in ornament from the *Gothic period onwards. It was also the emblem of the powerful Italian Farnese family and of the city of Florence.

fleuron A decorative carved or painted floral pattern, square in shape, employed in *Gothic architecture. The fleuron was also used for decorative borders and to embellish frames. In addition, it is often found as a decorative element at the centre of each face of the *Corinthian *abacus.

flock prints A rare type of 15th-century *woodcut in which the block is 'inked' with glue and then printed. While the glue is still wet on the paper the surface is dusted with 'flock' (fluff of minced wool) which adheres to the printed design. The technique was later adapted in the 19th century for the manufacture of 'flocked' *wallpapers, notable for their rich, heavy patterning.

fluting Concave decorative moulding, found in the shafts of all the *classical *Orders except the Tuscan; the opposite of *reeding.

flux A substance that lowers the melting point of the compound or substance to which it is added, thereby aiding its fusion or vitrification when it is heated up. Fluxes are widely used. In metalwork they are employed in soldering, welding, and brazing; in *ceramics they are used in various *glazes and *enamels. Substances used as fluxes include feldspar, white lead, red lead, and borax.

Fluxus Set up in Germany in 1962 and lasting until the early 1970s, Fluxus was a loosely organized group of international artists. It had no set programme but, in the spirit of its distinguished predecessor *Dada, was anti-art and revolutionary in spirit and was opposed to tradition and professionalism in the arts. Its leading figure was Joseph Beuys (1921–86), but as the movement spread rapidly abroad other famous names such as the Japanese-American artist Yoko Ono came to be associated with it. Fluxus festivals were held in many European and American cities and many of their activities were concentrated on *Happenings (called Aktions in Germany).

flying buttress *See* BUTTRESS.

foil A lobe or leaf-shaped curve in *Gothic *tracery formed by the *cusping of a circle or an arch. The number of foils involved is indicated by a prefix, e.g. trefoil, quatrefoil, cinquefoil.

folk art The art, handicrafts, and decorative ornament produced by people who have had no formal art training but have an established tradition of styles and craftsmanship. A country or region may have a characteristic folk art.

follower of A cataloguing term used to denote an unknown artist strongly influenced by a particular master's work, and sometimes of a later date, for example 'follower of Rubens'.

folly A building of no practical use built to satisfy the whim of its owner, often in an 18th-century *picturesque park. Many were deliberately constructed as ruins in the *classical or *Gothic style.

font The vessel in a church which contains the consecrated water for baptism. Most are carved from a large block of stone and consist of a basin (lined with lead) carried on a short *column or *pier usually elevated on a *plinth or series of steps.

Fontainebleau School The art produced for Francis I's palace of Fontainebleau from the 1530s to the first decade of the 17th century. In painting it was characterized by elegant, elongated figures, often in mythological settings. The description Fontainebleau School was first coined by Adam Bartsch in his *Le Peintre-Graveur* (21 vols. Vienna 1803–21) to refer to a group of *etchings, some of which were undoubtedly made at Fontainebleau, which is situated some 40 miles south-east of Paris. In fact, printmaking played only a brief role in the history of the Fontainebleau School, mainly in the 1540s. There were also important achievements in *stuccowork, *grotesque ornament and prints, and sculpture. The development of the palace at Fontainebleau was instigated by Francis I in 1528 after his release from two years of captivity under Charles V. His intention was to rival the greatest art produced for the Italian humanist princes. As France had no great indigenous tradition of mural painting, Francis imported Italian artists, the two most important for Fontainebleau being Rosso Fiorentino and Primaticcio, both of whom engaged French and Flemish assistants. Rosso's main work (he committed suicide in 1540) was in the Great Gallery of the King, Primaticcio's in the Ballroom and the Chamber of the Duchesse d'Étampes. Other major artists who worked at Fontainebleau included Benvenuto Cellini and Niccolò dell'Abbate. Activity at Fontainebleau was severely disrupted by the Wars of Religion (1562–98), but at the end of the 16th century a programme of decoration was resumed under Henri IV. This phase is now generally referred to as the 'Second School of Fontainebleau' which included artists such as Ambroise Dubois, Toussaint Dubreuil, and Martin Fréminet.

foreshortening The correct depiction in *perspective of a single figure or object or part thereof in relation to its distance from the eye of the viewer. Foreshortening has been discussed in treatises and taught in art schools since the *Renaissance.

Formalism An artistic and critical approach which stresses form over content in a work of art. According to the formalist doctrine, the qualities of line, colour, and shape are sufficient, and other considerations—be they representational, moral, or social—are deemed redundant or secondary. Such a concept played a crucial role in the development of abstract art, that

is art freed from any representational functions. In the early 20th century two of the leading formalist critics in Britain were Clive Bell and Roger Fry, while in the 1950s and 1960s the American critic Clement Greenberg was highly influential, urging a 'purity' in modern art.

forum In Roman civic architecture it was a central open space, a general place of rendezvous, usually surrounded by public buildings and colonnades. It was similar to the Greek *agora, but more formally planned.

foul-biting Caused by the collapse of the acid-resistant *ground in the *etching process. If this occurs the acid attacks the plate indiscriminately, which results in a deterioration of the original design.

foxing A general term for the discoloured marks (usually brown) which can occur on *paper. It is apparently a fungoid growth which thrives in damp conditions and is found particularly in late 18th- and 19th-century papers, earlier papers being relatively immune because they were made from purer materials.

fresco [Italian, 'fresh'] the most celebrated technique of wall painting, it consists of the application of pure powdered *pigments, mixed only in water, onto a wet, freshly laid lime-plaster *ground. The colours penetrate into the surface and become an integral part of the wall. Only a certain amount of wall can be painted in a day's work before the plaster (*intonaco*) dries out. These sections are called *giornate and vary in size according to the difficulty they present, to the part painted, and to the speed of the artist's hand. The technique thus far described is true fresco, *buon fresco* or *fresco buono*. There is also painting on dry plaster, known as *fresco secco*. True fresco has been practised since antiquity and is also found in China and India. It is best known, however, through the great cycles produced in Italy (blessed with a hot, dry climate) from Giotto onwards and stretching through to the *Baroque, including Masaccio's Brancacci Chapel, Florence; Piero della Francesca's cycle of the *Legend of the True Cross* in S. Francesco, Arezzo; Raphael's *Stanze* in the Vatican; Michelangelo's ceiling and *Last Judgement* in the Sistine Chapel of the Vatican; and Annibale Carracci's *Loves of the Gods* in the Palazzo Farnese, Rome. Its use became less frequent in the 18th century, though a number of major cycles were produced by Giambattista Tiepolo. It was revived by the *Nazarenes in the 19th century, though they encountered technical difficulties in their native Germany on account of the damper climate there. In the 20th century the most distinguished practitioners were Mexican artists such as Orozco, Rivera, and Siqueiros.

fret In architectural decoration, a geometrical pattern of horizontal and vertical straight lines repeated to form a band, for example a key pattern.

fretwork Carved geometric pattern, cut from thin wood and used ornamentally on furniture, without a contrasting backing, as in Chinese-style *Chippendale furniture ('open fretwork'), or with a backing ('blind fretwork').

frieze The middle division of an *entablature between the *architrave and *cornice. Also the decorated band on an internal wall, just below the cornice.

frit The mixture of ingredients used to make *glass, including calcined sand. The term is also used for the *paste that *soft-paste porcelain is made from.

fronton A *pediment crowning a subsidiary architectural element such as a *niche, door, or window.

frottage [From the French *frotter*, 'to rub'] an adaptation of the traditional method of making a rubbing, the technique of frottage involves the making of an impression of an object such as wood, stone, or fabric by placing a sheet of paper over it and rubbing the paper with *crayon or *pencil. Frottage was popular with painters in the *Surrealist movement, in particular Max Ernst.

fugitive colour A *pigment or dye that fades, especially on exposure to daylight.

full length Denotes a painted portrait which depicts the sitter standing or sitting in his or her entirety and normally life-size or larger.

Funk art A Californian reaction against the perceived good taste and hegemony of New York as a centre for contemporary art, Funk art originated around 1960, specifically in the San Francisco area, and promoted a deliberately distasteful approach which often incorporated tatty or pornographic imagery. The word 'funky' originally meant 'smelly' and 'Sick art' is sometimes used as a synonym for 'Funk art'. Its most famous practitioner was Edward Kienholz (1927–94).

furniture prints Prints produced in 18th-century Britain for the purpose of room decoration of the homes of the 'middle orders' of society, where they were hung framed. They were cheap, printed in large numbers, and available through the thriving print trade of the time. A wide variety of prints qualified as 'furniture prints', including engravings by Hogarth, satirical prints, maps, and *mezzotints.

fustian A coarse cloth with *linen warp and cotton weft, first made in Egypt in the 2nd century. In England it was manufactured between 1720 and 1774 when pure cotton materials were banned. The name was later applied to any thick cotton cloth with a short pile, usually dyed a dark colour.

Futurism An artistic movement of the early 20th century with political implications, Futurism embraced not only the visual arts but also architecture, music, cinema, and photography. Italian in origin, it expressed the disappointment felt there in advanced artistic and political circles at the apparent lack of progress the country had made since its unification in the mid-19th century. Accordingly, stress was laid on

modernity, and the virtues of technology, machinery, and speed were promoted by the Futurists, whose founder was the wealthy poet Filippo Tommaso Marinetti. He published the first Futurist manifesto in the French newspaper *Le Figaro* in 1909 and was soon joined by the painters Umberto Boccioni, Carlo Carrà, Luigi Russolo, Giacomo Balla, and Gino Severini, who all publicly proclaimed their allegiance to the movement in March 1910. This was followed by a technical manifesto a month later and further publications included Boccioni's manifesto of Futurist sculpture in 1912. That year also saw the first proper exhibition of Futurist art, which was widely shown around Europe in Paris, London, Berlin, Amsterdam, Zurich, Vienna, and Budapest. The Futurist style drew on a number of sources, including *Neo-Impressionism and *Cubism, and favoured faceted forms and multiple viewpoints allied to a sense of movement and speed. Although the movement lingered on in Italy until the 1930s, it was already moribund there by the end of the First World War. It had considerable influence abroad, however, most notably in Russia, where a vigorous Futurist movement sprang up which numbered Larionov, Goncharova, and Malevich among its principal adherents. In Germany the *Dadaists learnt from the noisy publicity techniques of the Futurists, as did the *Vorticists in England, while in France both Duchamp and Delaunay were sympathetic to the Futurists' promotion of a modern spirit in art.

gable The upper end wall of a building which mirrors the shape (usually triangular) of the pitched roof against which it abuts. It normally has straight sides, but variants can include a crow-stepped or corbie-stepped gable, which has stepped sides; a Dutch gable with curved sides crowned by a *pediment; a hipped gable with the uppermost part sloped back; or a shaped gable with multi-curved sides.

gadroon A convex curve or inverted fluting found as decoration on the upper surface of convex mouldings in architecture and the decorative arts (particularly 17th- and 18th-century silverware).

galilee A porch or chapel usually situated at the west end of a church, sometimes called a *narthex or paradise. The term can also be applied more generally to the western part of the *nave. There is a particularly fine galilee in Durham Cathedral. The function of galilees implies partial exclusion from the main body of the church: originally they were for the use of penitents, later they were often reserved for women or were places where monks could meet female relations.

gallery In religious architecture a gallery is an upper storey over an *aisle opening on to the *nave; it is also called a *tribune. In secular architecture the term denotes a long, narrow room used for the display of pictures and sculpture, commonly found in larger *Elizabethan and *Jacobean houses. A gallery is also a room or building devoted to the display of works of art. In Italy a shopping arcade is called a *galleria*.

gamboge A bright, transparent, golden-yellow gum resin produced by trees of the genus *Garcinia* found in southeast Asia. It was used in medieval times in powdered form as a yellow *pigment which, due to its transparency, was suitable for *glazes and *watercolours. It fades, however—slowly in *oil paint and more rapidly in watercolour—and has been replaced as a pigment by *cobalt yellow. It is still sometimes employed for the colouring of *varnishes.

gamepiece A type of elaborate still-life painting in which dead game, the fruits of the hunt, features prominently. It was first developed in Flanders by artists such as Frans Snyders (1579–1657) and then became popular in Holland with artists like Jan Baptist Weenix (1621–before 1663).

garderobe A wardrobe or a small room; also a medieval lavatory.

gargoyle A projecting water spout which throws water away from the gutter of a building. Gargoyles are often carved in grotesque animal or human form to represent the spewing out of evil away from religious buildings. They are perhaps most famously illustrated in the *etchings of the 19th-century French printmaker Charles Meryon.

garniture de cheminée A set of three or more vases of related form intended for display on a *chimney-piece.

gate-house A defensive or semi-defensive structure for the protection of the entrance to a *castle, residence, or community.

gaufrage A French term for *embossing, used particularly by writers on Japanese prints.

gazebo A small tower or summer-house with a view, set in a garden or park; sometimes situated on the roof of a house in which case it can also be called a *belvedere.

gem-engraving Has been practised since ancient times. Gemstones can be *engraved in *intaglio or cut in *cameo to give a raised relief image. More generally, gem-engraving can refer to shell cameos and moulded, glass-paste imitations of engraved gems.

gems Minerals (usually of crystallized matter) used for decorating items such as *textiles and liturgical objects or for personal adornment. The most highly prized are the *precious stones, *diamonds, *emeralds, *rubies, and *sapphires; less value is attached to *semi-precious stones such as garnets, *opals, *topazes, and *tourmalines. The organic gems are *amber, *coral, *ivory, and *jet.

genre [French, 'kind' or 'type'] originally, and still, used to denote different categories of painting—portraiture, landscape, still life, etc. More usually, however, it is now specifically associated with scenes of everyday life, especially those produced by the painters of 17th-century Holland such as Gerard ter Borch, Jan Steen, and Pieter de Hooch. The term was first used in this sense by the French critic Quatremère de Quincy in 1791—'genre properly speaking, [is] scenes of everyday life'—and had gained widespread acceptance as such by the middle of the 19th century.

Geometric art The name for Greek pottery of the 9th and 8th centuries BC, after the style of decoration found in this period. Vases were painted with horizontal bands and filled in with geometric designs, gradually developing into stylized human and animal forms.

Georgian The art and architecture produced in Britain and Ireland during the period covered by the reigns of George I (1714–27), George II (1727–60), and George III (1760–1820). This embraced a wide range of styles including *Rococo, *gothick, *chinoiserie, and *Adam. Georgian as a term retains a more specific connotation with regard to architecture, however, implying an underlying classicism manifested in the large number of well-proportioned domestic buildings erected throughout the period. Urban town planning also developed schemes of great elegance, such as John Wood the Elder and Younger's Circus and Royal Crescent at Bath, and James Craig's New Town in Edinburgh. The Georgian style, if such it can be called, was also exported with great success to the townships of the eastern United States, where countless brick and timber buildings of great charm were

erected. Today, on both sides of the Atlantic, the architectural achievements of the period are vigorously promoted and protected by the Georgian Society. *See* REGENCY STYLE; NEO-GEORGIAN.

Gesamtkunstwerk [German, 'complete or unified work of art'] a term associated with the composer Richard Wagner (1813–1883) and discussed by him in his *The Artwork of the Future* (1849) to describe a dramatic form in which all the arts—poetry, drama, the visual arts, music, song—should be united so as to form a new and complete work of art. *See* BALLETS RUSSES.

gesso [Italian, 'gypsum'] a brilliant white preparation of glue and burned *gypsum (plaster of Paris) used as a *ground in the Middle Ages and *Renaissance to prepare the surface of a wooden panel or other surface before painting. The preliminary coating was made with a layer of relatively coarse *gesso grosso*, over which was laid *gesso sottile*, which was fine and smooth to paint on. Gesso can also be used as a coating on wooden furniture and picture frames prior to *gilding.

gilding The application of a thin layer of *gold to the surface of an object for decoration. Gold could be applied to furniture, picture frames, *ceramics, *silver, and metalwork. An ancient practice, gilding was used by the Egyptians and the Chinese. During the Middle Ages a high level of craftsmanship was reached when it was used for *illuminated manuscripts and *panel painting. It was employed regularly from the 17th century for interior decoration and furniture. There were two main methods for gilding on furniture and frames. Oil, or *mordant, gilding was laid on any treated surface. Water gilding, the older method, was laid on a *gesso ground, then polished and burnished. On ceramics, early methods included pulverizing gold with *lacquer and painting it on to the surface. Later, gold was chemically transformed into a powder, which was applied to the surface and fired at a low temperature. It could then be polished. On *silver, a chemical process known as fire-gilding was used to create *silver-gilt, later replaced by *electroplating. Other metals, such as *brass and *bronze, could be gilt in this way, making *ormolu.

gillotage Invented in 1850 by Firmin Gilot, this was a now obsolete process whereby a *lithographic plate was turned into a *relief block. A lithographic drawing was made on or transferred to zinc and dusted with *resin which stuck to the drawn parts and acted as an acid-resist when the plate was immersed in acid, as in the process of *etching. The resulting relief block was then inked and printed from. Many of Daumier's lithographs were transformed in this manner before they were printed in newspapers, the relief illustrations being perfectly compatible with the blocks of type used.

giornata [Italian, 'a day's work'] the area of new plaster in *fresco painting which can be painted in one day. The joins between the various *giornate* are clearly visible in many old frescoes.

girandole Originally an elaborate *candelabrum with pendants of cut *glass, later the term was applied to all candelabra as well as chandeliers or

*lustres. It was also used for a carved wall bracket or *sconce, often with a mirror back to reflect the candlelight.

gisant A French term used from the 15th century onwards for a lying or recumbent effigy on a funerary monument. The *gisant* figure usually represented a person in death (sometimes in decomposition) and was often contrasted with the *orant*, showing the person as if alive in a kneeling position of prayer. In *Renaissance monuments the *gisant* figure often occupied a lower register with the *orant* above.

glair The white of an egg, used as a relatively weak *medium or *binder in some manuscript *illumination. Mixed with water and left to stand overnight it is also used as a *size in *gilding.

Glasgow Boys The nickname given by critics to a loosely associated group of predominantly Glasgow-based artists on the occasion of their work being shown at the Grosvenor Gallery, London in 1890. Their art represented a reaction against the Edinburgh establishment's (in particular the Royal Scottish Academy's) control of artistic matters in Scotland at that time. It was also an affirmation of Glasgow's industrially-based rise to a commercial prominence whereby it could justly claim to be the second city of the British Empire after London. The sources for the 'Boys' (their own preferred label) work were various and embraced J. F. Millet and the *Barbizon School, French *Realism (above all the paintings of Jules Bastien-Lepage with their peasant subject-matter and earthy palette), and the tonal harmonies of J. M. Whistler. Their own subject-matter was predominantly rural, drawing heavily on the Scottish landscape and the country way of life. Members of the Boys included W. Y. Macgregor, James Paterson, James Guthrie, Joseph Crawhall, George Henry, E. A. Walton, and John Lavery. Their work was first seen together at the annual exhibition of the Glasgow Institute in 1885. The success of the 1890 London exhibiton led to many invitations to exhibit abroad and by 1900 the group had dispersed and very few of its members were still Glasgow-based.

Glasgow School A group of artists and architects including Charles Rennie Mackintosh and Margaret Macdonald who worked in Glasgow from the 1890s and were influenced by *Art Nouveau and the *Arts and Crafts Movement.

glass A hard, transparent material, made from silica (sand, quartz, or flint), an alkaline *flux (such as potash or soda), and other ingredients such as *limestone or potash of lead, which fuse when heated to a high temperature. In its hot, molten state, the glass, or 'metal' as it is known, can be drawn into long threads, blown into bubbles and shaped with tongs, and blown into a *mould or press-moulded. Glass can be decorated in many different ways: clear glass can be ornamented with molten threads, painted with enamel colours, engraved with a *diamond point or lapidary wheel, acid-etched, or the surface can be cut to reflect light. The glass can also be coloured with the addition of metal oxide to the raw ingredients or *frit. Glass was first discovered in Egypt, reputedly by the accidental presence of

sand or quartz in early *pottery *kilns, and glass beads and other small objects were made from 1500 BC. Glass blowing originated in the first century the first century BC in Syria, leading to the production of a full range of functional domestic objects, particularly drinking vessels. During the Roman Empire techniques spread across Europe and the Near East. By the Middle Ages in northern Europe much glass production was devoted to the creation of coloured pieces for *stained glass. A major industry developed in Venice from the 10th century and the area is still important for glass making today. In England George Ravenscroft invented a type of *lead crystal glass in 1677, the basis of most glass produced today. The 19th century saw great technical advances, particularly in moulding, leading to mass production of both useful items, such as bottles, and decorative objects. The *Art Nouveau period saw a reaction against this and the elevation of glass to an art form, as can be seen in *Tiffany glass, the work of Réné Lalique and Émil Gallé, and continued in the 20th century in the work of Scandinavian glass artists.

glass painting This can refer to two techniques, both of which involve painting on glass. In the first *ceramic colours are applied to sheets of clear glass and are then *fired in a *kiln and used as segments of a *stained-glass window. In the second, oil or glass colours are painted onto glass and viewed from the unpainted side of the glass with the aid of illumination from behind. The English painter Thomas Gainsborough (1727–88) executed a number of landscapes in this manner (now in the Victoria and Albert Museum, London).

glass prints A technique in fashion in the late 17th and early 18th centuries whereby *mezzotints were pasted face down on to sheets of glass. They were then rubbed from behind until the paper was worn away but the inked design of the original mezzotint was left adhering to the glass. It was then hand-coloured and the resulting 'glass prints' were framed for display.

glaze In painting, a glaze denotes a thin layer of transparent or semi-transparent colour laid over another underlying colour. The transparent colours, used in glazes have low refractive indices (e.g. *lake, ultramarine, copper resinate, *Prussian blue). The careful building up of final colours by using layers of glazes was common from the 15th to the 19th centuries until the more widespread availability of stronger, industrially produced paints. A glaze is also a glassy coating on a *ceramic *body which provides a waterproof covering and a surface for decoration. The ingredients used are similar to those in *glass, with a *flux added and then ground to produce an insoluble powder. This can then be sprayed or dusted on to a ceramic body. Alternatively, the powder can be mixed with water and the body dipped into this solution. The water is absorbed by the porous body, leaving a coating of glaze, ready to be fired. The glaze is fused to the body after a *glost firing, which follows an initial *biscuit firing. *Earthenware was commonly covered with *lead glaze or *tin glaze, *stoneware with *salt glaze, and *hard-paste porcelain with feldspathic glaze. Decoration can also

be glaze. Decoration can also be applied under the glaze, usually using cobalt, or over the glaze using a wide range of *enamel colours.

glost The *firing of a *ceramic object to fuse the *glaze to the body, at a slightly lower temperature than the initial *biscuit firing.

glyptotheca A building used for the display of sculpture.

Gobelins The most famous of all *tapestry factories, the name derives from Jean and Philibert Gobelin who set up a scarlet dyeing shop on the outskirts of Paris *c*.1440. These premises were converted into a tapestry factory before 1607. It was taken over in 1662 on behalf of the Crown under the directorship of Charles Le Brun. Its official title was the *Manufacture royale des meubles de la Couronne*. It was intended to provide furnishings of magnificence for the royal residences and employed tapestry weavers, painters, bronze workers, furniture makers, goldsmiths, and silversmiths. The factory was closed in 1694 on account of the king's financial difficulties, reopened in 1699 and thereafter was devoted solely to the manufacture of tapestries. In the first half of the 18th century the rather grand style of Le Brun was gradually succeeded in the designs for tapestries by the more decorative *Rococo of Boucher and Oudry. The factory continues in production today. The term is sometimes used generically to denote tapestry, especially imitations of the old Gobelins style.

goblet A drinking vessel with a tall stem supporting a bowl.

gold Since the earliest times, gold has been regarded as the most precious of metals. It is found in many parts of the world, but not in large quantities. In addition to its beauty, it is remarkably soft yet durable. When used for sculpture it is generally alloyed with *silver or *copper to give it added strength.

Golden Age painting A term which has gained currency in recent years and is used to describe the flowering of a distinctive Danish school of painting following the final defeat of Napoleon in 1815. The father of the school was Christoffer Wilhelm Eckersberg who, after training in Paris and Rome, returned to Copenhagen in 1816. Among his pupils was Christen Købke, now acknowledged to be the greatest of the Golden Age painters. Their work is small in scale, fine in detail, and wonderfully conveys a sense of fresh observation of the Danish town- and landscape and of bourgeois life. *See* BIEDERMEIER.

Golden Section A harmonic proportional ratio thought to have originated in the circle of Pythagoras (6th century BC) and which was discussed by both Euclid and Vitruvius in their writings. A straight line or rectangle is divided into two unequal parts in such a way that the ratio of the smaller to the greater is the same as that of the greater to the whole. It cannot be expressed as a finite number but an approximation is 8:13 or 0.616:1. With the invention of algebra it became possible to express the ratio as ϕ (phi, the initial letter of Phidias's name): $\phi = 1$ plus the square root of 5, divided by 2. The Golden Section was thought to have great

inherent aesthetic value and was much studied during the *Renaissance, especially by the mathematician Luca Pacioli, a close friend of Leonardo da Vinci and Piero della Francesca. In Pacioli's book *Divina Proportione* (1509), illustrated with drawings by Leonardo, the Golden Section is described as this 'divine proportion' and Pacioli endeavours, in true Renaissance fashion, to combine the knowledge of antiquity with the Christian faith by claiming that the ratio of the Golden Section is beyond definition and in this respect is like God.

gold ground A term used to refer to Italian *panel paintings of the 13th to 15th centuries distinguished by their *gold leaf backgrounds which were polished with a *burnisher and thereby acquired a shining intensity. Once burnished, the gilded surface was decorated with patterns of incised lines, *tooling, and ornamental *punching.

gold leaf A piece of *gold which has been beaten until thin and can then be applied to a wide range of objects or artworks, for example furniture, picture frames, or *gold ground *panel paintings.

gospel book A book containing the canonical texts of the four Evangelists Matthew, Mark, Luke, and John. The illustration of these books played an important role in early medieval art in the West, especially in the *scriptoria of Irish and Northumbrian *monasteries in the 7th and 8th centuries, with one of the most famous examples being the Lindisfarne Gospels (British Library, London). Many important gospel books were also produced during the *Carolingian and *Ottonian periods. In the eastern Christian tradition of Byzantium gospel books were a constant feature throughout the history of manuscript production.

Gothic The style of art and architecture in Europe which came between the *Romanesque and the *Renaissance. It was prevalent in Italy from the mid-12th to the early 15th centuries and continued until the early 16th century in northern Europe and the Iberian peninsula. 'Gothic' was a term originally coined in a pejorative sense by Italian *Renaissance architects such as Alberti to describe the preceding medieval style of architecture, which they condemned as barbaric and mistakenly attributed to the Gothic tribes who had sacked Rome in the 5th century and were perceived to have swept away the ideals of *classical art. Gothic architecture, as exemplified in the great cathedrals of northern France and England, was characterized by its qualities of lightness, verticality, and, especially in later Gothic, increasing intricacy. It is generally agreed to have made its first appearance at the abbey church of St Denis, just to the north of Paris, in the 1140s. Common features of Gothic architecture as it developed were the pointed *arch (though this also occurs in some Romanesque architecture), *flying buttress, and elaborate *tracery.

gothick A term used to denote works of architecture and interior design produced in Britain during the earlier, 18th-century phase of the *Gothic Revival, most famously exemplified in Horace Walpole's remodelled home at Strawberry Hill, Twickenham, London.

Gothic Revival A term used to describe the architecture and decorative arts produced as a result of a revival of interest in the medieval Gothic style. From hesitant beginnings in England and Scotland in the 18th century, it became in the 19th century one of the principal building styles employed throughout the world. In post-Napoleonic Europe (Napoleon had very much favoured the *classical style) Gothic was seen as a valid alternative and a reaffirmation of the cultural traditions and independence of many countries after the traumas of war. The rapid expansion of many industrial cities also created a huge demand for the building of churches, most of them executed in the Gothic style. Prominent architects and designers of the Gothic Revival included A. W. N. Pugin, Viollet-Le-Duc, and George Gilbert Scott. The recognition in print of the movement was established by the publication of Charles Locke Eastlake's *A History of the Gothic Revival* (1872), later reinforced by Kenneth Clark's youthful masterpiece *The Gothic Revival: An Essay in the History of Taste* (1928).

gouache Also called *bodycolour, is *watercolour which is opaque (as opposed to its more common transparent form). This opacity is achieved by the addition of white paint or *pigment (such as *Chinese white). Gouache was used in *manuscript illumination and early watercolours (for example by Albrecht Dürer). It was also employed by *miniature painters in the 17th and 18th centuries. Many of the watercolours of Paul Sandby (1731–1809), generally credited as the founder of the English watercolour school, were in gouache.

gouge A chisel for carving wood, the blade of which has a curved section which produces a concave cut.

goût grec [French, 'Greek taste'] a term used to describe the first phase of French *Neoclassicism which lasted from the mid-1750s to the late 1760s. Strictly speaking it should only be applied to French decorative arts and architecture of this period. Its style was severe, with chunky classical details, and its first significant appearance was in a set of furniture made for the Parisian financier and collector La Live de Jully from designs by the painter and amateur architect Louis-Joseph Le Lorrain. The austere monumentality of these pieces was in stark contrast to the light and elegant shapes of the *Rococo which had dominated French art in the first half of the century.

gradation A series or progression of shades, tints, or values, which occur in a sequence from light to dark. More generally, the term refers to the smooth blending or fusion of adjacent colours or tones.

gradual [From the Latin *gradus*, 'step'] a type of *choir book containing the parts of the Mass sung by the choir on the altar steps. From around AD 1000 onwards graduals were richly illustrated, at first with pictorial cycles, but then from around 1400 with *historiated initials and *grotesques in the margins. Graduals were often large in size as the choir sang from a single book which had to be clearly visible to all participants.

Graffiti art A phenomenon of the mid-1970s to 1980s and mainly based in New York, Graffiti art was inspired by the colourful graffiti sprayed with aerosol paint onto New York subway trains by the streetwise teenagers of the Bronx and Brooklyn. In response to this, professionally trained artists such as Keith Haring deliberately cultivated a graffiti style, though it should be remembered that earlier artists such as Cy Twombly, Jackson Pollock, and Jean Dubuffet had already been generally interested in *graffiti (the original meaning of which was drawings scratched onto the surfaces of walls). The move of Graffiti art from the street to the gallery was heralded in its first major museum exhibition at the Boymans-van Beuningen, Rotterdam in 1983. Critical opinion was sharply divided as to whether Graffiti art represented a form of social liberation or was merely a voguish exploitation of street vandalism by the commercial art market.

graffito (plural graffiti) [Italian, 'scratched'] a term commonly used to mean a design (often obscene) drawn or scratched on a wall. It is also applied to the spray paint designs and words which disfigure so many contemporary urban environments around the world. In a broader sense it denotes any technique of producing a design by scratching through a layer of paint or other material to reveal a *ground of a different colour—for example scratching ornamental designs through the *gold leaf applied to medieval *panel paintings.

graining Painting on furniture, panelling, or other woodwork, in imitation of another wood, usually a more expensive one.

Grand Manner The term used to describe the elevated style of *history painting advocated by teaching academies throughout Europe from the 17th century onwards, based on the classical balance of the art of Raphael, Poussin, and the Carracci. In his *Discourses* the painter Sir Joshua Reynolds (1723–92), first President of the Royal Academy, referred to it as the 'Great Style'. One of its greatest exponents was the French painter Jacques-Louis David, in paintings such as his *Belisarius* of 1781 (Musée des Beaux-Arts, Lille).

Grand Tour The almost obligatory tour to Italy, usually via Paris, undertaken by the nobility of northern Europe, especially from Britain. It is associated particularly with the 18th century. The participants were normally young aristocrats, dispatched before they had succeeded to the family title and accompanied by their tutors. Rome was the principal destination, though Venice, Florence, and Naples were also extremely popular. The tour actually originated as early as the late 16th century and the term 'Grand Tour' was first used in print by Richard Lassels in his *Voyage of Italy* (1670), in which he claimed no one could understand Livy and Caesar if they had not undertaken the 'Grand Tour of France and the Giro of Italy'. By the second half of the 18th century such an experience had become almost de rigueur and possible itineraries expanded to include southern Italy and Greece. Apart from the perceived educational benefits, both cultural and sexual, of such tours, they also played a crucial part in the

collecting activities of the wealthy. Many of the *classical, *Renaissance, and *Baroque masterpieces in British country house collections were acquired on these Grand Tours or as a result of interests which they awakened. The Napoleonic Wars (1793–1815) greatly restricted the possibilities of travel in Europe, but when peace was finally re-established travellers flocked again to Italy. By mid-century, however, the coming of the railways and cheaper travel and the development of tour companies such as Thomas Cook changed the nature of foreign travel fundamentally, opening it up to the middle classes.

granite An immensely hard igneous rock made up of feldspar, mica, and *quartz, granite is found in all parts of the world. It has been used for sculpture by a number of civilizations, including the ancient Egyptians.

granulation Tiny grains of *gold, collected together and used to decorate a gold surface, usually jewellery. The technique was known since the 3rd millennium BC but it was the Etruscans who were particular experts in the craft.

graphic arts In the *fine arts this refers to all the various techniques used in the production of *original prints, and in the commercial arts to all the processes involved in the production of text and artwork.

graphite A crystalline form of carbon found widely around the world, it has long been employed as a writing and drawing material. When compressed with fine clay it is used in *lead pencils.

graver (or *burin) an *engraving (printmaking) tool with a shaped point and a wooden handle. Gravers are held in the palm of the hand, with the point facing outward and, in the engraving process, are pushed against the surface of the copper plate, thereby gouging out the desired design in a V-shaped channel. Printing ink is forced into this channel and, after excess ink has been cleaned from the surface of the plate, it is then printed from.

grazia [Italian, 'grace'] a quality in art which, in Italian *Renaissance theory, was originally synonymous with beauty. However, the artist and writer Giorgio Vasari, author of the *Lives of the Artists* (1568), equated it with sweetness and softness and identified it as a separate attribute, dependent on judgement and the eye. For Vasari, the *High Renaissance artist Raphael was the embodiment of grace.

Greek art A term used to describe the art and architecture of ancient Greece, which consisted of many independent city states around the Aegean Sea bound together only by a shared language and religion. Alexander the Great, until his death in Babylon in 323 BC, succeeded in imposing a sense of Greek empire and unity in the face of the seemingly perennial threat from the Persians, but this cohesion soon fell apart under his successors. Nevertheless, the artistic achievements of the Greeks were enormously innovative and formed the basis for much of the later art and architecture of the Romans, by whom they were conquered in the middle of the 2nd century BC. Ancient Greek art is divided into three main periods:

*Archaic (*c*.700–*c*.480 BC), *Classical (*c*.480–323 BC), and *Hellenistic (323–27 BC). Further sub-divisions have been applied to *Greek pottery, the most significant styles of which are *Geometric (*c*.900–*c*.700 BC), Orientalizing (from around *c*.700 BC and with many distinct regional schools), *black-figure (7th and 6th centuries BC, originating in Corinth), and *red-figure (6th century BC onwards).

Greek cross A cross with all four arms of equal length, as a type of central plan it was frequently used in Early Christian churches and can be found in the later Byzantine empire down to the 14th century.

Greek key pattern A decorative pattern consisting of lines turning at right angles to one another forming a continuous meander.

Greek pottery The type of pottery which developed throughout the Greek world during the *Archaic and *Classical periods. Patterns were *Geometric on early pieces (*c*.900–*c*.700 BC); gradually figures were introduced on a black ground. This *black-figure painting gave way to the more naturalistic *red-figure style. The Greeks introduced a range of conventional pottery shapes, many of which have continued in use until the present day. They were usually made for a specific purpose, such as the *amphora for wine, *hydria for water, and *kylix, a drinking cup.

Greek Revival An architectural style inspired by the architecture of *classical Greece. It began in Europe, stimulated by the archaeological rediscovery of Greek architecture which gathered momentum from the early 18th century onwards. The style first manifested itself in mid-18th-century England in the Scottish architect James Stuart's garden buildings at Hagley Hall and Shugborough. By the turn of the century it was being widely adopted for urban planning schemes and new public buildings in both Europe and the United States. The Scottish capital city of Edinburgh took to the style so enthusiastically that it came to be known as the 'Athens of the North', exemplified by W. H. Playfair and C. R. Cockerell's unfinished National Monument astride Calton Hill, a conscious evocation of the Parthenon. It was Cockerell who is credited with the first use of the phrase 'Greek Revival' in a lecture he delivered in 1842 to the Royal Academy in his capacity as Professor of Architecture there.

green earth A green *pigment made from a clay containing iron silicate, it is cheap to produce and has been particularly popular for use in *watercolour and other aqueous media.

grisaille [From French *gris*, 'grey'] a method of painting solely in shades of monochrome grey or another neutral colour. In the *Renaissance and later grisaille was used for paintings, often those imitating the appearance of *relief sculpture. It was also sometimes employed for *underpainting, or for sketches (for example the oil sketches of Rubens). Grisaille enjoyed a revival of popularity among French 18th-century artists such as François Boucher. It can also be found on *painted furniture and *ceramics of the late 18th century.

grog A filler used for the *moulds and *cores used in the making of *cast sculpture.

groin In architecture the intersection of two *vaults crossing each other at the same height.

grotesque [French, from the Italian *grottesco*] a term used to describe a type of European ornament composed of small, loosely connected motifs including scrollwork, architectural elements, whimsical human figures, and fantastic beasts, often organized vertically round a central axis. The original inspiration for such ornament was provided by the archaeological excavations undertaken at the end of the 15th century of the ancient Roman interiors of the Domus Aurea of Nero and of other villas in Rome and Naples. These revealed a hitherto unknown side of Roman art in the playful decorations found in the underground rooms (*grotte*) of these buildings. They were soon copied by Italian artists and their designs were disseminated in the form of prints. The use of grotesque decoration spread throughout Europe in the 16th century. Raphael incorporated it into his decoration of the Vatican Loggia (1518–19) and in France it constituted one of the main achievements of the *Fontainebleau School. In the 18th century there was a strong revival of interest in grotesque ornament, both in the development of the *Rococo style, and in the renewed exploration of Roman domestic decoration following the publication in 1752 of the recent excavations at Pompeii and Herculaneum.

grotto An artificial cave, usually with fountains and cascades and adorned with shells. They are first found in *Renaissance buildings and gardens but were particularly popular in the 18th century.

ground A coating material used to prepare a surface for painting; oil mixed with white pigment is used for canvas, an oil ground or *gesso is employed on board or panel.

Group of Seven A group of Canadian painters, based in Toronto, some of whom had been working together since 1913 but were officially established in 1920 when they held their first official exhibition at the Art Gallery of Ontario. Painting in an *Expressionist style, they drew their inspiration from the landscape of northern Ontario and constituted the first major national movement in Canadian art.

Gubbio A *maiolica factory, established in 1498 by Giorgio Andreoli (Maestro Giorgio), specialising in *lustre decoration, in operation until 1576. Maiolica made at *Urbino and elsewhere was often sent to Gubbio for the addition of lustre. This technique was revived at Gubbio in the 19th century.

guéridon [French] a candle-stand or a small, usually circular, table for holding a candle, normally in the shape of a pedestal or column supported on feet and surmounted by a tray. The name is said to derive from that of a Moorish slave in a popular Provençal song from the time of Louis XIV.

guild Of medieval origin, guilds were the trading and training associations of the various professions, crafts, and trades and were often associated with a patron saint. Painters and *limners, for example, belonged to the Guild of St Luke. In the *Renaissance there was a conscious desire to elevate both the social and intellectual standing of the artist and the first artists' *academies were formed.

guilloche A classical ornament consisting of a pattern of bands interlaced or plaited over each other and used to enrich a moulding; also found in picture frames and on 18th-century furniture.

gules The *heraldic term for red, it is probably Arabic in origin, deriving either from *gul* ('a rose') or *ghül* ('a feeder on carcases').

gum A sticky liquid exuded by certain trees and shrubs. Gum has been used as a painting *medium since ancient times. It is the normal medium of *watercolour (see *gum arabic) and *pastel.

gum arabic The usual *medium of *watercolour, gum arabic dissolves in water, but when the water has evaporated it binds the *pigments of watercolour to the painting surface (usually paper). Gum arabic is obtained from a species of the acacia tree, the best examples coming from Sudan and Senegal.

gypsum Mineral calcium sulphate, of which *alabaster is a variety. When heated to about 100°C it forms a powder which, if mixed with water, sets hard and is known as *gesso or *plaster of Paris.

gyronny The division of a *heraldic shield into eight by the combination of a *quarterly and a saltire.

H

Hague School The term coined in 1875 by the critic Jacob van Santen Kolff to describe a group of Dutch artists who lived and worked mainly in The Hague, Holland, between 1870 and 1900. Its members included the Maris brothers, Anton Mauve, and Jozef Israëls. In their work they were directly inspired by the flat *polder* landscape and the everyday lives of the peasants and fishermen around The Hague and the nearby port of Scheveningen. Their subject-matter mirrored that of 17th-century Dutch art, but stylistically they were much closer to the French *Barbizon School painters. The group's headquarters was the artists' society Pulchri Studio in The Hague.

ha-ha A sunken fence or trench which marks off one part of a park from another, usually the formal house and gardens from the rest of the estate where livestock are allowed to roam. The purpose of the ha-ha (as opposed to a wall or fence) was to allow an unbroken vista from the house while preventing the beasts from approaching the gardens. The ha-ha normally provides a good vantage point for views of the landscape. The term may originate from the cries of surprise of persons first coming across the 'ha-ha' unawares.

half-length An English size of canvas used for portraits showing half the figure. The normal dimensions of a half-length are 50 × 40 inches (125 × 100 cm.) but there is a variant, known as a 'bishop's half-length', which measures 56 × 44 inches (140 × 110 cm.)

half-tone A method of creating tone in printing images, especially those to be reproduced in newspapers and magazines. The image is photographed through a cross-line screen which produces a negative composed of lines of dots of varying sizes depending on the tonal density of the original image.

hall chair An English chair with a solid seat and back, usually of *mahogany, manufactured from the early 18th century to the mid-19th century, used in halls and corridors. They were often decorated with a *coat of arms in the centre.

hall church A *Romanesque church in which the *aisles are of equal, or near equal, height to the *nave. Hall churches therefore give the impression of a large interior space which is often dark, on account of the lack of a *clerestory, which is found in the rival *basilica plan in which the nave is higher than the aisles. The hall church format dominated Romanesque Europe, stretching north to south from the Loire to the Alps, and east to west from Portugal to Westphalia, the middle Danube, and the Palatinate.

hall-mark A mark on *silver or *gold, applied by an assay office, to guarantee it is of the required legal standard. Most English silver bears four

marks: the sterling silver mark, the town mark, the maker's mark, and the date letter. The silver mark indicates that it is 92.5 per cent pure—from 1300 a leopard's head was used for this, which changed to a lion in 1544. The leopard's head became the town mark of London and, as assay offices opened in the provinces, each adopted their own mark, such as the town coat of arms in Chester, an X in Exeter, a castle in Edinburgh, and an anchor in Birmingham. The date letter was used in London from 1478 and then in other parts of the country. It usually followed an alphabetical sequence but was unique from year to year and to each assay office. From 1363 the maker's mark was added, at first a device, but by the 18th century initials were used. A variation to these marks occurred between 1697 and 1720 when a higher standard of silver was established and the sterling and town marks were replaced by Britannia and a lion's head in profile. From 1784 until 1890 the sovereign's head was added to the marks, to indicate that duty had been paid. Throughout Europe gold and silver was usually stamped with the *guild mark as well as the maker's and date mark.

hammerbeam A horizontal bracket projecting from the wall surface which supports the arched braces and struts of the roof, thus lessening the span and allowing shorter timbers to be used.

Happening An event or entertainment presented by an artist or group of artists which combines elements of theatre and the visual arts and often involves spectator participation. The term was coined in 1959 by Allan Kaprow, having originally appeared in the title of a score he published in the *Anthologist* of Rutgers University. Happenings implied a rejection of the traditional concepts of both craftsmanship and permanence, furthermore they were not restricted to the confines of an art gallery. Of direct relevance were the composer John Cage's theories on the importance of chance in artistic creation. In America the most important visual artists involved in the early development of Happenings were Jim Dine, Claes Oldenburg, Robert Rauschenberg, and Roy Lichtenstein.

hardboard A board made from compressed wood pulp. Sometimes used as a painting surface, hardboard is also employed as a *marouflage support.

Hard Edge painting A term first coined in 1958 by Jules Langsner and applied to a type of painting (mainly abstract) in which areas of colour are defined by hard edges, in contrast to the free mix of colours and shapes in *Abstract Expressionism. In the 1960s the term was used generally to include a wide range of artists such as Elsworth Kelly and Kenneth Noland.

hard-paste The name given to true *porcelain. The two most important ingredients are *kaolin (china clay) and *petuntse (china stone) which, when fired to a high temperature (1250 to 1350 degrees celsius), fuse to a glassy matrix, forming a hard, white, translucent body. It is usually covered with a *glaze made from powdered feldspar before *firing. Hard-paste porcelain was first made in China, where both ingredients were available. Kaolin was only discovered in Europe at the beginning of the 18th century and the first hard-paste porcelain was made by Johann Friedrich Böttger at

*Meissen in 1709. In England, after the discovery of kaolin in Cornwall, hard-paste was produced in Plymouth from 1768 until 1770.

hardstone A general term used to describe a wide variety of stones such as *agate, calcite *alabasters, *jasper, and various *marbles used for inlays and small-scale sculpture. *See* PIETRE DURE.

hatching The use of finely drawn parallel lines to suggest shading, hatching is employed in drawing, *underdrawing, printmaking, and *tempera painting. *See* CROSSHATCHING.

Hausmaler [From the German, literally 'home painter'] an independent artist, not attached to a factory, who painted *porcelain, *glass, or *faience in his own studio. The best known and most accomplished *Hausmaler* worked on porcelain in Germany in the 18th century. They purchased undecorated porcelain locally or used Chinese wares. Factories such as *Meissen tried to discourage *Hausmaler* by refusing to sell white porcelain or only disposing of imperfect pieces. Despite this, much fine work was produced by *Hausmaler* such as Franz Ferdinand Mayer, Daniel Preissler, and Johann Auffenwerth.

hazzle A zigzag patterning used as a decorative background in gilt picture frames and against which a design such as a leaf pattern may be set.

Hellenic art The name given to the art of the Greek-speaking cultures from the beginning of the Iron Age (11th century BC) to about 323 BC, encompassing the *Geometric, *Archaic, and *Classical periods of art. The later period is called *Hellenistic.

Hellenistic The term for *Greek art of the late 4th to late 1st centuries BC. During this period Greece lost its political importance and new centres of patronage emerged in Asia Minor, Egypt, and then Rome, leading to cosmopolitan influences and diverse styles of art. The harmony and beauty of the preceding *Classical period gave way to dynamism and individuality. Sculpture showed great technical expertise and, at its best, drama and emotion, as in the *Laocoon* of *c*.25 BC, now in the Vatican Museum, Rome. During the 19th century, when Greek art of the Classical period was well known, Hellenistic art was dismissed as decadent.

Hepplewhite style The style of 18th-century English furniture which follows on from *Chippendale, named after the *cabinet-maker George Hepplewhite (d. 1786). No pieces of furniture have been identified as his work, but his fame lies in the posthumous publication in 1788 of his book of designs *The Cabinetmaker and Upholsterer's Guide*. This contained around 300 illustrations of all types of furniture and was widely used as a trade catalogue. The furniture was light, simple, and elegant, often in *satinwood inlaid with other exotic woods. Styles included serpentine and bow-fronted chests and shield-back chairs, with which the Hepplewhite name is synonymous. These complemented the fashionable *Adam style and were as popular as the designs of Thomas *Sheraton, the other leading furniture maker of the period.

heraldry The systematic hereditary use of the arrangement of *charges or devices on a shield denoting families and institutions. Heraldry emerged around the middle of the 12th century over a wide area of Europe. It seems most likely that the use of heraldic devices began with the lance flags of knights before being transferred to shields. Heraldry has special rules and methods, provides a display of pageantry, and is an invaluable aid to understanding history and genealogy.

herm A sculpture of a male *bust or head, without arms, surmounting a *shaft and tapering towards the bottom. Named after the god Hermes, herms are first found in Greek art from the 6th century BC and originally displayed a phallus on the shaft. They were placed at street corners in ancient Athens and outside the city as milestones. From the *Renaissance onwards they have formed part of the general vocabulary of decorative art.

hermitage A small building in a secluded spot, suitable for the abode of a hermit, in a park or estate, often constructed in a rustic style. This fanciful concept was particularly popular in the 18th century.

hieratic A term used particularly in connection with the art of ancient *Greece and *Egypt to refer to styles which remained relatively fixed on account of their adherence to religious convention.

hieroglyph [From the Greek, 'sacred carving'] the term used to describe the stylized picture which formed the writing practised by the ancient Egyptians. A hieroglyph represented a complete word or a syllable and was usually written on *papyrus, a species of rush which was flattened to provide a surface.

high relief Sculpture which projects almost fully, or at least half of its natural circumference, from its background. *See* ALTO RILIEVO.

High Renaissance A term which is generally taken to refer to art produced in Italy in the early decades of the 16th century when the careers of the great *Renaissance masters, Leonardo da Vinci, Raphael, and Michelangelo overlapped. The technical mastery and graceful harmony they achieved in their work was held up as the ideal by writers such as Vasari.

high tech A label applied to modern architecture which deliberately reveals its structure as part of its external appearance. The forms and materials are derived in part from developments in the aircraft and space industries. Largely a British phenomenon, two of its most famous buildings are Norman Foster's Stansted Airport and Renzo Piano and Richard Roger's Pompidou Centre in Paris.

hipped roof A roof with sloped rather than vertical ends.

hippocamp A fabulous marine creature from *classical art with the front half a horse, the hind parts a fish, often shown drawing the chariot of Neptune.

Hispano-Moresque *Tin-glazed *earthenware with *lustre decoration, produced in Spain from the 12th to the 18th centuries. Moorish centres in southern Spain, such as Malaga and Murcia, predominated until the overthrow of the Moors in the 15th century, when potters moved north to Valencia. The lustre technique was first used in Persia and arrived in Spain via North Africa. Dishes, large *chargers, tiles, vases, and drug jars were the main products, painted with patterns derived from Islamic sources often combined with European motifs and *heraldry.

historiated Describes an initial letter in an *illuminated manuscript which is decorated with designs representing scenes from the text.

history painting Painting in which the subject-matter is taken from classical, mythological, or biblical history. From the *Renaissance to *Neoclassicism this was regarded in academic circles as the highest form of painting, for the artist had to show all his talents—not only the skill of eye and hand, but also his mastery of the often complex and erudite subject-matter.

hôtel particulier A French town-house, usually having a court towards the street enclosed by a wall and then the main building (*corps-de-logis*) with a garden at the back. One of the finest examples is the Hôtel Carnavalet in Paris.

hot table Used for the *lining of pictures, it is a table top with facilities for extremely uniform heating and cooling which are necessary for the removal and application of the various glues and waxes used in the lining process.

Hudson River School A term applied retrospectively to a group of American landscape painters working *c*.1825–*c*.1875 in the Hudson River Valley, the Catskill Mountains, and other areas of remote beauty. Their work was particularly popular in the mid-19th century. Three of the most important members of the group were Thomas Cole, Thomas Doughty, and Asher B. Durand. They and their colleagues had all studied in Europe and been inspired by landscape painters such as J. M. W. Turner and John Martin.

hue Nowadays hue is generally synonymous with colour or shade. It is more accurately used to denote the particular tint or quality of a colour.

husk A wheat ear motif, used particularly on furniture and metalwork during the *Neoclassical period.

hydria An ancient Greek water jug, with rounded shoulders, horizontally attached handles, and a vertical handle at the neck for use when pouring.

hypo Sodium thiosulphate, used as a *fixative in photography.

icon [From the Greek *eikon*, 'likeness'] an image of a saint or other holy personage. The term is applied particularly to such images produced for the *Byzantine and Russian and Greek Orthodox churches. Recently, icon in popular parlance has become a secular extension denoting a particular person as a figurehead or archetype (for example Elvis Presley as an icon of Rock and Roll).

iconography A term used in *art history, referring to the study of the subject-matter rather than the form of a work of art. Although it can be used in connection with any period of art, iconography is most usually discussed in the context of medieval and particularly *Renaissance studies. The term can also be applied to a collection of portraits, for example Van Dyck's great series of portrait etchings of his contemporaries entitled *Iconography*. As a development of this theme, it can also describe the body of portrait images of a particular individual.

iconology Closely related to *iconography, but whereas that term is essentially descriptive (for example identifying a saint by his or her visual *attributes), iconology is more interpretative. It implies an examination, for example, of the meaning of an image or work of art by setting the iconographical evidence it offered in a wider context, be it historical, social, or whatever. The term was particularly advocated by the great German art historian Erwin Panofsky (1892–1968).

iconostasis [Greek *eikonostasis*, 'placing of an image'] in Russian and Byzantine churches a partition covered with *icons which separates the sanctuary from the laity. The icons are arranged in tiers which, in ascending order, are as follows: (1) the Virgin Mary, Christ, and the saint(s) to whom the church is dedicated; (2) the Deisis ('intercession') with the Virgin and John the Baptist standing either side of Christ and accompanied by icons of angels, apostles, hierarchy, and other saints; (3) icons of the liturgical feasts; (4) the forefathers of Christ; (5) the highest tier shows icons of the prophets. There was also a smaller, portable version of the iconostasis, probably for use in military campaigns etc., which consisted of only three tiers, in ascending order: (1) Deisis; (2) liturgical feasts; (3) prophets and patriarchs.

ideal The concept, deriving from Plato's *Theory of Ideas*, of perfection which is only mirrored imperfectly in real life. This perfection was the ideal to which artists should strive. The concept was revived in the *Renaissance when artistic perfection was thought to be embodied in the surviving examples of *classical statuary. The pursuit of the ideal gained widespread credence in art *academies throughout Europe. The 17th-century biographer G. P. Bellori claimed the French painter Nicolas Poussin was the artist who most fully embodied the ideal.

ideal landscape A type of landscape painting, developed at the
beginning of the 17th century in Italy, in which nature is depicted as it
ought to be, rather than as it is. In this idealized state it is used as the setting
for subjects from *classical antiquity or the Bible. The compositions of such
pictures, populated by small-scale figures, are formally balanced, with a
carefully staged recession into the far distance. Annibale Carracci (1560–
1609) is generally credited with the invention of ideal landscape, which
found its greatest exponents in Claude Lorrain (1600/5–82) and Nicolas
Poussin (1594–1665). Ideal landscape was enormously influential on
European landscape painting in the 18th and 19th centuries and formed the
basis for the quadrennial *Prix de Rome for Historical Landscape, first
awarded in 1817 and not discontinued until 1863.

illuminated manuscript [From the Latin *illuminare*, used in the sense 'to
adorn'] a handwritten book, illustrated with images. Most of the
outstanding illuminated manuscripts were produced in the Middle Ages
and the *Renaissance. They were written on *vellum or *parchment until
the 14th century when paper began to be used for less sumptuous books.
Many of the great medieval manuscripts were intended for ecclesiastical
libraries, whereas in the Renaissance patronage became more secular. The
decorations of illuminated manuscripts are of three main types:
*miniatures or small pictures, incorporated into the text or occupying the
whole or part of the page; initial letters, either containing scenes
(*'historiated' initials) or decoration; borders, which may consist of
miniatures or decorative details, and which can often be amusingly
irreverent. The work of illumination was executed by specialist monks in
the Middle Ages, and then increasingly by professional artists in the
Renaissance. The last great illuminated manuscripts were produced in the
16th century.

illusionism The use of pictorial devices such as *foreshortening and
*perspective to heighten the illusion of reality in a picture. Specific
examples of illusionism include *quadratura, in which painted
architecture seems to extend the space of a room, and *trompe-l'oeil, in
which the artist tries to trick the spectator into thinking that something
like a painted fly on a picture frame is real. Another form of illusionism was
the *peep show popular in 17th-century Holland.

Imari The European name for a type of Japanese *porcelain made in Arita
and exported from the port of Imari. It is usually richly painted with the
characteristic palette of *underglaze blue, red, and gold, occasionally with
green, manganese, and yellow added. Although first exported in the late
17th century, Imari porcelain continued to be made until the early 20th
century. 'Japan' pattern, as it was known, was popular in England and much
copied and improvised, especially at *Worcester, *Spode, Masons, and
Royal Crown *Derby, where the richly decorated 'Imari' pattern remains a
favourite today.

imbrication Any decorative pattern composed of overlapping elements
arranged like shingles or roof tiles.

imitator of A cataloguing term used to denote a work of art that has been executed by someone seeking to imitate the style of a particular master, for example 'imitator of Rubens'.

imp. [An abbreviation of the Latin *impressit*, 'he/she printed [it]'] found on prints after the name of the printer, if different from that of the artist of the original design. *See* EXC.

impasto Paint, applied with the brush or the palette knife, which stands up above the surface to which it has been applied. *Impressionist paintings typically have thick impasto, for example, as did many of Rembrandt's paintings. Impasto is only possible with certain categories of paint such as oil and various types of *acrylic.

impost A member in a wall, usually consisting of a projecting bracket-like moulding, from which an *arch springs. *See* SPRINGER.

impresa An emblem used in Italy during the *Renaissance as a personal badge by princes, scholars, and other prominent persons.

impression An individual copy of a print, the quality of printing of which may give rise to the description of a 'good', 'fine', 'poor', etc. impression when the print comes to be catalogued or described.

Impressionism A movement in French painting, associated particularly with Monet, Pissarro, Sisley, Degas, and Renoir, characterized by the use of a bright palette, broken brushwork, and an emphasis on depictions of contemporary life and landscape. The term was originally coined as a form of satire by the critic Louis Leroy reviewing the first exhibition of the *Société Anonyme des artistes, peintres, sculpteurs, graveurs*... which opened on 15 April 1874, at the Parisian studio of the photographer Nadar on the boulevard des Capucines, and is nowadays referred to as the first Impressionist exhibition. Monet's painting *Impression: Sunrise* 1873 (Musée Marmottan, Paris) was singled out for particular attack, Leroy maintaining that the term 'impression' was too personal and should not have been used in a picture title (*effet*, i.e. an effect of nature, would have been preferable). In fact, 'impression' had a complex duality in 19th-century artistic theory, implying on the one hand the reception by the artist of the scene presented to him, on the other the subjective trace of the artist's own nature or temperament in the resulting work of art. The term 'Impressionist' rapidly went into widespread usage as a result of the 1874 exhibition and a further seven shows were staged, the last in 1886. There were a number of important contributory factors to the evolution of Impressionism: a growing interest in colour theory and the laws of complementary contrasts; an increasing liking, among landscape painters, for working en *plein air*; and a growing dissatisfaction with the official *Salon exhibitions where many of the young Impressionists experienced frequent rejection. By the time of the final 1886 Impressionist exhibition, many of the participants had begun to experience considerable success, lauded by avant-garde critics and increasingly patronized by enlightened collectors. It was in the 1890s,

however, that Impressionism really began to find its international market, especially in America (Britain by contrast was curiously slow to appreciate its merits). Paradoxically, it was also around this time that Impressionism began to be perceived, in certain right-wing religious circles in France, as the art of materialism, concerned only with the everyday. As a style it had become widespread, attracting a plethora of minor and repetitive adherents. Nevertheless, in the course of the 20th century Impressionism can fairly claim to have become the most widely popular of all movements with art lovers and collectors. *See* POST-IMPRESSIONISM.

imprimatura A coloured *ground or thin, coloured undertint applied over an outline or preliminary drawing.

incunabula [From the Latin *incunabulum*, 'swaddling band'] in the plural refers to books printed before 1501 in the very earliest years of printing.

Independent Group A group of artists formed in the early 1950s at the Institute of Contemporary Arts, London and first convened to hold exploratory meetings to discuss techniques. Its members included Richard Hamilton and Eduardo Paolozzi and from it originated the first phase of English *Pop art.

Indian red One of the artist's basic *pigments, Indian red is of a relatively deep brick hue with a bluish under-tone. Originally a native *earth imported from the East, since the 19th century Indian red has been a furnace product, usually made from steel-mill wastes.

indigo A deep blue *pigment which is not particularly colourfast, indigo was originally made from a natural dyestuff obtained from plants of the genus *Indigofera*, cultivated in India, and exported to Europe since Roman times ('Indian blue' is an old name for indigo). Indigo is now made synthetically from coal tar.

infra-red reflectography A photographic technique used to reveal *underdrawing in a painting which would otherwise be invisible to other investigative methods such as *x-ray photography.

inglenook A recess for seating, sometimes with a window, built in the *chimney-breast or adjacent to the chimney. Inglenooks were particularly popular in large period-revival houses of the 19th century.

ink A coloured fluid used for writing, drawing, and printing. The earliest inks from China and Egypt date from at least 2500 BC. They were usually black (lampblack) or red (red ochre) and were moulded, with glue or *gum as the binding agent, into dry sticks or blocks which were then mixed with water for use. Inks brought in such form from China or Japan were known in the West as 'Chinese' or 'Indian' ink, though these names are also given to a similar preparation made in Europe consisting of a dispersion of carbon black in water, usually stabilized by an alkaline solution. Printer's inks consist of *pigments mixed with oil and *varnish and are opaque.

Inkhuk [An abbreviation of Institut Khudozhestvennoi Kulturi, 'Institute of Artistic Culture'] an organization set up in Moscow in 1920 to determine the course of artistic experiment in post-Revolutionary Russia. Its first director was Kandinsky. Further sections were formed in Petrograd under Tatlin and in Vitebsk under Malevich. Kandinsky's ideals soon proved uncongenial to the more widespread desire to create an art suitable for a Communist utopia. After Kandinsky was voted out of office, two different programmes emerged. 'Laboratory art' involved a rationalizing, analytical approach often using traditional artistic materials (such as paint and canvas); 'production art', as its name implies, placed the emphasis more on designers and craftsmen working for machine production. The latter group proved the more influential of the two, contributing to the development of *Constructivism.

inlay A type of decoration which involves cutting small pieces of wood, *ivory, or precious metals and fitting them into carved-out recesses on solid wood furniture. It was replaced by *marquetry in the 17th century.

inro A Japanese *lacquer box divided into compartments for holding small objects, attached to a cord and worn over the belt (*obi*) of a kimono in place of a pocket, secured at the other end by a *netsuke. Decoration of very high quality was produced on inro in the 18th and 19th centuries.

Installation Installation art is an assemblage or environment specifically created for a particular interior (very often a gallery). The term came into common use in the 1970s but it was only in the 1980s that artists regularly specialized in this particular art form. Whereas early Installations were viewed as temporary, many are now intended to be permanent and are viewed as collectable. One well-known example is *20:50*, a piece by the British sculptor Richard Wilson (*b*.1953) which consists of a room filled with used sump oil (now in the Saatchi Collection, London).

insula A multi-storey Roman apartment building, the earliest examples of which appeared in the 3rd century BC and were probably produced in response to the increased population density. Many wood and mud insulae in Rome were destroyed by the fire of AD 64, later examples were of brick-faced concrete. Insulae were found in cities throughout the Roman empire.

Insular A term applied to the art produced in northern Britain and Ireland between the 6th and 9th centuries. Much of this art was Christian, inspired initially by the foundation in 563 of the monastery of Iona by St Columba, which served as a mission station for northern Britain. The great Gospel books, the Lindisfarne Gospels (British Library, London) and the Book of Kells (Trinity College, Dublin), were among the glories of Insular art, which also saw the production of much distinguished metalwork.

intaglio [From the Italian *intaglio*, 'carving'] in sculpture the term denotes a hollow or negative design which is usually cut into a *hardstone or metal die that, when pressed or stamped onto a soft substance, gives an impression or a positive relief, for example on early Mesopotamian

cylinders. In printmaking, intaglio refers to all metal-plate processes, such as *engraving and *etching, in which the recessed areas which have been created and then inked are printed from (as opposed to the raised areas of *relief printing or the flat surface adhesion of *planography).

intarsia [Italian, more properly *lavoro di intarsia*, 'inlay-work'] the inlay of woods of different shape, grain, and colour to form a pattern or picture. Sometimes *ivory or, more commonly, bone was added. Intarsia work was first developed in ancient Egypt and Mesopotamia and revived in Renaissance Italy for the decoration of choir stalls, etc. Paolo Uccello and Piero della Francesca were among the artists known to have designed intarsia panels, though the craft developed its own specialists such as Lorenzo and Cristoforo da Lendinara. Elsewhere in Europe intarsia developed into *marquetry, in which thin *veneers were laid side by side, as opposed to the inlay of intarsia.

interlace Decoration of intertwined lines, curves, and circles, particularly found in *Celtic art.

International Gothic A style manifested in the painting, sculpture, and *decorative arts of western Europe between *c.*1375 and *c.*1425. International Gothic was distinguished by its elegance and fascination with delicate, naturalistic detail. Its origins lay in the courtly style developed in France in the middle of the 13th century with its predilection for elongated and supple form and a new appreciation of sensuous qualities. This style was fused to the Italian interest in naturalism by the Sienese painter Simone Martini (*c.*1285–1344) who went to Avignon *c.*1340–41 to work for the papal court there. International Gothic first fully established itself in Franco-Flemish Burgundy with artists such as André de Beauneveu, Melchior Broederlam, and the Limburg brothers. From there it spread to northern Italy where it attracted artists such as Gentile de Fabriano and reached its most ornate achievement in the art of Pisanello.

Intimisme A term, first used in the 1890s, to describe the type of intimate, domestic *genre painting that developed from Impressionism in the late 19th and early 20th centuries and whose most celebrated practitioners were Pierre Bonnard (1867–1947) and Edouard Vuillard (1868–1940).

intonaco The final layer of plaster on which *fresco is painted. It is laid in sections (*giornate*) small enough to be painted on before they dry out.

intrados The underside of an *arch, also called a *soffit.

inv. (or invent.) [Abbreviation of the Latin *invenit*, 'he/she designed [it]'] sometimes inscribed below the main image of a print after the name of the artist who did the original drawing or painting on which the print is based.

investment The *mould applied to the original wax model in the *lost-wax process of making cast metal sculpture.

Ionic Order *See* ORDER.

iron A silver-white metal that goes a familiar dark red-brown on oxidization (rust). It has been used for the manufacture of sculptural tools such as chisels, drills, files, and hammers, and forged into various ornamental forms and hollow cast as sculpture. Cast-iron sculpture is particularly associated with ancient China, but was also popular in the 19th century in Britain, France, and Germany.

iron-gall ink An ink, first used for writing, made from a suspension of iron-salts in gallic acid obtained from the nutgall, a growth on certain oak trees caused by disease. Originally black, iron-gall ink turns brown with time as the acid eats into the paper with damaging results. Many drawings and manuscripts executed with this ink are, as a result, often extremely fragile. Iron-gall ink was originally used for writing, the first extant examples dating from around AD 200. The earliest iron-gall drawings are from the beginning of the 13th century. Most artists of the early Italian *Renaissance employed it for drawing. Many artists of the*Baroque era also employed it, such as Rembrandt and his pupils, the Italians Guercino and Pier Francesco Mola, and the Frenchmen Claude Lorrain and Nicolas Poussin. From a later period, much of Van Gogh's correspondence and many of his drawings were also executed with this ink.

ironstone An opaque and heavy glazed *stoneware, patented by the Masons' factory in Staffordshire in 1813. Stronger and more durable than *porcelain or *earthenware, it was used for dinner services and large vases or *garnitures. It was often decorated with an *Imari or Japan pattern.

Islamic art [Arabic *islām*, 'surrender (to God)'] art produced in the service of Islam, the monotheistic religion revealed to the Prophet Muhammad (d. 632) in early 7th-century Arabia, which quickly spread throughout much of Eurasia and Africa to become one of the major world religions. Islamic visual arts are decorative, colourful, and, in the case of religious art, non-representational. The Koran regulated every detail of the lives of the Faithful but gave few precise rules for the arts apart from banning the production of cult images. The characteristic Islamic decoration is the *arabesque, which is used in both architecture and objects. Some of Islam's greatest achievements lie in the *applied arts, particularly in the field of *ceramics where *lustreware represents Islam's most distinguished contribution. *Calligraphy also holds a special importance, as a central tenet of Islamic belief is that the written word is the medium of divine revelation. Islamic architecture is best exemplified in its mosques and related religious buildings, two of the greatest examples being the Dome of the Rock (691) in Jerusalem and the Great Mosque (705) in Damascus.

istoriato A style of decoration on Italian *maiolica pottery, in which a painted scene, usually of a mythical, historical, or biblical subject, covers the entire surface. In the 16th century *Urbino was the main centre for this style of decoration.

ivory An organic substance that has been used for some of the most highly prized small-scale sculptures in many civilizations. Its most frequent

sources are the tusks of elephants and the teeth of hippopotami, though it can also be obtained from walruses and the teeth of sperm whales. In colour it can range from rusty brown to white. It is shaped with tools generally associated with the woodworker. It has been used to make a very wide range of artefacts: Chinese seals, Japanese *netsuke, Moghul chess pieces, cups, statuettes, handles, historiated reliefs, and musical keyboards. In western religious art it is most closely associated with sculptures of the Crucifixion and the Virgin and Child. The latter were mainly manufactured in 13th-century Paris; the swaying elegance of the figure group exploited the natural curve of the elephant's tusk.

Iznik A *ceramic ware produced at Iznik in Turkey from the 15th century. The *clay body was covered with a white *slip, providing a background for strong designs and bright colours. Under Suleiman the Magnificent (1520–60) the pottery flourished, producing dishes, *ewers, lamps, and tiles, particularly for the mosques in Istanbul. Initially these were decorated with scrolls, *arabesques, and foliage; later stylized flowers were introduced, particularly carnations and tulips. By the 17th century standards declined and decoration became lifeless and repetitive.

Jacobean The style of architecture, interior decoration, and furniture which flourished in England during the reign of James I (1603–25); it was characterized by the blending of classical features such as the *Orders with *strapwork and other motifs from northern Europe.

Jacobite glass Wine-glasses engraved with decoration to show support for the Jacobite bid for the throne, first produced in 1688 and in large quantities after 1745. They were used for drinking loyal toasts, which was an act of treason. Glasses were engraved with Jacobite anthems or a variety of symbols, such as the rose with two buds (for the Old and Young Pretender), lily of the valley, daffodils, oak leaves, and moths. Glasses with this type of decoration have been extensively faked or the decoration added at a later date.

jade A semi-precious *hardstone that has been particularly associated with China, where it has been worked since before 3000 BC and where some of the most beautiful of all jade sculptures have been produced. It is a member of the tremolite-actinolite family of minerals and is found in pebble or boulder form. Extremely hard, it cannot be scratched with steel and has to be worked with abrasives. It is found in a range of colours (including white and brown), though in the popular imagination it tends to be most associated with green. Jade is also found in other parts of the world including North America, Mexico (where it was used by the Aztec civilization), and New Zealand, where it has long been known to the Maoris. Some of the most beautiful jade sculpture was produced in Moghul India.

jadeite Similar to *jade, but of a different structure (a sodium-aluminium silicate), it was mainly worked in China from the 18th century, for items of jewellery. It is also found in Mexico.

jamb The side of an archway, door-opening, or window that, properly speaking, is load-bearing; generally used to describe the vertical linings of such architectural openings.

Japanese prints *Woodcut prints produced in Japan from the 17th century. They were made by transferring the artist's original design on to a wood block, inking it, and printing it on to paper, with a different block being used for each colour, so building up the picture. The prints were created entirely by hand by a team of craftsmen, overseen and employed by a publisher. Artists such as Shunsho (1726–92) and Utamaro (1754–1806) were centred in Edo (modern Tokyo), and depicted images of beautiful women, courtesans, actors, and scenes from the Kabuki theatre, all known as *'Ukiyo-e', or 'Pictures of the Floating World'. During the 19th century artists including Hokusai (1760–1849) and Hiroshige (1797–1858) depicted landscapes and country life. After Japan opened up to trade with the West in

the 1850s, artists could not compete with western technical innovations such as photography, and the art began to die out. When the prints themselves arrived in Europe, with their fluent outlines, large areas of flat colour, and unusual compositions, they influenced a whole generation of artists including the *Impressionists.

japanning A name given to various methods of imitating oriental *lacquer, it was employed in the 18th century to decorate wooden objects such as boxes, trays, and small pieces of furniture. Using gum-lac, seed-lac, or *shelllac, dissolved in spirits of wine, many layers were built up, usually in black, red, or green. Gold decoration was added by applying *gum arabic and sawdust gilded with metal dust and then *burnished. *Chinoiserie was a popular style of decoration on japanned objects. Japanning could also be applied to metal items, such as trays, teapots, and *tea caddies. The tin-plated sheet iron was covered with black varnish and then decorated in gilt and colours.

japonaiserie A 19th-century European decorative style based on Japanese works of art. The opening up of Japan to western trade in the 1850s led to an enormous export of Japanese objects to Europe and their exhibition for the first time in London in 1858 and 1862. This stimulated a craze for anything Japanese, satisfied by the arrival of items such as prints, *inro, *netsuke, pottery, and metalwork. These works of art soon influenced designers and manufacturers to produce styles loosely based on originals. Artists of the *Aesthetic Movement produced many designs incorporating Japanese motifs, such as the *ebonized furniture of E. W. Godwin and the widespread use of fans, peacock feathers, oriental flowers, and exotic birds.

japonisme A French term, coined by the art critic Philippe Burty in 1872, to describe 19th-century European artists' interest in Japanese art, culture, and aesthetics. Many galleries and shops sold Japanese goods, including Liberty's in London (see LIBERTY STYLE). Influence of Japan can be seen in much French art of the later 19th century, such as the asymmetrical compositions of Edgar Degas and Toulouse-Lautrec, and the flat patterns and pure colours of Paul Gauguin.

jardinière [French] a stand for flower pots, usually made of metal but sometimes of wood or *ceramic.

jasperware A fine-grained *stoneware perfected by Josiah Wedgwood in 1775. Pure white, it was stained with colour, blue being the most popular. The earliest pieces were made in solid jasper, in which the colour was mixed with the body, later the colour was applied to the surface in the form of a 'dip'. Classical-style moulded decoration in white was applied to the surface of a wide range of objects, which included small plaques used for buttons, large plaques used in interiors or on furniture and ornate vases. Jasperware is still made by the *Wedgwood factory today.

jet A hard black fossil, related to coal, which can be polished. It is often worked into small ornaments and sometimes into sculpture, as for example

with the amulets, badges, rosaries, and statuettes of saints produced from the late Middle Ages onwards in northern Spain, especially in the pilgrimage centre of Santiago de Compostela. In the 19th century small items of jewellery made from jet were produced on an industrial scale, mainly in Whitby on the Yorkshire coast.

Jingdezhen The main centre in China for *ceramic production, in the province of Jiangxi in the south. It was here the Imperial wares were produced regularly from the beginning of the *Ming dynasty, at the end of the 14th century, although *kilns had been in operation before this time. The area is particularly rich in all the raw materials needed for *porcelain manufacture and production still continues today.

Jugendstil The German form of *Art Nouveau, based in Munich, which takes its name from the periodical *Jugend* (Youth), founded in 1896. The style was generally more restrained than the Art Nouveau found in France and Belgium, although influences included *Symbolism and an interest in nature. Leading designers associated with the style included Hermann Obrist and Richard Riemerschmidt. Obrist was noted for his *embroidery designs based on plant forms, with a strong use of the *whiplash curve for foliage and tendrils. Riemerschmidt was a furniture designer, influenced by the *Arts and Crafts Movement in England and contemporary Art Nouveau, and produced pieces in a simplified, restrained, and practical style. His most famous design, a chair first exhibited in Dresden in 1899, demonstrates his interest in formal and structural qualities. Both designers founded the *Vereinigte Werkstätten für Kunst im Handwerk* (United Workshops for Art in Handicraft) in Munich in 1897, to promote the production and sale of modern design.

Junk art Art which is composed from humble, worthless things and is deliberately anti-aesthetic, as opposed to the fine art tradition with its use of traditional materials. The term was first applied by the critic Lawrence Alloway to the *Combines produced in the mid-1950s by the American painter Robert Rauschenberg: these consisted of canvases to which Rauschenberg fixed rags, torn reproductions, and other waste materials. The concept of Junk art is ultimately rooted in *Cubist *collage and was later manifest in the work of Kurt Schwitters that he produced after the First World War, much of which was made from rubbish. Junk also played a prominent role in the *Environment Art and *Happenings of the late 1950s and early 1960s. *See* COMBINE ART.

Kakiemon The name given to a style of decoration on *porcelain, first practised by the Kakiemon family of potters in Japan in the mid-17th century. Working in Arita, a province in southern Japan, Sakaida Kakiemon and his two sons produced a fine, white, translucent porcelain which they painted with *enamel colours, usually iron-red, blue, green, yellow, and black. Vases, small bowls, and dishes were decorated with figures, birds, squirrels, flowers, bamboo fences, and symbolic animals, in a sparse and asymmetrical way, to enhance the white porcelain ground. During the 17th and 18th centuries these wares were exported to Europe, where they were much admired and imitated, especially at *Meissen, *Chantilly, *Bow and *Chelsea.

kantharos An ancient Greek drinking cup with two handles and a wide, footed bowl.

kaolin Fine white *clay, also known as china clay, which is an essential ingredient of true or *hard-paste *porcelain. It was first discovered in China.

keep The main tower or *donjon of a *castle, of sufficient size to serve as the chief living-quarters, particularly in time of siege. The largest keeps are English, for example the White Tower in London and that at Colchester, Essex.

kendi An oriental drinking vessel, usually of *porcelain, with bulbous body, tall neck, and bulbous spout, designed for drinking without touching the vessel to the lips.

Kent style The style of early 18th-century English furniture named after the architect and designer William Kent (1684–1748). As an architect, Kent adopted the severe *Palladian style of his patron, Lord Burlington. In contrast, his interiors and furniture were sumptuous, much influenced by Italian designs. Furniture was solid, richly carved, and gilt, with *scrolls, *festoons, and *putti, often supported by an eagle with outstretched wings or intertwined dolphins, or surmounted by shell motifs. Much of his furniture was designed as part of a unified decorative scheme, as at Houghton Hall in Norfolk (1726–30). Kent's designs were extremely influential during the first half of the 18th century.

keystone The central stone of an *arch or *rib vault, it is sometimes carved with a design.

kilim A tapestry-woven rug from the Islamic lands of western Central Africa, the Middle East, the Balkans, and North Africa. They are between two and five metres in length and one to two metres wide. The colours tend to be strong and bold and the designs angular, based on geometric shapes. Most surviving examples date from the 19th century or later, though

flat-weaving techniques had long traditions. Kilims only began to be studied in the West from the late 1960s onwards and are now popular items of interior decoration, often as wall hangings (though their original uses were many and varied).

kiln An oven used to bake or *fire *ceramics. Early *pottery was simply baked in trenches with brushwood. Proper kilns were developed later with the fire walled in to conserve the heat and using various forms and types of air circulation. The most popular design in Britain by the 18th century was the bottle oven or kiln, with its characteristic chimney, fired by coal. Unglazed pieces were stacked up in the kiln for the *biscuit firing, but once the *glaze was applied the wares needed to be separated to avoid the melting glaze sticking them together. During the *glost firing, kiln furniture, such as *stilts, spurs, and firing rings, was used to separate the glazed pieces or raise them off the shelves. A muffle kiln was used to fire *enamel colours on to pieces, protecting them from direct flames.

Kinetic art The word 'kinetics' comes from the vocabulary of science and was first used in the middle of the 19th century to denote the branch of dynamics concerned with the motions of bodies and the forces acting upon them, as opposed to 'statics'. 'Kinetic' entered the artistic lexicon in 1920 and refers to all forms of art in which movement appears to take place or actually does so. Movement can be in the object itself or in the eye of the viewer and is often induced by the effect of light. Kinetic art could take many forms including *automata, mechanical marionettes, and motion pictures. The widely differing pioneers of Kinetic art included Boccioni, Duchamp, the brothers Gabo and Pevsner, and Moholy-Nagy (for whom the painter was a co-ordinator of 'light-relations' and the sculptor one of 'voluminal and kinetic relations'). Later manifestations of Kinetic art have included structures concerned with light and electrically driven sculptures. A related development has been the more recent *Op art.

kingwood An orange-brown wood from the West Indies, with a striped figuring, used in the 18th century by French *cabinet-makers as a *veneer. It was also employed for *bandings on English furniture of the late 18th century. It is very similar to *tulipwood.

kiosk A light, usually free-standing roofed structure, often with open sides. The term derives from the Turkish *Kösk*, a free-standing palace structure. Today it is associated most frequently with more mundane structures such as ticket or telephone booths.

kitcat An English canvas size, measuring 36 × 28 inches (90 × 70 cm), particularly suitable for life-size head and shoulder portraits. The name derives from the series of portraits (now in the National Portrait Gallery, London) of the members of the Kit-Cat Club painted by Sir Godfrey Kneller (1646–1723) between c.1702 and 1721. The club originally met at a tavern near Temple Bar, London kept by Christopher Cat (or Kat) which was famous for its mutton pies known as 'Kit-cats'. Its members, predominantly Whigs, included the architect Sir John Vanbrugh and the portraits were

commissioned by the club secretary, Jacob Tomson, who in 1735 published a series of *mezzotints of the portraits.

Kitchen Sink School A group of British painters, the best known of whom was John Bratby, who in the years following the Second World War practised a form of social realism in their art which led them to concentrate on drab and sordid themes. A literary parallel was to be found in the plays of Arnold Wesker, Alun Owen, and other 'angry young men'.

kitsch [German, 'trash'] a term which first became fashionable in the early 20th century, continues to be widely used today, and is associated with vulgarity and a lack of taste such as are to be found in many tourist souvenirs and in works of art which exhibit similar qualities. In the later 20th century kitsch has been deliberately embraced by artists such as Jeff Koons in their all too obvious rejection of any notions of taste and rigour.

kore [Greek, 'maiden'; plural *korai*] a term applied to the draped standing female figure characteristic of the Greek *Archaic period. The male figure is known as a *kouros.

Korean pottery and porcelain Although strongly influenced by Chinese styles, the *ceramics produced in Korea have their own individual characteristics. The earliest *pottery, a hard grey *stoneware, dates from the 1st century BC. *Porcelain was made from the 10th century. A particularly fine *celadon ware was produced during the 12th century, with inlaid decoration in black and white, applied with great subtlety. Blue and white porcelain was made from the 15th century, but only for the Korean Royal Household. After a period of turbulence in Korea in the late 16th century, when many potters moved to Japan, the industry was re-established and large blue and white jars were a speciality. Korean ceramics often appear crude compared to the refined Chinese porcelain of the same period, but the 'hand-made' quality and free decoration has great appeal.

kouros [Greek, 'young man'; plural *kouroi*] a term applied to the standing male nude statues typical of the *Archaic period. A female figure is known as a *kore. The earliest examples date from around 600 BC, their rigid, frontal poses exhibiting the influence of *Egyptian art.

kraak A type of Chinese blue and white *porcelain produced during the late *Ming and early Qing dynasties, decorated with panels of repeating designs. 'Kraak' is the Dutch word for 'carrack', a Portuguese galleon trading with the East Indies, one of which was captured in 1603 carrying porcelain of this kind. Kraak was the first Chinese porcelain to reach Europe in large quantities and was much imitated at *Delft.

krater An ancient Greek vessel for mixing wine and water, with a hemispherical body and wide mouth.

Kufic script A type of Arabic script which is particularly suitable for use as architectural decoration on account of its angular shape. Sometimes a

meaningless series of letters was used for purely decorative effect and this practice found its way into *Romanesque and *Gothic art.

Kunstkammer [German, 'art chamber'] first used in the mid-16th century to describe princely collections of paintings, precious goblets, games, and natural history specimens. By the end of the century the concept was widespread throughout the German courts. Its origins can be traced to the study collections of late 14th-century French courts and religious institutions. Such all-embracing collections were perceived to promote wisdom (*sapientia*) in kings and leaders. In the 15th century outstanding study collections were established in many Italian courts such as those at Urbino and Mantua, which differed from their French counterparts by having a stronger artistic and aesthetic content (for example an interest in small *bronzes). One of the finest of all Kunstkammern was that established by the Habsburg Emperor Rudolf II in Prague Castle which included works of art by Dürer, Correggio, and Titian, in addition to commissioned works from goldsmiths, clockmakers, and stone-engravers. Such collections, ordered and classified, were forerunners of the modern concept of a *museum collection. *See* CABINET PICTURE; WUNDERKAMMER.

Kutani Japanese *porcelain made at Kutani in the 17th and 18th centuries, but the name also applies to 19th- and 20th-century wares in the same style, characteristically decorated in iron red and gilt on a white ground.

kylin A Chinese mythical beast with the head of a dragon, scaly body, hooves, and a bushy tail.

kylix An ancient Greek drinking cup with a wide, shallow-footed bowl and two horizontal handles.

L

labbretto [Italian, 'little lip'] a stylized leaf contour with turned-back tips, used to decorate the *sight edge, found on certain 18th-century Bolognese picture frames. Its scalloped contour picks up light and diffuses it in a flickering manner, entirely appropriate to the *Rococo and the work of painters such as the Gandolfi.

laboratory art *See* INKHUK.

lace A decorative openwork fabric, usually made of *linen, but sometimes also of gold or silver thread. Lace first appeared in Italy and Flanders in the 15th century and has been employed for liturgical vestments and for cloths for both ecclesiastical and domestic use. *See* NEEDLEPOINT; PILLOW LACE.

lacquer Distinguished by its hard, shiny surface, lacquer is most commonly associated with the bright, clear (though it can be coloured) *varnish applied in several layers to oriental wares and their western imitations. True lacquer is derived from the sap of the *rhus vernicifera*, a tree found in China, and later in Japan. The first plastic known to man, it polymerizes on exposure to air. It can be carved in sculptural form and small lacquer objects from China are known from as early as the 4th century BC. A wide variety of lacquered objects such as boxes, screens, and vases were imported into Europe from Japan and China from the 16th century onwards. Another type of lacquer, known as *shellac, is produced from the secretion of the lac insect *Coccus lacca* found in India. It was widely used in European imitations of lacquer in the 17th, and more particularly the 18th century.

lady chapel A *chapel dedicated to the Virgin, usually built east of the *chancel and projecting from the main building. English lady chapels are normally rectangular in shape, a particularly fine example being that at Ely Cathedral.

laid paper *Paper which has been made in a wire mould of mesh intersecting at right angles and thus leaving its mark in the form of chain lines on the paper surface. This was the standard method of manufacture for older, hand-made papers. *See* WOVE PAPER.

lake A *pigment made by precipitating or developing a dyestuff on an inert pigment. All the older pigments made in this way are still called lakes. The word may be derived from the Italian *lacca*, a term used by medieval dyers for the scum they removed from their dye vats and sold to painters. Lake making goes back to Egyptian and Greek antiquity.

lambrequin A *Baroque ornament used in France, resembling lacework or tracery. It was used by *faience potters, particularly in Rouen, in the late 17th century.

lamé A textile with a *weft of metallic yarn.

lancet A slender pointed-arch window, used particularly in *Early English architecture from the late 12th to the mid-13th centuries.

Land art A form of art practised since about 1967 by a group of American artists (including Walter de Maria, Carl Andre, and Robert Smithson) in remote parts of the world such as the Sahara, the Mojave desert, or the dried-up Lake Mirage in California. Protesting against what they perceived as the utilitarianism of much contemporary art, they used the land itself as their raw material, digging trenches in it, drawing lines by spreading lime on the earth, or making mounds of rocks.

lantern A small structure, circular or polygonal in shape, and with windows for the admission of light, placed at the top of a roof or *dome, or at the *crossing of a church.

lapis lazuli A *semi-precious blue stone used for jewellery; also the original raw material of the ultramarine blue *pigment which was highly prized in the *Renaissance and on occasion specified by patrons in their contracts with artists.

Latin cross A cross with three short and one long arms.

latten An *alloy resembling *brass which is used in monumental work.

lattice A perforated panel or network of strips used as a screen, particularly associated with *chinoiserie.

lattice window A window with diamond-shaped leaded *lights or with glazing bars arranged like an open-work screen. Also loosely used to describe any hinged as opposed to *sash window.

lay figure A movable model of a human figure which is used by artists as a substitute for a living model. The best lay figures are made of wood with all of the joints articulated. Although movable dolls and marionettes were known in antiquity, the first description of an artist's lay figure is given in the third book of Filarete's *Treatise on Architecture* (1461–4). Early lay figures were small in size, but 18th-century portrait painters used life-size ones on which they would arrange the costume and drapery in the absence of the sitter.

lead A heavy, base metal of a dull grey colour, it was added to *bronze alloys used for sculpture by many ancient civilizations including the Chinese, the Etruscans, and, most especially, the Romans. Metal sculptures of which lead was the main constituent were made in 18th-century Austria. Lead had also been used since the 16th century for the manufacture of fine *medals.

lead crystal *Glass made using a large proportion of lead oxide, first made by George Ravenscroft in England in the late 17th century. It was heavy, usually of a greyish colour, and was the main type of glass produced in England after this date.

lead glaze A transparent *glaze, applied to the surface of *earthenware, to provide a shiny surface and to protect the *body beneath. After an initial *biscuit firing, the glaze, using lead oxide as the *flux, was applied to the vessel and fired again at a lower temperature, when it melted on to the surface. Lead glaze was widely used in the Middle Ages and could be coloured brown or green with the addition of copper oxide. Later the clear, colourless glaze was used to cover painted decoration. As fumes of lead proved dangerous to workers, lead glaze was rarely used after the early 19th century.

lead pencil The modern lead pencil was introduced in 1795 and is a writing or drawing tool consisting of a thin rod made from a mixture of *graphite, fine *clay and *binder, which is encased, either in lacquered red cedar, or in a mechanical pencil holder. It is normally available in seventeen grades of hardness, ranging from 9H to 6B (the softest, containing practically no clay).

leadpoint *See* METALPOINT.

lead white The most important of all lead *pigments, it is the basic carbonate of lead. Known since early times, it was one of the first artificially prepared pigments.

lectern The reading-desk in a church, usually made of wood or *brass but sometimes of stone or *marble.

letterpress Book printing from a relief press using individual letters which have to be set in place. It has recently been superseded by photo-typesetting and offset *lithography.

liberal arts According to the canon of *classical antiquity, the seven 'liberal' arts comprised arithmetic, astronomy, geometry and music (the theory as opposed to the practice), grammar, rhetoric, and logic. All seven were subordinate to philosophy, the supreme art. The liberal arts were deemed to be exercises of the intellect and therefore placed on a far superior level to such 'vulgar' achievements as practical skill and craftsmanship. The visual arts were only raised to the status of a liberal art in the *Renaissance. This elevation came about as the result of the efforts of figures such as Alberti, Ghiberti, and Leonardo da Vinci, who argued that the true visual artist was a creative thinker imbued with a proper knowledge of subjects such as mathematics. This concept gradually gained currency in other countries and led to the establishment of artists' *academies.

Liberty style The *Art Nouveau style named after the department store Liberty, founded by Arthur Lazenby Liberty (1843–1917) in 1875 in Regent Street, London. The name Liberty became synonymous with advanced design and influenced the spread of the Art Nouveau style throughout Europe. A successful trader and entrepreneur, Liberty began by importing Persian, Chinese, Indian, and Japanese artefacts to fill up his store. By the end of the 1870s he started to commission work from leading *Arts and

Crafts designers, including textiles and fabrics from C. F. A. Voysey, eventually stocking a wide range of metalwork, *glass, jewellery, furniture, and clothing, by designers such as Christopher Dresser, E. W. Godwin, and C. R. Ashbee. From 1894, Liberty produced its own range of Art Nouveau-style *silver, named 'Cymric', and from 1903, *pewter, named 'Tudric', decorated with Celtic-style ornament and adorned with panels of *enamel. Liberty opened a shop in Paris in 1889 which helped to disseminate the Art Nouveau style throughout Europe. In Italy, the style became known as *Stile Liberty. The store is still in existence today, in its original Regent Street location.

lierne A *rib in a *vault which starts neither from a *springer along the wall nor from one of the main *bosses.

lift-ground etching Another name for *sugar aquatint.

Light art A general term for works of art in which artificial light (usually electric) plays an important role. Although artists had experimented with artificial light since the 18th century, it was not until the 1960s that Light art could claim to be a recognized movement and there was widespread use of fluorescent and neon lighting, lasers, and holography. Several important exhibitions of Light art were held in both Europe and the United States.

lights Openings between the *mullions of windows.

limestone A stone chiefly composed of calcium carbonate. It is mainly used for building, but also sometimes for sculpture. Limestone that can be polished is often incorrectly called *marble.

limewood A soft and pale wood used for sculpture in parts of Europe, particularly in Bavaria, Swabia, and Austria. The most famous of the so-called 'limewood sculptors' was Tilman Riemenschneider (c.1460–1531).

limited edition A set number of a multiple work of art such as a *print or a sculpture cast in *bronze. The limiting is usually more to do with the maintenance of a certain commercial exclusivity rather than any concern with possible diminution of quality resulting from a large edition.

limner [From medieval Latin *illuminare*, 'to paint'] a word for a painter that has had various meanings. In the Middle Ages it denoted a painter of *illuminated manuscripts, and from the 16th century it referred to painters of *miniature portraits (such as Nicholas Hilliard). A third meaning came about in 17th- and 18th-century America where it referred to itinerant and anonymous painters, very often portraitists.

Limoges enamel A school of *enamel painters which began in Limoges, France, in the mid-12th century and flourished until the 14th, using the *champlevé technique. It became the main centre for ecclesiastical enamels, producing large numbers of crucifixes, candlesticks, and *reliquaries for use in churches throughout Europe. In the late 15th century and throughout the 16th Limoges was the focus for painted

enamels, producing particularly fine work in the *Mannerist style. All kinds of Limoges enamels were extensively faked in the 19th century.

Limoges porcelain Limoges has been the main area for *porcelain production in France since the 18th century, when the ingredients for making *hard-paste porcelain, *kaolin and *petuntse, were discovered nearby in 1768. Porcelain began to be made in the town, and for a short while plain white wares were supplied for decoration at the *Sèvres factory. After the French Revolution a number of factories were established and Limoges remains the most important area for porcelain in France today.

linear perspective *See* PERSPECTIVE.

linen A *textile woven from treated stalks of the flax plant. First known in ancient Egypt, the fabric was particularly good for *lace and household textiles, the best being produced in Germany and the Low Countries in the 18th century.

linenfold A representation of *linen laid in vertical folds, of Flemish origin in the 15th century and used by Tudor woodcarvers, mainly for decorating panelling, doors, and chests.

lining The fixing of a fabric (traditionally a fine *linen *canvas) to the back of a canvas picture for the purposes of strengthening it if it has been damaged or stucturally weakened. The majority of older pictures have been lined. Adhesion is achieved by a mixture of heat and glue or wax. The paint surface of a picture is inevitably somewhat 'flattened' in the course of lining and this is the main drawback of the whole process.

lino-cut A relief print cut in linoleum, similar to *woodcut. It was first used early in the 20th century and was taken up by Matisse in the late 1930s, and by Picasso, the majority of whose lino-cuts date from the late 1950s. Its cheapness and ease of use have meant that it has found particular popularity with *amateurs and schools.

linseed oil The principal drying oil used in *oil paints, it is obtained from the seeds of the flax, the same plant that furnishes linen fibre.

lintel A horizontal beam over an opening used to support the wall above it.

lithograph A *planographic method of printmaking based on the antipathy of grease and water. Invented in Munich in 1798 by Aloys Senefelder, lithography involves drawing or brushing the design with a greasy, lithographic ink on to a specially prepared and smoothed limestone which is kept moist. The stone (lithography means 'drawing on stone') is then inked with lithographic ink which only adheres to those areas of the stone previously fixed with lithographic ink, the rest of the ink is repelled by the water. The stone is then printed from in a flat-bed lithographic press. Lithography was particularly popular in Germany, France, and England in the early to mid-nineteenth century for reproducing topographical

drawings and watercolours in publications devoted to landscape. It also attracted some of the great masters of *Romanticism such as Delacroix and Géricault. Later in the century it was taken up by a number of the most distinguished French artists including Manet, Redon, and, above all, Toulouse-Lautrec. Lithography was used throughout the 20th century by some of the most distinguished artists including Braque, Picasso, and Miró. It should be remembered, however, that the actual production and supervision of printing lithographs is normally undertaken by specialist printers and not the artists themselves. Original drawings could be made by the artists in lithographic chalk or ink on a sheet of transfer paper which could be laid down by the printer on to the printing surface and the design transferred. Alternatives to limestone as a printing surface included zinc (from about 1830) and aluminium (from about 1890). A recent development, offset lithography, involves the picking up of the design by a rubber roller from the original lithographic stone or plate. Large print-runs can then be easily and rapidly made from the roller and, because the original image has been 'reversed' twice, it prints the right way round. Offset lithography has all but replaced the traditional technique of *letterpress for book printing. Lithographs printed in a combination of different colours are known as *chromolithographs.

lithophane A *porcelain panel moulded with a scene in relief, often after a famous painting, which was visible when held against a strong light. Usually white, they were made in panels and used in lampshades, hand screens, candle shields, and children's night lights. The technique was invented by Baron de Bourgoing in 1827 and first manufactured at *Meissen in 1828. Lithophanes were also produced at the *Berlin, *Minton, Copeland, and Grainger's Worcester factories.

Little Masters [German, *kleine Meister*] the name, possibly first used by Joachim von Sandrart in 1679, given to a group of German artists active in the first half of the 16th century who produced a wide range of small-scale, intricately worked prints, nearly all of which were *engravings. The most famous members were the brothers Sebald and Barthel Beham, and Georg Pencz. All three belonged to the generation immediately following Albrecht Dürer in Nuremberg. When used in a broader sense, the term 'Little Masters' may also embrace other engravers of that period who also produced small format prints including Jakob Binck, Master I.B., and Heinrich Aldegrever in Germany, and Allaert Claesz and Dirk Vellert in the Low Countries.

Liverpool porcelain The general term for the products of several small *porcelain factories in Liverpool in the second half of the 18th century. The manufactories included those founded by Richard Chaffers (1754–65), Samuel Gilbody (c.1755–61), Philip Christian (1765–78), and Seth Pennington (1778–c.1800). There are few contemporary records so it is often difficult to attribute wares to a particular factory.

Liverpool pottery Pottery, particularly *delftware, produced in Liverpool from the 18th century. Large punch bowls were a speciality, often

painted in blue with a ship and motto. *Creamware was made from the end
of the 18th century at the Herculaneum factory.

local colour The 'true' colour of an object or area when seen under
normal daylight conditions, without allowance for the modifying effect of
factors such as distance or reflections from other objects. For example, the
local colour of a typical grass field is green, though at a certain distance it
may appear blue on account of *aerial or atmospheric perspective.

locutory A place in a *monastery where talking is permitted.

loggia A part of a building where one or more sides are open to the air, the
opening being *colonnaded or *arcaded. Normally it is an open gallery or
an arcaded or colonnaded large recess at ground floor or *piano nobile
level.

Lombard style Architecture of the *Romanesque period in northern
Italy. It was revived in the 19th century.

London Group An exhibiting group of British artists, founded in 1913.
They embraced a broad church and were initially formed from an
amalgamation of the *Camden Town Group and various smaller groups and
individuals. They were soon joined by *Futurists and *Vorticists and the
first group exhibition was held at the Goupil Gallery, London in 1914,
where the most impressive work on show was David Bomberg's *Vorticist
In the Hold (Tate Gallery, London). Although the founding premise of the
London Group had been a protest at the perceived conservatism of the
Royal Academy, it too lost its reforming edge and less avant-garde artists
soon joined, including many members of the *Bloomsbury Group. The
London Group still exists and continues to hold exhibitions.

long gallery A very long room with high ceilings, often extending the
length of an *Elizabethan or *Jacobean house, and used as a gallery,
promenade, and multi-purpose space.

Longton Hall porcelain. The first *Staffordshire factory to make
*porcelain, Longton Hall was founded in 1749 by William Littler, a *salt
glaze manufacturer. It made eccentric and slightly primitive wares,
including a range of fruit and vegetable-shaped tureens. In 1760 the factory
closed and Littler moved up to Scotland and started another porcelain
factory at West Pans, near Edinburgh.

loo table A large Victorian card or games table, usually circular in form.

lost-wax casting [French, *cire perdue*] the most common method of
making cast metal sculpture, it has been known since ancient times and
had been brought to a high level of technical sophistication by the ancient
Greeks as early as the 5th century BC. The original model is made in wax
and is then encased in a clay *mould known as the *investment. This is
then heated up and the wax poured away leaving a hollow interior, the
inside surface of which carries a negative impression of the original wax

model. Molten alloy, such as *bronze, is then poured into the mould and allowed to cool. The clay mould is then broken and removed, leaving an alloy replica of the original wax model. This is the lost-wax process in its simplest form, used to produce a solid metal sculpture. However, most lost-wax casting is more sophisticated and produces a hollow sculpture, the advantages of which are that less metal is used, the sculpture is lighter, and the problem is avoided whereby solid metal sculpture can be prone to cracking in the casting process. The necessary extra element in hollow lost-wax casting is a *core, usually made of clay or plaster with *grog, placed inside the original wax model. When the core, wax, and outer mould are heated up and the wax runs out a hollow sandwich is created into which the molten alloy is then poured. After cooling the outer mould and core are removed leaving a hollow metal sculpture. In the process metal pins called *chaplet pins are used to keep the core in place. The original wax model would also have been fitted with wax 'branches' extending out through the clay mould. These create channels into which the molten alloy is poured during the casting process. These channels are also cast, of course, and have to be removed from the surface of the sculpture once it has cooled down after the casting process.

Louis XIV style The term used to cover the arts in France in the period associated with the reign of Louis XIV (1643–1715), especially after he assumed direct personal control in 1661. The prototype for Louis's all-embracing unity of architecture, painting, interior decoration, and landscape gardening could be found at the *château of Vaux-le-vicomte, created in the 1650s for Nicolas Fouquet, *Surintendant des Finances*. The three major figures who had worked there—architect Louis Le Vau, garden designer André Le Nôtre, and painter and designer Charles Le Brun—were engaged by Louis to transform the King's hunting-lodge at Versailles, just to the west of Paris. The massive complex developed at Versailles became a major statement and display of monarchical power and magnificence. It was characterized by sumptuous materials, exquisite craftsmanship, a profusion of classical motifs, and strict formality of organization. A desire for symmetry and axial planning determined the layout of the gardens and interiors. Ceilings were painted with allegorical or mythological scenes glorifying the Sun King (as Louis became known). Furnishings were on a grand scale and tapestries were extensively displayed, sometimes hung above a marble *dado. Strict control and the exactingly high standards of the royal manufactories ensured that France became pre-eminent in the arts of design and decoration during this period and the example of Versailles was imitated by other European monarchs.

Louis XV style A term used primarily in France to describe the decorative arts and interior decoration produced in the period c.1700–c.1750, roughly corresponding to the Régence (1715–23) and the first half of the reign of Louis XV (1723–74). In contrast to the large-scale magnificence of the Versailles of Louis XIV, the era that followed was more informal and

intimate and suited the interior decoration of *petits appartements* in the *hôtel particulier*. Attention was focused on carved *boiseries in the *Rococo style and on incorporating features of *chinoiserie and *singerie. The influence of the Louis XV style diminished after 1750 when it fell out of favour with the onset of the taste for the severer style of *Neoclassicism.

Louis XVI style A term that loosely refers to a decorative style that first emerged in France in the 1750s and was fully developed by the time Louis XVI ascended to the throne in 1774. Essentially it consisted of a preference for more classical ornament after the decorative frivolity of the *Louis XV style. This was stimulated by the excavations at Herculaneum and Pompeii and the numerous publications on antiquity which followed.

Lowestoft porcelain The *porcelain factory founded *c*.1757 in the small Suffolk fishing port of Lowestoft. It first produced blue and white wares, then pieces decorated in the *Chinese export porcelain style in the *famille rose palette. Although a long way from the fashionable marketplaces and out of touch with changing tastes, the factory survived nearly fifty years.

Luminism A term with three different meanings. The first describes an aspect of mid-19th-century American landscape painting in which the effect of light and atmosphere was paramount. The second is as an alternative term for *Light art. The last is as a name for *Neo-Impressionism in Belgium, derived from the group Vie et Lumière, founded in 1904.

lunette In architecture a semicircular opening framed by an *arch or *vault, the term can generally be applied to any flat, semicircular space. In painting it denotes the semicircular part of a picture with a rounded top.

lustre An iridescent decoration applied to the surface of *ceramics, using a metallic film. Oxides of metals, such as *silver and *copper, were dissolved in acid, combined with an oily *medium, and then painted on to glazed wares. These were then fired, at a low temperature, leaving a metallic film on the surface which, when burnished, became iridescent. This technique was first developed in the Middle East in the 8th century and used throughout the Islamic world. From there it spread to Spain, where lustre was used extensively on *Hispano-Moresque pottery, and then to Italy, where it was used on *maiolica in the early 16th century, particularly at *Deruta and *Gubbio. By the 18th century, an easier and less subtle process was developed in England, using platinum, for a silver surface, or *gold, for a pink surface. The original technique was revived in the late 19th century by William de Morgan. Lustre is also the name given to a vase with cut glass drops hanging from the rim.

Lyrical Abstraction A somewhat vague term used by various writers to describe a type of expressive, but non-violent abstract painting which flourished chiefly in France in the 1950s and 1960s.

Macchiaioli A group of painters working in Florence *c*.1855–65, their name derived from the Italian *macchia* 'stain, blot', referring to the patches of bright, fresh colour they used in their paintings. Influenced by painters such as Corot and Courbet, they represented an important trend in the development towards *naturalism in Italian painting. Prominent members of the group included Giovanni Boldini, Giovanni Fattori, and Telemaco Signorini.

machicolation A *gallery or *parapet built on the outside of fortified walls and towers of *castles with openings in the floor through which to drop boiling oil or molten lead or to shoot arrows.

macramé [Turkish *macrama*, 'towel'] a knotted fringe similar to those found on traditional Turkish towels. By extension a technique of knotting derived from this, and used to create a variety of craft objects.

maculature An impression of a *print taken with a clean sheet of paper from a printing block or plate to remove any traces of ink left on it.

madonnero A term of Venetian origin, mainly used between the 15th and 18th centuries to denote a painter who specialized in images of the Virgin. Such artists, many of whom were anonymous, worked in an old-fashioned, pseudo-*Byzantine style.

maestà The Italian term for 'majesty', it is used to describe a representation of the Virgin and Child in which the Virgin is enthroned as the Queen of Heaven, surrounded by a court of saints and angels. Perhaps the most famous Maestà is the great, multi-panelled *altarpiece of 1308–11 by the Sienese painter Duccio, now dismembered but preserved for the most part in the Opera del Duomo of Siena Cathedral.

Magic Realism A style of painting popular in Europe and the USA between the 1920s and 1940s, with some followers in the 1950s, it occupied a position somewhere between *Surrealism and Photorealism— photographic realism was mixed with flat tones, ambiguous perspectives, and strange juxtapositions. The term was introduced by the art historian Frank Roh in his book *Nach-Expressionismus: Magischer Realismus* (1925).

mahlstick (or maulstick) A wooden stick used by a painter to steady his hand when painting detailed parts of a composition. It usually has a ball-shaped end made of soft leather to minimize the risk of damage to the painting.

mahogany A rich, brown, close-grained wood from Central America and the West Indies. It was imported for furniture making in the early 18th century and became very popular with *cabinet-makers, particularly in

England, both as a solid wood and as a *veneer. It was used extensively during the *Victorian period, when it was usually polished to a red colour. Today a more natural finish is preferred.

maiolica *Tin-glazed *earthenware made in Italy during the *Renaissance. The name derives from Majorca, the island from where much *Hispano-Moresque tin-glazed pottery was imported to Italy in the 15th century. The technique of covering earthenware with a tin glaze was similar to that used for *delftware and *faience elsewhere in Europe. The opaque white ground set off the brilliance of the brightly coloured, pictorial decoration characteristic of maiolica. Many of the designs in this *istoriato style were based on Renaissance prints and some of the finest pieces can be attributed to particular artists. The main maiolica potteries were located at *Castel Durante, *Deruta, *Faenza, *Gubbio, *Urbino, and Venice. By the 18th century maiolica was superseded by *porcelain and *creamware, but it still flourished in Castelli and the Genoa area.

maison de plaisance [French, 'country house'] a term used during the 18th and 19th centuries to describe rural and suburban houses designed as retreats for the wealthy and the nobility. A typical example was the Petit Trianon (1762–8) at Versailles designed by Ange-Jacques Gabriel for Louis XV.

majolica The name, derived from *maiolica, given in the 19th century to a type of *earthenware covered with thick, brightly coloured *glazes. It was first produced by the *Minton factory and shown at the Great Exhibition in London of 1851 and became much used for large, naturalistically modelled objects, such as *jardinières, tureens, umbrella stands, and even fountains. Majolica was made by other English factories, such as George Jones, Copeland, and Royal Worcester, during the second half of the 19th century, as well as in America.

malachite A banded green ornamental stone, available in large quantities from Russia; it has been much used as a *semi-precious stone in jewellery.

mandorla [Italian, 'almond'] an almond-shaped aura or series of lines surrounding the body of a divine personage, most frequently Christ in post-Resurrection scenes (notably the Transfiguration) when He is seen in His heavenly glory.

manière criblée *See* DOTTED MANNER.

Mannerism A confusing term, subject to radically different interpretations but generally used to describe the art in Italy which directly succeeded that of the *Renaissance and preceded the *Baroque. Its first widespread use, in the 17th century, was pejorative, implying an over-elaborate distortion, an imbalance, and a neurosis first discerned in the later work of Michelangelo and in the followers of Raphael. 'Typical' Mannerist painters were artists such as Parmigianino, with his elegant elongation of the human form, and Pontormo, whose compositions exhibit a disturbing psychological tension. This essentially negative view held sway

until the mid-20th century when John Shearman propounded an alternative theory whereby *maniera* ('style' in English, originating in French *manière* and borrowed from the French courtly literature of manners) should be equated with skill and the overcoming of difficulty. He cited impressive historical proof of the positive connotations of the term: a sonnet of 1442 listing *maniera* among the heaven-sent gifts of Pisanello, Vasari (1552) including it as one of the five qualities which made his century, the 16th, superior to the preceding one. Although 'Mannerism' is mainly applied to Italian art, there was also 'Northern Mannerism', used to describe the work of north European artists such as Goltzius, Uytewael, and Spranger active in the late 16th and early 17th centuries, whose twisting, intricate compositions reached a large audience through the highly accomplished prints made after them by printmakers such as Müller and Sadeler. Many of these artists worked from the 1580s onwards for the Emperor Rudolf II at his court in Prague.

mansard A roof with a double slope, the lower one being steeper and allowing rooms to be built within it. Named after the French architect François Mansart (1598–1666).

Manueline A Portuguese style of architectural decoration, named after Manuel I with whose prosperous reign (1495–1521) it roughly coincided. A mixture of *Gothic, Moorish, *Renaissance, and possibly Indian influences, it was characterized by richly encrusted carved ornamentation, the most common feature being a twisted rope motif, used for *tracery, *vault ribs, *columns, etc. The style also spread to the *decorative arts.

maquette [French, 'model' or 'sketch'] the preliminary idea for a sculpture in the form of a wax or clay model, to be shown to a prospective client or to be entered in a competition for a prize or scholarship.

marble Much used for sculpture, marble is a metamorphic rock, that is one that has been subjected to great heat and changed its crystalline structure in the process. White marble has been quarried in many parts of the world, but the most famous is that from Carrara in the Apuan Alps in Italy. It was used in antiquity and much favoured in the *Renaissance, especially by Michelangelo. The *Neoclassical sculptor Antonio Canova (1757–1822) was also attracted by its purity. Many forms of hard *limestone are incorrectly termed marbles.

marbling A painted effect, in imitation of *marble, on wooden surfaces such as skirting boards or plinths. It also denotes free, swirling, coloured patterns produced on paper, most commonly the endpapers of books.

marouflage [From the French *maroufler*, 'to stick down'] originally referred to murals on canvas attached to a wall with white lead as the adhesive. However, the term is more commonly used to describe the sticking down on to canvas of oil sketches on paper, particularly landscape sketches of the *Neoclassical French School by masters such as Pierre-Henri de Valenciennes (1750–1819).

marquetry A type of ornamental *veneer, in which shaped pieces of wood or other materials create a mosaic, usually forming floral, landscape, or arabesque patterns. If the design is geometric it is called *parquetry. Marquetry differs from *inlay, where a cut-out recess on solid furniture is filled with decoration.

marshalling In *heraldry, the proper arrangement of armorial bearings to denote rank and condition, connection by marriage, or representation of families. Most marshalling consists of a combination of two or more *coats of arms.

Martinware The name given to the type of pottery produced in the late 19th century by Robert Wallace Martin and his three brothers, Charles, Walter, and Edwin at their studio in Southall, Middlesex. Robert trained at the Lambeth School of Art and, as well as working for Doulton, he also undertook some stone carving for the Houses of Parliament, which gave him a taste for the *grotesque. With his brothers he set up a studio in 1877; they worked as a team, designing, making, and decorating their own pieces, in the spirit of the *Arts and Crafts Movement. Using *salt-glazed stoneware they produced models and vessels of medieval inspiration, especially grotesque bird jars, with removable heads, and jugs decorated with faces. Their studio closed in 1914, but their techniques and methods of working show them to be precursors of 20th-century *studio potters.

Marxist art theory Derives from the writings on social theory of Karl Marx (1818–83) and his associate Friedrich Engels (1820–95). Elaborating on his fundamental critique of capitalism (*Das Kapital*) and his belief in the value, both social and economic, of labour, Marx set down in his scattered writings on the subject the proposition that art should not, by circumstances of demand, be concentrated in certain individuals (such as Raphael), but should be democratized. 'In a communist society, there are no painters, but at most men who, among other things, also paint'(*Die Deutsche Ideologie*). This view, with considerable and varying modifications, has exerted considerable influence in the 20th century, most particularly in the development of the study of the social history of art and, more recently, of the *New Art History.

mascaron A decorative *grotesque mask, usually found over a door or a fountain.

mason A craftsman who builds in stone or brick. Until the 18th century a mason also designed buildings and performed the functions that in modern times would be divided between architect, contractor, engineer, and builder.

mason's mark A symbol, monogram, or initial carved by the *mason in the stonework for which he was responsible. Mason's marks are particularly found in *Romanesque and *Gothic buildings.

mastaba [From the Arab *mastaba*, 'a low mud-brick bench'] a term used to describe the shape of private tombs of the Old Kingdom in ancient Egypt

(*c*.2575–*c*.2150 BC). A mastaba consists of an underground burial chamber over which, at ground level, is a rectangular superstructure built of mud-brick or stone with a flat roof and *battered sides. The term is also used generally in architecture to denote structures of this shape which are said to be in mastaba-form.

Master of A term used in art history to denote an unidentified artist whose work can nevertheless be associated with a certain place, style, motif, group of works, or individual work of art. The practice of such nomenclature began in Germany in the early 19th century with the classification of unknown early Netherlandish masters. From the many thousands of artists thus classified, examples of the better known include the Master of Flémalle, the Master of the Housebook, and the Master of the Female Half-lengths.

masterpiece In present-day usage denotes a work of art of supreme quality, or the greatest work produced by a particular artist. The latter definition derives from the original meaning of the term which was a piece of work by which a craftsman, having finished his training, gained the rank of 'master' in his *guild.

mastic A *resin derived from a tree (*Pistachia lentiscus*) that grows in Mediterranean countries. A solution of mastic and turpentine was widely used as a picture *varnish in the 19th century but was superseded in the first half of the 20th century by *dammar which, unlike mastic, does not yellow or crack with age.

matt Describing a surface, most commonly of paint, with a dull, lustreless effect, giving very little, if any, reflection. A matt is also the framing board cut round a print or drawing and used both for its storage and display.

mattoir A tool used in *crayon manner and *mezzotint printmaking consisting of an irregularly spiked, rounded knob at the end of a handle of wood or metal. In crayon manner it is used to create lines and areas on the plate which will print in a grainy manner; in mezzotint it is worked over areas where a richer *burr is required than could normally be provided by the *rocker. Also known as a matter or mace-head.

Mauchline ware A distinctive form of decorated *treen, named after the Ayrshire town where it was first made in the late 18th century. Small boxes and wooden articles, made of Scottish planewood, were decorated with transfer-printed views, portraits, or landmarks in black or covered with tartan paper and then varnished. Snuff boxes, pill boxes, *étuis, and stamp boxes decorated in this manner were popular tourist souvenirs.

mausoleum A monumental tomb, either free-standing or attached to another structure, which may contain cinerary urns, coffins, or *sarcophagi. Named after the tomb of King Mausolus of Caria at Halicarnassus, a 4th-century BC *Hellenistic structure of great size.

medal A circular disc of metal, usually with images on both sides, the *obverse carrying a portrait with identifying inscription, the *reverse a text or a figurative scene associated with the obverse. (A medal with an image on only one side is said to be *uniface.) Medals are not unique works of art and, like *prints, are produced in numbers. The medal's original function was to honour, satirize, or criticize the subject of the portrait. The production of medals originated in early *Renaissance Italy, inspired by an interest in the art of antiquity and its coinage and small-scale sculpture. The first true Renaissance medal was that produced c.1438 by Pisanello, perhaps with the assistance of Leon Battista Alberti, and depicted *John VIII Palaeologus*. Enthusiasm for the medal spread throughout western Europe, fuelled by an interest in Renaissance culture, and has continued to this day. Medals are manufactured in one of two different techniques. Until the second half of the 16th century most medals were produced by the *casting method. This involves a model, from which a mould is then taken and into which the hot metal is poured. Increasingly, from the mid-16th century, medals were also produced by striking (*struck medal), in which the design was stamped onto the medal surfaces by means of a screw press.

medallion A large medal; a circular or oval decorative motif, often framing a figural subject, used in architecture or on furniture; a strong central motif on a Persian carpet.

medium A term used generally to describe both the various methods and materials used by artists. For example, painting, drawing, and sculpture are three different media, and bronze and marble are two of the media of sculpture. More specifically, 'medium' also refers to the liquid in which *pigment is suspended in any kind of painting, for example *linseed oil is the most commonly used medium in *oil paint.

megalithic A term used to describe a prehistoric style, characterized by structures made up of very large standing stones or megaliths.

megastructures Contemporary towers built as symbols of (usually corporate) power in a variety of styles: examples include I. M. Pei's Bank of China in Hong Kong and Cesar Peli's Canary Wharf in London.

megilp A *mastic *varnish mixed with *linseed oil to form a jelly-like substance. It was used as a painting *medium in the 18th and 19th centuries and gave a rich, 'buttery' quality to the colour with which it was mixed. Its use was discontinued, however, when it was discovered that pictures painted with it were likely to crack, blister, and turn brown.

Meissen The first factory in Europe to make true, or *hard-paste, *porcelain and, for the first half of the 18th century, the leading porcelain factory in Europe. It was founded in 1710 by Augustus the Strong, Elector of Saxony and King of Poland, in the Albrechtsburg Fortress in Meissen, near Dresden. Early experiments into porcelain production were conducted by Johann Friedrich Böttger (1682–1719) who had been working as an alchemist. He first made an extremely hard, dense, red *stoneware, which

could be polished and engraved. After further experimentation he created a hard-paste, white porcelain in 1709, with *clay from Colditz in Saxony. In 1720, the factory's management was taken over by Johann Gregor Herold, who perfected the process of decorating on porcelain with coloured *enamels. Many early pieces were inspired by Chinese and Japanese examples from Augustus the Strong's personal collection. In 1733 Johann Joachim Kändler was appointed chief modeller and produced a large number of figures for which the factory became famous. At the height of the *Rococo period, these delicate porcelain objects were popular and much imitated throughout Europe. During the Seven Years War (1756–63) the factory came under Prussian control, production slowed down, and tastes changed. The era of dominance and prosperity came to an end and the *Sèvres factory took the lead. Attempts were made to adapt its style but the factory was never again to regain its supremacy in Europe. Meissen continued to produce porcelain throughout the 19th century and is still in operation today. From 1723 pieces were marked with a pair of crossed swords in underglaze blue, derived from the saxon *coat of arms.

menhir [From the Breton *men*, 'stone'; *hir*, 'long'] a tall, upright stone set in open ground and originating from prehistoric times.

menuisier A furniture-maker specializing in carved pieces, the term is usually applied to craftsmen in 18th- and 19th-century France.

Merz The invention of the *Dada artist Kurt Schwitters (1887–1948). He first applied the term in 1919 to the *collages he made from refuse such as bus tickets, cigarette wrappers, and string. The word *Merz* was chosen by chance, being extracted from a business letterhead for the *Commerzbank* that Schwitters was cutting up for his collages, which he called *Merzbilder* (Merz pictures). Around 1923 he built his first Merzbau in his house in Hanover and in the same year began publication of his magazine *Merz* which appeared until 1932.

metal cut A relief method of printmaking, but using a metal plate rather than a wooden block from which to print the design. The technique was used from the 15th to the 19th centuries for decorative designs which would be frequently printed, such as borders and titles in book-illustration. Metal was harder than wood and therefore less subject to wear.

metal point A method of drawing using a thin rod of metal tipped with either *silver, *copper, *gold, or *lead. The last is the only one which leaves a mark on unprepared paper and was gradually replaced in the Middle Ages by *graphite. The other metal points require a prepared surface if they are to leave a mark, and to that end both *vellum and paper were abraded beforehand. Paper could also be prepared with a coating of opaque *pigment. The resulting marks made by metal point were originally greyish black but then oxidized to yellow or black. It is a very exacting technique as mistakes cannot be rectified. Silver point was the metal point most favoured in the *Renaissance.

metope The square space between the *triglyphs in the *frieze of the *Doric Order.

mezzanine [From the Italian *mezzano*, 'middle'] a low storey inserted between two higher ones; also called an entresol.

mezzo-rilievo An Italian term used to describe sculpture or ornament executed in middle or half-*relief, for example much of the sculpture adorning the sides of ancient *sarcophagi.

mezzotint ('Half-tone'), a tonal technique of printmaking working from dark to light. The printing plate (usually *copper) is first roughened overall with a spiked tool known as a *rocker. Inked and printed from, this would just print black. However, graduated highlights are scraped out with a 'scraper' or *burnisher. These areas hold correspondingly less ink and print lighter. The finest and most richly inked mezzotint impressions are the earliest, produced before the rich copper *burr thrown up by the rocker has worn away. Such impressions were highly prized in 18th- and 19th-century England, where the mezzotint (known abroad as '*la manière anglaise*') enjoyed its greatest popularity. The technique had been 'invented' by *c.*1642 by a German soldier, Ludwig von Siegen, who used a *roulette, however, to roughen his printing plate. The invention of the rocker is credited to Prince Rupert of the Rhine *c.*1661. He instructed a number of professional printmakers, mainly Dutch, in the technique and they brought it over to England in the late 17th century. There it was rapidly adopted as the preferred manner for reproducing painted images during the great age of portraiture from Kneller to Reynolds. In the early 19th century mezzotint was also employed to reproduce the landscape designs of Turner's *Liber Studiorum* (1807–19) and Constable's *Various Subjects of Landscape* (1830–3). Around 1820 steel plates began to be used. Harder than copper and producing less burr, they produced blander, less subtle impressions.

Migration Period A term used to describe art produced by the Teutonic tribes—Visigoths, Ostrogoths, Lombards, Franks, and Vandals—who overran the Roman empire in its declining years 370–800. Their surviving art consists mainly of portable objects for personal use and adornment and they excelled at goldsmith's work and jewellery.

millefiori Brightly coloured discs of *glass, cut from coloured rods and fused together to form a bundle. The technique was first used by the Romans and rediscovered in Murano, Venice, in the 16th century. It was particularly popular for the manufacture of paperweights in the 19th century. *See* VENETIAN GLASS.

minaret A tall, slender, circular tower attached to a mosque, used for the call to prayer.

Ming The dynasty which ruled China from 1368 until 1644, particularly well known for the fine *porcelain produced, including beautiful and restrained blue and white vessels in the early years. Later, the introduction

of additional colours led to richer effects. The trade in *Chinese export porcelain was begun during this period.

miniature A term that originated in the early 18th century as an anglicization of the Italian *miniatura*, which in turn derived from the medieval Latin *miniare*, 'to rubricate, illuminate', adapted from the Latin *minium*, the 'red lead' used to mark or rubricate particular words in manuscripts. Due to a mistaken etymology, 'miniature' has now become associated with 'minute', and is used to describe small paintings, usually portraits, the vogue for which enjoyed wide popularity in Europe from the early 16th to early 19th centuries. Miniature likenesses could be carried or worn and often conveyed a more intimate interpretation of character than could be displayed in a large-scale oil painting. Most early portrait miniatures, such as those produced by Nicholas Hilliard (1547–1619), were painted in *watercolour and *gouache, at first on *vellum, later on thin sheets of *ivory or card. From the 17th century *enamel was also used. Reflecting their jewel-like appearance, many miniatures were circular or oval in shape, though later miniatures were often larger in size and rectangular in imitation of their cousin, the portrait in oil. By the middle of the 19th century painted miniatures had been superseded by photographic portraiture.

Minimal art A type of abstract art, particularly sculpture, which is characterized by simplicity of form and a deliberate lack of expressive content. Its aim is a concentration on the pure qualities of colour, form, space, and materials without the distractions of 'composition'. The term was first used in print by the British philosopher Richard Wollheim in 1965, though some have credited its invention to the American critic Barbara Rose. It first emerged in the 1950s and flourished particularly in the 1960s and 70s. Minimal art was mainly an American, as opposed to a European, phenomenon and among its main practitioners were Carl Andre, Don Judd, and Tony Smith in sculpture, and in painting Frank Stella (early work), Elsworth Kelly, and Kenneth Noland.

Minoan A term applied to the art produced in ancient Crete between *c.*2500 and *c.*1100 BC. It was first used in 1894 by the archaeologist Sir Arthur Evans and derived from the Palace of Minos (named after the legendary king of Crete), which was one of the buildings he uncovered during his lengthy excavations at Knossos. The Minoans were non-Greek speakers and their art shows many eastern influences. Minoan art embraced sculpture, pottery, and wall-painting in addition to architecture. It had a great influence on *Mycenaean art.

minster Originally used to describe the church of a *monastery, it has come to be applied more generally to large and important churches such as the Minsters of York and Strasbourg.

Minton The *ceramics factory founded in Stoke-on-Trent, Staffordshire, in 1796, by Thomas Minton. Many of the products were richly decorated in a variety of historical styles, such as *maiolica and *Sèvres. New materials

and decorative techniques were introduced, such as *Parian ware, *pâte-sur-
pâte, and *majolica. Extremely elaborate creations were often exhibited
throughout the 19th century, from the Great Exhibition of 1851 onwards.
The factory still produces high quality *porcelain today.

misericord The bracket or 'mercy-seat' on the underside of the hinged
seats in the choir stalls of a church. When turned up the bracket served as a
support for the occupant while standing during long services. The brackets
were often ornamented with comic figures or allusions to fables.

missal A liturgical book used for the celebration of the Mass throughout
the year. It developed from the 10th century, incorporating the *gradual
and the sacramentary, and eventually replaced them. Missals normally
contained only two illustrated *miniatures—the Crucifixion and Christ in
Majesty—though some examples were more profusely illustrated.

mobile A term invented by Marcel Duchamp to describe certain
sculptures by Alexander Calder, exhibited in 1932, which consisted of flat
metal shapes suspended from wires which were moved (hence 'mobile') by
currents of air or by their own structural tension. Many other sculptors
have made mobiles and they have also been used for interior decoration.
The term can also be applied to certain babies' toys.

modello [Italian, 'model'] a drawing or sculpture made prior to a larger
work and usually shown to a patron for comment and approval. A modello
was often more fully worked up than a preparatory sketch.

Modernism A broadly used architectural term and movement, tracing its
origins to Le Corbusier's (1887–1966) designs such as that for the 'floating
box' (i.e. it was on stilts) Villa Savoye, Paris 1933, the five main points of
which were a grid, free plan, free facade, strip windows, and a roof garden.
These features were adapted by Mies van der Rohe (1886–1969) for his
seamless glass pavilions. In Modernist architecture there are no projecting
features such as *cornices, mouldings, *architraves, or skirting boards. By
the 1970s, however, Modernism had come to mean squat concrete
blockhouses and impersonal skyscrapers. The social optimism of
Modernism has all too often been exploited by unscrupulous property
developers. *See* POST-MODERNISM.

Modernismus A derogatory term adopted into English from German by
the writer and architect Sir Reginald Blomfield (1856–1942). He used it,
most notably in his book *Modernismus* of 1934, to denigrate those aspects of
modern art which he felt wilfully ignored the accumulated wisdom of the
past.

Moghul (or Mughal) the art of the Muslim rulers of India, from the 16th to
the 18th centuries. In the early days, artistic influence came from Persia,
but under Shah Jehan (1628–57), the builder of the Taj Mahal, the style was
noticeably more *Islamic. The art of *miniature painting flourished, but
exquisite work was also produced in metalwork, *ivory, and hardstone

carvings as well as carpets and *textiles, which were exported to Europe. Although the quality of products declined with the arrival of European styles brought to India by missionaries and merchants, the tradition survived into the 19th century in Jaipur and other Rajput states, where textiles and carpets were made.

moiré [French, 'watered, shimmering'] a watered or rippled effect, it is produced in certain *textiles and in watered *silk. The moiré effect has also been adopted by a number of *Op artists.

monastery A complex of buildings of a religious community living apart from the world. Monasticism originated in Egypt with the hermits who chose to live alone. A more organized monastic existence was conceived in the 4th century AD by St Pachomius, whereby monks still lived on their own but shared certain buildings such as a church and a refectory. The monastic architecture of medieval times evolved from the 6th century onwards in response to the rules established by St Benedict at Monte Cassino, though other orders such as the Cistercians also later established monasteries. The earliest surviving complete plan for a monastery is that of *c*.820 AD for St Gall in Switzerland. A typical monastery would include a church and an *almonry, cells, *cloisters, *chapter-house, *dormitory, guest-hall, library, *locutory, and a *refectory. On a more practical level, and underlining the self-sufficiency of such communities, there would also be bakehouses, gardens, graveyards, smithies, etc.

monolith An architectural member, such as a *column or an *obelisk, made from a single piece of stone.

monotype A technique of printmaking whereby the design is drawn or brushed in ink on to the unworked plate and printed from. This usually yields one good and one weak *impression. Extremely free and atmospheric effects can be obtained and it is debatable whether monotype qualifies as true printmaking. The process was invented by G. B. Castiglione in the 1640s and was revived in the late 19th century by Gauguin and Degas in particular. It has continued to be used by artists to the present day.

monstrance An open or transparent vessel in which the Host (the bread consecrated in the Eucharist) may be displayed, either on an altar or in processions. It is usually made of *gold or *silver and is often decorated with *precious stones. From the *Baroque period onwards it has been usual for the Host to be surrounded by a representation of a sunburst.

montage [French, 'mounting'] a pictorial technique developed in the 20th century in which a number of pre-existing pictorial images are cut out and reassembled on a flat surface. It is most frequently associated with advertising but has also been used by artists. *Photomontage involves the use of photographic images. Montage differs from *collage in that the latter uses cut out shapes which are not necessarily representational.

monteith A deep bowl, of oval or circular shape, with scalloped rim to hold the feet of wine glasses whilst their bowls were suspended in iced

water to cool them. It was reputedly named after the eccentric Scot, Monteith of Monteigh, who wore a cloak with a scalloped hem. Monteiths originated in the 17th century, were usually made of *silver, but were later also manufactured in *glass, *porcelain, and *delftware.

morbidezza [Italian, 'delicacy' or 'softness'] used in the 18th century to describe the depiction in painting of flesh tints with softness and delicacy, particularly with reference to the works of the 16th-century painter Correggio.

mordant [French, 'biting'] An acid or acid mixture used for the *biting process in *etching, that is the eating into the image-bearing surface of the artist's design. The mordants most commonly used in printing from metal plates are dilute solutions of nitric acid or hydrochloric acid. Hydrofluoric acid is normally employed for etching on glass.

mordant gilding The laying of metal leaf with an oil or varnish size, rather than with water as in *water gilding. The finish is matt and can not be *burnished. Mordant gilding is used to lay *gold leaf in oil painting.

morocco Originally a goatskin leather from Morocco, but also applied to sheep or lambskin, used for bookbinding from the 17th century onwards.

Mortlake The most important English *tapestry factory, founded in 1619. In 1623 Prince (later King) Charles acquired for the factory Raphael's cartoons for the *Acts of the Apostles* and many copies were made by the Flemish workers. The tapestries produced at this time rival those made in France and Flanders, but during the Civil War standards declined and later tapestries were of poorer quality. By the 1670s many of the weavers had moved on to other factories and Mortlake finally closed in 1703.

mosaic The technique of making pictures or patterns from small pieces of coloured stone or *glass set into cement or plaster. It was invented by the Romans and first used for pavements. In the *Early Christian and *Byzantine periods it was adapted for wall and ceiling decoration: outstanding surviving examples include the 6th-century mosaics of San Vitale, Ravenna. Mosaic has also been used for the decoration of the facades of medieval churches and in modern architecture.

Mosan School A school of manuscript illumination, metalwork, and *enamel work which flourished between the late 11th and early 13th centuries in the valley of the Meuse (Maas), more particularly on the stretch of the river which is located in modern Belgium around Liège and the Benedictine *monastery of Stavelot. Mosan art was noted for its sumptuous qualities and Mosan metalworkers were famous throughout Europe.

mother of pearl The pearly substance which lines shells, it was used for the decoration of metalwork and jewellery. Since the 17th century it was used as an *inlay for furniture, especially on *papier mâché furniture of the 19th century.

motte A steep mound on which stood the *keep of an 11th- or 12th-century *castle. Motte-and-bailey was a post-Roman and *Norman system of defence consisting of a motte surmounted by a tower, placed within a *bailey with an enclosing ditch and palisade.

moulage The technique of taking an *impression or making a *cast from a ready-made or natural object, for example a *death mask.

mould A cavity, usually made of *plaster of Paris, but sometimes *gypsum, *clay, rubber, or metal, in which a fluid clay, *paste, or other malleable substance is given form.

moulding A narrow strip used for framing pictures and for finishing or decorating walls, furniture, etc. It is usually constructed of wood but it can be carved or fashioned from the material of the structure it decorates.

mount A protective surround for a print or drawing which is made of board or card and is hinged at the top or the side. Its constituent parts are the support (backboard), to which the work of art is attached, and the window (mat) through which it is viewed. The earliest collectors of drawings, such as the Italian artist and author of the *Lives of the Artists*, Giorgio Vasari (1511–74), pasted their drawings into *albums. In the early 17th century, however, separate mounts were also beginning to be used, particularly in France, and by the middle of the 18th century mount-cutting had became a specialist trade. Today most major museum collections of graphic art are conserved in mounts which are stored in boxes of varying sizes. Modern mounts are always made of acid-free multi-ply board, thereby ensuring the work of art can not be damaged by any impurities in the mount.

Mozarabic Christian, but Muslim-influenced, art of Spain of the 10th and 11th centuries.

ms. (or mss) Abbreviations for 'manuscript' and 'manuscripts'.

Mudéjar A decorative and architectural style, part *Islamic and part *Gothic, which evolved in Spain after the reconquest of the peninsula from the Moors between the 13th and 15th centuries. It was created by Muslims working for Christians and also by Christians influenced by Muslim design. The name derives from an Arabic word meaning 'allowed to remain'. Perhaps the best-known example of Mudéjar architecture is the Alcázar in Seville.

mull The Scottish name for snuff box, usually made of natural horn, with a decorative lid.

mullion The vertical post dividing a window or other opening into two or more *lights.

multiples Works of art designed to be mass produced in theoretically limitless numbers, thereby negating the perceived exclusivity and rarity of an individual artwork. The concept was first proposed in the 1950s but it

was not taken up until 1962 when the first examples were produced by artists such as Claes Oldenburg. In practice, many multiples proved too expensive for the everyday buyer and by the end of the 1970s the concept was dying out, though it was revived in the 1990s.

mural A painting made on or fastened to a wall, the main type of the former being *fresco painting.

musée imaginaire A concept deriving from the writings of André Malraux (1901–76), author, war hero, and French Minister of Culture 1959–69. In the first volume of his major work *La Psychologie de l'art*, entitled *Le Musée imaginaire* (published in 1946 and translated in 1949 as *Museum without Walls*), he proposed that all works of art, widely available in the modern age to a mass audience through the means of photographic reproduction, should be appreciated for their formal qualities, whatever they originally signified.

museum A building used for the storing and exhibition of objects including antiquities, natural history, and works of art. The etymological root is the Greek *mouseion*, originally meaning anything consecrated to the Muses: a hill, a shrine, a garden, a grotto, a festival, even a textbook. In time it came to be associated with ancient Greek temples dedicated to the Muses of the arts and sciences. They were originally used for funerary cult ceremonies, but by the 4th century BC Aristotle, in the school or Lyceum he founded, had a *mouseion* for the collection and classification of specimens in his pioneering zoological studies. Ptolemy I Soter established the pattern for the *mouseion* in the ancient world when he had one incorporated in his plans for the city of Alexandria (*c*.290–48 BC). Its primary functions included the recovery and preservation of texts and objects, the collection of samples, and the encouragement of study. Such institutions became widespread in the ancient world, with the Greek word *mouseion* slipping into Latin by transliteration (i.e. 'museum'), though it denoted 'Muses' shrine' (a collection of objects) rather than a picture gallery (*pinacotheca). In the Middle Ages inspirational collections of precious and semi-precious objects were kept in the *sacristies, treasuries, and Schatzkammern of larger churches and *monasteries and consisted of bejewelled relics of saints and martyrs. Princes, and later merchants, formed analogous collections which included natural curiosities: narwhal (known as 'unicorn') horns, ostrich eggs, fossil bones, dried crocodiles, and so on. They also contained coins and gems as well as, increasingly, paintings and sculpture. With the *Renaissance revival of antiquity, fragments of sculpture were given higher status and arranged for artists to study from, for example the Medici garden near San Marco in Florence, and the Belvedere and Capitol in Rome. In the 17th century royal, aristocratic, and church collections were increasingly opened to public access. The Ashmolean Museum, Oxford University opened its doors in 1683, for the benefit of staff and students, and in the 18th century further major collections were opened to the public—the Uffizi, Florence (1743), the Capitoline Museum, Rome (1734), and the Belvedere, Vienna (*c*.1781). The

British Museum, London opened in 1753 as a public collection. In 1793, as a result of the French Revolution, the Louvre in Paris was declared a public museum and a symbol of egalitarianism. In the 19th century many further national museums and galleries followed, statements of nationhood as much as institutes of collection and learning—among them the Altes Museum, Berlin (1830), the National Gallery, London (1824), the National Gallery of Victoria, Melbourne (1856), and the National Museum, Tokyo (1872). Many of the great American museums were also formed in this period—the Museum of Fine Arts, Boston (1870), the Metropolitan Museum of Art, New York (1870), the Philadelphia Museum of Art (1876), and the Art Institute of Chicago (1879). The 20th century has seen the setting up of many museums devoted to modern works of art—the Museum of Modern Art, New York (1929), the Musée Nationale d'Art Moderne, Paris (1936). Furthermore, the museum building has itself come to be seen as a work of art in its own right with the standard classical temple-like structure abandoned in favour of striking avant-garde architecture, for example Frank Gehry's Guggenheim Museum at Bilbao, Spain.

Mycenaean A term applied to denote Greek art of the Late Bronze Age, from about 1500 to about 1100 BC. The name is derived from the fortress-city of Mycenae, the site of the most important remains of this period of art which were excavated by the German archaeologist Heinrich Schliemann in the 1870s. The term is usually understood to include both the Greek mainland and islands, with the exception of Crete. *See* MINOAN ART.

Nabis, les [From the Hebrew, 'prophets'] the name suggested by the poet Henri Cazalis and adopted by a group of French artists working in the 1890s who were very much inspired by the *Symbolist art of Paul Gauguin and his expressive use of flat areas of colour and rhythmic pattern. Exhibitions were held 1892–9, after which the group gradually drifted apart. The driving force had been Paul Sérusier and the main theorist was Maurice Denis; other members included Bonnard, Maillol, Vallotton, Vuillard, and the Dutchman Jan Verkade. They worked in a wide range of media embracing painting, book illustration, posters, *stained glass, and theatre décor. Strongly held religious beliefs continued to inform the art of a number of members of the group, notably Sérusier, Denis, and Verkade, long after the Nabis had disbanded.

naïve art Painting and, to a lesser degree, sculpture produced in the so-called sophisticated western or westernized countries but lacking in conventional representational skills. Although the first notable practitioner was perhaps Edward Hicks (1780–1849), an American Quaker preacher famous for his religious scenes, naïve art really gained widespread popularity only in the 20th century, particularly through the writings of the critic Wilhelm Uhde after the First World War, and through a series of exhibitions of naïve art. Henri Rousseau (1844–1910), 'Le Douanier' ('the customs officer'), was the first well-known naïve painter. Other now famous names have included Alfred Wallis and Grandma Moses), and in the decades following the middle of the 20th century there was a particular concentration of naïve painters in what is now the former Yugoslavia, particularly Croatia.

Naples porcelain A *porcelain factory was founded in Naples in 1771 by Ferdinand IV. It used a similar paste to that utilized at the earlier *Capodimonte factory and employed some of the same workmen. By the early 1780s most pieces were in the *Neoclassical style and included *biscuit figures and large dinner services made for diplomatic gifts, such as the Etruscan Service presented to George III in 1787, now at Windsor Castle. The mark of an N surmounted by a crown was regularly used. In 1807 the factory was sold to a French company and it finally closed in 1821.

Naples yellow (or antimony yellow) A yellow *pigment which varies in colour from sulphur-yellow to orange-yellow, it consists of a combination of lead and antimony oxides. It was known since ancient times and is still used as a *ceramic pigment.

narthex The part of a church screened off from the rest of the building and near the western end.

National Socialist art The art encouraged and endorsed by the Nazis in Germany 1933–45 under Hitler as Chancellor. The regime promoted the concept of Nordic racial superiority and repressed art that conflicted with its ideology in any way, labelling it *Degenerate art. Hitler's minister of propaganda, Joseph Goebbels, organized the Great German Art Exhibition in Munich in 1937, the first of an annual series held until 1944. These showpieces of National Socialist art were enormous, each containing over 1,000 works from a total of more than 500 exhibitors, many of which were distributed to museums throughout the country. National Socialist art was typified by its chilling banality, a form of debased academic art. Militarism aside, it occupied itself with blonde, Nordic, Herculean males, their hard-working wives, and their children born seemingly of some ghastly genetic attempt at racial conformity, all of whom were placed in idealized urban and rural settings conceived to the glory of the German state and its people (*Volk*).

naturalism An approach to art in which objects are depicted by the artist as they are empirically observed rather than according to stylistic or conceptual preconceptions. Art of the Greek *Classical period is sometimes described as the first naturalistic art and that of the Italian *Renaissance as a revival of naturalism.

nautilus shell cup A cup made from a nautilus shell (a large *mother-of-pearl from the Indian Ocean) elaborately mounted in gold or silver. Such cups were intended for display rather than use and the finest were made in late 16th- and early 17th-century Germany.

nave The central *aisle of a *basilican church, situated to the west of the *choir and generally reserved for the laity. Normally it consists of a tall central division with two side aisles, but it can also be found without aisles.

Nazarenes The name given to a group of early 19th-century Austro-German painters who wished to rediscover the purity and morality they perceived to have been inherent in the art of the late Middle Ages and in the early *Renaissance. Among the artists they admired were Dürer, Perugino, and the young Raphael. The term was originally coined in derision of their affectation of wearing biblical dress and hairstyles. The nucleus of the group was established in 1809 by six students at the Vienna Academy, including Friedrich Overbeck and Franz Pforr, who formed an association, the Brotherhood of St Luke (*Lukasbrüder*), named after the patron saint of painting. In keeping with their ideals they lived together in quasi-monastic style, with Overbeck, Pforr, and two other members leaving for Rome where they occupied the disused monastery of S. Isidoro, and were joined by Peter von Cornelius and others. By the time they completed the second of their two major commissions for monumental *frescoes, those in the Casino Massimo, Rome 1817–29, the group had ceased to exist as a coherent entity. Cornelius moved to Munich where he attracted a large number of pupils and assistants who spread the Nazarene style to other German cities, notably Düsseldorf. Some of the Nazarene ideals were exported to Britain

by the Scottish painter William Dyce and later exerted some influence on the *Pre-Raphaelites.

nécessaire A portable case used to carry a collection of articles such as toilet necessities, sewing instruments, toothpicks, cutlery, etc., usually for the purpose of travelling. The earliest nécessaires were small and pocket-sized and often elaborately decorated, for example in *shagreen mounted with *silver. Larger ones were sometimes in the form of caskets or trunks.

necropolis [From the Greek, 'city of the dead'] and consequently also a large burial place or cemetery.

needlepoint Essentially a type of *embroidery, it is made from a single thread and a needle making embroidery stitches. Early needlepoint *lace designs were usually based on a drawing on paper or parchment which was then cut away after the work was finished.

needlework The practice of sewing or a method of decorating a *textile using a range of stitches in wool, *silk, or cotton, as in *embroidery.

nef A vessel shaped like a ship and usually made of *silver. They were used in the later Middle Ages to hold the lord's napkin, knife, and spoon. By the 16th century they were employed as table ornaments, especially in Germany and Switzerland, and were often very elaborate and accurate models of fully rigged ships.

Neoclassicism Now understood to describe the classicizing style which evolved in European art of the later 18th and early 19th centuries in reaction to the florid sensuality of the *Rococo. It embraced the *fine and *decorative arts and architecture, and its masters included the painter David (*The Oath of the Horatii*, Louvre, Paris), the sculptor Canova, and the architects Ledoux and Soane. The term was actually devised later, in the 1880s, and was originally pejorative, denoting 'pseudo-classical', and particularly directed at Jacques-Louis David and his school. Neoclassicism is now seen to have achieved a purity of expression, however, and would have been referred to by its practitioners as the 'true' or 'correct' style. It was based on the study of antique art, which was to be imitated but not slavishly copied, and thus embody what were perceived to be the general and permanent principles of the visual arts as formulated by the ancients. Its first great theorist was J. J. Winckelmann (1717–68), whose *Reflections on the Painting and Sculpture of the Greeks* was published in English translation in 1765.

Neo-Dada The term by which *Junk and *Pop art have sometimes been known in America. *See* DADA.

Neo-Expressionism A movement in painting, and to a lesser degree sculpture, which emerged in the late 1970s and was firmly established on the critical map in the early 1980s with a number of major exhibitions, especially 'A New Spirit in Painting' held at the Royal Academy, London in 1981. The paintings are typically on a large scale, rapidly executed, and display a raw, expressive approach to their materials. Objects such as straw

or broken crockery may be embedded in the paint surface. Subject-matter is usually figurative but often infused with a spirit of pessimism. Neo-Expressionism has enjoyed particular success in Germany (Anselm Kiefer, Georg Baselitz) and the USA (Julian Schnabel).

Neo-Geo An abbreviation of 'Neo-Geometric Conceptualism', it is a term applied to the work of a group of American artists active in New York in the mid-1980s. Although they worked in a variety of styles, they were characterized by the cool, ironic approach they brought to their art, in contrast to the emotionalism of *Neo-Expressionism. Jeff Koons, with his stainless-steel replicas of *kitsch consumer objects (including whisky decanters in the form of celebrity portraits), is the best-known figure of the group.

Neo-Georgian A revival of the *Georgian style of architecture during the last years of Queen Victoria's reign later.

Neo-Impressionism A movement in French painting that developed from and in reaction to *Impressionism, considered by some to be too improvisatory a technique. Neo-Impressionism (the term was devised by the critic Félix Fénéon in 1886) sought to apply a more rational and scientific method, whereby pure dots of colour, of equal size, gave a maximum of luminosity; *see* DIVISIONISM; POINTILLISM. The leader of the group was Georges Seurat (1859–91), its theorist Paul Signac, and its elder statesman Camille Pissarro; all three exhibited at the last Impressionist exhibition in 1886. Although it was very short-lived as a movement, Neo-Impressionism's influence was considerable and affected the paintings of such diverse figures as Gauguin, Van Gogh, Toulouse-Lautrec, and Matisse.

Neo-Plasticism A term coined by the Dutch artist Piet Mondrian (1872–1944) to describe the severely geometrical, abstract art he developed which he claimed was 'denaturalized', freed from the obligation of naturalistic representation. He restricted the elements of pictorial design to the straight line and the rectangle and to the *primary colours together with white, black, and grey.

Neoplatonism A philosophical and religious system developed by the followers of Plotinus in the 3rd century AD, it combined ideas from Plato, Aristotle, Pythagoras, and the Stoics with elements of oriental mysticism. It envisaged the human soul rising above the imperfect material world towards contemplation and knowledge of the transcendent One. Its importance for the visual arts lies in its domination of late *Quattrocento Florentine thought as revealed in the writings of Marsilio Ficino and Pico della Mirandola. These intellectual circles greatly influenced artists under the patronage of Lorenzo de' Medici, especially the young Michelangelo, whose understanding of spiritual beauty derived from Neoplatonism.

Neo-Romanticism A term applied to a movement in British art *c.*1935–55 which consciously looked back to the visionary landscape art of 19th-century *Romantic artists such as William Blake and Samuel Palmer.

nereid A sea nymph, the daughter of Nereus, the 'Old Man of the Sea' in Greek mythology. As attendants of the sea god Neptune, nereids are often depicted reclining on the backs of *hippocampi.

Netherlandish A *school designation used to describe artists from the northern and southern Netherlands working prior to the Union of Utrecht in 1579. Thereafter those from the north are usually described as Dutch and those from the south as Flemish.

netsuke A small Japanese ornament used as a toggle, attached to a cord which held an *inro (*lacquer box) at the other end. The cord was looped over the obi (belt) of a kimono and the netsuke held it in place. The literal translation of netsuke is 'root-fix' and its origins may lie in a farmer or woodcutter using a piece of root wood to make a simple toggle. During the 17th and 18th centuries netsuke developed in popularity and sophistication and many woodcarvers and artists devoted their spare time to creating them. After Japan opened up to the West in 1868, many craftsmen specialized in netsuke, mainly for export. Demand for them in Japan declined as western dress became popular. *Ivory and wood were the most common materials used to create a wide variety of forms in miniature, such as animals, mythical creatures, figures, Noh masks, and plants.

Neue Künstlervereinigung [German, 'New Artists' Association'] was founded in Munich in 1909 by Kandinsky, Jawlensky, and Gabriele Münter. Heavily influenced by the expressive colours of the Paris-based *Fauve painters, its members were very much opposed to the then pervading orthodoxy in Munich contemporary art circles of the *Jugendstil. The NKV staged exhibitions in 1909 and 1910, the second of which embraced a wide range of European artists, including Rouault, Picasso, and many of the Fauves such as Braque and Derain. Der *Blaue Reiter, led by Kandinsky, was formed as a splinter group from the NKV in 1911.

Neue Sachlichkeit [German, 'New Objectivity'] a term coined in 1923 by Gustav Hartlaub, director of the Kunsthalle, Mannheim, as the title of an exhibition he arranged to show the development of post-war painting in Germany. Such art was representational rather than abstract and was characterized by a world-weary cynicism devoid of the idealistic aspirations of many prewar movements. Its most famous exponents were Otto Dix and Georg Grosz. In the 1930s Neue Sachlichkeit was denigrated and swept away by the ideologically inspired art of *National Socialism.

New Art History Something of an umbrella term, embracing elements of *Marxism, *semiotics, and deconstruction, it is generally used to describe the various approaches to *art history as an intellectual discipline which developed after the Second World War. This occurred in reaction to the earlier, predominantly literary and *Renaissance-based tradition of art-historical scholarship which was widely perceived to have dominated the subject and to have become increasingly irrelevant to the modern world.

New British Sculpture A term which describes a loose grouping of British sculptors who emerged in a group of exhibitions in the early 1980s, notably *Objects and Sculpture* shown in London and Bristol in 1981. Most of their work is abstract and makes use of industrial or junk material. Prominent members include Tony Cragg, Richard Deacon, Anish Kapoor, David Mach, Alison Wilding, and Bill Woodrow.

newel The central column or space around which wind the steps of a circular staircase.

New English Art Club A club founded in 1886 by John Singer Sargent and a group of young painters representing the most progressive tendencies in English art in protest against the conservative *Royal Academy. Other founder members included George Clausen, Wilson Steer, Stanhope Forbes, and Frederick Brown. The club held annual exhibitions 1886–1904, but by the early 20th century was itself perceived as failing to keep pace with progressive trends. Splinter groups from the club included the *Newlyn and *Glasgow Schools.

Newlyn School A group of artists who worked in the Cornish fishing village of Newlyn in the 1880s and 1890s and were important pioneers in Britain of *plein air painting. The leading figure of the group was Stanhope Forbes and many of its members were also associated with the *New English Art Club.

New Realism A term used in the late 1950s and early 1960s to describe the realistic art which evolved in America in reaction to *Abstract Expressionism. Many of its images were derived from the popular mass media and featured mass-produced goods of everyday life.

New Sculpture A term coined by the critic Edmund Gosse in a series of four articles, 'The New Sculpture, 1879–1894', published in the *Art Journal* in 1894. It is used to describe a trend in British sculpture which reacted against the blandness of much *Neoclassical sculpture and sought instead to promote 'ideal' sculpture, often of single figures and usually in *bronze, with the subjects taken from mythology or poetry. Leading exponents included Gilbert Bayes, Sir George Frampton, Sir Alfred Gilbert, and Sir Hamo Thorneycroft

New York School A general term applied to the artists, particularly the *Abstract Expressionists, working in New York in the 1940s and 1950s who were responsible for it replacing Paris as the major centre for avant-garde art. Among the artists included under this umbrella were Willem de Kooning, Arshile Gorky, Hans Hofmann, Franz Kline, Robert Motherwell, Barnett Newman, Jackson Pollock, and Mark Rothko.

niche A recess in a wall, often used to hold a statue or other ornament.

niello [Latin *nigellus*, 'black, dark', hence the Italian *niello*] a black metallic amalgam which was used since antiquity as decoration to fill the furrows on engraved metalware (usually *gold or *silver). It was particularly

popular in Bologna and Florence between about 1450 and 1520. Many *impressions have survived of prints made on paper from these engraved decorations prior to their being filled with niello; they are known as niello prints. They are small in size and highly decorative and may originally have been made by Italian gold- and silversmiths to check the progress of their designs. However, it is likely that many were also deliberately made as prints for their own sake.

nimbus A (usually) circular radiance around the head in a representation of a sacred personage, a nimbus is a symbol of glory or veneration. It is found on images of Christian saints, Old Testament figures, angels, imperial personages, ancient Greek and Roman gods, and other venerated figures in Buddhist and Asian art. After the 5th century Christ was often depicted with a nimbus containing a Cross.

Non-objective art A general term applied to art which is not concerned with the depiction of the visual world. It was apparently first used by the Russian artist Alexander Rodchenko (1891–1956), but was spread to the West in Kandinsky's publication *Concerning the Spiritual in Art* of 1912.

Norman The *Romanesque architectural style which developed in northern France and in England from around the middle of the 11th century. It saw the construction of many great cathedrals and churches. Norman architecture is generally massive, plain, and rather fortress-like with features including relatively small windows, simple shallow *buttresses, round *arches, and simple *vaulting. It found its most complete and distinguished expression in Durham Cathedral (1093–*c*.1130). The *Gothic architectural style which followed was lighter and more complex in form and more graceful in articulation.

Northern Renaissance The adoption in northern Europe, mainly Germany and the Netherlands, of the artistic ideals of the Italian *Renaissance. The prime mover was the German artist Albrecht Dürer (1471–1528) who travelled twice to Italy to discover the 'secrets' of the Italian masters, especially the mathematical principles of *perspective and proportion. Dürer's own ideas were widely disseminated through his prints and his writings. Flemish artists who travelled to Italy and were strongly influenced by its art included Jan Gossaert and Jan van Scorel. *See* ROMANISM.

Norwich School A regional school of English landscape painters based in Norwich and particularly associated with the Norwich Society of Artists founded in 1803 with John Crome as its first president. From 1805 to 1825 the Society held annual exhibitions at Sir Benjamin Wrench's Court, the first instance of a regular provincial exhibiting society in England. The Norwich painters drew their inspiration in particular from Dutch 17th-century landscape painting. The School's leading figures included, in addition to Crome, John Sell Cotman and James Stark.

Nouveau Réalisme A term coined in 1960 by the French critic Pierre Restany to characterize a group of artists who included real objects (often

junk) in their work with the intention of making ironic comments on modern life. Yves Klein and Tinguely were among the leading artists of Nouveau Réalisme.

nymphaeum A *grotto or structure containing pools, plants, rockwork, fountains, and statues, often used as place of relaxation.

Nymphenburg One of the most important German *porcelain factories, Nymphenburg was founded in 1747 near Munich, under the patronage of the Elector of Bavaria. Within ten years an exceptionally fine, white body was produced and many pieces show this to full advantage. The most outstanding creations are a series of *Rococo-style figures modelled by F. A. Bustelli, who was chief modeller at the factory 1754–63. Many of the figures were taken from the *Commedia dell'Arte and show great liveliness and originality. Later products show the influence of *Meissen or *Sèvres and by the mid-19th century, when state support for the factory ended, only utilitarian wares were made. A revival was experienced during the *Art Nouveau period. The factory is still in existence today.

oak A hard and coarse-grained wood, of a light brown colour, which was the predominant wood employed for furniture in Britain from the Middle Ages until the late 17th century. Later it was used for simple, country furniture. It was also the traditional *support for *panel paintings in northern Europe. *See* POPLAR.

obelisk A tall, tapering *shaft, usually square in plan, with a pyramidal top. First used in ancient Egypt where they are found in pairs at the entrances to tombs. The emperor Augustus brought back several obelisks to Rome where their incised *hieroglyphs attracted considerable speculation during the *Renaissance. Obelisks were also a common feature of northern European Mannerist architecture and are found in funerary monuments to the present day.

Objective Abstraction A term used to describe the work of various British artists in the 1930s, including William Coldstream, Ivon Hitchens, Victor Pasmore, Rodrigo Moynihan, and Graham Bell, who experimented with depicting natural objects in such a way that they were transformed into lyrical patterns of coloured shapes. Analagous in that sense to the paintings of late Monet, they more probably drew their inspiration from the later works of J. M. W. Turner.

objet d'art [French, 'art object'] a term normally applied to small, precious objects such as *ceramics, metalwork, and curios intended for private ownership.

objet trouvé [French, 'found object'] an object found by an artist and displayed, with little or no alteration, for its aesthetic value. Objets trouvés could be natural, such as a pebble or a shell, or man-made, for example a fragment of pottery. The practice began with the *Dadaists and *Surrealists.

observatory A building in which astronomical studies are carried out using a powerful telescope; it can also denote an upper room in a building from which extensive views can be had (a *belvedere).

obsidian An igneous rock, black or very dark volcanic *glass, shattered into very sharp blades and sometimes used as a tool for working marble on a small scale. It has also been employed since ancient times as an ornament in sculpture, in particular for the pupils of inserted eyes.

obverse The face carrying the principal design on a two-sided object such as a coin or *medal; the other side is known as the *reverse.

Oceanic art Art produced by the indigenous inhabitants of the island chains of Melanesia, Micronesia, and Polynesia situated in the South Pacific

to the east and north-east of Australia. It is particularly noted for its achievements in painting (especially of the human body), cordage (baskets, belts, and mats), and sculpture. The best-known monuments in the last category are the monumental, long-headed statues carved from soft volcanic tufa on Easter Island. In the earlier part of the 20th century western artists such as Picasso and the *Surrealists took a strong interest in Oceanic art.

ochre Any clay used to make the earth colours red ochre and yellow ochre (for which it is also used as a synonym).

oculus A small circular panel or window; also known as a bull's eye or *oeil-de-boeuf (for example the window lighting the octagonal room at Versailles).

odalisque [French, from the Turkish *odalík*] a female slave in an oriental harem. The odalisque was adopted as a subject by a number of French artists in the 19th and 20th centuries, most famously by Ingres (whose 1814 *Grande Odalisque* is in the Louvre, Paris), and was usually shown nude or semi-nude, reclining in a voluptuous manner.

oeil-de-boeuf *See* OCULUS.

oeuvre [French, 'work'] the total output of an artist.

offset A reproduction made from a drawing by dampening it and/or a sheet of paper and pressing them together by machine or hand. The image produced is in reverse to the original and fainter. Offsets were often produced for working purposes by designers of ornament who needed either a copy of a design in reverse or wished to complete a symmetrical design. In the field of *Old Master drawings, many red *chalk drawings were reproduced as offsets, particularly in 18th-century France with the drawings of artists such as Watteau. *See* COUNTERPROOF.

offset lithography *See* LITHOGRAPHY.

ogee An S-shaped double curve, commonly used in *Decorated and Gothic *Perpendicular architecture.

oil gilding The application of gold leaf to a surface, such as a picture frame, usually with a linseed oil-based adhesive. Unlike *water gilding, it can be applied without the necessity for a preparatory layer of *whiting. However, it can not be *burnished as water gilding can, and it does not last as well, the oil often darkening with age.

oil paint Paint in which drying oils are used as the *medium. *Linseed oil has been the most commonly used for this purpose, but walnut and poppy oil have also been employed. The invention of oil paint was traditionally credited to the Netherlandish painter Jan van Eyck (d. 1441), but its origins are considerably older and it is discussed in Theopilus's treatise *De Diversis Artibus*, which has been dated to 1110–40. Van Eyck and other northern painters certainly developed the use of oil paint, however, and contributed

to it gradually superseding *tempera as the principal medium for serious painting in Europe. It was adopted more slowly in Italy than in the north, but it gained particular currency in *Renaissance Venice, where Titian was perhaps the first to realize its full potential. The traditional method of oil painting involved the building up of the paint surfaces in thin transparent *glazes, and this helped to create the richness of tone with which it is associated. Tubes of ready mixed oil paint were introduced in the 19th century, thereby greatly increasing the range of colours and effects which could be achieved.

Old English An English architectural style of the later 19th century in which vernacular forms such as steeply pitched roofs, timber framing, and tall ornamental chimneys were revived. It was particularly associated with the *Domestic Revival and *Arts and Crafts Movement.

Old Master A term applied to any of the great painters working between the *Renaissance and the 18th century, or to their actual paintings. It can be used adjectivally to refer to Old Master sales or collections.

oleograph A process developed in the 19th century whereby colour *lithographs were made to look like *oil paintings; they were varnished and impressed with a canvas grain. Framed oleographs still lie in wait in antique shops to trap the unwary into believing they are acquiring a genuine oil painting.

Omega Workshops Founded in 1913 by the critic and artist Roger Fry, they were a community of artists, paid a retainer of seven shillings and sixpence a day, who made 'objects for common life' such as rugs, *pottery, fabrics, and *painted furniture. In their aims and choice of a communal environment they were similar to William Morris's various co-operative enterprises in the 19th century. However, in their choice of motifs derived from Matisse, the Cubists, and other avant-garde contemporaries, they were ahead of their time in England. Among the most important artists of the group were Fry, Vanessa Bell, Duncan Grant, and, briefly until they left in the autumn of 1913 to form the Rebel Art Centre, Wyndham Lewis, Frederick Etchells, and Edward Wadsworth. The Omega Workshops were finally sold up in 1919.

onyx A type of *quartz with striped markings, usually black or brown and white. It was used for *cameos.

opal An iridescent gemstone, the name probably derives from the Sanskrit word *upala* meaning stone. The special characteristic of opal is its opalescence, the rainbow colours caused by the reflection and scattering of light from minute silica spheres within the mineral and changing with the angle of view. The body colour varies from clear or milky, as in white opal, to grey or black, as in the most precious form, black opal. The Romans used opals from Czechoslovakia in their jewellery. It was not until the late 19th century that opals were found in Australia, which is still the best area for opal mining today.

opaline An opaque *glass of milky appearance, created by adding gold oxide to the glass mix. Opaline vases painted in *enamels with exotic birds, flowers, and animals were popular in France in the 19th century.

Op art An abbreviation of 'optical art', a form of *abstract art which developed in the early 1960s and aimed at stimulation of the eye through a radical use of space and colour. This was achieved by the deployment of hard-edged, flatly painted shapes in black and white or in *complementary colours of full intensity. The term 'Op art' was first used in *Time* magazine in 1964 and had become a household phrase by the following year when the defining exhibition *The Responsive Eye* was held at the Museum of Modern Art, New York. Two of the most prominent Op artists were Bridget Riley and Victor Vasarely. Op art exerted a considerable influence on women's fashion in the mid-1960s. *See* KINETIC ART.

opus anglicanum English *embroidery of the Middle Ages, it reached the zenith of its achievement in the 13th and 14th centuries, coinciding with the *Decorated style in architecture and East Anglian manuscript illumination. The great Vatican inventory of 1295 includes far more pieces of *opus anglicanum* ('English work') than any other kind of embroidery. Much of it was produced in professional workshops in the City of London and was carried out in silk and silver-gilt thread, often supplemented with pearls and precious stones and therefore immensely valuable and related to jewellery and goldsmith's work. Most surviving examples, such as the famous Syon *Cope in the Victoria and Albert Museum, London, are ecclesiastical, despite the destruction of many such works during the Reformation.

opus sectile The name given by the Romans to *marble inlay in *mosaic work which follows the lines of the pattern or picture, as opposed to the small fragments of stone or glass (*tesserae) which fill in the rest of the design. *Opus sectile* originated in Egypt and Asia Minor, lands rich in coloured marble. It was considered a rarer and more luxurious art than straightforward mosaic. Little survives before Roman times and it was also used in *Early Christian and *Byzantine churches. It continued to be popular in Italy for decorating church floors throughout the Middle Ages and *Renaissance.

orangery A garden building for growing oranges and other ornamental trees, it has tall windows on the south side. An orangery can be either an independent building or attached to a larger structure.

oratory A small private chapel, either in a church or house; more generally a place of prayer, but specifically a church or religious establishment of the Order of St Philip Neri, known as the *Oratorians*.

Order In *classical architecture, the Orders consist of variations of an assembly of parts made up of a *column (usually with a base), a *capital, and an *entablature. These structural units may be repeated and combined to form the elevation of a building and its architectural vocabulary. There are eight Orders in total: Doric (Greek and Roman versions), Tuscan, Ionic

(Greek and Roman), Cerinthian and Composite. The simplest is the Tuscan, supposedly derived from the Etruscan-type temple. It has a base and capital and a plain column. The Doric is probably earlier, however, its Greek version having no base, as on the Parthenon. The Ionic Order, with its twin *volute capitals, originated in Asia Minor in the mid-6th century BC. The Corinthian Order was an Athenian invention of the 5th century BC and was later developed by the Romans. The Composite Order is a late Roman combination of elements from the Ionic and Corinthian Orders.

Ordinary A simple geometrical shape on an heraldic shield, such as a cross. In English *heraldry there are nine Honourable Ordinaries:
1. The cross, classed first because Christ died on the Cross.
2. The chief, created by a straight line dividing the top third or fifth of the shield.
3. The pale, a vertical stripe occupying one-third or one-fifth of a shield.
4. The bend, a diagonal line stretching from *dexter *chief to *sinister *base.
5. The fess, a horizontal band across the centre of the shield.
6. The inescutcheon, a shield borne as a *charge on the arms.
7. The chevron, two diagonal bands meeting in the centre of the shield and forming an inverted V.
8. The saltire, better known as St Andrew's Cross.
9. The bar, a border round the shield.

Orientalism The depiction of the Near East by western artists, primarily in the 19th century. The Orient became generally associated with the exotic in the popular imagination and provided a rich vein of subject-matter for much of the century. Interest in the area was initially stimulated by the French government's *Description de l'Egypte*, published in Paris in 24 volumes (1809–22) in the aftermath of Napoleon's Egyptian campaign. Travel opened up the whole region stretching from Egypt through to Turkey. Oriental costume, architecture, history, and customs excited the interest of artists as diverse as Eugène Delacroix, Horace Vernet, Sir David Wilkie, and William Holman Hunt. Biblical history could be reinterpreted in its original setting. Eroticism could be depicted in the harem or the slave market. Those with a penchant for scenes of violence were catered for in pictures of execution and massacre. A 20th-century counterpart could be found in films of biblical and historical epics such as those directed by the legendary Cecil B. de Mille. Nowadays there is an increasingly strong market for Orientalism, with the artists who specialized in this genre commanding high prices.

original print The problem of defining what constitutes an 'original print' has given rise to much debate, not least with regard to the art of the 19th and 20th centuries. The division of labour between the artist who creates the original design and the specialist printer who facilitates the production of the print lies at the heart of the matter. The industrialization of the reproduction of images and the invention of photomechanical techniques have also blurred the boundaries of definition. With techniques

such as *etching it is normally the artist himself who carries out all stages
of the printmaking process. However, *lithography or *screenprinting, for
example, usually involve a collaboration between artist and printer. Various
international committees have met in attempts to standardize terminology,
but it is perhaps wisest to maintain the utmost flexibility when tackling this
vexing question.

ormolu Decorative objects in *bronze, usually furniture mounts, which
have been *cast, *chased, and fire-gilt. Ormolu is normally associated with
18th-century and later objects. The two best-known manufacturers were
Gouthière in France and Matthew Boulton in England.

Orphism A lyrical movement in French painting that developed *c*.1912
from the relative austerity of *Cubism and placed much greater emphasis
upon colour. The term was first used by the poet Guillaume Apollinaire and
derived from Orpheus, the singer and poet of Greek mythology. The
painters mentioned as practitioners of Orphism by Apollinaire were Robert
Delaunay, Fernand Léger, Francis Picabia, and Marcel Duchamp. František
Kupka (the most important figure omitted by Apollinaire) and Delaunay
claimed an analogy between abstraction and music in their works. Orphism
had a strong influence on German painters such as Klee, Macke, and
Kandinsky, who all visited Delaunay in 1912, and on *Synchronism.

orphrey A decorative band, often embroidered, used on ecclesiastical
vestments such as *chasubles, *copes, *dalmatics, etc.

osculatory A pendant worn and kissed by the celebrant of Mass at the
mingling of the bread and wine to signify the unity of the Church through
the bond of charity.

Ottocento [Italian, 'eight hundred'] 19th-century Italian art.

Ottoman An *Islamic dynasty which ruled from the late 13th century
until the establishment of the Turkish Republic in 1924. Its greatest sultan
was Süleyman the Magnificent who reigned 1520–66, a period when the
Ottoman empire embraced Anatolia, the Balkans, the Crimea, Iraq, Syria,
the Hijaz, Egypt, and North Africa. This was widely recognized as
representing the apogee of Ottoman political, economic, and cultural
development. Throughout their history the Ottomans supported the arts
and artists. A distinctive architectural style evolved which combined
Islamic traditions with *classical and *Byzantine forms. Their buildings
were richly decorated with tiles, woodwork, and carpets, and there was also
extensive production of *pottery, manuscripts, and metal wares.

Ottonian art The art of the Holy Roman Empire in the 10th and most of
the 11th centuries. The Ottonian dynasty of emperors reigned from 919 to
1024 and took its name from Otto the Great (936–73). Ottonian art
incorporated strong elements of *Carolingian, *Byzantine, and *Early
Christian art. Its typical sculptural products were in *ivory and metalwork,
notably book covers and altar reliefs. A rich store of Ottonian *illuminated

manuscripts has also survived, characterized by the emphasis placed on the human figure.

outsider art A term used since the 1940s to describe art produced 'outside' the normal *fine art tradition. Synonymous in many ways with *Art Brut, many of its practitioners have, in fact, been stimulated to create as a result of experiencing a psychological trauma or some other mental disturbance.

overpainting The finishing coat or layer of paint applied to a painting after the undercoat has been applied. *See* GLAZE; SCUMBLE.

ovolo A wide quarter-round convex moulding much used in *classical architecture: Greek ovolos are flatter than Roman ones. The term is also applied to such mouldings when used in picture frames.

oystering Also called oyster veneer, a type of *veneer made from cross-sections of small branches of trees such as *walnut or olive, symmetrically arranged, resembling oyster shells. Originally a Dutch technique, it was popular in the late 17th and early 18th centuries.

ozier Relief ornament simulating basketwork, used for decorating *porcelain, particularly borders of plates and dishes; first used at *Meissen in the mid-18th century and much copied.

P

pagoda Originally a Buddhist temple in the form of a tower, usually polygonal, and commonly found in India and China. The form was adapted in European *chinoiserie in the 18th century for elaborate garden pavilions such as that at Kew, London.

paint Used for colouring and protecting surfaces, it consists of colour in the form of ground *pigment held in a liquid vehicle (such as oil, gum, or an industrially made equivalent) which is then dispersed onto the surface to be painted, most frequently by means of a brush. Depending on its make-up, paint can be thinned by the use of diluents such as white spirit or water.

painted furniture Furniture ornamented with painted decoration, a practice widely carried out in the Middle Ages, *Tudor, and early Stuart periods, usually using *tempera and *gilding. Under Charles II *japanning superseded painting on furniture and the art was not revived until the end of the 18th century by Robert Adam. Furniture was painted with garlands, borders, and medallions to fit in with the *Adam style of decoration. By the end of the 18th century the style was so popular that painting had taken over from *marquetry as a form of decoration. Painted furniture became fashionable again during the *Gothic Revival, seen in the work of the architect and designer William Burges (1827–81). Inspired by the Middle Ages, his painted furniture was part of his schemes of interior decoration. Many pieces were painted by leading *Pre-Raphaelite artists of the period, such as Edward Burne-Jones (1833–98).

painterly [German, *malerisch*] originally coined by the German art historian Heinrich Wölfflin (1864–1945) to distinguish *Baroque from *Renaissance art. According to Wölfflin, the former was painterly and concerned with mass, light, and shade, whereas the latter was basically linear and depicted the world in clearly outlined shapes. Such a distinction is, of course, overly simplistic, though it may function as a useful guide. 'Painterly' has acquired wider currency and is now applied to the works of artists such as Titian, Rembrandt, Velázquez, and Goya in which the brushwork and the substance of paint are clearly visible.

paint film A thin, continuous layer of *medium and *pigment combined.

paisley A pattern used on textiles, based on Indian motifs, named after the town of Paisley in Scotland where shawls were made throughout the 19th century, inspired by shawls from Kashmir with their rich colours and densely packed motifs.

pala d'altare An Italian term, usually shortened to *pala*, for a large altarpiece, often consisting of a single picture.

palazzo [Italian] a large palace, private house, or public building in Italy; many of the major buildings of the *Renaissance were palazzi designed by the leading architects for powerful families such as the Farnese, Pitti, and Rucellai. The 'palazzo style' evolved in 19th-century Britain in conscious emulation of the Renaissance and is found in buildings such as Charles Barry's Reform Club, Pall Mall, London.

palette A thin oval or oblong board with a thumb hole and finger board at one end on which the painter arranges his colours. Traditionally made of light wood, some are now made of aluminium or plastic. 'Palette' can also be used to refer to the range of colours used by a particular artist.

palette knife A painter's tool consisting of a flexible, flat blade of tempered steel with a round end, set in a wooden handle. It serves a number of purposes: handling paint on the *palette, scraping, mixing *pigments with oil or other vehicles. As early as the the 17th century artists used palette knives for spreading paint on to the canvas prior to achieving their painterly effects with the paint brush. In the 19th century, however, a number of painters, most famously Gustave Courbet (1819–1877), abandoned the traditional smooth finish achieved with the paint brush for a much more extensive use of the palette knife. Courbet's paintings had a crudity of finish allied to a strong, elemental power that offended reactionary critics but which attracted and influenced Cézanne and Pissarro.

Palissy ware *Earthenware produced by the potter Bernard Palissy (1510–90) at Saintes and in Paris. Palissy was a scientist and a geologist and he created pieces in imitation of ponds and rivers, with naturalistically modelled snakes, lizards, snails, and foliage. He cast from life reptiles, crustaceans, and leaves and attached them to plates, dishes, and plaques, which were then covered with greenish-grey *glazes to give a slimy appearance. Palissy's style was very popular, much copied in his lifetime, and revived in the 19th century.

Palladian An architectural style derived from the buildings and publications of the Italian architect Andrea Palladio (1508–80) who was himself influenced equally by the architecture of antiquity and by that of his contemporaries. His particular contribution lay in his elegant town and country houses (*palazzi* and *ville*) set in and around Vicenza. Of particular importance to later generations was his blending of secular architecture and landscape, in effect the prototype of so much later classicizing park and country-house architecture. Palladio promulgated his theories in his *Quattro libri dell'architettura* (1570). His style was introduced to England by Inigo Jones in the following century, but then fell out of favour until it was consciously revived by Colen Campbell and Lord Burlington, as in the latter's Chiswick House, near London, begun c.1720. Palladianism later spread from England to Germany, Russia, and the United States.

Palladian window *See* SERLIANA.

palmette A fan-shaped pattern, derived from a palm frond, which was popular during the *Neoclassical period.

panel Any flat, rigid support, such as wood or metal, prepared with a *ground for painting upon. Until the adoption of *canvas in the 15th century, most movable paintings in Europe were painted on wood, which continued to be used as a painting surface in Holland and Flanders until well into the 17th century. Although many different woods were variously employed by artists, it is generally true to say that Italian artists worked on *poplar and those from northern Europe favoured *oak. Painting directly onto wood is unsatisfactory as it tends to absorb too much of the paint and does not reflect enough light. Consequently wood is normally prepared prior to painting with several layers of white *gesso which serve as a *ground. For large compositions several wooden panels may be joined up together to form the support. One of the prime disadvantages of wood is that it has a tendency to split if subjected to climate changes, particularly those of humidity. For this very reason many celebrated *Old Master paintings originally painted on wood have in the past been transferred onto the suppler support of canvas, especially in the 18th century in France where a high degree of expertise in this skilled process was developed. Nowadays most public museums and galleries maintain proper air-conditioning which greatly reduces the risk of any splitting occurring. Nevertheless, paintings on panel are rarely lent to exhibitions elsewhere due to concern at possible damage occurring, especially in transit. Other panel supports which have been used for painting include *copper (especially for small-scale works in the 16th and 17th centuries) and *slate.

panorama A term originally coined in the late 18th century from two Greek roots (*pan*, 'all', and *horama*, 'view') to describe a specific form of landscape painting, comprising a 360-degree view, invented independently by several European artists *c.*1787, perhaps most famously by the Irish painter Robert Barker with his panorama of Edinburgh from Calton Hill. Many panoramas, housed in either temporary or permanent circular structures, were produced in the course of the 19th century but hardly any survive, an exception being Hendrik Mesdag's panorama (1881) of the beach at Scheveningen on the outskirts of The Hague. The term panorama is more widely used today in its metaphorical sense of a survey or overview.

pantheon An antique temple dedicated to all the deities; specifically the Pantheon in Rome, the great *rotunda built about AD 125.

pantograph An instrument by means of which copies in larger or smaller size can be made by a process of tracing over the work to be copied. The usual construction is of four strips of wood set as the overlapping sides of a square with flexible joints, to which are attached two drawing instruments such as two *pencils. The scale of the enlargement can be changed by adjusting the relations of the overlapping strips. Pantographs have been known since the early 17th century.

paper A drawing and printing surface, invented in China *c.* AD 100, in common use in Europe by the 16th century, superseding *vellum or *parchment. Fine paper is made from rag fibres mashed into a pulp which is laid across a wire mould that normally contains a wire design or *watermark denoting the papermaker or paper size. The mould is pressed on to blankets or felts to which the paper adheres. After squeezing in a press to remove moisture, the sheets of paper are separated from the blankets or felts and hung up to dry. They are then coated with animal or gelatine size to prevent them being porous like blotting-paper. Woven wire, in place of the 'laid' and 'chain' wires crossing each other at right angles in the traditional mould, was introduced in 1750. *Wove paper is smoother than *laid paper. Machine-made paper, produced in rolls and made from wood-pulp, was developed in the early 19th century. It is coarser, impure, and discolours rapidly.

papier collé [French, 'pasted paper'] a process, first used by the *Cubist painter Georges Braque in his *Fruit-Dish and Glass* (Private Collection) of 1912, in which pieces of decorative or printed paper cut into certain shapes are incorporated in a painted composition or, when stuck down on a canvas, themselves constitute the picture. Associates of Braque such as Picasso and Gris rapidly adopted the technique, as did Matisse in his later work.

papier mâché Is made from pulped paper, glue, chalk, and sometimes sand. This mixture hardens, after moulding and baking, into a material which will take a high polish after *japanning or painting. Possibly of oriental origin, the technique first appeared in Europe in the 17th century in France and was known in England by 1672. A major development was that of Henry Clay in Birmingham who, in 1772, patented a method of gluing together sheets of paper under heat which resulted in strong panels that could be made into tea-trays, etc. At first known as 'paper ware', it was called *papier mâché* (French, 'chewed up paper') in 1816 by the Birmingham firm of Jennens and Bettridge. With further modifications it became very popular in England and America. Often embellished with inlays of *mother-of-pearl, it was used for household objects and light furniture such as tables and chairs.

papyrus The main writing material of the Egyptian and classical world, it was prepared from the stem of the marsh plant of the same name (Latin) found in Egypt and what is now Sudan. Papyrus was used in Egypt from as early as the 3rd millennium BC and was not replaced by *parchment until the 4th century AD onwards. It continued to be used in the Papal Chancery, however, until the 10th century.

parapet. A low wall used as protection in any location where there is a drop, for example at the edge of a roof, *balcony, or terrace.

parcel-gilt *Silver or furniture gilded in parts.

parchment Writing material made from animal skins (usually sheep or calf, less frequently pig, goat, and other animals) which are specially

cleaned and stretched. According to Pliny, parchment was discovered in the 2nd century BC by Eumenes II of Pergamum after the Ptolemies had banned the export of *papyrus from Egypt in an attempt to prevent the growth of the Pergamene Library. Parchment had been known before this, however. Until it was gradually superseded by *paper from the 14th century onwards, parchment was the main writing material in the West and was used in bound form for many of the great books reproducing the writings of the classical authors and for medieval *illuminated manuscripts. Today the term is also used to denote fine quality *paper.

Parian ware A type of white *porcelain, with a slightly granular surface, which resembles pure white statuary *marble and was used mainly for busts and figures. It was first produced at the Copeland factory in 1844 and the following year the Art Union of London commissioned Copeland to reproduce in Parian ware the work of several leading sculptors of the day. Other factories such as *Minton, *Wedgwood, and *Worcester soon followed suit. A number of manufacturers exhibited very large pieces made in Parian ware at the Great Exhibition, London of 1851. Similar wares were produced on the Continent and in the United States.

Paris porcelain The general term used for the products of numerous *porcelain factories and decorating workshops in and around Paris between 1780 and 1840. After the French Revolution, when the monopoly of the *Sèvres factory came to an end, a number of other establishments also produced high quality, lavishly gilded vases and services in the *Empire style. The factories were known either by the name of the proprietor or that of the street where they had their shop and included Darte Frères, Feuillet, and Rue de Crussol.

parquetry The geometrical inlay of various coloured woods or of the same wood so laid as to contrast the grain (as in parquet flooring).

parsonage A building which serves as the dwelling of a priest, the most celebrated literary example being that of the Brontë family in Haworth, Yorkshire.

Parthenon The 5th-century BC Greek Doric temple of Athena Parthenos on the Acropolis in Athens, regarded as one of the greatest of all *classical structures and the model for many *Greek Revival buildings.

paste A mixture of *clays and other materials which make a *ceramic body, usually used to describe *porcelain. *Hard-paste is the name given to true porcelain, first made in China, using the ingredients *kaolin (china clay) and *petuntse (china stone). *Soft-paste is the term for artificial porcelain made in Europe before the discovery of kaolin. Also the name given to imitations of *precious stones, such as *diamonds, made of a hard, vitreous substance backed by foil.

pastel A drawing material consisting of a stick of colour made up of ground *pigment mixed with just enough *gum or *resin to bind them

together. Pastels originated in the 16th century in Italy, developed from the technique of drawing in coloured chalks, and one of the earliest exponents was the Urbino artist Federico Barocci. Pastels produce bright, pure colours which, unlike paints for example, do not change colour as they dry out. Early pastels were restricted to black, white, and red or flesh-colour and the invention of a fuller range of colours is credited to the landscape painter and etcher Johann Alexander Thiele (1685–1752). The Venetian artist Rosalba Carriera, famed throughout the courts of Europe for her portraits, introduced pastel to France where, in the course of the 18th century, it enjoyed its heyday. Among the most prominent exponents were Chardin, Perronneau, and Maurice-Quentin de La Tour. The technique also found popularity elsewhere: for example in England it attracted portraitists such as John Russell and Francis Cotes. The most individual pastellist of the 18th century, however, was the Swiss painter Jean-Etienne Liotard who travelled widely in Europe and also visited Constantinople. Interest in pastel revived in the later 19th century, especially in the work of Degas and his followers. The Société des Pastellistes was founded in Paris in 1870 and in 1880 the Pastel Society held its first exhibition in London. Apart from Degas, other distinguished artists of this period who worked in pastel included Cassatt, Redon, Renoir, Toulouse-Lautrec, and Whistler. A major conservation problem with pastel is caused by the weak adhesion of the crumbly drawing material to the paper surface, consequently pastels are relatively fragile and suffer from loss of pigment if subjected to movement. *Fixatives can be applied, usually in the form of a spray, to remedy this, but it is now generally accepted that the fixatives themselves can cause injurious effects of discoloration, etc.

pastel-manner A method of colour printing using multiple plates engraved in the *crayon-manner. Invented by Louis-Marin Bonnet in 1769, it was generally used to imitate *pastels by artists such as François Boucher, done à *trois crayons with a different plate for each of the colours red, white, and blue.

pastiche A work of art produced, often with fraudulent intent, in imitation or in the manner of an original one.

pastiglia A paste used in *Renaissance Italy for the decoration of cheap wooden boxes, probably produced as substitutes for caskets of precious metals. The paste was made either of *gesso or white lead mixed with an egg *binder. After the paste had been applied to the box, moulded in relief, and allowed to harden, it was then usually painted and gilded.

pastille burner The term for a perfume burner, in which a small pellet is burned to remove unpleasant odours. In *Staffordshire in the mid-19th century they were usually in the form of a cottage in *pottery or *porcelain.

patchwork A textile technique used mainly for quilts and bed-covers; small patches of many different pieces are sewn together to produce a bright, multicoloured design. Of peasant origins, and carrying with it

connotations of folk art, the technique enjoyed a great revival in popularity in the 'swinging sixties' and in hippy culture.

pâte de verre Coloured, powdered *glass which is refired in a *mould so that it fuses and gives the appearance of a *semi-precious stone. The technique was popular during the *Art Nouveau period.

patera A small, flat, circular ornament, decorated with acanthus leaves, used to decorate furniture and silver 1770–1830.

pâte-sur-pâte A technique of layered *porcelain manufacture in imitation of *cameos developed in the late 19th century by Marc-Louis-Emanuel Solon for the *Sèvres and *Minton factories.

patina The colouring and/or incrustation that may occur on metal sculpture. Ancient *bronzes, when buried in soil or immersed in water, can acquire rich greens and sometimes blues and reds. Patinas can be deliberately stimulated by the use of various chemical treatments (for example sulphides which produce an artificial black on bronze or other *copper alloys). 'Patina' is also more generally used to describe the varnishes and paints that are sometimes applied to metal surfaces.

patio Originally an inner courtyard, open to the sky, found in Spanish or Spanish-American architecture, the term has been debased by estate agents' employment of it to denote any small paved area attached to a property.

pattern book A book containing samples of patterns and designs of cloth or *wallpaper.

pavilion A lightweight, ornamental building, whose uses include those of a pleasure-house or summerhouse in a garden, or a building in a sports or cricket ground. A pavilion, usually square and with a dome, can also be a projecting subdivision of another building.

paw foot A leg terminal found on furniture in the form of an animal's paw. Originating in ancient Egypt and also used in classical Greece and Rome, this shape enjoyed a revival from the late 17th to the 19th centuries. A variation is the hairy-paw foot, which included carving of animal fur above the paw.

pearl An organic gemstone, obtained from the pearl oyster, a natural growth produced by irritation inside the shell. Pearls are usually ivory-white in colour with a lustrous sheen, although they can also be pink or steel grey. They have been used in jewellery since ancient times, usually set in gold, often as a border decoration or in settings with precious stones. 'Baroque' pearls are large, misshapen pearls which were particularly popular with *Arts and Crafts jewellers. In 1899 the Japanese firm of Mikimoto developed cultured pearls.

pearlware A form of *earthenware, developed by *Wedgwood (1775–9) as a whiter version of its *creamware body. A greater quantity of white

*clay was used in the body and the transparent lead *glaze included traces of cobalt, giving the surface a pearly white appearance. It was soon adopted by other potteries, such as *Spode, Leeds, and Swansea.

pedestal The area below the base supporting a *column or *colonnade; the term is also used more loosely to describe the base for a statue or any other building resting on it.

pediment In classical architecture a pediment is a low-pitched *gable crowning a *portico or facade, often containing sculpture in its *tympanum. Most pediments take the form of a depressed isosceles triangle, though segmental pediments were introduced during the Roman empire. A broken pediment has an incomplete bottom *cornice and no apex or top. *See* FRONTON.

peep-show box A cabinet with scenes portrayed on the interior walls which, when viewed through a small opening or eye-piece, gives the illusion of three-dimensional reality. Such boxes may have been invented by the *Renaissance artist and theorist Alberti, but they really gained in popularity in 17th-century Holland where the foremost exponent was Samuel van Hoogstraten (1627–78), by whom a fine example, *A Peep-show with Views of the Interior of a Dutch House*, is in the National Gallery, London.

peintre-graveur [French, 'painter-engraver'] an artist who makes original prints, as opposed to ones that are reproductions of other compositions.

pele, peel In Scotland, Ireland, and in northern England a fortified tower-house; most examples date from the 16th century.

Pembroke table An elegant type of drop-leaf table, probably named after the Countess of Pembroke. It has rectangular leaves supported on hinged wooden brackets and was made from the mid-18th century onwards.

pen A writing and drawing instrument, the nib of which retains *ink with which the design is drawn. The pen has been known since classical times and its earliest form was probably the reed, cut from bamboo or the tubular stock of coarse marsh grass. The common pen, until very recently, was the quill: in the West the feathers of geese and turkeys have often been employed. Metal pens have also been in use since Roman times but did not appear in machine-made form until the early 19th century.

pencil A writing or drawing instrument consisting of a thin shaft of *graphite or a related substance encased in a wooden holder. Graphite, a crystalline form of carbon, was first used by artists for underdrawing in the 16th century, supplanting *lead point. It began to be mined on a large scale in Cumberland in 1664 and Britain became the major source of the material. Necessity bred invention when, in 1795, the Frenchman Nicolas-Jacques Conté, denied access to British graphite on account of British–French hostilities, patented a method of eking out graphite with varying amounts of clay. The resulting pencils could be produced in several degrees of hardness, graphite being soft and clay hard. From that time on the pencil

was recognized as a major drawing instrument, as it still is today. Indeed, until the late 18th century the term 'pencil' more commonly meant a brush (particularly a small one such as that used for *watercolour) and 'pencilling' could mean 'colouring' or 'brushwork' as well as 'drawing'.

pendant A picture intended to hang as one of a pair. The most celebrated examples are found in the work of the 17th-century landscape painter Claude Lorrain in which typical pendants might consist of a landscape and a marine scene.

pendentive A concave support or *spandrel joining the angle formed by two walls to the base of a circular dome. It is one of the means of placing such a dome over a square or polygonal compartment. Pendentives were widely used in *Byzantine architecture, most famously in the Hagia Sophia, Istanbul, and also occasionally in *Romanesque architecture.

pensiero [Italian, 'thought'] a drawing, painting, or model serving as a sketch for a larger composition.

pentimento [From the Italian, 'repentance'] part of a picture or drawing which has been painted or drawn over after the artist has changed his mind about a particular motif, for example the pose of a figure. In paintings these earlier thoughts can become visible, either to the naked eye on account of the upper layer of added paint becoming more transparent with time, or through scientific examination by *x-ray photography or *infra-red reflectography. The existence of pentimenti in a painting is often thought to increase the likelihood of its authenticity, the theory being that only the original artist would make such changes, whereas a copyist would merely reproduce the final composition.

Performance art An art form in which artists become participants in their own work of art and often combine elements of theatre, music, and the visual arts. The variety of activities is extraordinarily wide, ranging from acts of self-mutilation to journeys through the landscape. Performance art gained widespread recognition in the late 1960s and 1970s. It is closely related to *Happenings, but Performance art is usually more programmed and does not involve audience participation. Artists whose work has often embraced Performance art include Joseph Beuys, Gilbert and George, and Bruce Nauman.

pergola A covered walk in a garden, the overhead structure of which usually consists of posts or pillars with wooden cross-members, richly decorated with plants and flowers. Pergolas were a relatively common feature in the garden paintings of certain artists working in Italy in the later 18th and early 19th centuries.

peristyle [From the Greek *peri*, 'round', and *stylos*, 'column'] a range of *columns surrounding a building or open court.

Perpendicular The last of the English *Gothic styles of architecture, it developed in the 14th century and survived until as late as the early 17th. It

is characterized by straight verticals and horizontals, especially in *tracery. There is overall emphasis on the panel motif, both in tracery and in blank-wall decoration. *Arches are flat and *vaulting complex (culminating in the English *fan pattern). One of the most important early Perpendicular structures is the *chancel of Gloucester Cathedral, while from the middle period of the style there are the *naves of Canterbury (c.1375) and Winchester (mostly c.1394) Cathedrals. Fine examples of late Perpendicular include St George's Chapel, Windsor (1474 onwards), King's College Chapel, Cambridge (1446 onwards and 1508–15), and the chapel of Henry VII at Westminster Abbey (1502 onwards).

perspective The art of drawing solid objects on a two-dimensional or shallow surface so as to give the right impression of their height, width, depth, and position in relation to each other. Only certain cultures have embraced perspective, for example the art of the ancient *Egyptians took no account of the effects of spatial recession. Mathematically-based perspective, ordered round a central vanishing point, was developed in early *Renaissance Italy. It was invented by Filippo Brunelleschi (1377–1446), described by Leon Battista Alberti (1404–72) in his treatise *De Pictura*, and is often referred to as linear perspective. The Florentine obsession with perspective was ridiculed by Vasari in his *Life* of the painter Paolo Uccello (1397–1475), who would stay up all night in his study trying to work out the vanishing points of his perspective, and, when called to bed by his wife, would say 'Oh, what a lovely thing this perspective is!' The stage-like organization of pictorial space, in which the composition of a picture is conceived as though viewed through a window, remained a central feature of much western art until the later part of the 19th century. *See* AERIAL PERSPECTIVE.

petit point Embroidered *canvas used mainly for chair and cushion covers, originating in the Middle Ages but popular from the 18th century onwards.

petuntse A feldspathic mineral that, at a high temperature, becomes glass. It is an essential ingredient in *hard-paste *porcelain which, when mixed with *kaolin, provides hardness and translucency. The name derives from the Chinese *baidunzi*, meaning 'little white bricks', the form in which it was transported to the potters in China.

pew A fixed wooden seat in a church, in use by at least the 14th century. An elaboration, which evolved in *Georgian times, was the 'box-pew', which had a high wooden enclosure all round and a small door.

pewter A cast *alloy, mostly made of *tin, used mainly for the manufacture of useful wares such as plates, drinking vessels, bowls, spoons and ladles, candlesticks, etc. Pewter has been known in Europe since the earliest times but was not really developed until the Middle Ages. The best pewter ('English pewter') contains *copper, occasionally bismuth, but no lead. When polished it can be as bright as silver. Ordinary pewter ('test pewter' and 'low-grade pewter') contains lead in varying quantities (the

more lead the cheaper) and is relatively dull in tone with a blackish-grey colouring. Large quantities of lead increase the risk of lead poisoning when pewter wares are used as vessels for food and drink. In the 16th century more elaborate 'display pewter', with relief decoration and intended to be shown on dressers and sideboards, was manufactured, at first in France and then also in Germany. Much of the best pewter was made in France throughout the 17th century and pewter was also manufactured in North America from that date. Pewter became largely obsolete in the 19th century with the introduction of the cheap pewter substitute *Britannia metal and the reproductive technique of *electroplating. It enjoyed a revival, however, around 1900 in England and Germany with the firms of *Liberty and Kayser.

photogravure A photomechanical process of reproducing an image or design, it is basically a combination of photography and *etching. Crucially, the gelatine in the photographic negative of the image acts as the acid resist when the image comes to be *etched. There are two types of photogravure. Hand photogravure, hardly used now but very popular in the later 19th century, involves the photographic transfer of the image to a copper plate, prepared with *aquatint to give it tone, into which the design is *etched. The plate is then hand-inked and printed from in the same way as an ordinary *intaglio plate. Machine photogravure, very much more commercial, is similar except that a cross-line screen, instead of aquatint, is used to provide the tone, and a cylinder is employed rather than a plate. Very fast printing in large editions, for example of magazines, is possible with this technique.

photomontage A technique of image-making from bits of different pre-existing photographs which are cut out, arranged, and pasted down to form a composition, it was largely the creation of the Berlin *Dadaists. Prominent among its pioneers were Raoul Hausmann, John Heartfield, and Hannah Höch. Photomontage has also been used by *Surrealists such as Max Ernst and *Pop artists such as Richard Hamilton.

piano nobile [Italian, 'noble floor'] the main floor of an Italian *palazzo or grand town house, containing the reception rooms, raised one storey above ground level with a basement or ground floor below.

piazza [Italian, 'square'] an open space, usually oblong, surrounded by buildings, for example the Piazza Navona, Rome. In 17th- and 18th-century England a piazza was also a long covered walk or *loggia with a roof supported by columns.

picture plane The plane occupied by the surface of a picture. Since the development of perspectival theories in the *Renaissance, the picture plane has been considered as the equivalent of a window through which the spectator views the world depicted in the picture.

picturesque [Derived from the Italian *pittoresco*, 'from a picture'] a term which, when first applied to the forms of nature, denoted an object or view

as worthy of being included in a picture. The canon for judging 'picturesqueness' was provided by the varieties of Italian landscape as found in the works of the 17th-century painters Claude Lorrain, Nicolas Poussin, and above all Gaspard Dughet. The 'Picturesque' appeared as a distinct category in English aesthetic theory in the later 18th century, formulated by figures such as the country squire and landscape gardener Uvedale Price who, in his *Essays on the Picturesque* (1810), posited it midway between the Beautiful and the *Sublime. A 'beautiful' landscape was serene, a 'sublime' one awe-inspiring, whereas a 'picturesque' view was full of variety, curious details, interesting textures, and roughness and irregularity. Medieval ruins, country cottages, partly kept woodland—all motifs found in profusion in the English countryside—were typical picturesque subjects and were depicted by a host of landscape painters and draughtsmen, including Turner and his great contemporary Thomas Girtin.

piece mould A mould used in the manufacture of cast sculpture and assembled out of separate pieces, generally of *plaster but also of *clay. Piece moulds are put together like jigsaw puzzles and could be disassembled and re-used many times. Complex piece moulding was developed as early as the 4th century BC by Greek sculptors.

pier In architecture, a solid support designed to sustain vertical pressure.

pier glass A tall, narrow mirror within a frame, originally placed between windows to enhance light coming into a room. A pier table usually accompanied it.

Pietà [Italian *pietà*, 'pity'] a term applied to a painting or sculpture depicting the Virgin Mary supporting the body of the dead Christ on her lap, sometimes accompanied by other figures such as St John the Evangelist or Mary Magdelene. The image is timeless and hieratic and does not, unlike scenes of the Lamentation, depict a particular moment in the Passion story. The subject originated in early 14th-century Germany where it was known as a *Vesperbild* and was more popular in northern Europe than in Italy. However, the best-known Pietà is probably the sculpture by Michelangelo in St Peter's, Rome.

pietre dure The normally used plural of the Italian term for hardstone (*pietra dura*). Stones such as *agate, *chalcedony, *jasper, and *lapis lazuli have been used for small decorative objects since early times. In late *Renaissance Italy, particularly in Milan and in the Grand Ducal workshop at Florence, large bowls, *ewers, and vases of elaborate *Mannerist design were made of such stones set into *gold and *enamel mounts. Italian craftsmen also produced similar work for the court of Rudolf II in Prague. From around this time also dates the first use of *mosaics of hardstones for the decoration of cabinets, table-tops, altar-frontals, etc.

pigment A finely divided colouring material which is suspended in a medium, such as oil in *oil paint. Pigments are derived from a wide variety

of substances, organic and inorganic, natural and artificial. For the purposes of painting a pigment needs to be stable and withstand light, air, and moisture.

pilaster A shallow *pier or rectangular form projecting from a wall and, in *classical architecture, conforming to one of the *Orders and carrying an *entablature. See ENGAGED (column).

pillar A free-standing upright architectural member which, unlike a *column, need not be circular nor conform with any of the *Orders.

pillow lace (or bobbin lace) is a type of *lace made from numerous threads (wound on bobbins) plaited and twisted in a variety of ways. Elaborate types of pillow lace were manufactured at various centres including *Brussels (from the early 16th century), Chantilly, Mechlin, and Valenciennes.

pinacoteca [Italian, *Pinakothek* in German] a picture gallery, for example the Pinacoteca Nazionale in Bologna.

pinchbeck An *alloy of *copper and *zinc which looks like *gold, invented by the English watchmaker Christopher Pinchbeck (fl. 1695–1732), and used for inexpensive jewellery, watch cases, and snuff boxes.

pinx. [Latin, an abbreviation of *pinxit*, 'he/she painted [it]'] was often inscribed after the artist's signature in a painting to indicate he was the author. It was also found in the lower corners of the margins of prints where it had the same meaning as *inv.*, or *invenit*, 'he/she designed [it]'.

pittura metafisica [Italian, 'metaphysical painting'] a painting style that developed from the art of Giorgio de Chirico (1888–1978), in which there was a disconcerting image of reality and an attempt to capture the disquieting nature of the everyday. Guillaume Apollinaire, in an article of 1913, was the first to refer to de Chirico's art as 'metaphysical'. De Chirico was joined by the Futurist Carlo Carrà in 1917 and the latter published *Pittura Metafisica* in 1919. Featureless mannequins set in sharply perspectival town- and landscapes were typical of de Chirico's work and were taken up by, among others, George Grosz, Rudolf Schlichter, and Oskar Schlemmer. A number of the major artists of *Surrealism, including Max Ernst, Salvador Dalí, and Alberto Giacometti, owed a strong debt to de Chirico.

planography A term used to describe a surface technique of printmaking, such as *lithography or *screenprinting, as opposed to *relief or *intaglio where the surface of the printing plate or block is cut into or incised.

plaquette A small, portable, replicated sculpture relief in metal (usually *bronze, though lead, *gold, and *silver were also used). Plaquettes were first developed in Italy in the 1440s and were later popular in France, Germany, and the Netherlands in the 16th and 17th centuries. The word itself was invented in France in the 1860s to describe this particular art

form. Most plaquettes were made by the *lost-wax process. Like reproductive prints, they were responsible for the wide dissemination of antique and *Renaissance imagery.

plaster A soft mixture, generally composed of lime, and mixed with sand and other substances. Animal hair or hemp have often been used as binding agents. Plaster has been used since ancient times for sculpture and for the lining of walls.

plaster of Paris Another name for *gesso, the main constituent of which is *gypsum, vast deposits of which were found in the hill of the Parisian suburb of Montmartre.

plate [From the Spanish *plata*, 'silver'] a generic term for any flat or flattish sheet of metal or other hard material, it is generally used for objects wrought in *silver or *gold. It also refers to articles in base metal which have been plated with precious metal (as in *electroplating). The term is also used to describe a broad piece of armour; a sheet of metal (normally *copper) employed in printmaking as well as an *impression printed from it; a film-coated sheet of glass used in photography.

platemark In *intaglio printmaking the edge of the *impression left on the paper by the printing plate. Although impressions are sometimes trimmed within the platemark, the finest are normally deemed to be those with the platemark intact.

Plateresque [From the Spanish *plateresco*, literally 'silversmith-like'] an ornate 16th-century style of architecture of Spanish origin, incorporating elements of *Gothic, Moorish, and *Renaissance ornament, often unrelated to the main structure of the building.

plein-air [French, 'open air'] used in the context of painting or sketching *en plein air*, 'out of doors', a practice recommended by the highly influential French landscape painter Pierre-Henri de Valenciennes in his treatise *Élémens de perspective* ... (1800). According to Valenciennes, studies (or *études) in oil on paper were to be made quickly on the spot and then used as points of reference back in the studio where the final, finished landscape painting was produced. Later in the century the *Impressionists would dispense with this distinction between sketch and finished picture and undertake much of their work *en plein air*. It has been pointed out that Valenciennes was not the first artist to work out of doors. For example, the 17th-century landscapist Claude Lorrain may well have executed his brown wash nature studies out in the Roman *campagna* (countryside).

plinth A monumental base for a statue; more generally, any solid base.

plique à jour [French, 'openwork fold'] a technique of *enamel decoration in which enamel is applied to cells formed by wires with no back, so it appears translucent. The technique was much used by the *Art Nouveau designer René Lalique in his jewellery.

plumbago An obsolete term for the drawing material *graphite.

Plymouth porcelain The first English factory to make true or *hard-paste porcelain was established at Plymouth in 1768 by William Cookworthy, a chemist, who discovered a source of *kaolin in Cornwall. The factory produced useful wares painted in *underglaze blue, *enamelled ornamental wares, and some large, ungainly figures. Many pieces had flaws or were distorted during *firing, so in 1772 the factory moved to *Bristol, an important ceramics centre, where it was easier to find experienced workers and good technical advice.

poblano An architectural and sculptural style that developed in and around the city of Puebla, Mexico, in the 18th century. It combined *Baroque elements with ornate *stucco, geometrically patterned red brickwork, and *polychrome glazed tiles.

pochade [French, 'quick sketch' (in colours)] a term used particularly in 19th-century France to describe a rapidly executed sketch in oils, usually made out-of-doors preparatory to a finished studio painting. A landscape *pochade* was one in which the painter attempted to capture the tonal values of a particular motif.

pochoir [French, 'stencil'] a highly skilled stencil technique practised in a specialized workshop and used for making multicolour prints, for tinting black-and-white prints, and for colouring reproductions and book illustrations

poesia [Italian, 'poem', 'poetry'; 'dream, fancy'] a term used in the *Renaissance to describe paintings inspired by the myths, fables, and legends related by the classical authors. Some Renaissance theorists discussed the degree of fantasy permitted and the laxness of the moral content of many *poesie*. The most celebrated *poesie* were those painted between *c.*1550 and *c.*1562 by Titian for Philip II of Spain including subjects such as *Diana and Calisto* and *Perseus and Andromeda*.

point A pointed chisel which is mainly used for the rough dressing of stone. If it is hammered vertically with force it punctures the surface and causes a small circle of stone to come away around the puncture. Used more softly it can achieve a crumbly surface effect on the stone.

Pointillism The term was derived from the French critic Félix Fénéon's phrase *peinture au point* ('painting in dots') used in 1886 to describe Georges Seurat's masterpiece *La Grande Jatte* (Art Institute, Chicago). However, Seurat and his chief disciple, Paul Signac, preferred the word *Divisionism. *See* NEO-IMPRESSIONISM.

pointing machine A device capable of three-dimensional measurement, used for making an exact copy of a statue. In its most elementary form, as used by Greek and Roman sculptors, it consisted of a cage constructed round the model corresponding in its dimensions to the stone block from which the new sculpture was to be carved. Measurements were then taken

from the top and sides to various key points on the original and the block was cut down in accordance to the data thus obtained. The use of pointing machines was revived in *Renaissance Italy, stimulated by its renewed interest in the art of antiquity and its own vigorous sculptural production. More sophisticated pointing machines were developed in the 18th and 19th centuries which were capable of taking measurements from a small sculptural model and scaling up, providing the measurements for the full-scale final sculpture. Perhaps the most celebrated of all sculptors to make extensive use of the pointing machine was the great *Neoclassical sculptor Antonio Canova (1757–1822). The procedure was directly analogous to the preliminary sketch and final composition in painting. These more sophisticated *pantographic machines consisted of an upright stand carrying movable arms, each of which had attached to it an adjustable rod used to measure a particular point on the original. Measurements could be scaled up accordingly.

polychrome A term meaning painted, printed, or decorated in many colours. It is most frequently used in relation to sculpture, especially pre-*Renaissance, much of which was originally coloured. In the Renaissance white marble, in imitation of the antique, became the dominant material. A strong tradition of polychrome sculpture survived in religious art produced in Spain and Naples in the *Baroque era and polychromy continued in the art of the *Rococo in southern Germany and Austria.

polymer colour An alternative name for *acrylic paint or any similar paint based on plastic polymers.

polyptych [Greek *polyptychos*, 'of or with many folds'] an object with several *panels, usually an altarpiece. A polyptych normally consists of a centre panel with an even number of side panels which are often hinged to fold. In practice, the term is normally used for anything larger than a *triptych.

Pompeian Revival A decorative style derived from the frescoed rooms unearthed at Herculaneum (from 1738) and Pompeii (from 1748). It is distinguished by rather flimsy and fantastical architectural features allied to a strong preference for a dull, dark terracotta red called 'Pompeian red'. The Pompeian style first became popular in the late 18th century and continued into the middle of the 19th. It was found mainly in wall decorations, *wallpaper, furnishing textiles, *painted furniture, and *ceramics.

pompier A pejorative term applied to French artists of the 19th century (such as Adolphe-William Bouguereau) working in an unoriginal manner, mainly in a late *Neoclassical style. The word alludes to the habit of posing nude models wearing firemen's helmets to substitute for ancient helmets (*pompier* means 'fireman' in French).

Pont-Aven School The group of painters associated with Paul Gauguin in Brittany. The name is taken from the little town of Pont-Aven in the south of

Brittany in which Gauguin stayed on a number of occasions 1886–94 and where he painted some of his best-known works such as the *Vision after the Sermon* 1888 (National Gallery of Scotland, Edinburgh) and the *Yellow Christ* 1889 (Albright-Knox Art Gallery, Buffalo). Although Gauguin's professed aim was to discover a primitive 'ideal' in Brittany, in reality Pont-Aven had already been extensively developed since the 1860s as an artists' colony, mainly by Americans. However, they are largely forgotten today and by Pont-Aven School is usually meant associates of Gauguin such as Paul Sérusier, Meyer de Haan, Emile Bernard, Armand Séguin, and Roderic O'Conor.

pontil mark The round mark made on *glass by breaking off the pontil or iron rod used in making the piece. On older glass the mark is usually still rough on the base.

Pop art A term coined by the English critic Lawrence Alloway to describe a movement in modern art which flourished, mainly in the United States and Britain, from the late 1950s to the early 1970s. Pop art drew its imagery from the world of consumerism and popular culture, claiming no distinction between good and bad taste. In a sense it gave validity to a new *iconography based on the culture of the everyday. In its desire to shock or reject the supposed higher ideals of more intellectual art it had some links with the earlier *Dada movement. However, any pretensions to iconoclasm on the part of most Pop artists were in part compromised by the monumental status and beauty they accorded much of their allegedly banal imagery: for example, in the United States, Jasper John's paintings of flags and targets and his sculptures of ale cans; Robert Rauschenberg's *collages with Coke bottles, stuffed birds, and photographs from newspapers and magazines; Andy Warhol's *screenprints of Campbell's soup-tins, heads of Marilyn Monroe, etc. In Britain notable Pop artists included Allen Jones, Eduardo Paolozzi, Derek Boshier, and Richard Hamilton, who wittily described Pop art as 'popular, transient, expendable, low-cost, mass-produced, young, witty, sexy, gimmicky, glamorous, and Big Business'—a definition which could equally have been applied to the popular music of the age and its associated culture, so nostalgically celebrated in the paintings of the British Pop artist Peter Blake.

poplar A light coloured, fine-grained wood which was traditionally used in Italy as the *support for *panel paintings. *See* OAK.

populist A label currently attached to the architecture of structures such as the various Disneyland theme parks throughout the world. In the new town of Celebration (opened 1996), Florida, just down the road from Disney World, *kitsch meets *Modernism with sculptures of the Seven Dwarves adorning the facade of the main office headquarters and a town hall of pure white in the shape of Snow White.

porcelain A hard, white, translucent *ceramic *body, which is fired to a high temperature in a *kiln to vitrify it. It is normally covered with a *glaze and decorated, under the glaze (usually in cobalt), or, after the first firing,

over the glaze with *enamel colours. If left unglazed it is called *biscuit porcelain. It is usually divided into two types, *hard-paste, or true porcelain, and *soft-paste, or artificial porcelain. True porcelain was first made by the Chinese in the 7th or 8th century AD, using *kaolin (china clay) and *petuntse (china stone), which were easily available. There were many attempts to reproduce this in Europe. An artificial porcelain was first made at the Medici factory in Florence from 1575 until about 1587, using a large proportion of ground *glass mixed with china *clay to give translucency. From 1700 soft-paste porcelain was produced in France. Kaolin was discovered in Europe in the early 18th century, in Saxony, and the first hard-paste porcelain was made in 1709 by Johann Friedrich Böttger at *Meissen. The secret formula, or *arcanum, spread throughout Europe and factories opened in Vienna (1719), *Nymphenburg (1747), *Berlin (1752), and elsewhere. In England, kaolin was not found and used until 1770 (at *Plymouth), so early factories, such as *Chelsea, *Bow, *Derby, and *Worcester, made soft-paste porcelain. In 1799, Josiah Spode developed a porcelain body containing bone ash, which proved both durable and attractive and, as *bone china, became the standard *paste used in England.

porcelain room A room, common in palaces throughout Europe from the middle of the 18th century, to display a *porcelain collection, or, more unusually, made of porcelain. The Museum für Angewandte Kunst in Vienna has a room from the Dubsky Palace in which the chandelier, *sconces, and *chimney piece are all of Vienna (du Paquier) porcelain and the walls, mirrors, and furniture are inset with porcelain plaques of 1725–35.

porphyry A hard igneous rock of which the most famous type, 'Imperial' porphyry, is deep red or purple in colour and speckled with feldspar. It was quarried at Mons Igneus, Gebel Dokham in Egypt and greatly prized by the ancient Romans. Porphyry is now more generally used to describe rocks of various rocks of different colours, including green porphyry from Greece.

porringer A small bowl with one or two handles, usually made of *silver or *pewter, and popular in England and America from the 17th to the 19th centuries.

port crayon [French, 'chalk holder'] an instrument for holding a piece of *chalk, *crayon, or *pastel used for drawing.

porte-cochère A carriage entrance, or porch large enough to admit a vehicle to pass from the street to a court behind.

portfolio A protecting and carrying cover for drawings and similar works on *paper. It is usually made with two sheets of board, covered and hinged at one of the long sides. The other three sides are provided with tapes for tying the portfolio shut, and flaps are sometimes attached for protecting the edges of the contents. By extension, a 'portfolio' can also refer to a body of work contained therein which is presented, for example, by a student artist for examination or for the purpose of gaining entry to an artistic institution.

portico A covered area before the entrance to a building. A portico usually forms the central element in the facade and is grander than a mere porch. From the *Renaissance onwards porticoed buildings usually made reference to *classical architecture and the portico itself, open to the elements on one or three sides, resembled a temple entrance, usually with a triangular *pediment supported by columns. Porticoes were important features of much 18th- and 19th-century architecture. In classical architecture a portico could also denote a covered colonnade in a public area such as a market.

Portland stone A high quality limestone from Portland, Dorset, which bleaches white when exposed to the elements. It was first used for architecture and sculpture in 17th-century London, for example St Paul's Cathedral, and its environs. Improvements in steel tools and in the means of transport contributed to its widespread use in 19th-century Britain for grand, particularly classical architecture.

posset pot A vessel for posset (hot milk curdled with ale or wine and seasoned with spices). They were made in England in the 17th and 18th centuries of *slipware, *stoneware, *tin-glazed earthenware, or *glass.

post-and-lintel Any type of architectural construction with uprights and horizontal beams to carry the loads. *See* LINTEL.

poster Developed in the 19th century, the poster is a printed design of images and words on paper, produced in large numbers for the purposes of publicizing its subject through visual display. Its evolution was closely linked to the introduction of *lithography, a printmaking technique which facilitates the rapid production of large editions. With the advent of colour lithography the poster reached its apogee as an art form and its greatest exponent was undoubtedly Toulouse-Lautrec at the end of the 19th century, though it should be borne in mind that artists such as Lautrec produced the coloured drawings from which specialized master printers worked to produce the resulting poster. Most modern posters are produced by photolithographic means.

poster paint Inexpensive opaque colours made with a simple water-soluble *binder such as gum or glue-size and sold in jars. They are much used in children's art classes.

Post-Impressionism As the name implies, a term used to describe developments after and arising from *Impressionism. It was first coined by the English painter and critic Roger Fry (1866–1934), who organized the exhibition *Manet and the Post-Impressionists* held at the Grafton Galleries, London in 1910–11. The imprecision of such an umbrella term, for all its undoubted usefulness, is demonstrated by the wide variety of developments from Impressionism: the quasi-scientific examination of colour by Seurat and the *Neo-Impressionists; the structured examination of landscape by Cézanne in which lay the seeds of *Cubism; the writhing,

expressive brushwork of Van Gogh; the flat colour *Symbolism of Gauguin and his followers.

Post-modernism A term which describes the reactions to the dominance of *Modernism in architecture and the visual arts. It came into use in the 1970s, at first mainly in connection with architecture, and then later with the visual and decorative arts. Post-modernist architecture is in fact an eclectic fusion of Modernism and selected classical elements. It is inventive, often playful, and frequently mannered. In contrast to the clean logicality of the best Modernism, Post-modernism proposes imbalance, disjunction, and spatial ambiguity. Its best-known exponent is the American architect Robert Venturi. As a definition, Post-modernism is harder to pin down in the visual arts, being a reaction against the formalism of Modernism, and embracing such disparate groups as the American and German *Neo-Expressionists and the Italian 'Bad Boys'.

Post-Painterly Abstraction A general term introduced by the American critic Clement Greenberg in 1964 to cover the wide variety of artists who broke away from the previously dominant style of *Abstract Expressionism and were still working in an abstract manner. They rejected 'painterly' qualities such as expressiveness and a fascination with *facture, and instead opted for coolly planned and unmodulated areas of colour.

pot pourri vase A vessel to hold aromatic leaves and petals, made in *porcelain at *Meissen from 1748 and later at many other European porcelain and *faience factories.

pottery A coarse textured ware made from *clay and fired in a *kiln. The earliest examples date from the Neolithic period when nomadic life was abandoned and settled life began. Early pieces were hand built, using a thumb pressed into a ball of clay, or coiled, where a long strip of clay is coiled into a pot and pressed together. The wheel was the main piece of equipment used in manufacture and was known in ancient Egypt, China, and the Near East. Pottery is normally divided into two types, depending on the temperature it is fired at in the *kiln. *Earthenware is normally fired up to 1,000 degrees celsius, to produce a fairly coarse body. It is *glazed in order to make it non-porous, usually with a translucent lead glaze, or an opaque white *tin-glaze, when it is known as *faience, *delft, or *maiolica. *Stoneware is fired up to 1,400 degrees celsius to produce a close-textured, non-porous body, which can be white, brown, red, or buff, depending on the natural colour of the clay. It can be left unglazed, or glazed with the addition of salt in the kiln, when it is known as *salt-glazed stoneware.

pouncing [French *poncer*, Italian *spolvero*] known in China from the 10th century, and in Europe from the 14th, pouncing is a transfer technique. The contours of the original design are pricked at regular intervals. It is then laid over the surface (paper, cloth, wall, or panel) to which it is to be transferred and rubbed with 'pounce' to create a dotted drawing underneath. The 'pounce' is dark coloured if the surface to which it is to be applied is light, or vice versa. Pouncing was used mainly during the Italian

*Renaissance for transferring a *cartoon to the moist plaster in *fresco painting. A particularly large number of pounced drawings by Raphael survive, testament to his reliance on the ordered workshop procedure for the production of his art.

poupée, à la Colour printing in which the various colours are all applied to the printing surface before printing takes place. Only a limited number of *impressions can be pulled before re-inking is required.

Poussinisme One of two conflicting currents in French art, the one supporting the balanced, intellectually rigorous art of Poussin, the other the more colourful and sensual manner of Rubens (*Rubénisme). This dichotomy was debated at length during the so-called *Querelle du coloris* ('Dispute on colour') which lasted 1672–8. It was instigated by the criticism voiced by the painter Philippe de Champagne at a lecture given at the French Royal Academy of Painting and Sculpture in 1671 in which he denigrated the painting of Titian, but praised the art of the recently deceased Nicolas Poussin (1594–1665). The *Poussinistes* took the mature work of Poussin as their point of departure and also admired classical sculpture and Raphael. Theirs was an essentially academic canon which valued design, decorum, and the correct expression of the passions, and they had a powerful supporter in the Director of the Academy, the painter Charles le Brun. Essentially, the Poussin/Rubens debate was a restatement of the design versus colour debate in Italian art which had surfaced during the *Renaissance and whose champions were Florence and Rome on the one hand, and Venice on the other. *Poussinisme* continued to be the inspiration of classically minded artists in France until the early 19th century.

praticien The French word for a skilled *marble carver who worked as an assistant to a master sculptor. In the 19th century sculptors increasingly confined themselves to modelling and the *praticiens* transferred the design to marble using *pointing machines.

prattware An *earthenware or *creamware decorated in a characteristic palette of yellow ochre, green, blue, and brown and made widely throughout England and Scotland in the early 19th century.

precious stone One of the four intrinsically valuable gemstones, *diamond, *sapphire, *ruby, and *emerald, which are used in jewellery.

Precisionism A type of painting which evolved in America in the 1920s, took its formal language from *Cubism, and depicted forms in a sharply defined manner. Typical subject-matter included skyscrapers, bridges, docks, chimney-stacks, and barns. The scenes were usually highly structured and devoid of figures, but unlike in Cubism, made no play on *abstraction. The three major Precisionist painters were Charles Demuth, Georgia O'Keeffe, and Charles Sheeler.

pre-Columbian art A term derived from the name of the explorer Christopher Columbus, traditionally credited with the discovery of the

Americas in 1492. It is used to describe art made by the indigenous peoples of Meso-America (part of Mexico and Central America) and the Andean region (western South America) before the Spanish exploration and conquest of those regions in the 16th century. Among the highly sophisticated cultures included under this label are those of the Mayan, Aztec, and Inca civilizations.

predella [Italian, 'platform', 'altar step'] the horizontal band, cut from a single plank, below the main panels of an *altarpiece. The small scenes painted on the predella form part of the integrated *iconographic programme of the altarpiece, which often reached a high level of sophistication during the *Renaissance. Sadly, many predellas containing a sequence of painted scenes were later separated from their original altarpieces and cut up and sold as individual paintings.

prehistoric art Art created before the existence of written records, the period varying enormously between different cultures. Writing came into existence in various parts of the world between the 4th and 1st millennia BC. Much of our knowledge of prehistoric art and culture, therefore, has been derived from archaeological investigations. In Europe the ending of the prehistoric period is often associated with writings about European Iron Age societies by classical authors. The term 'prehistoric' was first coined by a Frenchman, Gustave d'Eichthal, in 1843. In the 20th century the term has been criticized in some quarters as patronizing and implying a western sense of superiority over 'backward' cultures.

Pre-Raphaelite Brotherhood A group of English painters, founded in 1848, who took as their inspiration Italian art which predated the *Renaissance, i.e. 'before Raphael'. They admired the simplicity and sincerity of *Quattrocento art, which they came to know through prints such as the line engravings made by Lasinio after the *frescoes in the Campo Santo at Pisa. Conversely, they detested much academic art, which they found heavy and debased, and despised contemporary *genre painting with its trivial anecdotage. The founding members of the group were John Everett Millais, Dante Gabriel Rossetti, and William Holman Hunt, later to be joined by the painter James Collinson, the sculptor Thomas Woolner, and the art critics W. M. Rossetti and F. G. Stephens. Though never a member, Ford Madox Brown came to be associated with the group. The initials 'PRB' were first seen in public on Millais's *Lorenzo and Isabella* (Walker Art Gallery, Liverpool) exhibited in 1849. The three original members were only 21 when the group was founded and their humour was suitably high-spirited: thus suggested interpretations of the famous acronym included 'Please Ring Bell' and 'Penis Rather Better'. The subject-matter of Pre-Raphaelite art was predominantly literary, drawing on a wide range of sources including the Bible, Shakespeare, Keats, and Tennyson. Technically, the Pre-Raphaelites brought about a revolution, banishing the heavy, dark colours of much academic painting and replacing them with bright, naturalistic detail painted on a wet, white *ground to give added brilliancy. By 1853 the group had virtually dissolved, with only Hunt

remaining true to Pre-Raphaelite doctrines. The name stuck to Rossetti and his followers William Morris and Edward Burne-Jones, however, and the term Pre-Raphaelite is often associated, somewhat mistakenly, with the dreamy, yearning images of women they produced.

presbytery The part of the church containing the *altar, reserved for officiating clergy. The presbytery can also be the priest's house or *parsonage.

presentation drawing A term coined in the 20th century by the Hungarian art historian Johannes Wilde to describe certain drawings made by Michelangelo, for example those he gave as presents to various aristocratic young men. Presentation drawings were finished, non-utilitarian works of art, as opposed to preparatory drawings for a work in another medium. The earliest known presentation drawings dating from the Italian *Renaissance are two drawings of the 1420s by Lorenzo Monaco.

pricking The puncturing of a *cartoon with a needle, following the line of the drawn design, prior to its transferral via *pouncing to the painting surface. *See* POUNCING.

prie-dieu [French] a small prayer desk.

primary colour One of the three chromatic colours—red, yellow, and blue—from which all other colours may be mixed, with the assistance of black and white.

priming In painting the layer applied immediately over the *ground, providing a modified colour base and/or textured surface on which to paint. Today priming is synonymous with ground.

Primitifs, Les A group of artists, from the studio of Jacques-Louis David (1748–1825), formed in 1797 in reaction to that master's *Intervention of the Sabine Women* (Louvre, Paris). In their quest for an extreme neo-Grecian purity and simplicity in their art Les Primitifs denounced David as being too decorative and *Rococo. The members of the group were relatively minor figures and by 1801 they had left David's circle and withdrawn to a disused convent at Chaillot, where they wore ancient Greek dress and practised vegetarianism. Their ideas, however, had some influence on artists such as Gérard and Ingres.

primitive A term which used to be applied to the art produced by cultures such as those of Africa and the Pacific Islands, which were perceived by western historians and critics to have undergone little if any evolution. Such a use is now viewed as patronizing and pejorative, however, and symptomatic of unjustified western feelings of cultural superiority. A second use of the term pertains to the work of western artists such as Henri Rousseau (1844–1910) and Grandma Moses (1860–1961), self-taught painters all but unaware of the avant-garde currents of their day.

primitivism The approbation of and enthusiasm for *primitive art, generally understood to mean the art of Africa and the Pacific Islands.

Western artists had a particular interest in this type of ethnic art c.1905–c.1935, beginning with the *Fauves, *Cubists, and Die *Brücke who incorporated elements of it into their own work. This in turn led to a deeper study of this subject by both anthropologists and art historians.

print An image or design impressed or stamped on a support such as paper or fabric. The term encompasses a wide range of techniques used to produce multiple versions of an original design. *See* DRYPOINT; ENGRAVING; ETCHING; JAPANESE PRINTS; LITHOGRAPH; MEZZOTINT; SCREENPRINTING; WOODCUT; WOOD-ENGRAVING.

priory A small *monastery, dependent on an *abbey, governed by a prior or prioress.

private presses Printing presses set up by individuals or groups for essentially non-commercial purposes and for the furtherance of particular artistic ideals. Perhaps the most celebrated was the Kelmscott Press instigated by William Morris which revived the interest in fine *typography and book production around 1900. English private presses brought about the revival of *wood-engraving in the early decades of the 20th century.

Prix de Rome [French, 'Rome Prize'] the foremost student award given by the French Academy to architects, sculptors, and painters, the winners of which took up scholarships at the 'Académie de France à Rome' (established 1666) and resided there as *pensionnaires*. During their time in Rome they were expected to study and copy from the major works of *classical and *Renaissance art there. *History painting rapidly became the dominant genre as far as the painting prize was concerned. The painting competition, held in Paris, took the form of ten finalists being confined to their cells (*loges*) where they had ten weeks to complete their entries on a set theme. The Prix de Rome enjoyed its greatest years in the late 18th and early 19th centuries when the winners included David and Ingres. The administration of the prize passed in the Revolution to the Institut de France and École des Beaux-Arts, which replaced the Académie. In 1817 a prize for Historical Landscape was set up, though this was contested only every four years as opposed to the usual annual main competition. The landscape prize was discontinued in 1863, whereas the main Prix de Rome lasted until 1968 when it fell victim to the changes wrought in French society by the student unrest of that period and was abolished by André Malraux, the Minister of Culture.

production art *See* INKHUK.

profil perdu [French, 'lost profile'] a profile of a human head that is not seen directly side-on, but more from the back of the head.

projection Any part of a structure or fabric which obtrudes or projects. An 'architectural projection' is a drawn representation to show and explain a design, giving it the illusion of three dimensions.

pronkstilleven [Dutch, 'ornate still life'] a category of 17th-century still-life painting distinguished by its large and complex compositions and elaborate colouring. The type originated in the 1640s in Antwerp where artists such as Frans Snyders and Adriaen van Utrecht produced still lifes which gave an impression of overwhelming abundance in their diversity of objects, fruits, flowers, and dead game, often accompanied by living human and animal figures. It was rapidly taken up in Holland where its leading practitioners included Jan Davidsz. de Heem, Abraham van Beyeren, and Willem Kalf. *See* BREAKFAST PIECE.

proof Generally the term can be used to describe any print, but more specifically the *impression of a print taken from a plate or block before the published edition.

proportion The mathematical relationship of the parts in any composition to each other and to the whole. More specifically, it refers to the mathematical and geometric relationships of the parts of the human body and the ratio of each part or unit of parts to the whole mass and form. The proportions of the human body have been debated throughout the history of art, the most famous early treatise being Vitruvius's *De Architectura* written in the 1st century BC. Major *Renaissance studies of the subject included those by Leonardo da Vinci and Albrecht Dürer.

propylon [Greek, literally 'in front of the gates'] an ancient Greek monumental roofed gateway, originally to a religious sanctuary; the term was later expanded to include civic buildings. A simple propylon had an outer and an inner porch separated by a wall; more elaborate propylaia had three or more doorways.

provenance The listing of the previous ownership of a work of art, forming an essential part of its history. Provenance is usually given in the entries for works of art in scholarly catalogues of a particular collection or artist's *oeuvre.

Prussian blue Developed in the early 19th century, it is the earliest of the modern synthetic colours and is a complex chemical compound. Prussian blue is fairly permanent but is very sensitive to alkalis and cannot, therefore, be used in *fresco.

psalter A liturgical book containing the 150 psalms of the Old Testament and divided into sections for use at Matins and Sunday Vespers. In addition to the psalms, psalters generally also contained the ecclesiastical calendar, canticles, creeds, and the litany of the saints.

pulpit An elevated stand for a preacher or reader in a church, made of stone or wood. Pulpits came into general use in the later Middle Ages. They were often elaborately carved and sometimes had an acoustic canopy with which to amplify the speaker's voice.

punch A tool used to stamp designs on surfaces such as *gilded *gesso panels and leather articles. A punch is usually a slender, tapering, small rod

of steel or *brass with the design cut onto its point. The design is stamped onto a surface by holding the point of the punch against it and striking it with a light mallet.

Purbeck marble A dark *limestone from the Isle of Purbeck in Somerset, widely used in English medieval cathedrals (such as Salisbury), and some in Normandy, for *column *shafts and tomb slabs. It was relatively fragile and therefore put to decorative rather than structural use.

Purism A movement in French painting which flourished *c*.1918–25 and was set up by its founders Amédée Ozenfant and Le Corbusier in reaction to the perceived degeneration of *Cubism into a mere decorative art. Purism eschewed emotion and expressiveness and advocated 'the spirit of the age', setting great store by 'the lessons inherent in the precision of machinery'. Typical Purist paintings were still lifes which were cool, clear, and impersonally finished. Purism had little effect on French painting and its most lasting legacy lay in the theories and buildings of Le Corbusier.

putto [Italian, 'little boy'] a chubby, naked child, represented in art since *classical times, often as a decorative feature. Originally derived from ancient representations of Eros, the Greek god of love, since the *Renaissance putti have often been associated with his Roman counterpart, Cupid. *See* CUPID.

pyramid A monumental structure with a square or triangular base and inclined triangular sides meeting at a point. The most famous pyramids are those used as *mausolea in ancient Egypt, though they are also found in Central American *pre-Columbian architecture.

pyxis [Greek *pyxos*, 'box-tree'] a covered cylindrical box, originally used in *classical times as a toilet box or container for jewels or incense and made of box-wood. Later examples were made of metal or *ivory. The shape was adopted as early as the 4th century by the Church to hold relics or the reserved Host. Most *Early Christian pyxides were made of hollowed-out sections of elephant tusks closed at one end with an ivory disc. In the 13th and 14th centuries small *enamelled copper pyxides with conical covers, made in Limoges, became popular in the West.

Q

quadratura Illusionistic painting in which the architectural elements of a wall or ceiling painting appear to be part of the real architectural setting. Common in Roman art, it was revived by Mantegna in the *Renaissance, became widespread in northern Italy, and reached its peak in *Baroque Rome where its greatest exponent was the painter and architect Andrea Pozzo (1642–1709), whose masterpiece was the ceiling of S. Ignazio. Many artists employed specialist *quadraturisti* to paint architectural settings for their figures.

quadri riportati [Italian, 'carried paintings'] mural and ceiling paintings given surrounds in the form of painted illusionistic picture frames as though they were suspended easel pictures; a variation on *quadratura* painting. The most celebrated examples are Michelangelo's Sistine Chapel ceiling (1508–12) and Annibale Carracci's cycle of the *Loves of the Gods* (1597–c.1608) in the Palazzo Farnese, Rome.

quaich A Scottish drinking bowl, circular in form, with two flat handles. Originally made of wood, later examples are of *silver or *pewter.

quarterly A division of a heraldic shield into four compartments as if by a cross.

quartz A mineral form of silica, used since ancient times in sculpture and particularly valued when tinted rose or smoky grey, or when transparent (when it is known as *rock crystal). Many hardstones are types of quartz, including *agate, *amethyst, bloodstone, *chalcedony, and *cornelian, and were most frequently fashioned into miniature works of art.

quartzite An extremely hard form of beige or brown *sandstone, used by the ancient Egyptians for monumental sculpture.

quatrefoil A decorative architectural form consisting of four arcs, with *cusps, in the shape of a flower with four leaves. Bands of quatrefoils were much used as ornaments in *Perpendicular architecture of the *Gothic period.

Quattrocento [Italian, 'four hundred'] a term used to describe the 15th century (the 1400s) in Italian art.

Queen Anne Revival Also known as the Free Classic style, an architectural style popular from the 1870s until the early 20th century in England and the United States. It developed in reaction to the *Gothic Revival and drew freely from the late 17th- and early 18th-century brick houses of the William and Mary and Queen Anne periods. It was characterized by asymmetrical plans, the use of red brick, and a mixture of medieval and classical motifs. Its origins can be found in buildings such as

William Morris's Red House (1858) at Bexleyheath, London, designed by
Philip Webb and influenced by 17th-century Dutch architecture. Queen
Anne Revival came to be associated with progressive social attitudes and a
desire to make good design widely available, for example in the many Board
School buildings, distinguished by their Flemish gables, constructed in
England subsequent to the Elementary Education Act of 1870. The greatest
contribution of the Queen Anne Revival style was in the realm of private
houses, however, such as Norman Shaw's Cragside in Northumberland or,
in London, the houses of the Cadogan estate in Cadogan Square and Pont
Street.

quoin [From the French *coin*, 'corner'] the dressed stones at the external
angles of buildings.

R

radiating chapel A *chapel which projects radially from the *apsidal *ambulatory of a large *church. Such chapels are found in Continental churches of the *Romanesque and *Gothic periods. Their origin lay in the growing custom of more priests saying Mass every day, hence the need for more *altars and chapels to accommodate them.

raking light Applied across an artwork such as a painting at an acute angle can reveal damages and imperfections. Raking light photography is often used to aid investigations prior to restoration.

raku Japanese *pottery made for the tea ceremony, usually of an irregular shape and texture. It was fired at a low temperature and covered with a thick, usually dark, coloured *glaze. The name derives from the Japanese word 'enjoyment', which was adopted as a seal by the family of potters who first made this ware, *c.*1580.

rasp A toothed metal *file used for shaping and smoothing *plaster, *ivory, stone, and wood. It usually leaves a scratchy surface which can be smoothed with abrasives.

raw sienna A brownish-yellow *earth colour obtained from a natural clay containing iron and manganese, raw sienna is one of the basic artist's colours and is often used for flesh colours. As its name implies, raw sienna was originally found near the the Tuscan city of Siena and the best grades are still imported from Italy. *See* BURNT SIENNA.

Rayonism A type of abstract or semi-abstract painting practised in Russia 1912–14 by Natalia Goncharova and Mikhail Larionov and their followers. It represented a fusion of the various leading contemporary European styles at that time, as Larionov claimed in his 1913 manifesto 'Rayonism is a synthesis of *Cubism, *Futurism, and *Orphism'. It was also bound up, however, with a rather confusing theory of invisible rays or lines which were thought to be emitted by objects and were, in their turn, intercepted by other objects in their vicinity. It was the artist's task to manipulate them for his own artistic purposes.

rayonnant [From the French, 'radiating'] used in particular to describe French *Gothic *tracery which appears as rays bursting forth.

ready-made A term devised by Marcel Duchamp to describe pre-existing, mass-produced objects, selected at random, which were then accorded the status of works of art. His first ready-made was a bicycle wheel mounted on a stool (1913). Ready-mades differed from *objets trouvés (found objects such as stones, shells, etc.) as the latter were chosen for their aesthetic beauty. Perhaps the most notorious ready-made was *Fountain* (1917),

consisting of a urinal which Duchamp signed 'R. Mutt'. The ready-made was one of Dada's most enduring legacies to modern art and was adopted by both *Nouveau Réalisme and *Pop art.

Realism A term used generally to refer to art in which subjects from real life are depicted. More specifically, it has been associated with a movement in French painting which lasted from c.1830 to the 1860s and deliberately eschewed the obscure subjects normally found in academic art in order to concentrate on portraying contemporary themes, including urban or rural life, landscapes of the various regions of France, still lifes, and portraits of the artists' families and friends. This democratization of art received considerable impetus from the 1830 Revolution and ensuing July Monarchy, the supporters of which were of a liberal political persuasion. By the 1850s the painter Gustave Courbet was generally perceived as the leader of the movement and his circle of artist and writer friends met at the Brasserie Andler in Paris where Courbet put forward his theories of Realism, which he published in a manifesto entitled *Réalisme* to accompany his purpose-built Pavillon du Réalisme in 1855. A number of influential critics also played important roles, including Courbet's major supporter Champfleury, and also Théophile Thoré and Jules Antoine Castagnary. In their writings they stressed that art should be made available to all the people and should record the visible world rather than obscure *allegories and histories. Certain artists of the past were greatly admired and cited as worthy of study, including Caravaggio, Velázquez, the Le Nain brothers, Chardin, Rembrandt, and Vermeer. Contemporary *genre painting was also promoted because it could emphasize the factual and at the same time include common customs and traditions. In the mid-1860s the novelist and critic Emile Zola proclaimed Realism and its practitioners such as François Bonvin to be outdated and too reliant on tradition. This was partly a ploy to promote the paintings of his friend Edouard Manet, but it was also symptomatic of aspects of avant-garde opinion which welcomed the technical advances and more brilliant colouring of the young *Impressionists.

rebate A groove or channel cut in one member so it may receive another: for example, so that a window opening may receive the window frame, or that a picture frame may receive a panel or canvas.

rebus [From the Latin phrase *de rebus quae geruntur*, 'concerning the things that are taking place'] a word, usually a proper name, represented by a picture. In the Middle Ages a rebus was often adopted as a badge by ecclesiastics and others not entitled to bear arms.

reçu [French, 'received'] denoted the award to an artist of full membership of the French Royal Academy on the acceptance of his *morceau de réception* ('reception piece')

red-figure vase painting The style of Greek vase painting of the 6th and 5th centuries BC which succeeded *black-figure vase painting. The background and outlines of the figures were painted in black *slip, leaving

the design in the red of the *clay. Details could be added in black with a *brush, leading to greater sophistication.

reeding Decoration consisting of parallel convex moulding, often found on various types of columns; the opposite of *fluting, which is concave.

refectory The dining-hall of a college, *monastery, etc.

refractive index The refractive index of a *medium (such as the oil used as the medium in *oil paint) is expressed as the ratio of the velocity of light in free space in that medium. The opacity or translucence of a paint film is in part determined by the difference between the refractive indices of the *pigment and the medium in which it is suspended. A pigment with a high refractive index (such as titanium oxide or vermilion) will be opaque in an oil medium. Conversely, a pigment with a relatively low refractive index (such as *whiting) will be transparent in oil: in an aqueous medium it is opaque, however, due to the different refractive index of that medium. The refractive index of oil increases with age, causing the paint to appear more transparent and often revealing underlying *pentimenti.

Regency style A modern and imprecise term for the English late *Neoclassical style of the early 19th century. It is a useful label for the period from the 1790s until the early Victorian 1840s. Strictly speaking it should refer to the Regency (1811–20) of George, Prince of Wales, who ruled as George IV (1820–30). It is most commonly applied to the *decorative arts of the period, in particular furniture, *silver, and *porcelain.

Regionalism A movement in American art, dating from the 1930s and 1940s, which concentrated on the depiction of scenes and types from the American West and Deep South. Its concern was to develop specifically national imagery, often in celebration of small-town America, in a relatively traditionalist style and in opposition to the then perceived domination of French art. The most vociferous member of the group was Thomas Hart Benton and other prominent figures included Grant Wood, Andrew Wyeth, and Edward Hopper. Many of these artists produced outstanding *lithographs in addition to their paintings.

registration In colour printmaking requiring separate screens, plates, or blocks for each colour, these must be accurately 'registered' or placed correctly in the printing process to ensure they print over the same area.

relative humidity The ratio of the mass of water vapour per unit volume of the air to the mass of water vapour per unit volume of saturated air at the same temperature. Relative humidity is usually expressed as a percentage to indicate the humidity (i.e. the amount of water vapour present in the air) of a particular environment. Rapid changes in the humidity level can damage works of art; for example *panel paintings can split. Excessive humidity can saturate a work such as a *tapestry, causing the colours to run and can encourage the growth of fungi, etc. The normally accepted standard for humidity in relation to the protection of artworks is 55 per cent

± 5 per cent. Many public museums and galleries now have air-conditioning plants installed with which to control the interior temperature and humidity.

relief [From the Italian *rilevare*, 'to raise'] a sculpture made so that all or part of it projects from a flat surface. *See* LETTERPRESS; WOODCUT.

relining The replacement of a *linen *lining (for which relining is a common misnomer) originally applied to the back of an oil painting on canvas in order to strengthen it.

reliquary A vessel to hold the relic or relics of a saint, it is usually made of precious metals and richly decorated.

Renaissance Originally a French term (*renaissance*, 'rebirth') pertaining to cultural history, it is now employed to describe the arts in Italy from the early 14th to the mid-16th centuries. By extension it is also more loosely applied to other European countries of that era. It was first sanctioned as descriptive of a particular period and all that happened in it by the French historian Jules Michelet in a section entitled *La Renaissance* (1855) of his history of France. The Swiss historian Jacob Burckhardt specifically associated the term with Italy in his *Civilisation of the Renaissance in Italy* (1864), in which he stressed, albeit in a somewhat discursive manner, the difference of the 'Renaissance' from what went before (the so-called 'Dark Ages') and after. For cultural historians such as Burckhardt the term is all-embracing and covers the arts and sciences and politics. Art historians have based their perception of the Renaissance on the *rinascita* in the arts proposed by the artist and writer Giorgio Vasari in his *Lives of the Artists* (1550). According to this tradition, Renaissance art was based on renewed study of the art of antiquity and of nature. Vasari saw himself as living in a 'New Age'. Its 'Infancy' had been marked by Giotto and Cimabue in painting, Arnolfo di Cambio in architecture, and the Pisani in sculpture. 'Adolescence' had been reached through the art of Masaccio, Donatello, and Brunelleschi, and 'Maturity' had begun with Leonardo da Vinci and culminated with the model of the *uomo universale*, Michelangelo. Although the validity of the term 'Renaissance' has been frequently challenged (earlier 'rebirths' of interest in classical art and learning have been labelled 'renascences') it remains enormously useful, for all its imperfections. It is irrevocably associated in popular understanding with masterpieces such as Michelangelo's sculpture of *David* (Accademia, Florence), Leonardo's painting of the *Mona Lisa* (Louvre, Paris), and Bramante's building of the Tempietto of S. Pietro in Montorio, Rome.

repairer A worker in a *ceramic factory responsible for joining together separately cast or moulded pieces of a figure or object before *firing.

repoussé [French, 'pushed back'] *relief decoration on metal which is achieved by hammering and punching mainly from behind so the decoration projects. It was one of the first metal-working techniques to be developed and is found in many early civilizations.

repoussoir [From the French *repousser*, 'to push back'] an object, motif, or figure placed in the right or left foreground of a picture to act as a framing element which leads the spectator's eye back into the composition.

reredos A wall or screen, of wood or stone, rising behind an *altar in a church. It is usually ornamented with *niches, pinnacles, statues, etc., or may have a painting, often in the form of a *triptych.

resin A natural resin is a sticky flammable organic substance, insoluble in water, exuded by certain plants and trees (notably fir and pine). Synthetic resins can also be manufactured. Resins are mainly used in the production of picture *varnishes.

retable A shelf behind an *altar, or a carved altarpiece behind the altar and below the *reredos.

reticulated Used to describe masonry which is decorated or cut in a net-like pattern.

retroussage [From the French *retrousser*, 'to roll up'] a method of removing excess ink from an *intaglio printing plate after it has been inked, but prior to printing. The plate is blotted with balls of cotton gauze or muslin which absorb the excess ink.

reveal The side of an opening in a wall between the framework, such as a door or window frame, and the outer wall surface.

reverse The back of a *medal or coin, subordinate to the *obverse.

Rhenish School A group of German artists of the late *Romanesque period centred round Cologne. The most prominent figure was Nicholas of Verdun whose masterpiece of goldwork, the *Three Kings' Shrine* (1200), is in Cologne cathedral. The Rhenish School was also distinguished for its *enamelwork.

rhyton A Greek drinking vessel of *pottery, metal, or stone, of horn shape often modelled as an animal's head.

rib A projecting band on a ceiling or *vault, it can be decorative or structural in purpose. *Gothic ribs are enriched with complex mouldings and have carved bosses at their intersections.

rilievo schicciato [Italian, 'flattened relief'] a type of low *relief sculpture in which the spatial transitions are compressed. It was practised in the 15th century, particularly by Donatello and Desiderio da Settignano.

rinceau A French term for decorative foliage, a motif popular with 18th-century ornamental designers, usually in the form of scrolls of acanthus-like leaves.

rocaille A term originally used from the 16th century onwards to describe fancy rock-work and shell-work for fountains and grottoes. It was identified

in the 18th century with ornament based on such forms and hence with some of the more fanciful and decorative aspects of *Rococo, a term with which it has since become synonymous.

rock crystal A transparent form of *quartz, it was highly prized by the ancient Egyptians who used it for the eyes of their statues. Its use for ornamental vessels and some figurative sculpture spread to the Near East and China and then to western Europe, where by the 12th century it was associated with fine objects such as the *altars of the richest churches and displays on palace banqueting tables. It is very hard and can only be carved with difficulty, usually with a lapidary wheel. Colourless *glass was made to imitate rock crystal and named *crystal in emulation.

rocker The spiked tool used for the preparatory work of roughening the plate in the *mezzotint technique of printmaking.

Rocky Mountain School A group of artists, of whom Albert Bierstadt (1830–1902) was the most prominent, who painted the landscape of the Rocky Mountains in a similar spirit to that practised by the contemporaneous *Hudson River School.

Rococo A term used to describe the light, elegant, and sensuous style in the visual arts which originated in France at the beginning of the 18th century, reached its apogee in the 1730s, and was eventually supplanted by the stern, moralizing qualities of *Neoclassicism in the 1760s. Like so many terms of stylistic or period definition it was originally pejorative: it was said to have been coined in the 1790s by one of the pupils of the great Neoclassical painter Jacques-Louis David to refer disparagingly to the art produced during the reign of Louis XV. The word Rococo was apparently a combination of *rocaille and *barocco* (*Baroque). It was used formally as an art-historical term from the middle of the 19th century. It is now generally accepted, though its exact definition has been much debated. Purists might argue that Rococo, with its love of shell-like curves and S- and C-curves, was essentially a style of decoration and should be applied to art forms such as *boiserie*, metalwork, furniture, and *porcelain. Today its wider use is generally countenanced, however, and it is also applied to painting, sculpture, and architecture. Watteau is widely considered to have been the first great Rococo painter and Boucher and Fragonard the masters of its mature style. In sculpture Falconet has often been thought the pre-eminent Rococo practitioner and many of his designs were reproduced in porcelain. In architecture its influence spread rapidly abroad, particularly to southern Germany and Austria where it is evident in churches such as Vierzehnheiligen and Die Wies. However, certain architectural historians would argue that this Germanic Rococo was in fact a manifestation of late Baroque rather than a new stylistic development.

Rococo Revival A renewed interest among artists, writers, and collectors between *c.*1820 and 1870 in Europe (mainly France) and America in the *Rococo style in painting, the decorative arts, architecture, and sculpture. Artists who rediscovered aspects of the Rococo, such as its frivolity and

grace, ranged from Delacroix, R. P. Bonington, and Paul Huet to Franz Xaver Winterhalter. The Empress Eugénie, wife of Napoleon III, was an important patron of the Revival, both in the fields of furniture and sculpture. 19th-century taste for the Rococo was summed up in the Goncourt brothers' *L'Art du XVIIIe siècle* published in Paris in three volumes (1881–4).

Roman art The art and architecture of ancient Rome, the foundation of which is traditionally given as 753 BC. From then until 509 BC it was ruled by Latin and Etruscan kings, but a crisis of monarchy led to the establishment of a Republic, which lasted from 509 to 27 BC. After the successful Punic Wars against Carthage in the 3rd and 2nd centuries BC, Rome became a world power and its culture was rapidly hellenized after the conquest of Greece in 146 BC. Civil wars caused the Republic to collapse and it was replaced by the Empire, distinguished by the magnificent and ambitious building programmes instigated by many of its emperors. The spread of Christianity undermined the structure of the Empire, especially after it was recognized as the official religion of the Empire under the Edict of Milan in 313 AD during the reign of Constantine the Great. With the foundation of Constantinople in 324 AD the Empire was effectively split into eastern and western halves with Rome becoming the centre of the Roman church and Constantinople the capital of the Empire and centre of *Byzantine art.

Romanesque A term now used to describe the architecture of western Europe from the 10th to the 12th centuries. By extension it is also applied to the *fine and *applied arts of the period, but it is predominantly used in an architectural context. 'Romanesque' came into common usage in the early 19th century, originally to denote the architectural style (until then referred to by English writers as 'Saxon' or 'Norman') that was pre-*Gothic. The word was adapted from the vocabulary of linguistics, its original meaning being 'to do with Romance languages'. Romanesque acquired its more precise definition in the first half of the 20th century when its application was restricted to the late 10th and to the 11th and 12th centuries. Its architecture was essentially produced for the increasingly affluent *monasteries of the period, allied to expanding urban communities. It is characterized by the clear articulation found in the great cathedrals and abbey churches whereby new features and functions were accommodated generally within the overall design of the building. Although Romanesque architecture is generally associated with the use of the round arch, this is something of an over-simplification, for the pointed arch (normally associated with *Gothic) was also known at that period. What the Romanesque certainly established, with the aid of ever-improving standards in construction, was a major development of the *basilica pattern of earlier Christian and *Carolingian churches. This included a grand nave, with a vaulted stone roof, articulated by bays on either side and punctuated with alternating *piers and *columns—the *Gothic cathedral would be basically a lightening and elaboration of this Romanesque pattern. By the first half of the 12th century the Romanesque style covered most of western Europe, from Scandinavia to Sicily and from Ireland to

Hungary. Prominent buildings included Durham Cathedral and the abbey church at Cluny.

Romanism A term, less used nowadays, coined in connection with those Netherlandish artists who travelled to Rome in the 16th century. The most important Romanists included Jan Gossaert, Jan van Scorel, Maarten van Heemskeck, and Lambert Lombard. Their often muscular, figurative art derived from a number of influences—above all Michelangelo, as well as the works of Raphael and his students, and the classical monuments and artefacts to be found in the eternal city.

Romantic Classicism A term sometimes used to characterize an aspect of *Neoclassicism in which an interest in antiquity is tinged with *Romantic feeling.

Romanticism Inherently the most unstable of the major definitions of a particular period or style, Romanticism can at one level be seen simply as a late 18th- to early 19th-century reaction against the reason of the Enlightenment and the order of *Neoclassicism. Implicit to this process were beliefs in the primacy of individual experience and in the irrational as well as the rational. Romanticism was more an attitude of mind than a set of particular traits, hence in the visual arts it could embrace such apparently diverse artists as Goya, Blake and Turner, Delacroix and Géricault, Friedrich and Runge. Originally, however, it was a literary term, first defined by the German critic Friedrich Schlegel in an essay of 1798 on Romantic poetry which, he stated, was 'in the state of becoming; that, in fact, is its real essence; that it should forever be becoming and never be completed'. The sketch-like quality (and indeed the growing importance of the sketch) characterized much Romantic visual art. The word itself was derived from the late medieval Romance, seen as a fruitful literary alternative to the traditions of Classicism. Romanticism was not essentially backward-looking, however, and was responsible for a general 'freeing-up' of content and form in art. Classical subject-matter was largely rejected in favour of that drawn from a wide variety of literary sources—the aforementioned medieval Romances, Dante, Shakespeare, and contemporary literature (especially Sir Walter Scott). Nature, hitherto viewed as an ordered part of man's environment, was seen as an elemental force inspiring an emotional reaction in man and a concomitant interest in landscape painting of all types. *See* PICTURESQUE; SUBLIME. Romanticism remained the dominant current in European art until around 1840 when it was superseded by *Realism.

rood Originally the Saxon word for a cross or crucifix. In churches the rood was placed at the east end of the *nave flanked by the figures of the Virgin and St John. It was often of timber, more than life-size, and placed over the screen separating the *choir from the nave. Many roods were destroyed during the Reformation and subsequent iconoclasm.

rose window A circular window with compartments of *tracery arranged like the spokes of a wheel.

rosewood A dark, highly figured wood, with black streaks, used for furniture during the *Regency period, mainly as a *veneer.

rosso antico A red unglazed *stoneware created by Josiah Wedgwood (1730–95) used for designs based on Egyptian or Greek prototypes.

rotunda A circular building or room, usually with a *dome or domed ceiling over it, for example the Pantheon in Rome.

roulette A printmaking tool, consisting of a spiked wheel, used in some of the 18th-century dot techniques of printmaking such as the French *crayon-manner and the English *stipple process. The earliest recorded use of a roulette was in 1642 by Ludwig van Siegen, a pioneer of the *mezzotint technique.

Royal Academy of Arts Founded in London in 1768 with Sir Joshua Reynolds (1723–92) as its first President, the Academy was intended to be the national school of art in England. The members had to be professional artists and were entitled to use the initials RA (Royal Academician) after their name. In 1769 the category of Associate (ARA) was also established. The Academy's aims were to raise the professional status of artists and to encourage public awareness of the visual arts. Reynolds's fifteen *Discourses*, the most important text on the visual arts to have appeared in English to date, enshrined many of the Academy's ideals (a number of later Presidents also published their Lectures, but none would prove as influential as Reynolds). The Academy's first premises were in Pall Mall, in 1780 it transferred to Somerset House, and from 1837 to 1868 the Academy shared accommodation with the National Gallery in Trafalgar Square. Finally, in 1869, it moved to its present home in Burlington House. By the end of the 19th century the Academy's reputation had sunk to a low ebb, the art it promoted judged as too conservative, and rival exhibiting bodies such as the *New English Art Club and the *London Group had been formed. In recent decades the Academy, while maintaining its annual summer shows of members' works, has reinvented itself to become the most important international exhibition venue in Britain.

Royal Scottish Academy The major artists' exhibiting society in Scotland to have emerged from a number established in the Scottish capital of Edinburgh in the 18th and 19th centuries. Founded in 1826 and granted its royal charter in 1838, in the 1850s it moved in to share half of W. H. Playfair's newly completed National Gallery of Scotland building (opened to the public in 1859). In 1910–11 it relocated again to the former Royal Institution building, in front of the National Gallery, which it still occupies today. Annual exhibitions are held and members are elected to associate and full membership, like the London *Royal Academy.

Rubénisme One of two opposing currents in French artistic theory of the 17th century, the *Rubénistes* championed the art of the great Flemish painter Peter Paul Rubens (1577–1640) and upheld the supremacy of colour over

design. Their cause was supported by Roger de Piles in the ensuing debates at the French Academy. *See* POUSSINISME.

ruby A rich red gemstone, the name derives from the Latin word *rubens* meaning red. It is a variety of the mineral corundum, which is colourless when pure. The addition of tiny quantities of chromium provides the colour red, whilst iron and titanium give the colours of the other variety, *sapphire. As a rough stone ruby appears dull and greasy, but with skilled cutting and polishing the lustre can be that of a diamond. The main deposits of rubies are in Burma. Large rubies are very rare and most rubies are mounted in jewellery. Rubies usually form part of a royal insignia.

rummer A large, short stemmed drinking glass common in the late 18th and early 19th centuries. The word is possibly derived from the German 'Römer'.

runner A long narrow carpet for corridors and halls, runners originated in Asia and were used to cover the sides of tents.

rustication Stonework cut in massive blocks which are separated from each other by deep joints, giving an exaggerated textural effect. It is applied to an exterior wall, normally the lower part. A particularly good *Renaissance example is the Palazzo Pitti, Florence.

S

sabre leg A leg used on furniture, shaped like a sabre, either round or square-sectioned and tapered. It was first used on the classical Greek chair or *klismos*, and was revived for 18th- and 19th-century seat furniture, particularly during the *Neoclassical period.

sacra conversazione [Italian, 'holy conversation'] a type of religious painting which first evolved in Florence in the mid-15th century. The Virgin and Child are depicted flanked on either side by saints, without the hierarchical disparity in size found in earlier Christian art, as though they occupy the same space and light. The first true *sacra conversazione* was Domenico Veneziano's *St Lucy* altarpiece (*c.*1445–7) now in the Uffizi, Florence. The pattern was quickly taken up by North Italian and Venetian artists.

sacristy A room attached to the church where the vestments, sacred vessels, and other furniture used in worship are kept.

saggar A thin-walled box of fireclay, used in a *kiln as a container for firing delicate articles of *ceramics.

St Ives School A loosely structured group of British artists who were drawn to the Cornish fishing port of St Ives between the 1940s and 1960s. The area had been favoured by artists since the 1880s. Its more widespread popularity dated from 1939, however, when Ben Nicholson and Barbara Hepworth settled there, anxious to bring up their children far away from London and its attendant dangers with the outbreak of war. They were joined by the critic Adrian Stokes and the artist Naum Gabo. After the end of the Second World War in 1945 a number of abstract artists, including Terry Frost and Patrick Heron, also settled there. They were greatly attracted by the qualities of light and atmosphere and the distinctive landscape of the St Ives area. A branch of the London Tate Gallery was opened in St Ives in 1993 and holds changing exhibitions of the work of 20th-century artists associated with the town.

Salon Normally refers to the exhibitions which took place in Paris from 1667 onwards under the auspices of the French Royal Academy of Painting and Sculpture. The name derives from the Salon d'Apollon in the Louvre where the exhibitions were first held, usually on a biennial basis. From 1855 onwards the Salons were held in the Palais de l'Industrie constructed for the World's Fair that year. In the 19th century a number of rival salons were established and in 1881 the government withdrew official support from the main Salon. Thereafter it began to lose its prestige and influence in the face of competition from the various independent exhibitions such as the *Salon des Indépendants and the *Salon d'Automne.

Salon d'Automne An annual exhibition, its name derived from the fact it was held in autumn in Paris. It was established in 1903 as an alternative to the official *Salon. Bonnard, Matisse, Marquet, and Rouault were foundation members. Its best remembered exhibition was that held in 1905 when Matisse and his associates were labelled *Fauves by the critic Louis Vauxcelles. The early Salons d'Automne were also important in establishing the reputations of Gauguin and Cézanne, with major retrospective shows in 1906 and 1907 respectively.

Salon de la Rose + Croix An art exhibition held annually in Paris 1882–7, organized by the Rosicrucians, an esoteric brotherhood which in the late 19th century had close connections with the *Symbolist movement and whose own symbol was the rose and the cross combined. The exhibitions were organized by a branch of the order founded in France by Joséphin Péladan (1859–1918), who styled himself Sâr (High Priest). The order's aims were clearly stated in the catalogue to the first exhibition: 'to destroy *Realism and to bring art closer to Catholic ideas, to mysticism, to legend, myth, allegory, and dreams'.

Salon des Indépendants An annual exhibition established in Paris in 1884 by the Société des Artistes Indépendants, an association formed by Georges Seurat. There was no selection committee and artists could exhibit on payment of a fee. The exhibitions became the main exhibiting venue for the wide range of artists we now label *Post-Impressionist. They remained a major event in the Parisian artistic calendar until the outbreak of the First World War.

Salon des Refusés An exhibition held in Paris in 1863 of works that had been refused at the official *Salon that year. Many artists voiced their protest at this exclusion and the Salon des Refusés was set up on the orders of the Emperor Napoleon III. It attracted large crowds, who mainly came to pour scorn on the exhibited works, which included Manet's *Déjeuner sur l'herbe* (Musée d'Orsay, Paris). Other contributing artists included Boudin, Fantin-Latour, Pissarro, Whistler, and many others.

salt glaze A type of *glaze used on *stoneware. Common salt was thrown into the *kiln when it reached its maximum temperature. The salt combined with silicates in the clay to produce a thin, glazed surface with the texture of orange peel.

Salvator Rosa A type of Roman picture frame, named after the eponymous 17th-century painter but actually having no connection with him, which proved particularly popular from the 1680s to the 1760s. Basically a hollow section frame which leads the eye into the picture, it has a wide centre hollow (*scotia) and raised convex outer edge and inner *sight edge and *ogee moulding. The probable source of its profile was the vertical cross-section of the base of a column of the *Doric Order. With its play of convex and concave surfaces the frame type was particularly suitable for the mass framing of collections, and the 'Salvator Rosa' frame was used as the gallery or livery frame for the Barberini, Doria-Pamphilj,

and Spada galleries in Rome. The English version of this frame was the *'Carlo Maratta', so-called because it was found on works by that artist.

Samian ware A type of Roman *pottery, also known as *terra sigillata*, derived from ceramics made in the 3rd century BC in the eastern Mediterranean. Of a glossy red colour, it was produced in large quantities in various parts of the Roman empire, particularly at the Arretine potteries (in Arezzo, Italy), in south-west France near Toulouse, in the Rhineland, and in Britain. It was normally decorated with moulded, *slip trailed, or incised decoration and often marked with an impressed seal of the workshop.

sampler An embroidered panel on which various types of stitches have been worked, originally to demonstrate the skills of young embroidresses. The earliest surviving examples date from the second quarter of the 17th century. From the early 18th century onwards samplers were also made by children, often bearing their names, date of completion, the letters of the alphabet, and a pious text.

Samson porcelain A French *porcelain factory, established by Edmé Samson in Paris in 1845, which produced high quality copies of every kind of porcelain, including *Meissen, *Chantilly, *Chelsea, *Derby, and Chinese. These reproductions were created with great skill and can be difficult to distinguish from the original.

sand casting A method of *casting metal in a *piece mould of very fine and compacted sand. Only relatively simple sculptural forms can be made in this way. The technique was used for casting *medals during the *Renaissance and also for certain types of bronze ornament which were cast in large editions, particularly in 19th-century France.

sandstone A stone composed of grains or particles of sand which are either mixed with other mineral substances or compressed together. Sandstone can vary in colour from a rich red to dark grey-browns. Surprisingly, many sandstones are very hard and can be used for building or for carving.

sang-de-boeuf A rich, ox-blood red *glaze used on *porcelain, discovered by Chinese potters of the *Ming dynasty and imitated by European art potters of the 19th century. The colour is obtained from *copper in the glaze, fired in a reducing atmosphere. The difficulties of this type of *firing resulted in the glaze being attractively mottled.

sanguine A dark red colour that is close to burnt umber; a pencil or crayon of that colour made with clay or chalk containing red iron oxide. The term is also applied to drawings, usually French of the 18th century, incorporating a red chalk or *conté crayon of this colour.

Sansovino A type of picture frame, named after the Florentine sculptor and architect Jacopo Sansovino (1486–1570). Sansovino frames were produced in Florence and Venice in the mid-16th century and were so

popular in the latter that they were adopted as 'gallery' frames. The decorative vocabulary found on Sansovino frames was drawn from a wide variety of *Mannerist sources and included theatrical *volutes and radial flutes, often enlivened with clasps, masks, and *parcel-gilt.

sapphire A rich blue gemstone, the name comes from the Greek word for blue. Sapphire is a variety of the corundum mineral, as is *ruby. Tiny quantities of titanium and iron give rise to the colours of sapphire, which can be yellow, pink, or green, as well as blue. It is a more common gemstone than ruby and today is found mainly in Australia, although exceptional blue and pink sapphires have been extracted from the gem-rich gravels in Sri Lanka for over 2,000 years. Large sapphires are extremely rare; the largest cut star sapphire, the 'Star of India', is in the American Museum of Natural History in New York. Two famous sapphires, St Edward's and the Stuart Sapphire, form part of the English Crown Jewels.

sarcophagus [Greek *sarkophagos*, 'flesh-eating'] a stone or, more rarely, *terracotta coffin. Antique examples were often extensively decorated with *relief sculpture. Such reliefs were highly influential on *Renaissance artists. Many sarcophagi were also produced in the *Neoclassical era when the form enjoyed an understandable revival in popularity.

sardonyx A layer stone formed from *agate, with a brown base and upper white layer, which is usually cut and engraved.

sash A frame for holding the glass in a window which can be raised and lowered in vertical grooves. Sash windows were introduced to England from Holland in the late 17th century.

satinwood A yellow-coloured wood from the West Indies much employed by *cabinet-makers of the late 18th century. It was usually used as a *veneer as it was expensive.

Satsuma Cream-coloured Japanese *pottery, usually elaborately decorated with detailed painting and *gilding, produced mainly from the mid-19th century onwards, in Satsuma on the island of Kyushu.

satyr A creature from classical mythology with goat-like legs, hooves, a tail, a man's torso and bearded face, and horns. An attendant of Bacchus, he was often used to represent lust and licentiousness. The satyr was a popular ornament for furniture mounts in the 18th century, on table and chair legs and especially on wine-coolers.

Savonnerie The name derives from the old soap factory (*savonnerie*) on the quai de Chaillot in Paris where, in 1627, Dupont and Lourdet founded a factory for the manufacture of knotted-pile carpets. The Savonnerie factory became the most important of its type in Europe, enjoying its greatest success during the earlier part of the reign of Louis XIV when its commissions included those for the series of carpets in the Galerie d'Apollon and the Grande Galerie in the Louvre. It enjoyed a spectacular revival of fortune under Napoleon but was then amalgamated with the

*Gobelins tapestry factory in 1828. The term Savonnerie is sometimes mistakenly applied to pile carpets produced in other French factories.

sc. (or sculp., sculpsit., sculpt.) [Latin, 'he/she carved [it]'] sometimes appears on a piece of sculpture after the sculptor's name to indicate it is an original direct carving rather than a cast or copy. It can also occur in the margin of a *print after an artist's name to indicate he was the engraver or etcher (in a reproductive print the original design may have been by someone else). In a printmaking context it carries the same meaning as *inc.*, an abbreviation of the Latin *incidit*, 'he/she cut [it]'.

scagliola A material used since Roman times to imitate *marble. It is composed of pulverized selenite applied to a wet *gesso ground and then fixed under heat and polished. It was mainly used for the outer surfaces of *columns, *pilasters, and other interior architectural features. From the 16th century onwards it was also used for table tops.

scala The Italian for staircase, the most famous example of which is probably Bernini's Scala Regia in the Vatican, Rome (1663–6).

scarab The sacred dung beetle of the ancient Egyptians, often carved in a gemstone, engraved with symbols on the flat side, and used as a signet.

Schildersbent [Dutch, 'band of painters'] a fraternal organization set up by the Netherlandish painters in Rome in 1623 to protect their interests. Its members called themselves *Bentvueghels* or 'birds of a feather' and they had individual *Bentnames*, for example Pieter van Laer was called *il Bamboccio*, 'clumsy little one'. The Bent was dissolved and prohibited by papal decree in 1720 on account of its rowdiness and drunkenness. *See* BAMBOCCIANTI.

school Used to describe a group of artists working under the influence of a single master or sharing common characteristics because they come from a particular region or town, or practise the same local style.

school of A description, often used in collection or auction house catalogues, to designate a work of art by an unknown artist who nevertheless works discernibly in the style of a particular master, for example 'School of Rubens'.

schwarzlot Painted decoration in black *enamel on *glass or *ceramics, used in Germany in the 17th and 18th centuries, often by *Hausmaler.

sconce A bracketed wall-light consisting of a reflective backplate and candleholders. Popular from the late 17th century, during the *Rococo period they could be very elaborate and were often called *girandoles.

scotia A concave, semi-circular moulding in a picture frame.

Scottish Baronial The leading architectural style in mid-19th-century Scotland, it was based on the indigenous castellated style of the late 16th- and early 17th-century tower house. As such it was specifically identified with Scottish history and culture. A typical example was the remodelling of Balmoral (1853–6).

Scottish Colourists A term first used in 1948 to describe the work of four Scottish painters, F. C. B. Cadell, Leslie Hunter, S. J. People, and J. D. Fergusson, who spent time in France in the early 20th century and were strongly influenced by the freedom of handling and bold use of colour found in French painting from Manet to *Fauvism.

screen A partition or enclosure separating a portion of a room or church from the rest. Screens are found in churches shutting off *aisles from *choirs, *chapels from aisles, etc. Many fine chancel-screens survive, usually made of wood, but sometimes of stone.

screenprinting A technique of printmaking using stencils laid over a screen which can be made of cotton, nylon, or metal. The printing ink is forced through the screen by a rubber blade (a squeegee). The basic process was probably invented in Japan and was at first used in the West for commercial printing. By 1916 the photo-stencil had been developed. Although a few artists (mainly American) used the technique, it was not until the 1960s that screenprinting gained widespread popularity in Britain and the United States, particularly among *Pop artists such as Andy Warhol, Roy Lichtenstein, and Richard Hamilton.

scrim A thin *linen or cotton *canvas (usually of inferior quality, such as upholstery lining-cloth) used to *reline paintings in the 18th and 19th centuries, often in conjunction with an excessively strong glue.

scrimshaw Carvings on wood, *ivory, or bone made by sailors (mainly American) when on long voyages, often in connection with whaling.

scriptorium A writing-room or place where manuscripts were stored and copied, usually in a religious establishment such as an *abbey or *monastery.

scroll An ornamental design resembling a partly unrolled scroll of parchment which was a very common decorative motif. In stylized form it can be seen everywhere from the capital of a *column, to a chair leg, to the end of a violin. It was a particularly popular theme in the *Rococo period, often seen in the form of C-scrolls, in the form of a letter C, and S-scrolls.

scumble Essentially the partial application of one layer over another. In painting, a thin layer of opaque or semi-opaque colour applied over an area of an oil painting without completely obscuring the underpainting. Alternatively, a light application of transparent paint over a dried oil painting. In drawing, a light coating of *charcoal or chalk smeared or rubbed over an existing drawing to soften the design.

scutcheon The angle of a building or of part of a building; a shield charged with armorial bearings; the plate on a door from which the centre of a handle is suspended, or the plate over the keyhole.

secco [Italian, 'dry'] the technique of painting a mural on dried lime plaster. It is executed with colours ground in a *binder (*casein or

*tempera) and applied to set plaster. Although somewhat confusingly
known as *fresco ('fresh') secco, it is much less permanent than true fresco,
in which the colours are absorbed into the wet plaster of the wall which
then sets.

secondary colours The three colours which are produced by mixing
pairs of the three primary colours: thus green (blue and yellow), orange (red
and yellow), violet (red and blue).

Second Empire In general terms refers to the art and architecture
produced in France under Napoleon III who was Prince President of the
Second Republic (1848–52) and then Emperor (1852–70). It was an era when
both the traditional and the avant-garde currents in French art maintained
an uneasy but stimulating coexistence—the basking academic nudes of
Cabanel alongside Manet's startling reworking of Giorgione in his *Déjeuner
sur l'herbe* (Museé d'Orsay, Paris). The state under Napoleon III was a major
patron of the arts and supported the enormous Universal Exhibitions of
1855 and 1867, the annual *Salons, the 1863 *Salon des Refusés, as well as
Baron Haussmann's rebuilding of Paris. Two major architectural projects
were the construction of the Paris Opéra and of the New Louvre (1853–69 by
Visconti and Lefuel). The latter spawned an architectural style—
characterized by *mansarded pavilions, *pedimented *dormers, and French
Renaissance detailing—which is often specifically referred to as Second
Empire. Between the 1860s and 1880s it became popular in both Europe and
the United States for all types of secular buildings, from city halls and
mansions to country cottages. It is typified by the Grosvenor Hotel, London
(1860–2) and by the State, War, and Navy Building, Washington (1871–86).

secretaire A French term for a writing desk in which papers could be kept
hidden by the writing surface. It was first used to describe a free-standing
desk with a lean-to fall-front, which when open could be used as a writing
surface and when closed as a storage area for papers.

Section d'Or A group of French artists who worked in loose association
from 1912 to 1914 and embraced a remarkably wide cross-section of the
Parisian avant-garde at that time. Their common stylistic debt was to
*Cubism and they were particularly concerned with questions of
proportion and pictorial discipline. The name of the group was suggested
by one of its members, Jacques Villon, and is the French translation of the
*Golden Section, the harmonic proportional ratio (roughly 8:13) thought to
have originated in the circle of the 6th-century BC mathematician
Pythagoras and much admired by *Renaissance artists and theorists. The
Section d'Or also adopted this name for the magazine they published. In
addition to Villon, other members of the group included Delaunay,
Duchamp, Gleizes, Gris, Léger, Metzinger, and Picabia.

sedilia [Latin, 'seats'] the stone seats on the south side of the *chancel in a
Christian church for the use of the officiating priests. There are usually
three (for the celebrant, deacon, and sub-deacon), but sometimes four or
five. They are mainly found in English churches where many late medieval

examples survive, usually recessed in the thickness of the wall and surmounted by arches and canopies.

Seicento A term used to describe the 17th century (the 1600s) in Italian art, most famously in Sir Denis Mahon's classic work *Studies in Seicento Art and Theory* (1947).

selvedge The continuous border of a piece of cloth so woven that it can not unravel (the *weft threads are returned at the edge of the *warp). The selvedges of older paintings on *canvas rarely survive as many of them have been trimmed during later *lining undertaken to strengthen the original canvas.

semiotics A method of analysis, whose origins lie in the field of linguistics, but which has also been applied to *art history since the later 20th century. It has been described as structuralism applied to 'signs' (as opposed to language). The study of 'sign systems' is used to produce meanings. It is debatable, however, whether language (in which words are fixed signs) can be equated with the visual arts where individuality of touch or 'marks' are less suited to the structural classifications of semiotics. Equally, the application of semiotics necessitates so many qualifications that in practice it can seem intellectually maladroit. Linguistic semiotics does not, after all, involve the study of graphology.

semi-precious stone A natural gemstone, such as *amethyst, beryl, and *opal, which is less intrinsically valuable than a *precious stone, and is also used in jewellery. The term does not apply to organic substances, such as *amber, *pearl, and *coral.

sepia An ink obtained from the secretion of the cuttle-fish. Latin sources such as Pliny mention its occasional use in writing, but it was not employed for drawing until the 18th century (Goethe, in his *Italian Journey*, mentions its popularity), and it was even more widely taken up in the following century. The term is often used inaccurately to describe many types of brownish *wash.

sepulchre A grave or tomb. An Easter Sepulchre is a *niche in the north side of the *chancel and is designed to receive an effigy of Christ for Easter celebrations.

Serial art A term coined in the 1960s which is applicable to two types of avant-garde art, especially in the United States. The first meaning implies a kind of *Minimal art in which certain simple, basic, and widely available elements, such as bricks, are assembled in regular and easily comprehended patterns. Carl Andre is a well-known exponent of this type of art. The second is applied to works of art which are conceived in a series or as part of a larger group.

serigraphy *See* SCREENPRINTING.

Serliana In architecture, any central opening (usually an archway or window) with a semi-circular arch over it flanked by two tall rectangular

openings. So called because it was illustrated in Sebastiano Serlio's *Architettura* (1537), but probably invented by Bramante. It became one of the hallmarks of *Palladian architecture and is more commonly known as a Palladian or *Venetian window.

settee A seat with a back and, usually, arms, large enough for two or more persons and popular in England from the early 17th century onwards. It is more formal than a *sofa, which largely superseded it in the 19th century, and invites the sitter to sit rather than lounge.

settle A type of bench with panelled back and arms at each end, first developed during the Middle Ages, it was the earliest form of chair to seat two or more people. The shape was revived in the 19th century by designers of the *Arts and Crafts Movement, such as C. F. A. Voysey.

Seven and Five Society An association of progressive British artists, originally consisting of seven painters and five sculptors, which was established in 1919 and lasted until 1935. It played an important role in encouraging the development of abstract art in Britain. Its founder members were by and large minor figures but by the late 1920s it had become the most important British association of avant-garde artists. Ben Nicholson had joined in 1924 and by 1926 had become chairman. He steered the group increasingly towards abstraction, and its final exhibition, held in 1935 (by which time the group had changed its name to the Seven & Five Abstract Group), was the first show of all-abstract art to have been held in Britain. Both Barbara Hepworth and Henry Moore exhibited in this last group show.

Severe style The term applied to the style of much Greek sculpture of the period *c*.480–450 BC, a transitional style between the *Archaic and *Classical periods. Characteristics included simplicity, grandeur, and an increase in characterization.

Sèvres The French *porcelain manufactory originally set up in 1738 at the Château de Vincennes by workers from *Chantilly and which was to rival *Meissen as the leading factory in Europe. Producing only *soft-paste porcelain initially, it moved to Sèvres, west of Paris, in 1756. Louis XV, a shareholder in the factory, assumed full ownership in 1760, and placed stringent restrictions on other *ceramic producers in France. Sèvres employed the best artists and craftsmen, creating new shapes and designs of high quality. The factory developed a range of superb ground colours, such as *gros bleu* and *bleu celeste*, which were combined with tooled gilt decoration and painted panels in the style of François Boucher. Figures were made in *biscuit porcelain, modelled by leading sculptors, such as Falconet. Sèvres soon became the leading porcelain factory in Europe, taking over from Meissen. Both Louis XV and Louis XVI took a personal interest in the factory and porcelain was frequently given as diplomatic gifts. With the discovery of *kaolin near Limoges, *hard-paste porcelain began to be produced and soft-paste was phased out by 1804. The factory was nationalized during the French Revolution, but later Napoleon realized

its importance. Again, it set the fashion with the creation of new designs and ambitious services, many based on antiquity. The tradition of using work by famous artists and architects continued throughout the 19th and 20th centuries. Many designs embraced or set the fashion, such as those in the *Art Nouveau style, shown at the International Exhibition in Paris in 1900. Sèvres regularly marked its wares, initially with interlaced Ls, after Louis XV, together with each artist's personal mark.

Sezession The name used by a group of artists and architects in Austria who broke away from the official Academy in Vienna, which they thought too conservative, and set up their own group, the *Wiener Sezession*, in 1897, with Gustav Klimt as their first President. Although concerned with painting and architecture, several members were designers of *ceramics, *silver, furniture, and *textiles, including Josef Hoffmann and Koloman Moser. They developed a more rectilinear form of *Art Nouveau and opened their own craft studio in 1903, the *Wiener Werkstätte*. The Sezession also exhibited the work of foreign designers, including Charles Rennie Mackintosh, whose work proved extremely popular in Vienna.

sfumato [Italian *fumo*, 'smoke'] a term used to describe the subtle blending of colours and tones to such an extent that they seem subtly to melt into one another, in the words of Leonardo da Vinci 'without lines or borders, in the manner of smoke'. Leonardo was the supreme exponent of sfumato and achieved exceptionally airy and atmospheric effects in his paintings.

sgraffito Scratched decoration on *pottery, first used in China, which spread to Europe via Persia. A vessel is dipped in *slip and then decoration is scratched on the surface to reveal the darker *body underneath. It was often used on Italian *maiolica.

shaft The body of a *column or *pilaster between the *capital and the *base. In medieval architecture, the small, slender columns attached (in a cluster) to a *pillar, *pier, door *jamb, or window surround.

shagreen [From the Turkish *saghri*, 'the croup of an animal'] a type of untanned leather made in Persia from the hides of asses, horses, and camels onto which seeds were trampled when it was still moist, leaving a granular effect. Also the finely granulated skin of sharks and rayfish, used since the 17th century for covering small boxes such as *nécessaires and tea caddies.

Shaker The name given to a style of furniture developed in America during the late 18th century by the 'Shaking Quakers' (the United Society of Believers in Christ's Second Coming), initially for their own use, then for sale. The style was based on extreme simplicity, reflecting Shaker ideals of plain living. Many designs were derived from English 18th-century rustic furniture, made of good materials by quality craftsmen, the lack of ornament giving them a simple elegance.

shaped canvases A term first widely used to describe the unconventional (non-rectangular) shapes of the paintings on *canvas

exhibited by the American artist Frank Stella at the Leo Castelli Gallery, New York in 1960. Many other contemporary painters have since produced shaped canvases which, like Stella's, remain flat and two-dimensional, as opposed to three-dimensional and sculptural.

shard (or sherd) A fragment of *pottery or *porcelain.

Sheffield plate A metal produced as a cheaper substitute for solid *silver by coating *copper with silver and fusing the two metals together with heat, then rolling it into sheet form, which could be worked the same way as solid silver. The process was discovered in 1741 by Thomas Bolsover of Sheffield, who initially used it for making buttons. Matthew Boulton recognized its potential for useful wares, such as tea and coffee pots, and developed a method of applying solid silver wire to corners to stop the copper showing through. Although Sheffield plate did not have the value of silver, the workmanship was of a fine quality, which made it popular. By the mid-19th century it was almost entirely superseded by cheaper *electroplate.

shellac A *varnish which, when fluid, is cloudy, but which dries to a clear finish that is hard and glossy, with an orange peel effect. It is mostly used for varnishing floors and furniture and has a tendency to darken with age.

shell work Decorations made of sea shells applied to small objects, such as caskets, or to wall surfaces, such as in a *grotto. It was a popular amateur pastime in the late 18th and 19th centuries.

Sheraton style The style of furniture popular at the end of the 18th century associated with Thomas Sheraton (1751–1806), designer and author of several volumes, including *The Cabinet Maker and Upholsterer's Drawing Book* (1791–4). No pieces of furniture can be directly attributed to him, but he gave his name to the elegant style of this period. Pieces were simple in outline, usually made of *satinwood and often decorated with contrasting *veneers, showing the high quality of the wood. Delicate inlaid decoration was inspired by the *antique, which ensured Sheraton-style furniture combined well with Robert Adam's *Neoclassical interiors.

shibayama The Japanese technique of encrustation of *mother of pearl, *lacquer, precious metals, and hardstones, usually on a lacquer or *ivory ground, named after the Shibayama family of craftsmen who perfected the craft in the 18th century.

shingles Wooden tile for covering roofing or wall-coverings.

shrinkage The reduction in size which can occur over time in some painting *canvases due to the presence of moisture; this can cause *blistering and *cleavage of the paint surface.

siccative A material added to oil colours to speed their drying.

sight edge The inner edge of a picture frame. When a framed two-dimensional work of art can not be removed from its frame for measuring,

the measurements are taken to the sight edges and are said to be 'sight' measurements.

significant form A rather bewildering, but once very fashionable term, devised by the English critic Clive Bell (1881–1964) to denote 'the quality that distinguishes works of art from all other classes of objects'. It was much used in British artistic and theoretical circles in the earlier 20th century and, whatever its many shortcomings, was undoubtedly influential in furthering the appreciation of works of art for their formal qualities as well as their content or subject-matter.

silhouette A portrait of a person in profile showing the outline only, usually cut out of black paper on a white ground, extremely popular c.1750–1850 as the quickest and cheapest method of portraiture.
The name derives from Étienne de Silhouette, the parsimonious French finance minister under Louis XV, who cut shadow portraits as a hobby. In England they were normally called 'shades' or 'profiles' up to the end of the 18th century.

silk A fine, strong natural fibre produced by the silkworm when making its cocoon and woven into *textiles for hangings, furnishings, and costume. First used in China by 1000 BC, it was imported by the Romans, who established a silk weaving industry in the eastern Mediterranean by c. AD 2, from where it spread to Asia Minor, Syria, and western Europe. Italy and Spain were the main centres for silk production in the Middle Ages and the *Renaissance, to be superseded by France in the 17th and 18th centuries. Despite the development of man-made imitations, silk is still a popular fabric.

silver A precious metal, second only to *gold. In its pure state it is too soft for metalwork so it is usually alloyed with *copper. In Britain the normal sterling standard for silver is 92.5 per cent. It was widely used for both religious and household ornaments and jewellery. It can be engraved, embossed, and enamelled. Unlike gold, silver tarnishes and regular cleaning can wear away the decoration. Most silver today comes from America.

silver-gilt Silver that has been coated with a thin layer of gold. *See* GILDING.

silver point A drawing technique which first appeared in medieval Italy and was also very popular in the *Renaissance. The design was drawn with a small metal rod, usually of silver and pointed at one end, onto a paper surface specially prepared with white pigment. Minute particles of the metal are left in the paper surface and produce a greyish line which darkens with time. The technique requires great sureness of touch as the line produced is of almost uniform thickness and corrections cannot be made. Dürer and Leonardo were probably its greatest exponents. By the 17th century it had been largely supplanted by the use of *graphite for drawing. *See* METAL POINT.

simultaneity The representation of successive phases of movement in a picture, as found in certain aspects of *Cubism and *Futurism.

singerie Decoration based on figures of monkeys (French, *singes*), usually dressed in human clothes and involved in human activity, such as playing music or hunting. This type of decoration was very popular in the 18th century, when it became associated with *chinoiserie*. Singeries were painted on walls, embroidered on textiles, and modelled in *porcelain, such as the 'Monkey Band' made at *Meissen. They went out of fashion at the end of the century.

sinister [Latin, 'left'] used in *heraldry to describe the left-hand part of the shield, but as viewed from behind, therefore meaning right when the shield is seen from the front. *See* DEXTER.

sinopia An underdrawing in reddish-brown pigment made by a painter preparatory to painting a *fresco. Many *sinopie* have been revealed by modern restoration techniques.

size Any material used to seal a porous surface, the term is frequently applied to gelatin or the pure forms of glue. Painting canvases are normally 'sized' before the application of a *ground or *primer, and good quality paper is usually dipped in a bath of size to reduce its absorbent qualities.

skyscraper A very tall building, usually based on a steel- or concrete-framed structure. The term originated in the United States in the late 1880s.

slate A metamorphic rock normally used for roofing, but also sometimes for sculpture, for example in Genoa. On rare occasions it was also used by 16th- and 17th-century artists as a painting surface (for example by Sebastiano del Piombo and, for his altarpiece for the Chiesa Nuova in Rome, by Rubens).

slip *Clay mixed with water to form a smooth, creamy liquid. Slip was used to decorate *earthenware, by trailing lines or dots in a contrasting colour, usually cream on brown, or by combing and feathering. This type of decoration was used to great effect by potters in *Staffordshire in the 17th century.

slipware A type of *pottery decorated with *slip before firing. The earliest English examples were made at Wrotham in Kent in the early 17th century and some of the most decorative by Thomas Toft in *Staffordshire.

smalt An obsolete blue *pigment composed of glass coloured with cobalt oxide, it proved very difficult to handle. Smalt was developed in the 16th century but went out of use in the 19th after the introduction of *cobalt and ultramarine blues. Smalt is still employed, however, as a *ceramic colour.

soapstone A stone formed from igneous rocks, with a high magnesium content, which feels smooth and slightly greasy. It carves easily and was frequently used for figures and decorative objects in China and the Far East. Soapstone was also used as an ingredient in *soft-paste porcelain by some

factories, such as *Worcester, some *Liverpool factories, Caughley, and Swansea, to provide a strong translucent body that withstands hot water.

Socialist Realism The name for the officially approved art of Soviet Russia and other Communist countries, particularly under the dictatorship of Stalin 1924–53. It was intended to depict real life and inspire the masses, but usually resulted in an uncritical glorification of the State in which stereotyped images were produced in a conventionally academic style. Typical subject-matter included domestic scenes, portraits, industrial and urban landscape, and scenes on collective farms. During the Second World War patriotic episodes from Russian history were also popular.

Social Realism A very broad term applied to various aspects of late 19th- and 20th-century art which imply some degree of protest at prevailing social conditions, usually from a left-wing point of view, and utilizing realistic techniques to portray the injustices they wish to depict.

Société Anonyme, Inc. An association formed in 1920 by Katherine Dreier, Marcel Duchamp, and Man Ray for the promotion of contemporary art in America. The name, suggested by Man Ray, was a tautological *Dada jest, for in French *société anonyme* means 'limited company'. The society opened a museum in New York and between 1920 and 1940 organized 84 exhibitions in which the emphasis was on the avant-garde and the abstract. Klee, Malevich, Miró, and Schwitters were among the artists introduced to the American public through these shows. In 1941 the Société presented the superb permanent collection it had built up over those years to Yale University.

Society of Independent Artists Formed in New York in 1916, it was an association which succeeded the Association of American Painters and Sculptors, which had been dissolved after its successful mounting of the 1913 Armory Show. The successor organization was intended to give progressive artists the opportunity to hold rival annual exhibitions to those staged by the National Academy of Art and Design. Its first exhibition was held in 1917. Known as 'The Big Show', it was probably the largest art exhibition held in America up to that time. It achieved public notice as much for the works which were excluded as for those which were shown. Most famously, Marcel Duchamp's *ready-made in the form of a urinal was rejected. Although they declined in quality, annual exhibitions were held until 1944.

socle In architecture, a plain *base or *pedestal without mouldings.

sofa A long informal *settee, heavily upholstered and inviting the sitter to lounge rather than sit. It gradually replaced the settee in the 19th century.

sofa table A small table originally designed to stand behind a sofa, evolved from the *Pembroke table, but longer and narrow, first seen towards the end of the 18th century. Usually made of *mahogany or *satinwood, the finest examples were in the *Sheraton style.

soffit The ceiling or the underside of any architectural element such as an
*arch, *cornice, or *vault.

Soft art A term used to describe sculpture made of non-rigid materials
such as cloth, rubber, *canvas, leather, or *paper, it gained particular
currency in the 1960s and 1970s. The best-known exponent was Claes
Oldenburg whose giant sculptures of foodstuffs—such as ice-cream
sundaes, hamburgers, or slices of cake—were made from stuffed vinyl and
canvas. Possibly the earliest example of Soft art had been Marcel
Duchamp's typewriter cover exhibited on a stand of 1916.

soft-ground etching A technique of printmaking which reproduces the
effect of a *chalk or *pencil drawing. The design is drawn onto a sheet of
paper placed over an *etching plate that has been prepared with a 'soft'
ground including tallow so that it never hardens. The pressure of the
*crayon or pencil clears a path through to the ground so that, when the
plate is immersed in acid, the drawn design is etched and reproduces the
texture of the original drawing when inked up and printed from. The
technique was apparently first used by G. B. Castiglione in the 1640s and
was revived in the middle of the 18th century. It was particularly popular in
England and numbered among its practitioners Gainsborough,
Rowlandson, and John Sell Cotman. In the early 19th century it was much
used for the illustrations to *drawing manuals, but by around 1830 had
been displaced by *lithography.

soft-paste Artificial *porcelain, made in Europe before the discovery of
*kaolin, one of the ingredients necessary for true, or *hard-paste,
porcelain. It was manufactured from white *clays, mixed with ground
*glass to give it translucency. It was first produced at the Medici factory in
Florence between 1575 and 1587 and then in France in the early 18th
century. The *Sèvres factory made only soft-paste for its first thirty years
and it was the main type of porcelain produced in England in the 18th
century.

solomonic A barley-sugar or twisted *column, so called because of its
alleged use in the Temple of Solomon. Perhaps the most famous examples
are the four columns of Bernini's *baldacchino (1624–33) in St Peter's,
Rome.

Song The Chinese dynasty which flourished 960–1279. The art created
during the Song period was of outstanding quality, particularly *ceramics.
Beautiful, refined pieces of simple shapes were made, often covered with a
delicate *celadon glaze, sometimes with incised decoration. These wares
provided the prototypes for later Chinese potters and, when they were
exported to Europe in the late 19th century, inspired a generation of
*studio potters.

sotto in sù [Italian, 'from below upwards'] an extreme form of
illusionistic *foreshortening whereby figures and forms in ceiling painting
appear to be suspended or float above the spectator below. An early major

example is Mantegna's Camera degli Sposi in the Palazzo Ducale, Mantua (completed 1474), though the term is particularly associated with *Baroque ceiling decoration.

spalliera [From the Italian *spalla*, 'shoulder'] a painted panel depicting an *historiated scene and designed to be hung at shoulder height as wall decoration. *Spalliere* appear in Italian inventories shortly after the middle of the 15th century and formed part of the rich decoration of *Renaissance interiors. *See* CASSONE.

spandrel The triangular space between an arched opening and the rectangle formed by the outer mouldings above and to one side. In the *Renaissance and *Baroque periods these spaces were often filled with painted decoration. The term is also applied to the surface between two *arches in an *arcade, and to the surface of a *vault between two adjacent *ribs.

spatula A large blade, usually of flexible steel, used for mixing, grinding, and stirring paint in the studio. In conservation a spatula is a small electrically heated iron, often with a variety of shaped heads, used for applying heat to localized areas on a painting or other art object.

Spazialismo Or Spatialism, was a movement founded in Milan in 1947 by Lucio Fontana, according to whom the new 'spatial' art was in keeping with the spirit of the post-war age. Traditional easel painting was rejected and art and science were to be united to project colour and form into real space with the aid of modern techniques such as neon lighting and television.

spire An acutely pointed termination of a *turret, *tower, or roof (usually of a church). Spires can be made of stone or timber covered with slates, *shingles, or lead. In shape they can be pyramidal, polygonal, or conical. A 'broach spire' is usually octagonal, placed on a square tower, and rises straight up from the main roof without an intermediate *parapet. A 'needle spire' is a thin spire rising from the centre of a tower roof, well inside the parapet.

splat The central flat support on a chair back, between the chair's seat and top rail.

Spode A *pottery and *porcelain factory founded in 1776 by Josiah Spode in Stoke-on-Trent, Staffordshire. In 1796–7 it developed *bone china, which became the standard English *body during the 19th century. *Stone china and blue and white transfer-printed wares were also produced during the 19th century. In 1833 the factory was acquired by W. T. Copeland and T. Garratt. It is still in production.

sprezzatura [Italian, 'recklessness'] a term associated, for example, with the more freely executed productions of an artist such as Titian in which exactness of form is deemed secondary to the *painterly effects achieved.

springer The bottom stone of an *arch resting on the *impost on either

side, that is at the level at which an arch springs from its supports. The line across between the two springers is called the springing line.

springing line *See* SPRINGER.

squinch An *arch or series of concentric and widening arches placed across an angle, for example to ease the transition between a square compartment and a *dome or drum above.

staffage A term applied to the non-essential small figures and animals employed by the artist to animate a painted composition, for example in the landscapes produced in the 17th century by Claude Lorrain and his contemporaries.

Staffordshire The centre for the English *ceramics industry, based in North Staffordshire, around the Five Towns (Burslem, Tunstall, Stoke, Longton, and Hanley) known collectively as 'The Potteries'. The area had rich deposits of different types of clays, plentiful fuel in the form of coal and wood, and a system of waterways to transport products around England. It was here that many of the best known types of pottery were created, such as *slipware, *agate ware, *creamware, *pearlware, *jasper, and *salt-glazed *stoneware. *Porcelain was also made, briefly in the mid-18th century, and then from the 19th century. Many celebrated names in ceramics worked in the area, such as Thomas Toft, John Astbury, Thomas Whieldon, Josiah Wedgwood, and Josiah Spode. In the 19th century, huge quantities of ceramics were made and exported. A large industry also developed around the making of 'Staffordshire figures' between 1840 and 1900, popular moulded figures decorated in bright colours and representing social and political figures of the late 19th century. The British ceramics industry is still based around Stoke-on-Trent.

stained glass *Glass given translucent colours and used particularly for church windows. The earliest and traditional method of achieving this consists of composing a design made up from various pieces of dyed or coloured glass set in a framework, usually of lead, to form a decorative or pictorial design. The technique was *Byzantine in origin, though the most splendid surviving examples are those associated with *Gothic ecclesiastical architecture. Fragments of stained glass survive from as early as the late 7th century. The earliest extant complete windows are those from the cathedral at Augsburg dating from between 1050 and 1150. The introduction of enamel pigments in the 16th century made it possible to 'paint' a design on glass in a manner similar to painting a composition on canvas. An example of such pictorial windows are those designed by Sir Joshua Reynolds for the chapel of New College, Oxford (1778–85). In the 19th century *Gothic Revival artists such as William Morris sought to return to medieval principles and designed superb stained glass windows using separate coloured lights.

stamp A small, distinctive mark, sometimes embossed and usually composed of initials, often found on prints and drawings. A 'studio stamp'

was applied to materials sold from an artist's studio after his death. If the stamp is impressed on the sheet without ink it is known as a 'blind stamp'. Prints and drawings in private collections have also often been given a stamp known as a *collector's mark. In the later 19th century facsimiles of artists' signatures were sometimes printed on drawings as a form of studio stamp.

state A term used by cataloguers of artists' prints to distinguish between the alterations that are sometimes made to the *plate resulting in different versions of the design being produced, albeit the alterations are often only very minor. Thus a print could be described as, for example, 'iii/v', i.e. the third state of five. Perhaps the most inventive of printmakers was Rembrandt, who frequently altered his etchings and drypoints many times. There has been considerable debate as to whether accidental (i.e. inadvertent damage caused to the plate) as opposed to deliberate alterations by the artist qualify for the appellation of 'state'. Equally, *proofs before letters of 18th- and 19th-century prints cause 'stating' problems and are usually discounted. In the later 19th century some artists deliberately produced small, rare *editions of the early states of their prints in order to heighten their financial worth. Generally, but not always, earlier states of most prints command higher prices as they are considered to reflect more accurately the artist's original intentions and are often rarer. For a print collector a 'first state' is often the equivalent of the book collector's 'first edition'.

steel-facing A process, patented in 1857, in which the surface of a copper plate used in printmaking is given a thin coating of steel, thereby increasing its durability and enabling many more *impressions to be printed from it. The steel is deposited by electrolysis and can be removed simply by reversing the electrical current.

steel plates Introduced in the 1810s and used as *plates for *engraving and *mezzotint. Steel was much more durable than *copper and therefore virtually unlimited editions could be produced from steel plates, whereas copper tended to wear out very quickly. However, steel was much tougher to work than copper and manual engraving of a design with a *graver was virtually impossible. Accordingly, most 'engravings' produced in this manner were in fact *etched. With the introduction of *steel-facing in 1857 it was possible to combine the malleability of copper and the durability of steel.

steeple The tower and spire of a church considered together.

stele (or stela) An upright carved stone marking an *antique grave.

Stile Liberty The Italian *Art Nouveau style, named after the London department store Liberty. *See* LIBERTY STYLE.

still life A painting, drawing, or photograph of an arrangement of inanimate objects. Although still lifes can be found in pre-classical,

classical, and *Renaissance art, it was only in the 17th century that the form was recognized as a distinct genre. It was variously translated throughout Europe as follows: in France *vie coye* ('silent life'), then *nature morte*; in Italy *natura morta*; in Germany *Stilleben*; in Spain **bodegón* (after the lower-class inns and taverns they were painted for); in the Netherlands *stilleven*.

stilt A small three-pronged support made of hard fired *clay, on which ceramic wares are balanced for *firing in a *kiln, to separate them from the piece above and below. These three marks can often be seen on the finished article.

stipple print A printmaking technique developed in England by William Wynne Ryland (1733–83) out of the French *crayon-manner. The design is made up of dots created by the artist/printmaker on the *etching ground. It was first used successfully by Ryland in the mid-1770s to reproduce the paintings of Angelica Kauffman. The technique was enthusiastically taken up by Francesco Bartolozzi who was perhaps its best-known exponent. Stipple prints could be easily printed in colours and were often hung as so-called *'furniture' prints in schemes of interior decoration. The technique was revived in the late 19th century during the vogue for 18th-century subject-matter.

stone china A *vitreous, extremely strong *ceramic *body, usually greyish in colour and opaque. Invented in 1800 by John and William Turner, it was particularly suitable for domestic dinner ware. It was also produced by Mason's and *Spode and other factories in *Staffordshire.

stoneware A hard, dense *pottery, vitrified and non-porous after a single firing. It was first produced in the Rhineland in the Middle Ages and from the 17th century in England. It was usually white but could also be brown, red, or buff, depending on the natural colour of the clay. It could be left unglazed or was often covered with a *salt glaze.

stopping out The use of an acid-resistant *varnish to cover areas of a printing plate—in techniques such as *aquatint and *etching—which one does not wish to be re-bitten when the plate is re-immersed in the acid bath for re-biting.

strapwork Decoration resembling *fretwork or cut leather, but made of wood, *plaster, or carved masonry. It originated in the Netherlands *c.*1540 and was much used in Elizabethan and Jacobean England for ceilings, screens, and funerary monuments.

Strasbourg pottery The leading *faience factory in Europe, founded in 1720 and run by the Hannong family. During the 1740s and 1750s it developed a range of brightly painted, highly decorative services as well as tureens made in natural forms such as shells, birds, or vegetables. These were imitated in other factories throughout Europe, such as *Brussels. The family made *porcelain at the factory 1752–5, moving the enterprise to

Frankenthal in Germany after this date. The expense of the porcelain factory ruined the pottery business and the factory closed in 1781.

stretcher The wooden framework on which an artist's *canvas is stretched tight and to which it is fixed. The corners are jointed but not fixed so, by driving in wedges, the stretcher may be expanded and the canvas tightened. Also the horizontal bars that unite and strengthen the legs of chairs and other furniture.

striation A surface marking consisting of parallel lines or grooves which may be naturally occurring or man-made. Strictly speaking the term refers to straight, narrow lines, but it is also applied to broader stripes, for example the linear patterns in stone such as *marble.

strip lining The technique of using strips of canvas to reinforce the edges of a painting canvas when they have deteriorated and are no longer strong enough to be fixed with tacks to the edge of a *stretcher, but when the picture as a whole does not need *lining.

struck medal A *medal which is made by cutting or casting 'blanks'— simple discs of metal. Each blank is then put between two dies, one for each side, and this 'sandwich' is put in a screw press which forces the image on the dies to be pressed into the metal.

stucco A light, easily shaped, but hard and durable form of *plaster, stucco is used for sculpture and architectural decoration. It is made by burning *marble or Roman *travertine and combining the lime thus obtained with pulverized marble and other ingredients. It was invented by the ancient Romans, who employed it for the low relief decoration on the walls and vaults of their tombs and palaces. Its use was revived in 16th-century Rome by artists such as Giovanni da Udine working on the decoration of the vaults in the Villa Madama in the 1520s. High-relief stucco decoration was developed in 17th-century Italy and further elaborated by *Rococo craftsmen working in the churches of Austria and southern Germany in the 18th century. Stucco is sometimes confused with *gesso, which is made with *gypsum, as opposed to lime, is softer, and cannot be tooled or chiselled to the same extent.

studio of A prefix used in cataloguing which indicates that a work of art was produced by an unknown artist trained by or working in the studio of a particular master, for example 'studio of Rubens'.

studio pottery A type of *pottery produced by traditional methods, usually on a limited scale. The name is usually given to pottery of the late 19th and 20th centuries, created by potters who reacted against industrialization and returned to early hand-crafted techniques. The earliest studio potters are generally thought to be the Martin brothers (*see* MARTINWARE). In the 20th century, the leading figure was Bernard Leach (1887–1979), who trained in Japan, and set up a studio in St Ives in 1920. As well as a prolific craftsman, he was also an inspired teacher. He trained

Michael Cardew, who went on to open his own pottery in Winchcombe, Gloucestershire, in 1926. Cardew was inspired by early English pottery, such as *slipware. Lucie Rie came from Austria in 1938 and set up her own studio in London, where she was joined by Hans Coper, another émigré. Both developed their own distinctive style, and influenced the next generation of studio potters.

stump A piece of leather, felt, or paper, tightly rolled into the shape of a small stick and tapered at one or both ends. It is used for softening edges and smoothing tones in drawings made with *chalk, *pencil, *charcoal, *crayon, or any material that can be moved about by light abrasion after it is applied. Many of the chalk drawings of Thomas Gainsborough (1727–88), for example, show evidence of considerable stumpwork.

style of A cataloguing term which denotes a work of art that is executed in the style of a particular master but may be of a later date, for example 'style of Rubens'.

stylobate The substructure on which a *colonnade stands, more correctly the top step of the *crepidoma.

stylus A small pointed metal rod used to impress a design upon a surface. In *classical times it was employed for writing on wax tablets. More recently, particularly in the *Renaissance, the stylus was used for transferring, by tracing over the main lines, a composition from one sheet to another, or a *cartoon to the plaster for a *fresco.

Sublime An aesthetic concept which entered mainstream European thought in the 18th century. As a category it was distinct from, though often discussed in conjunction with, the Beautiful and the *Picturesque, both in relation to aesthetics and, in Britain, to landscape gardening. It originally derived from rhetoric and poetry and gained wider currency after the translation (1674) into French of the Greek treatise *On the Sublime*, attributed to Longinus (1st century AD). The major work in English on the subject was Edmund Burke's *Philosophical Enquiry into the Origin of our Ideas of the Sublime and the Beautiful* (1757) in which the Sublime was differentiated from the Beautiful by virtue of its ability to evoke more intense emotions through vastness, a quality that inspires awe. Travellers came to visit wild and rugged mountainous regions such as the Alps, Snowdonia, and the Lake District in search of the emotional thrills provided by the Sublime, and artists such as J. M. W. Turner responded to the demand for such imagery. Subjects from Homer, Milton, and Ossian were also considered suitable subject-matter in this context. Whereas Burke had considered the Sublime as an external force inherent in the properties of certain objects and nature, the German philosopher Immanuel Kant, most famously in his *Critique of Judgement* (1790), internalized it and focused on the individual's response, his contention being that the Sublime came from within the human psyche. A number of theorists and artists of the later 20th century have shown a revived interest in the Sublime.

sugar aquatint A method of *aquatint printmaking whereby the artist creates wash effects by brushing them on the printing plate with a fluid in which sugar has been dissolved. The plate is then covered with stopping-out varnish and immersed in water; the sugar swells and lifts the varnish off the plate, which is then bitten in acid. Those areas formerly covered by the sugar particles are exposed to the acid and produce a granular wash effect when inked up and printed from. Paul Sandby (1731–1809) was a particular exponent of the technique. Also known as 'lift ground etching'.

Superrealism A style of painting, and to a certain extent sculpture, popular in the United States and Britain from the late 1960s and characterized by its use of minute detail in its depiction of its subjects. A number of Superrealist artists used photographs as the basis of their work, projecting colour slides onto their canvases and often working to an over life-size scale. Leading American Superrealist painters include Chuck Close, Robert Cottingham, and Richard Estes.

support A term used to designate the physical structure which holds or carries the *ground or paint film of a painting; thus *canvases, *panels, walls, or any of the flat expanses on which paintings can be made fall under this heading.

supporters In *heraldry, the figures or animals which support the shield bearing the arms.

Suprematism A non-objective type of art, devised by Kasimir Malevich, in which 'new symbols' such as the square, triangle, and circle replaced the more traditional concern with the human face and natural objects. Malevich announced his new system at the exhibition *0.10* held in 1915 which included works such as *Black Square* (Russian Museum, St Petersburg), although his *Suprematist Composition* (Museum of Modern Art, New York) dated from a year earlier. After 1916 Malevich's compositions became more complex and, with the series *White on White*, more mystical. The graphic artist El Lissitzky exported Suprematism to Germany when he moved there in 1922 and the ideas of the movement were transmitted to the *Bauhaus via Laszlo Moholy-Nagy.

Surrealism One of the most important and subversive movements of the 20th century, it flourished particularly in the 1920s and 1930s and provided a radical alternative to the rational and formal qualities of *Cubism. Unlike *Dada, from which in many ways it sprang, it emphasized the positive rather than the nihilistic. Surrealism sought access to the subconscious and to translate this flow of thought into terms of art. Originally a literary movement, it was famously defined by the poet André Breton in the *First Manifesto of Surrealism* (1924): 'SURREALISM, noun, masc. Pure psychic automatism by which it is intended to express either verbally or in writing the true function of thought. Thought dictated in the absence of all control exerted by reason, and outside all aesthetic or moral preoccupations.' A number of distinct strands can be discerned in the visual manifestation of Surrealism. Artists such as Max Ernst and André Masson favoured

*automatism in which conscious control is suppressed and the subconscious is allowed to take over. Conversely, Salvador Dali and René Magritte pursued an hallucinatory sense of super-reality in which the scenes depicted make no real sense. A third variation was the juxtaposition of unrelated items, setting up a startling unreality outside the bounds of normal reality. Common to all Surrealistic enterprises was a post-Freudian desire to set free and explore the imaginative and creative powers of the mind. Surrealism was originally Paris based. Its influence spread through a number of journals and international exhibitions, the most important examples of the latter being the *International Surrealist Exhibition* at the New Burlington Galleries, London and the *Fantastic Art Dada, Surrealism* at the Museum of Modern Art, New York, both held in 1936. With the outbreak of the Second World War, the centre of Surrealist activity transferred to New York and by the end of the War the movement had lost its coherence. It has retained a potent influence, however, clearly evident in aspects of *Abstract Expressionism and various other artistic manifestations of the second half of the 20th century.

swagger portrait A term, of recent origin, which was celebrated in the eponymous exhibition held at the Tate Gallery, London in 1992–3. It describes a perceived current in British portraiture from the 17th to 20th centuries in which the subject is portrayed in the 'Grand Manner', which emphasizes public display and the social aspirations of the sitter.

Symbolism A European cultural phenomenon of the late 19th century which originated in France and was first defined as a literary movement by Jean Moréas in the Symbolist manifesto of 1886, and then in relation to visual art by Albert Aurier (1892) as the 'painting of ideas'. In painting, Symbolism was viewed as having developed from later *Impressionism and from *Neo-Impressionism which, in the 1880s, had increasingly concentrated on the suggestive rather than the descriptive. Significant predecessors of Symbolism included Gustave Moreau, Puvis de Chavannes, Edward Burne-Jones, and Arnold Böcklin. A basic feature of Symbolist art was the notion that another world lies beyond the world of appearances. The painter most often cited in this respect is Paul Gauguin and works such as his *Vision after the Sermon* of 1888 (National Gallery of Scotland, Edinburgh). However, a very wide range of art came to be labelled Symbolist and exact definition of the term is probably foolhardy.

Synchronism The first American movement to rise to prominence in modern art, Synchronism originated in Paris in 1912 with the painters Stanton Macdonald-Wright and Morgan Russell. It was based on the creation of shapes through colour and the juxtaposition of colours from different points of the spectrum. Its sources included *Impressionism, Cézanne, Matisse, and, later, the *Orphism of Robert Delaunay.

Synthetic Cubism *See* Cubism.

T

tabernacle [From the Latin *tabernaculum*, 'a tent'] a canopied structure in a Christian church which contains the reserved sacrament or holy relic; also an architectural frame, for example for a monument on a wall: *see* AEDICULE. Sepulchral monuments, choir stalls, etc. can be surmounted by rich canopy-work known as 'tabernacle-work' with *crockets, pinnacles, and so on.

tableaux de place [French, 'room paintings'] large-scale, portable pictures of secular subject-matter painted specifically for elaborately designed spaces in an interior scheme of decoration. The term is mainly applied to 18th-century paintings by artists such as François Boucher, Hubert Robert, and Claude-Joseph Vernet; a fine example is the series of four paintings *The Progress of Love* (Frick Collection, New York) painted by Fragonard for Madame du Barry.

Tachisme [From the French *tache*, 'a spot or blot'] a term devised in the early 1950s to describe a movement of Paris-based artists who were painting at that time in an abstract manner using irregular dabs or splotches of colour. Like their contemporaries, the American *Abstract Expressionists, the practitioners of Tachisme (such as Jean Fautrier, Georges Mathieu, and the German-born Wols) attempted to be spontaneous, gestural, and instinctive in their art. The term is generally accepted as synonymous with 'abstraction lyrique' and '*Art Informel', though the latter was sometimes claimed as implying more control. 'Tachiste' had also been used earlier in 1899 by the critic Félix Fénéon in connection with *Impressionism to distinguish it from the more studied technique of the *Neo-Impressionists and in 1909 he had applied the description to *Fauvism.

tactile values A term devised by the American art historian and *connoisseur Bernard Berenson (1865–1959) in his *Florentine Painters of the Renaissance* (1896) to describe those qualities in a painting that stimulate the sense of touch and which he deemed 'life-enhancing'. The phrase became something of a catchword for a whole generation of art historians and critics. Great art, for Berenson, consisted of the ability to give three-dimensional qualities to our perception of images made on flat surfaces. Berenson claimed that the power to stimulate the tactile imagination was particularly strong in the school of Florentine painters.

taenia The small moulding or fillet along the top of the *architrave in the Doric *Order. In a picture frame it is a flat, raised band in profile.

tallboy An item of furniture, usually made of *walnut and straight fronted, consisting of a chest of drawers or chest upon chest. Of Dutch origin, the tallboy was introduced into England in the early 18th century and was eventually superseded by the wardrobe.

tambour Thin strips of wood glued to a canvas backing to form a roll front, as used on desks or for sliding doors.

Tang The Chinese dynasty which flourished from AD 618 to 906 and witnessed a flowering of all the arts, especially *ceramics. Techniques improved which widened the range of coloured *glazes used on *earthenware and the dynasty is particularly famous for the creation of tomb figures, such as horses and warriors.

tanka [Tibetan, *thang-ka*] a Tibetan religious painting on cloth, depicting a subject from Tantric Buddhism.

tapestry A hand-woven fabric, usually of *silk or wool, with a non-repetitive pattern which is woven during the manufacture. The word is often applied mistakenly to other textiles used for wall-hangings and upholstery.

taste The faculty of discerning beauty or merit in art, thus someone might be described as possessing 'good taste'. The term first came into widespread use in this sense in the early 18th century in England and was soon regarded as the *sine qua non* of the educated and discerning classes. Taste has varied over the centuries, however. From the *Renaissance until the later 19th century, for example, the height of good taste in the visual arts was expressed by an admiration for the *antique.

tazza A saucer-shaped cup mounted on a foot.

tea caddy A container for storing tea in the 18th and early 19th centuries, it was made in a variety of shapes. Inside there were usually two compartments for storing different types of tea or *tea canisters. They normally had a lock as tea was very expensive.

tea canister A small vessel used in the 18th century for holding tea. They were usually made of *porcelain, *pottery, or *silver, in a small size because of the high cost of tea.

tempera [From the Latin *temperare*, 'to mix'] a painting *medium used to bind pigments, most commonly made from egg yolk. Although tempera was used since Roman times and remains the principal paint medium for the *icons of the Greek and Russian Orthodox churches, it is normally associated with Italian *panel painting of the 13th to 15th centuries. A reliable account of the technique is given by the Florentine painter Cennino Cennini in his *Il libro dell'arte* of around 1400: equal quantities of egg yolk were combined with pigment ground to a paste in water. After painting, the water evaporates and the protein of the egg yolk dries and forms a hard and waterproof film. There is some evidence, contrary to what was thought previously, that *varnishes were also occasionally applied. Unlike in oil painting, colours and tones in tempera have to be premixed before the paint is applied and can not be manipulated on the painting surface (which in Italy usually consisted of a white *gesso *ground). Tempera colours are therefore applied sparingly and the painted design built up with light and

rapid touches in thin layers. Tempera in early Italian panel painting was frequently combined with *gilding, used both for the background and for decoration on costume and drapery. By the early 16th century tempera had been all but replaced by *oil paint as the main painting medium, though in the preceding transitional years it had sometimes been employed in combination with oil. Thereafter its use virtually ceased, though it was revived in the 19th century by both restorers and forgers, partly due to the interest stimulated by the rediscovery of Cennini's treatise. A number of British artists (mainly followers of William Morris and John Ruskin) who admired early Italian art also practised the technique.

temple Its primary meaning is as a place of worship of pagan deities. *Classical temples were normally rectangular, surrounded by *columns and had *gables (*pediments) at either end, but they could be circular. Temple can also denote a synagogue, a Protestant church (especially in France), or a Masonic lodge.

tenebrism [From the Italian *tenebroso*, 'obscure'] a term used to describe dark tonality in painting, it is mainly applied to the works of the 17th-century painter Caravaggio and his followers.

term A *pedestal, tapering towards its base, which normally supports a *bust; also a pedestal which merges at the top into a sculpted human, animal, or mythic figure. *See* HERM.

terracotta [Italian, 'baked earth'] is made of baked *clay and has been used since very early times for sculptured figures and architectural ornament. In the *Renaissance many reasonably priced reproduction sculptures (often *polychromed) were produced in terracotta for merchant homes by workshops working after an established master. Sculptors have frequently used terracotta for their preparatory models. Although normally brown, terracotta is not always so on account of the presence of certain chemicals such as iron oxide which can affect the colouring.

tertiary colours Produced by the mixture of *secondary colours, tertiary colours are often very dull and tend to be variations of greys and browns.

tessella A small or miniature *tessera.

tesserae The small cubes of marble, pottery, brick, glass, tile, stone, etc., set in mortar to form a *mosaic.

tester A canopy, usually of carved wood, over a bed. A half-tester bed has a canopy only above the headboard.

textile A woven fabric, such as *silk, cotton, or wool, which can be used for furnishings, upholstery, or costume.

throwing A method of creating a vessel on a potter's wheel. A ball of *clay is placed on a rotating wheel and the piece is formed by the potter exerting

pressure with his hand on the spinning ball. The vessel can be shaped by hand or with the aid of tools and a sponge is used to clean the surface and to add or take away water.

tierceron A secondary *rib springing from one of the main *springers or from the central *boss and which rises up to the ridge-rib in a *Gothic *vault.

Tiffany glass The range of *Art Nouveau *glass created by the American Louis Comfort Tiffany (1848–1933). The son of a jeweller, Tiffany trained as a painter and then turned to the *applied arts and interior decoration. He became interested in glass and in 1892 he opened Tiffany Furnaces to produce his designs. In 1894 he patented his iridescent, hand-made glass, called *'favrile', from the Old English word 'fabrile', meaning hand-made. Shapes were elegant and organic, decorated in flowing patterns within the glass to suggest foliage, flowers, or peacock feathers, in iridescent gold, green, or mauve. The glass during firing was treated with metal oxides and exposed to acid fumes, to create the unique range of colours. Tiffany also designed lamps with shades made of a *mosaic of 'favrile' glass, *stained glass, and metalwork. His designs were popular in America and Europe, where he frequently exhibited, especially in Siegfried Bing's gallery in Paris, *L'Art Nouveau*.

tin A silvery-white metal made by smelting the mineral cassiterite, tin is often used in *alloys to make metals such as *bronze, *brass, and *pewter and for *electroplating iron or steel to make tinplate.

tincture A generic term used in *heraldry to encompass metals, colours, and furs.

tin glaze An opaque white *glaze used on *earthenware, made with the addition of *tin oxide to a *lead glaze, in an attempt to imitate the whiteness of Chinese *porcelain. First developed in the 9th century in Baghdad, tin glaze spread to Spain (*see* HISPANO-MORESQUE) and then to the rest of Europe. In Italy it was known as *maiolica, in France and Germany *faience, in Holland *Delft, and in Britain *delftware.

tintype An early type of photograph taken as a positive on a thin black lacquered iron plate. The process was patented in 1856 and soon came to be popularly known as tintype. It was cheap and easy to produce and played an important role in the popularization of photography, particularly portraiture.

toby jug A tankard in the form of a seated toper, wearing a tricorn hat (forming the cover) and holding a jug of ale, based on the figure 'Toby Philpot', who appeared in an engraving to illustrate the song 'Little Brown Jug', published in 1761. Toby jugs were first made at the *Staffordshire pottery of Ralph Wood, but were widely imitated throughout the second half of the 18th century and during the 19th. Many variations were made, including 'Rodney's Sailor', 'The Squire', and a model of a woman, 'Martha Gunn'.

toile de Jouy Cotton fabric printed with figure scenes, flowers, or *chinoiseries*, in monochrome, from engraved metal plates, named after the factory at Jouy, near Paris, where this type of fabric was first made in the middle of the 18th century.

tondo (or rondo) [Italian, 'circle'] a circular painting or relief carving. Tondi developed as an independent art form in Florence in the first half of the 15th century. They were mainly made for domestic settings and illustrated subjects such as the Adoration of the Magi and the Virgin and Child. The tondo may have developed from the *desco da parto*, a circular or painted tray made to celebrate the birth of a child and presented to the mother with gifts of sweetmeats and fruits. One of the most renowned carved tondi is Michelangelo's *Taddei Tondo* (Royal Academy, London) of *c*.1504 depicting the Virgin and Child with St John the Baptist. The tondo was also used as a decorative motif in architecture, most famously by Luca della Robbia in various examples in *terracotta. The circular format continued to be used by later artists ranging from Caravaggio to Jackson Pollock.

tonnerre A pale beige *limestone frequently used for sculpture in France, ranging from the medieval sculptural decoration of the cathedrals of Dijon (Claus Sluter) and Troyes to the work of 18th-century sculptors who normally worked in *marble.

tooling A term with a variety of related meanings. It can generally refer to the finishing of a piece of sculpture, for example squaring and smoothing a stone with a broad *chisel or removing the roughness and blemishes on metalwork after *casting. Alternatively, it can also refer to the adding of decoration to metalwork, in *intaglio or *relief, using various tools such as *punches or *gravers. Heated tools can also be used to add decoration to bookbindings and other articles made of leather.

topaz A gemstone which is usually golden yellow, although it can also be pink. In the 18th century the most famous topaz mine was in Saxony and topaz was popular for jewellery during this period. Today most topaz is found in Brazil. Some light blue topazes have also been found in Scotland and Cornwall.

topographical landscape The depiction of landscape, in paintings, drawings, or prints, which is topographically accurate rather than invented for purely aesthetic reasons. The majority of English *watercolours, for example, exhibit a relatively high degree of veracity, whereas the idealized landscapes of the 17th-century painter Claude Lorrain were invented.

torchère A portable stand for a candle or lamp, normally made like a tall table with a very small top (known in England as a candle-stand).

torso A sculpture representing the trunk of a nude model without head or limbs. From the *Renaissance onwards there developed the practice of adding contemporary limbs and heads to *antique statuary of which only the torso survived. More recently, sculptors such as Maillol and Rodin have deliberately made sculptures of the torso alone.

tortoiseshell A hard and translucent material, mottled yellow and brown in colour, which resembles the shell of a tortoise. The best 'tortoiseshell' is cut in thin sheets from the upper shell of the Far Eastern hawksbill turtle. It was first used by the Romans as a decorative *veneer.

torus A large convex *moulding, for example at the base of a *column. In picture frames a torus is a convex moulding that is semicircular in profile. The torus was usually decorated. The 'leaf torus' frame originated in the Roman *Baroque and was quickly adopted in France in the reign of Louis XIII. Further developments included the 'bunched-leaf torus' in the 18th century and the 'reeded torus' favoured by *Neoclassicism.

tourmaline A gemstone which shows a great range of colour, from yellowish-green through blue to pink and mauve. The cut stones incorporated into jewellery can sometimes show the variation to great effect. Pink and green tourmalines are found in California, others in Brazil and Madagascar.

tower A tall, narrow building used for defence, as a landmark, for the placing of a clock, or for the hanging of bells, as in a church tower.

toy A term used in the 18th century for a small decorative article, such as a snuff box, which could be made in a variety of materials, including *silver or *porcelain. Birmingham silversmiths who specialized in making such small pieces were called 'toy-makers'.

trabeated [From the Latin *trabs*, 'a beam'] used to describe a building constructed on the *post-and-lintel system, as in Greek architecture.

tracery The elaborate ornamental pattern-work in stone filling the upper part of a *Gothic window. The main types of tracery are: 'plate tracery', found in *Early English churches, consisting of flat panels of masonry pierced with *lights and often made up of two *lancets with the *spandrel above pierced by a *quatrefoil or circle; 'bar tracery', first found at Reims in the 13th century, where moulded *mullions and separate window-lights create bars of circular, quatrefoil, etc. forms leaving the rest of the spandrels open—during the later Middle Ages it was one of the principal decorative elements of churches; 'flowing tracery', in which compound *ogee curves create flame-like lights, also called 'curvilinear' or 'undulating' tracery, it was used from the beginning of the 14th century in England and throughout the 15th in France (where it developed into the *Flamboyant style); 'intersecting tracery', where each mullion branches into curved bars which are continuous with the mullions; 'panel tracery' is typical of late *Gothic *Perpendicular and consists of upright, straight-sided panels above the lights of a window—it is often carried over the wall surface and is also known as 'rectilinear tracery'.

transept The extensions to north and south of a cross-shaped church or cathedral, usually between the *nave and the *chancel, but occasionally at the west end of the nave as well. Some English Gothic cathedrals such as Salisbury have double transepts.

transfer printing A technique, invented in England in the 1750s, of decorating *enamels and *ceramics with engraved designs which are printed on to paper using a special ceramic ink. The paper is then pressed against the surface of the enamel or ceramic and the design thus transferred.

Transitional A term normally used to refer to the period of transition between *Romanesque and *Gothic architecture (in Britain between *Norman and *Early English).

transom A horizontal bar of stone or wood across the opening of a window or across a panel, usually for strengthening.

transom window A window set above the transom of a door or a larger window.

travertine A *limestone formed by the precipitation of the calcium carbonate in spring water upon exposure to air. It has been found in large quantities in the Tiber valley near Rome and elsewhere in Italy. It varies in colour from pale buff to orange pink and has been frequently used for the buildings of Rome, notably the Colosseum and the colonnade of St Peter's. It has also been used for outdoor sculpture such as Bernini's *Triton* fountain, also in Rome. Recently it has been exported in great quantities from Italy on account of its popularity as an external cladding material in some forms of modern architecture.

Trecento [Italian, 'three hundred'] used to describe the 14th century in Italian art.

treen The name given to household objects, such as bowls, boxes, and spoons, made of turned or carved wood, usually of a simple shape. All types of wood were used, although maple and *walnut were preferred for their hardness.

trefoil [From the French *trois feuilles*, 'three leaves'] a *Gothic ornament of three *foils, most often found in *tracery.

trencher A wooden plate or dish, smaller than a *charger, on which cut meat is served.

tribune An *apse in a *basilica or basilica-form church; a raised platform; the *gallery or arcade in the wall above the *nave arcade in a larger church.

triforium [From the Latin *tres*, 'three' and *fores*, 'openings'] an arcaded and, properly speaking, three-arched (distinguishing it from the less specific *tribune) wall-passage above the *aisle vaulting and below the *clerestory in a large church. As it has no windows to the open air it is often called a 'blind storey'.

triglyph [From the Greek, 'three channels'] the vertical block in a Doric *frieze, separating the *metopes. Strictly speaking it consists of two whole grooves with a half-length groove on either side.

tripod A three-legged vessel such as a pot or cauldron resting on three legs; a seat, table, or stool with three legs; a three-legged support of any kind, such as that for a camera, compass, or other apparatus.

triptych A picture consisting of three parts, usually a central panel flanked by wings (or shutters) which could be closed both for the protection of the central image and the limitation of when it could be viewed. Triptychs existed in antiquity, but the earliest Christian examples date from the *Byzantine era. In Italy triptychs are found from the middle of the 12th century onwards, at first in Rome, then in Tuscany (usually with a half-length figure of the Virgin on the central panel). Panels were generally rectangular, the central one (often with an arched top) being twice as wide as the wings. The triptych form was taken up in Germany and the Netherlands for *altarpieces from around 1300 and was opened or closed according to the liturgical calendar. The central panel was often sculpted with the wings being painted. The architecture of the exterior frame became increasingly ornate with the addition of *gables and pinnacles. Netherlandish triptychs frequently had wings painted in *grisaille. Triptychs continued to be popular in the 16th and earlier part of the 17th centuries with massive examples being executed by Flemish artists such as *Rubens, for example his great altarpieces of the *Raising* (1610–11) and *Descent of the Cross* (1611–14) for Antwerp Cathedral. The triptych was revived in the 19th century, at first by the *Nazarenes and *Pre-Raphaelites and then later by the *Symbolists who wished to give a religious connotation to their paintings.

triumphal arch A free-standing monumental gateway. The earliest triumphal arches were temporary structures erected in the 2nd century BC by Roman magistrates in honour of victorious generals. From the late 1st century BC they were constructed in stone, often richly decorated with sculptures, as city gates or entrances to *forums, but also frequently as urban decorations. Around twenty such arches survive from the reign of Augustus, mainly in Italy and Gaul. Later, they spread throughout the Roman empire and there are numerous examples in North Africa. There were two main types: a single archway (Arch of Titus, Rome *c.* AD 82) and the more elaborate large archway flanked by two smaller ones (Arch of Septimus Severus, Rome AD 203, Arch of Constantine, Rome AD 315). There was a revival of interest in the triumphal arch in the *Renaissance, often as a temporary festival decoration. Many triumphal arches were built in stone in the 18th and 19th centuries, such as the Arc de Triomphe, Paris by Chalgrin 1806–35 or John Nash's Marble Arch, London 1828.

trois crayons [French, 'three crayons'] the technique of drawing with black, white, and red chalks (*à trois crayons*) on a paper of middle tone, for example mid-blue or buff. It was particularly popular in early and mid-18th century France with artists such as Antoine Watteau and François Boucher.

trompe-l'oeil [From the French, 'trick of the eye'] used to describe pictures in which a deliberate visual illusion is intended by the artist. It is

particularly associated with naturalistic painting where artists are concerned to demonstrate their exceptional skill. Such visual tricks were known since ancient times: Pliny the Elder tells how, in a public competition between artists, Zeuxis deceived the birds into mistaking the grapes he had painted for real ones, but the prize was won by Parrhasios for fooling Zeuxis into trying to lift away a drape that was only painted. Similarly, the *Renaissance artist and writer Giorgio Vasari related how Giotto deceived his master Cimabue into trying to brush away a painted fly. The genre of trompe-l'oeil was particularly popular in 17th-century Dutch and Flemish art. It was also much practised in France in the 18th and early 19th century (for example by L.-L. Boilly); in Paris *genre painters used to display their trompe-l'oeil pictures in open-air exhibitions near the Pont-Neuf as public evidence of their talent. The contents of such pictures were often everyday objects such as those one might have emptied from a drawer or a pocket—pipes, pens, letters, etc. Similar subject-matter also features in the early *Cubist paintings of Picasso and Braque whose work at that time could be described as a deliberate fragmentation of the trompe-l'oeil tradition.

trophy A carved, painted, or engraved representation of a group of arms and armour, it derives from the real arms taken in battle by the ancient Greeks and Romans and set up as monuments of victory and hung on trees. Trophies were common decorative motifs on tomb sculpture and buildings.

troubadour A style of history painting that evolved mainly in France in the last years of the 18th century and early years of the 19th. It drew its inspiration from the art and history of the Middle Ages and the then current vogue for medieval literature and contemporary reworkings thereof. The wide range of subjects included, for example, scenes from Dante (*Paola and Francesca*), and from the medieval romances of Sir Walter Scott. Among its most famous practitioners were Ingres, Bonington, and Delacroix in certain of their paintings, but its most consistent adherents were minor masters such as Jean-Baptiste Mallet, Nicolas-Antoine Taunay, and Pierre Révoil, many of whom provided illustrations for publications of pseudo-medieval literature. Among the most important patrons of such art were the Empress Josephine and Caroline, Duchesse de Berry. The style was characterized by a love of fine detail (especially for recreations of medieval costume) and multi-figured compositions with a liberal helping of sentimental anecdote.

trumeau A stone *pier or *shaft supporting the middle of a *tympanum of a doorway; the term is also used more generally to describe supports between doors or windows.

tsuba A Japanese sword guard, usually very decorative, formed of a metal plate with a wedge-shaped hole for the haft of the blade to pass through into the hilt. During the Edo period (1616–1868) they were made for adornment, engraved, inlaid, and enamelled with mythological subjects, landscapes, birds, and animals, with details picked out in *gold.

Tudor The House of Tudor ruled England from the accession of Henry VII until the death of Elizabeth I in 1603. It is difficult to categorize the art and architecture of this period as specifically Tudor, indeed that of Elizabeth's long reign is usually referred to as *Elizabethan. Perhaps the epithet Tudor is best applied to Henry VIII's extensive building works, notably at the palaces of Hampton Court, Whitehall, and St James, where a relatively homogeneous style emerged involving the extensive use of brick, *gables, and battlements.

tulipwood Like *kingwood, an orange-brown wood, with striped figuring, popular as a *veneer with French *cabinet-makers of the 18th century and for *bandings on English furniture.

turning The art of shaping wood, metal, *ivory, or other hard substances into forms of curved shape. The shape of a piece of *ceramic is refined by turning, when the *clay has dried out, before it is fired.

turpentine The most commonly used *diluent or thinner for *oil paint, it is distilled from the resinous liquid exuded by various species of pine.

turret A *tower placed on top of a larger tower, or at the corner of a building or wall, typically of a *castle.

Tuscan Order *See* ORDER.

tympanum The area between the *lintel of a doorway and the arch above it; also the space enclosed by a *pediment. Tympana were frequently decorated with sculpture.

typography The art or process of setting and arranging printed text involving the choice of the typeface—the font, size, and spacing to be used—as well as the particular alphabet—Roman, italic, boldface, etc. Traditional printing involved the use of metal type which had to be set or composed by the typesetter. This particular skill has largely been superseded by the electronic arrangement of type.

typology The connecting in Christian thought and art of Old and New Testament subjects whereby the former were considered to prefigure the latter; thus Isaac's willingness to sacrifice his son was seen as anticipating God's preparedness to sacrifice His only son, Jesus Christ, etc. Typological juxtaposition was found in virtually every area of Christian art throughout the Middle Ages.

Ukiyo-e Japanese for 'pictures of the floating world' and referring to transient everyday life, it provided a major source of imagery in Japanese art from the 17th to the 19th centuries, particularly in the work of printmakers such as Hiroshige, Hokusai, and Utamaro. Typical subjects included theatre scenes, with actors in well-known roles, and views of the night-life of Edo (as Tokyo was then called). The resulting brightly coloured *woodcut prints were imported into Europe from the middle of the 19th century and had a great influence on many avant-garde artists, including the *Impressionists and *Post-Impressionists, who were particularly attracted by the bold compositions and striking colours of Ukiyo-e prints. *See* JAPANESE PRINTS.

underdrawing Preliminary drawing for a painting which is then painted over. As paint, especially *oil paint, often becomes more transparent with age, so the underdrawing sometimes becomes visible to the naked eye. It can also often be revealed with the aid of *infra-red reflectography.

underglaze Decoration painted on to a *ceramic body before the *glaze is applied and which is permanently fixed under the glaze when the piece is *fired.

underpainting As its name implies, this is the preparatory painting to establish the design and tonal values of a picture prior to the application of the final colours. By the later 19th century *alla prima* painting directly on to the canvas had dispensed with the need for underpainting.

uniface Used to describe a *medal of which one side is left blank while the other bears the design.

Unit One A group of British artists formed in 1933 including the sculptors Henry Moore and Barbara Hepworth, the painters Edward Wadsworth, Ben Nicholson, Paul Nash, and Edward Burra, and the architects Wells Coates and Colin Lucas. It held one group exhibition in 1933 and a book, *Unit One: The Modern Movement in English Architecture, Painting and Sculpture*, edited by Herbert Read, was published in 1934. The group had its headquarters at the Mayor Gallery, London and its secretary was Douglas Cooper. Unlike movements such as *Surrealism or *Vorticism, there was no common doctrine, the group's main concern being that of 'the expression of a truly contemporary spirit' (Paul Nash).

upholstering The provision of furniture with a soft, padded covering.

Urbino One of the most famous and important groups of 16th-century *maiolica factories patronized by the Dukes of Urbino. Although the term is now applied only to the factories in and around Urbino, it originally also

included other factories in the Duchy of Urbino such as those at *Castel Durante and *Gubbio. The greatest Urbino potters working in the *istoriato style (often based on reproductive prints by masters such as Marcantonio Raimondi) were Guido Fontana, who set up his establishment in the 1520s, and F. X. Avelli. Around 1560 a new style of *grotesque maiolica decoration, derived from Raphael, was introduced at the Fontana factory and featured designs painted in orange and other colours on a milky-white *ground.

urn A covered vase of rounded or ovoid form similar to those in which the Romans kept the ashes of the dead. The term is commonly but incorrectly applied to various other types of vase.

vanitas [Latin, 'vanity'] taking its inspiration from *Ecclesiastes* 1: 2 ('Vanity of vanities'), a 'vanitas' was an *allegorical *still-life painting in which the objects, such as an hour-glass or a human skull, were meant to be reminders of the transience of human life. This type of still life was especially popular in 17th-century Holland.

vargueño A Spanish term, first used in the 1870s, for a writing desk, and named after the town of Vargas in Castile where such desks were supposed to have been made in the 16th and 17th centuries. More accurately described as *escritorios*, these desks have a drop front and rest on a chest or a trestle stand. Their interiors are often elaborately decorated with *ebony, *tortoiseshell, *ivory, or other *inlays in elaborate geometrical patterns.

varnish A solution applied as a protective coat over a painting. Oil varnishes have been used since the Middle Ages and are made by dissolving resins (usually *amber, copal, or sandarac) in drying oils such as *linseed. Quicker drying varnishes are usually made from *mastic or *dammar resins dissolved in essential oil of *turpentine or petroleum: they can only be applied to paintings in which the paint has dried thoroughly. Temporary varnishes, which are removed about a year after the painting has been completed and are replaced with a permanent varnish, are made of albumen (usually white of egg). Spirit varnishes, in which alcohol acts as the solvent, were particularly popular in the 18th century and used as a *fixative for *watercolour or *tempera. Most varnishes deteriorate and darken with age, inevitably affecting the appearance of a painting. They can be difficult to remove, though this is one of the most frequently performed of a restorer's tasks. The situation is particularly complicated if coloured varnish has been used as a final *glaze.

vault An arched covering in stone or brick (occasionally in wood or plaster) over a room or space in a building. Vaults are particularly associated with *Romanesque and *Gothic church architecture. The simplest type is the *barrel or tunnel vault, known since Roman times, a continuous semicircular arch supported on either side by thick walls. A groin vault is formed by the intersection of two barrel vaults. A rib vault has a framework of diagonal arched ribs. A fan vault, essentially a tunnel vault with rich rib patterning, is formed of concave-sided cones or funnel shapes with their rims meeting at the apex of the vault with flat spaces between them. The entire surface of the ceiling is decorated with panels. Fan vaulting is found in English *Perpendicular architecture but not on the Continent.

veduta [From the Italian, 'view'] used to describe a painting, drawing, or a print of a landscape or townscape depicted with sufficient accuracy for

topographical identification. The term is particularly associated with 18th-century Italian art, for example Canaletto's paintings and Piranesi's great series of prints *Vedute di Roma* (published from 1745 onwards). A painter of vedute can be known as a *vedutiste* and an imaginary view which nevertheless appears realistic can be called a *veduta ideata*.

vellum A writing material, vellum is a fine kind of *parchment made from the delicate skins of young (sometimes stillborn) animals. During the *Renaissance parchment and vellum were almost entirely superseded by heavy, hand-made *paper.

velvet A silk textile with a pile, which was introduced to Europe from Persia. Italy was the main centre of production in Europe from the 13th century. Patterns can be made by cutting some areas of the pile.

veneer A technique of furniture decoration, developed in the later 17th century, whereby thin slices of fine wood such as *ebony, *rosewood, or *tulipwood are applied to the surface of furniture, the *carcase of which is made with coarser wood. Other materials such as *brass, *copper, *ivory, *pewter, and *mother of pearl can also be used in combination with such woods. Veneering is easier on a flat surface, but many superb examples of European furniture have complex veneering in which the thin slices of wood have been bent to match the moulding of the main body.

Venetian glass *Glass produced in Venice and the surrounding area from the 10th century. In 1292 most Venetian glassmakers moved to the island of Murano in the Venetian lagoon. By the end of the 16th century 3,000 of the inhabitants were involved in the industry, forming a tight-knit, secretive community. During the 15th century they had developed *cristallo* glass, which was very clear and could be blown into fine and elegant shapes of fragile appearance. Other techniques which the Venetians developed were *millefiori (a thousand flowers), an arrangement of coloured glass canes; *latticino*, lacy inclusions of coloured glass; and *reticello*, filigree glass. The growth of glass industries elsewhere and the invention of *lead crystal glass in England in the late 17th century led to the decline of Venetian glass. A successful revival began in the mid-19th century, when the Salviati glass house and others imitated the earlier fancy glass designs. In the 20th century Venini created unusual, modern designs which show the original qualities of Venetian glass.

Venetian window *See* Serliana.

verandah An open gallery or shelter set against a building with light, usually metal, supports. Its main purpose was to protect the principal rooms from the sun and it could be closed off to form a conservatory. Verandahs first became popular during the *Regency period.

verdigris A light bluish-green *pigment made of hydrated copper acetate. One of the earliest artificial pigments, it was made by the Greeks and Romans but eventually abandoned in the 19th century due to its instability in reaction to other pigments and to the atmosphere.

verism An extreme form of realism in which the subject is reproduced with rigid truthfulness and scrupulous attention to detail. The term has been applied to late Roman portrait sculpture, and more recently to aspects of such 20th-century art movements as *Superrealism and *Magic Realism, and to the *Surrealist painter Salvador Dalí and other artists who worked in his manner.

vermiculation [From the Latin *vermiculus*, 'a small worm'] a form of *rustication or surface decoration of masonry blocks with stylized features like worms or worm-holes. More generally the term is used to describe decoration with irregular wavy lines, for example that found in certain types of *mosaic work.

vermilion A brilliant, light-red *pigment manufactured from mercuric sulphide. Widely used from medieval times until the 20th century, vermilion is not wholly reliable and can darken, especially when not protected by *varnish, *wax, or *glazes. Vermilion was replaced in the 1920s by the completely reliable cadmium red.

vernacular A term used to describe local building styles or types, made with indigenous materials and without any pretensions to architectural grandeur.

vernicle The cloth or kerchief with which St Veronica wiped the face of Christ on His way to Calvary and upon which His features miraculously appeared. In the Middle Ages the name Veronica was thought to derive from *vera icon*, 'true image'. The subject of St Veronica holding the vernicle (or sudarium) was very popular in art from the 15th to 17th centuries.

Verona marble A *limestone that can be polished and varies in colour from deep orange pink to pale cream. It always has a mottled pattern and is quarried in the Adige valley between Trent and Verona. It has been widely employed in Lombardy and the Veneto—much of Venice is paved with it.

verre églomisé A type of *glass decoration. A piece of glass is painted, gilded, or engraved on the reverse, which is protected by another sheet of glass, a coat of *varnish, or a layer of foil. The technique was known to the Romans and fine examples exist from the *Early Christian period, as well as from medieval and *Renaissance times. The name derives from that of Jean-Baptiste Glomy (d. 1786), a Parisian picture framer, who used this method for decorating glass picture mounts.

vestiary A room for storing vestments or other clothes.

vestibule The anteroom or entrance hall to a larger space such as an apartment or building (in Latin *vestibulum* was a court in front of a Roman house with access to the street on one side).

vestry Sometimes called a *sacristy, a room next to the *chancel in a church in which sacred vessels and vestments are kept.

Victorian A general label applied to the art and architecture produced in Britain and its empire during the reign of Queen Victoria (1837–1901). The style most popularly associated with the period is that of the *Gothic Revival, with its love of rich, heavy colouring and historical use of motif. In the fine arts 'Victorian' has come to be associated with somewhat reactionary, academic art, technically of a very high standard, but turgidly regurgitating subjects from literary (especially medieval) and biblical history. The heavy-handed moralizing of much of this art has been seen as a further negative factor in the popular view of much Victorian painting. However, Victoria's reign was an exceptionally long one and in its later stages also encompassed such seemingly 'anti-Victorian' groupings as the *Aesthetic Movement and the *Arts and Crafts Movement. Furthermore, the Victorian period in general has undergone a major critical rehabilitation in the later part of the 20th century, beginning with the foundation of the Victorian Society in 1958.

video art Video made by visual artists, it originated in 1965 when the Korean *Fluxus artist Nam June Paik made his first tapes on the newly available Sony portable video camera and showed them a few hours later at the Café a Go Go in Greenwich Village, New York. Video is a medium, not a style, and embraces an extremely wide range of activity and level of achievement.

vignette Originally deriving from the French *vigne* ('vine') and used to describe foliage ornament in a manuscript, book, or decorative carving, it is now most commonly applied to an illustration or design that fades into the space around it without a definite border. It can also denote any small illustration placed at the beginning or end of a chapter or book.

Viking The Old Norse noun *víkingr* originally meant sea-pirate or raider. However, in art the term 'Viking' is now generally used to describe work produced in Scandinavia between the second half of the 8th century and the early 12th. Artefacts have also been found further afield on account of Viking expansion to Russia, Britain, Ireland, Normandy, Iceland, and Greenland. Much of the surviving art from this period consists of ornamental metalwork in which animal motifs play a prominent role. Sadly, only a few examples of wooden sculpture and textile have endured.

villa Originally a country house, but in modern usage it can denote merely a detached house. In Roman times the *villa rustica* was the headquarters of a farm or estate with accommodation for the owner's family, the steward, and the workers, and stalls for the animals; the *villa urbana*, however, was more of a pleasure-house set in a landscape, and had summer and winter quarters as well as facilities for leisure. In the *Renaissance the concept of the country house was expanded to include office wings and a design established, in particular by Palladio, that would be adapted in 18th-century Britain for buildings such as Lord Burlington's villa at Chiswick, just outside London. By the 19th century the term was used to describe a detached

house 'for opulent persons', usually located on the outskirts of a town or city.

vinaigrette A small box, usually *silver, with a pierced inner lid, used to hold a small sponge soaked in vinegar, an early version of smelling salts.

Vingt, Les The Association des Vingt was a group of twenty Belgian painters and sculptors who held annual exhibitions 1883–93 and whose members included James Ensor, Jan Toorop, and Henry van de Velde. They also showed the work of numerous leading avant-garde foreign painters and sculptors such as Van Gogh, Gauguin, Toulouse-Lautrec, Manet, Seurat, and Cézanne. The group was influential in spreading the ideas of *Neo-Impressionism and became the main Belgian forum for *Symbolism and *Art Nouveau.

virtu [From the Latin *virtus*, 'excellence', via the Italian *virtù*] in 18th-century England virtu meant a love for and knowledge of the fine arts. It is hardly used now, except in the phrase 'object of virtu', meaning a curio.

virtuoso Originally denoted someone who was learned in the arts or sciences. It was also applied to those skilled in distinguishing copies of antiquities from the originals. In England it came to be applied to professional artists. The 'Society of Virtuosi', founded in 1689, was composed of 'gentleman painters, sculptors, and architects'. In its modern usage virtuoso is usually applied to a musician or to a performance of exceptional technical merit and skill.

Visigothic A term used to describe the architecture and ornament (mainly goldsmith's work and jewellery) produced by the Visigoths, who ruled the Iberian peninsula from the 5th to the 8th centuries. Visigothic art was essentially a combination of *Roman and local *Byzantine styles.

vitreous The state of a *ceramic body which has been made non-porous after firing, without the addition of a glaze.

vitrine A glass-fronted cabinet used to display *china, *silver, and other small objects.

Vitruvian opening A doorway or window in which the sides incline slightly towards the top, so called because it was described by Vitruvius (fl. *c.*50–26 BC) in his *De Architectura*, the only surviving architectural text from antiquity. Vitruvian openings are found in *Neoclassical architecture, particularly that with Greek and Egyptian influences.

Vitruvian scroll A classical ornament, often used in an architectural frieze, consisting of a series of waves. Also called a 'running dog' or 'wave' scroll.

volute [From the Latin *voluta*, 'a scroll'] a spiral scroll, used on *Ionic but also found in smaller format on *Corinthian and *Composite Order *capitals.

Vorticism A British artistic and literary movement (its members included Ezra Pound and T. S. Eliot) founded in 1914 by Wyndham Lewis, editor of *Blast* magazine. Vorticism was viewed by Lewis as an independent alternative to *Cubism, *Expressionism, and *Futurism. The term was defined by Pound, Lewis's co-contributor to *Blast*, as follows: 'the vortex is the point of maximum energy. It represents, in mechanics, the greatest energy.' The Vorticists lambasted much that had gone before, including practically everything associated with the *Victorian era. Instead they advocated modernity, as reflected in the machine age, and clarity of definition. The movement held a show in 1915 at the Doré Gallery, London where exhibitors included Lewis, Gaudier-Brzeska, Jacob Epstein, Frederic Etchells, William Roberts, David Bomberg, and Edward Wadsworth. A second exhibition was held in New York in 1917, but by the end of the First World War in 1918 the destruction wrought by mechanization deterred further exploration of such imagery and the Vorticist movement had ceased by 1920.

voussoir (also known as a cuneus) the truncated, wedge-shaped bricks or stones which form an *arch.

wainscot The timber lining applied to walls, also used to describe the wooden panelling of *pews.

wallpaper Decorated paper applied to walls as a surface covering by means of a paste glue. It could be found in France and England as early as the late 15th century as a cheap alternative to leather hangings, *tapestry, or painted cloth. By end of the following century it was in fairly widespread use. The earliest examples (of which none survive) were probably hand-painted, though simple block-printing soon came to be utilized for the printing of repeated patterns. Hand-painted wallpaper was also imported from China in the early 18th century. France took the lead in wallpaper manufacture in the later 18th century, partly in response to the Revolutionary government's belief in wallpaper as an essentially democratic form of domestic decoration, culminating in the great scenic wallpaper developed by Zuber and Dufour in the early 19th century. Around this time, also, various wallpaper-printing machines were first developed which led to the production of relatively cheap rolls of wallpaper which were widely available by the mid-19th century.

walnut A hardwood that ranges from light to dark brown in colour with black or dark brown veining. It comes from the European tree *Juglans regia*. In England it was the most prized wood for furniture from the Restoration until the introduction of *mahogany in the early 18th century. It was also very popular on the Continent in the 16th and 17th centuries.

walnut oil Derived from the common walnut, it was one of the earliest oils to be employed for *oil painting, but is little used today. Although it dries more slowly than *linseed oil, it has a tendency to turn yellow.

Wanderers A group of Russian artists associated with the Society of Wandering (Travelling) Exhibitions, a body founded in 1870 by a number of artists who resigned from the Imperial Academy of Arts in St Petersburg because of its rigid traditionalism. They toured their works around Russia and painted in a *Social Realist manner, depicting scenes of peasant or middle-class life intended to arouse pity or inspire the oppressed to better themselves. The Society, which numbered Ilya Repin (1844–1930) and other leading Russian painters among its members, lasted until 1923, but by then it, too, had become conservative in the art it promoted.

warp In a woven fabric, the warp consists of the fixed, thicker threads, set up on the loom to provide the framework for the thinner *weft threads.

warping The crooked state of a *canvas or *stretcher produced by uneven expansion or contraction.

wash An application of diluted ink or transparent *watercolour to paper.

Washington Color Painters The name given to a group of painters, the two most prominent of whom were Morris Louis and Kenneth Noland, who were exponents of *Colour Field painting in the 1950s and 1960s and were based in Washington, DC.

watercolour A type of paint in which water is the dispersal agent. The particles of *pigment are bound together by a colloid, usually *gum arabic, which is spread on to the painting surface, normally paper, by the action of a brush loaded with water. After the water has evaporated the pigments remain bound to the paper by the gum arabic. Most watercolour is transparent, allowing the white of the paper to shine through and giving a luminous effect determined by the degree of dilution of the watercolour. However, when mixed with *Chinese or *lead white, the watercolour becomes opaque and is known variously as *gouache or *bodycolour. Varieties of opaque watercolour were used in medieval manuscript illumination. Some of the earliest watercolours in the modern sense were the landscapes and nature studies produced by the German painter Albrecht Dürer at the end of the 15th century. The materials necessary for the production of watercolours were compact and light and rapidly became popular with travellers, both professional and *amateur artists, for the recording of their journeys. Originally these materials would have been purchased in unmixed form from the apothecary's shop, but by the later 18th century in Britain (where watercolour was particularly popular) they were manufactured in small cakes (as found in the watercolour box of today). In the 19th century they were also manufactured in tubes, similar to those used for oil paints. The early decades of the 19th century can justly be claimed as the great age of watercolour when its exponents included such masters as Cotman, Girtin, and Turner. They also saw the foundation of artists' societies specifically devoted to the promotion and exhibition of watercolours such as the Society of Painters in Watercolour (1804). During the Victorian era watercolours were avidly collected by the newly emerging industrial and middle classes and were particularly championed by the artist and critic John Ruskin. As a medium it has continued to be popular to the present day.

Waterford glass The most famous Irish glassworks, founded in 1784, renowned for its deeply cut *glass vessels and chandeliers, particularly of the *Regency period. It finally closed in 1851, unable to compete with English glassmakers.

water gilding The technique of adhering precious metal leaf to a *gesso or *bole *ground that is moistened with water before each leaf is laid. It is employed for a wide variety of purposes including fine quality picture frames and decorative work, *illuminated manuscripts, the decoration of book covers, and the gilding on *tempera *panel paintings. Unlike *mordant gilding, water gilding can be burnished to a high degree of finish.

water-glass painting A technique of mural painting, developed in the early 19th century, that was intended to prove resistant to the harmful

effects of damp and pollution. It is essentially a variation of *fresco painting whereby, after the design has been painted (using a mixture of *pigments and water) on to the plaster, it is coated with a solution of water-glass (potassium or sodium silicate) which provides a protective film after it has dried. It proved unsuccessful, however, when employed for some of the mural decorations in the House of Lords as the paintings deteriorated within ten years. It was known as 'stereochromy' by the Victorians.

watermark The mark of a *paper manufacturer, it can be included in either *laid or *wove paper by incorporating a wire pattern in the mould in which the paper is made. These marks can usually be identified from the various dictionaries of watermarks which have appeared.

wax A malleable substance produced by bees to form the cells in a honeycomb. It has been used in sculpture since early times as the material in which sketch models were first worked out. When employed for *casting or modelling it is often shaped around a supporting *armature. Perhaps the most famous wax sculptures were Degas's ballerinas, the lost originals of which were originally in wax and were then cast in bronze after the artist's death by the Hébrard foundry. Small coloured wax portraits in relief were pioneered in the 16th century by the medallist Antonio Abondio the Younger and were produced for a number of European courts. In the 17th and 18th centuries full-size effigies of martyred saints and dissected corpses were made in coloured waxes. *See* LOST WAX.

weaving The process of making a fabric by intermeshing twisted or spun threads. The *warp threads are stretched on a loom and the *weft threads are passed through them to create a criss-cross of threads.

Wedgwood The factory founded by Josiah Wedgwood (1730–95) in 1759 in Burslem, Staffordshire, and probably the most famous name associated with English *ceramics. Wedgwood spent his life experimenting with different ceramic *bodies, *pastes, and *glazes. His earliest success was a *creamware in 1758, made into simple, elegant shapes, plain or painted with decorative borders. He renamed it Queensware, after Queen Charlotte. Its success led to a commission to produce a 925-piece service for Catherine the Great of Russia, known as the 'Frog' service, much of which still survives in the State Hermitage Museum, St Petersburg. From 1769 to 1780 Wedgwood went into partnership with Thomas Bentley, a Liverpool merchant. During this period the company began to copy vases of classical inspiration, initially in *black basalt. He also developed *jasperware, a fine-grained *stoneware, coloured throughout the body, usually blue but sometimes green, lilac, or yellow. Classical-style decoration in white was applied to the surface and the vases and ornamental wares produced in this style were suited to the fashionable *Neoclassical interiors of the architect Robert Adam. Wedgwood set up a new and efficient factory, which he named 'Etruria', outside Burslem, regarded as a model of its kind. Products included large ornamental vases, plaques for decorating interiors, and small medallions for portraits, furniture, and buttons, all of which were

widely exported to Europe and America. The Wedgwood factory continued to make wares in the Neoclassical style during the 19th and 20th centuries. In the early 20th century it produced a range of *lustre-decorated pieces, including Fairyland lustre. It also created pottery designed by named artists, such as Eric Ravilious and Keith Murray. The factory was the first pottery to mark its wares systematically. It is still in production today.

weft The thinner threads in a woven fabric which cross at right angles to the thicker threads of the *warp.

Wemyss Pottery A type of pottery produced at the Fife Pottery, in Kirkcaldy, Scotland, from c.1883 until 1930, characterized by colourful decoration of flowers, fruit, and birds. The pottery, named after the Wemyss family at nearby Wemyss Castle, was run by Robert Methven Heron who employed the painter Karl Nekola (d. 1915) as chief decorator. The wide range of shapes, including large pigs used as door stops, were painted with cabbage roses, daffodils, sweet peas, plums, dragonflies, mottoes, and other motifs. In 1930 production finally stopped in Scotland, but the rights and moulds were bought by the Bovey Tracey pottery in Devon and Nekola's son moved there and continued to produce Wemyss-style ware until 1942. Wemyss is nearly always clearly marked.

whatnot A small wood stand with three or more shelves supported on four uprights, to hold books or small objects, popular in the 19th century.

whiplash curve A long and sinuous curve resembling a tendril of foliage, synonymous with the *Art Nouveau style.

white heightening The use of unmixed white *bodycolour to highlight various parts of a composition executed in *watercolour. This technique was particularly popular with British watercolourists around the middle of the 19th century.

whiting The preparatory layer of white mineral and animal glue which is used to cover *earthenware, stone, and wood prior to painting and *gilding. It is often loosely described as *gesso.

whole-length A term used to describe a painted portrait in which the entire figure of the subject is shown. In British portraiture a whole-length canvas is 90 × 60 inches (225 × 150 cm).

Wiener Werkstätte The arts and craft studios established in Vienna in 1903 by members of the *Sezession group. They designed and made a wide range of artworks, from jewellery to complete room decorations. In their desire to combine usefulness with aesthetic beauty they mirrored the ideals of the Victorian artist and writer William Morris (1834–96). The workshops finally closed in 1932.

William and Mary style The style in the decorative arts and architecture which was predominant in England during the reign of William and Mary (1688–1702). The prevailing influences were naturally Dutch (William of

Orange was Stadholder of the Dutch Republic) and also French. The Revocation in 1685 of the Edict of Nantes led to the flight to England of numerous Huguenot craftsmen, many of them silversmiths and weavers. There was a resulting wider awareness of elegant French designers such as Ducerceau, Le Pautre, and Marot, while in architecture motifs such as the Dutch *gable were adopted.

willow pattern An English interpretation of a Chinese story set in a landscaped pleasure ground, which first appeared on blue *transfer-printed *earthenware.

Windsor chair A traditional English chair, with shaped wood seat, into which the legs and the spindles of the back are dowelled. They have been made since the 17th century, principally in High Wycombe.

woodcut A printmaking technique of printing in relief from a wooden block usually made from the plank of a fairly soft wood. The artist draws the design either directly onto the block or onto a sheet of paper which is then glued onto the block. A specialist is usually employed to cut away, with *gouges and *chisels, the wood at the sides of the lines the artist has drawn. The block is then inked and printed from, using either a printing press or hand pressure. Printing from woodblocks was invented in China but did not reach the West until the 13th century when it was at first used for printing designs onto textiles. The earliest woodcuts on paper date from the late 14th century and the technique soon became widely used for the production of relatively crude playing cards and religious imagery. Only in the late 15th century was it taken up by artists of the first rank such as Albrecht Dürer in Nuremberg, stimulated by the need for illustrations for printed books: type and woodblock could be printed in combination from the same press. Dürer's own great series of the *Apocalypse* (1499) and the *Great Passion* and *Life of the Virgin* (1511) originally had facing texts. The technique spread to other Germanic centres, but by the mid-16th century its popularity began to decline. The Netherlands, France (Paris and Lyons), and Italy (Florence and Venice) also had significant woodcut traditions. After 1600 there were sporadic revivals of the woodcut in the Netherlands (Jegher's woodcuts after Rubens) and in England (Hogarth's *Four Stages of Cruelty*), but it was only seriously taken up again in the late 19th century by artists such as Gauguin and Munch. In the early 20th century it was the favoured printmaking technique of the Dresden-based group of *Expressionists, Die *Brücke.

wood-engraving Something of a misnomer, it is a type of *woodcut, but more durable and capable of finer detail and being printed in larger editions. The design is cut away not with a knife, as in woodcut, but with the engraver's tool, the *graver or *burin. A very hard wood, such as boxwood, is used and cut across the grain ('end-grain'). As box has a small diameter, larger designs can only be achieved by combining a number of blocks, the relative heights of which can be varied when they are bolted together to give different qualities to the various parts of the design. The

technique developed out of the European woodcut tradition and was used from the 17th century onwards for book illustration, particularly vignettes and tail-pieces. In England it is particularly associated with the *vignettes of animals and landscapes designed and engraved by Thomas Bewick (1753–1828), and with William Blake's illustrations to Thornton's *The Pastorals of Virgil* (1821). From around 1830 onwards wood-engraving was very widely used in the commercial sense in Europe and America for the illustrations of works published in very large editions. Technological advances meant that from about 1860 it was possible to transfer a design photographically on to a block without the need for drawing on it. Wood-engraving also enjoyed sporadic revivals as a 'fine art' technique, most notably in England between the two World Wars.

Worcester porcelain One of the leading English *porcelain factories. Founded in 1751, it purchased the *Bristol factory of Benjamin Lund in1752 and so acquired much technical expertise. The factory soon began producing good quality, thinly potted, and durable *soft-paste porcelain. It made large quantities of tea and coffee wares and decorative vases, although figures were rare. The factory pioneered the use of *transfer-printing, from 1757 in black, and by 1760 in *underglaze blue. Some elaborate and richly painted pieces were decorated outside the factory, by London-based artists such as James Giles. During the first part of the 19th century much fine painting was produced within the factory. In 1862 it became the Royal Worcester Porcelain Company, creating many elaborate, richly gilded wares; by the end of the century the factory had assembled a team of many highly talented painters, such as Harry Davies and the Stintons. The factory is still in production today.

workshop/studio of A cataloguing term denoting that the work of art in question is by an unknown artist trained by a particular master or working in his studio, for example 'workshop/studio of Rubens'.

wove paper Was developed in 1755 in order to provide paper with a smoother surface than *laid paper. It is made from a tray with the mesh so tightly woven as to leave no marks.

Wrenaissance An architectural style of the 1880s in Britain, deriving from a study of the work of Sir Christopher Wren (1623–1723). Its chief practitioners were John Belcher and Mervyn Macartney.

Wunderkammer [German, 'collection of curiosities'] by the end of the 16th century the term was virtually synonymous with *Kunstkammer. However, it was originally used in mid-century to describe a room containing a private collection of rare natural history specimens such as corals, but above all curiosities such as mandrakes, misshapen antlers, or narwhal tusks. Wunderkammern were predecessors of natural history *museums.

X, Y, Z

x-ray photography Photography which uses x-radiation or gamma radiation to penetrate objects that are opaque to light. Such examination is frequently made of paintings to determine paint loss, repaints, and, in certain cases, can reveal underlying compositions which may be completely different.

xylography A now semi-obsolete term which describes any type of printing from a wooden block, including both *woodcut and *wood-engraving.

YBA An abbreviation of 'Young British Artists', a term developed from the eponymous title of the first (1992) in a series of exhibitions by young British artists (mainly in their late 20s or 30s) at the Saatchi Gallery, north London. Leading artists included Damien Hirst, Rachel Whiteread and Tracy Emin.

yew A reddish-brown hardwood much used on the best English provincial furniture of the 17th and 18th centuries, either as a *veneer or in solid form.

Zeitgeist [German, 'spirit of the age'] is a term most generally used to evoke the intellectual and artistic atmosphere of a particular epoch. More specifically, *Zeitgeist* was the title of an exhibition of *Neo-Expressionist paintings held in Berlin in 1982 and is sometimes synonymous with Neo-Expressionism.

ziggurat [Assyrian *ziqqurati*, 'pinnacle'] a high, pyramidal, staged tower found in temple complexes in ancient Mesopotamia and Assyria (where the stages were developed into one continuously inclined ramp round the four sides of the tower). The term is also often applied generally to stepped, pyramidal shapes in *classical architecture.

zinc A white metal essential to the manufacture of the copper alloy *brass and which is sometimes also alloyed with *silver. It was much used for *cast sculpture in the 19th century, overlaid with a varnish intended to resemble the colours of *bronze.

zincograph A type of *lithograph in which a suitably prepared sheet of zinc is substituted for the more traditional slab of *limestone and from which the image is printed.

zinc white A brilliant, snow-white *pigment, zinc white (zinc oxide) first became commercially available as an alternative to *lead white in the 1830s (it was marketed in *watercolour form by the English firm of Winsor and Newton as *'Chinese white'), and by 1850 it was regularly made as an oil paint.

zoomorphic ornament Ornament, usually linear, based on the stylizations of various animal forms. *See* ANIMAL STYLE.

Zwischengoldglass [German, 'glass with gold between'] *glass of two layers which sandwiches gold decoration between, first developed by the Romans in the 4th to 6th centuries and revived in Germany in the 18th century.